Songbird Carving

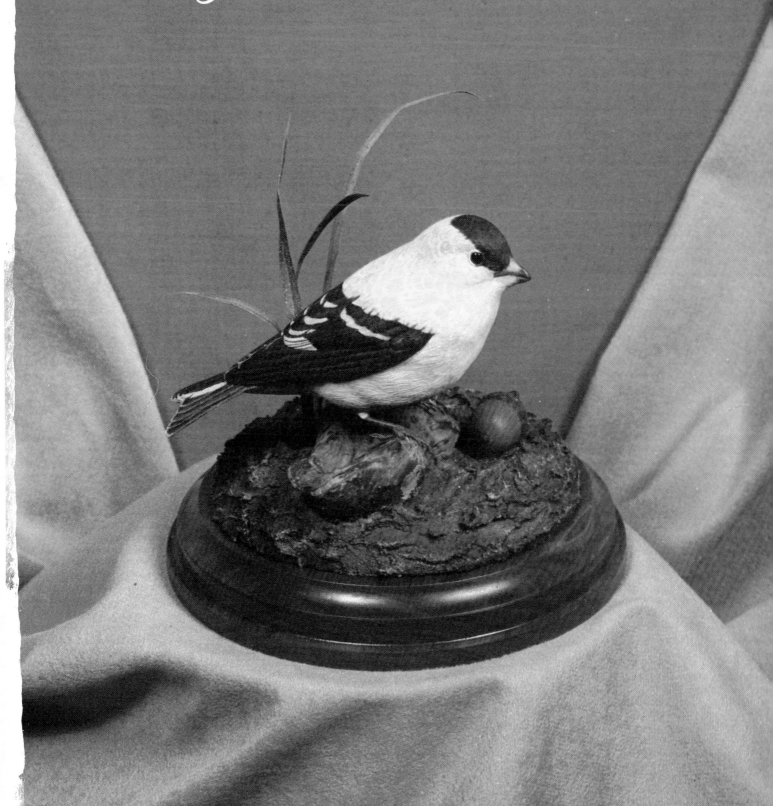

Dedication

This work is dedicated to my father and mother,
Brady and Dorothea Leach, for continually opening
my eyes to the wonders and beauty of nature.

Printed in the United States of America.
ISBN: 0-88740-057-4

Published by Schiffer Publishing, Ltd.
1469 Morstein Road
West Chester, Pennsylania 19380
Please write for a free catalog
This book may be purchased from the publisher.
Please include $2.00 postage.
Try your bookstore first.

Foreword

The combination of talent, determination and hard work generally produces great results. Such is the case, once again, with the efforts of Roz Daisey and Pat Kurman.

I first met Roz at a six day long seminar which I conducted and by Thursday she was quite sure she was so far behind the group that she would never finish—but finish she did—remarkably well in fact. This was in late summer and having spent some time with Avis Brown carving animals, Roz was on her way to becoming a fine carver. She stayed with regular weekly classes and by the following spring it was my great pleasure to call and inform her that she had won her first Best of Show at The U.S. National Decoy Show.

Since that time she has grown and matured as an artist. She has accepted the opportunity of teaching and conducts song bird and habitat seminars. She has also achieved a great many ribbons and awards and has shown at the most prestigious shows in the country.

Pat Kurman's flip presentation may fool some people initially but not for long. One is quite soon impressed by the "dead serious" attitude with which she approaches her work. Her first competition bears this out. She had taken some classes and it was only three weeks until the "World". She had just finished her first class project and I issued a challenge which she grabbed. I suggested she do a Woody Hen, a quite difficult project, for the World competition. She did it in three weeks while working a full time job and won her first Blue Ribbon.

The rest of the story is interesting history. She has won so many blues and best of shows that it is almost incomprehensible.

Pat also rose to the challenge of teaching and has conducted many seminars. In addition she is quick to share her knowledge with others and has added the further dimension to her art by judging the competitions.

Somewhere along the way Roz and Pat became friends after sharing ideas at shows, traveling together and being totally supportive of each other as artists.

Having earned the respect of one another it was natural when the opportunity came about for this book, that they collaborate.

I have seen the work—the carvings are exquisite and alive. The drawings and paintings are magnificent. As a result of this collaboration a major work is being added to the body of literature in the carving field—beyond that there is a whimsical magic in the work that will appeal to everyone interested in birds, and further I am quite certain that because of the quality of the sculpture, drawing and painting this will also become a reference for artists as well as carvers.

I am proud to have had a small part in creating this project. I am prouder still of my association of these two great artists.

Bill Veasey

Songbird Carving

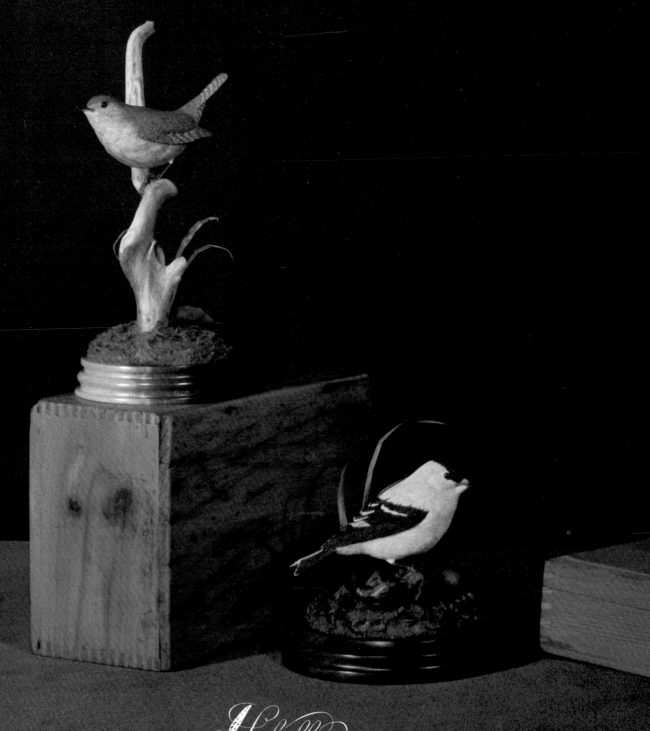

Schiffer Publishing Ltd

Rosalyn Leach Daisey
illustrated by Sina Patricia Kurman

Acknowledgments

My sincerest thanks to Bill Veasey for all his help and encouragement over the years, as well as his suggestion for the need of this book. Here is a man who has singlehandedly been one of the greatest influences and catalysts advancing the art of wooden bird sculpture.

I would like to thank Jack and Betty Holt for generously and warmly sharing their perception and knowledge of birds and nature and the need for accuracy in carving.

My warmest thanks to Tom Donnelly for his support and encouragement, as well as his research on bird anatomy.

I would like to thank Dr. David Niles and the staff at the Delaware Museum of Natural History for their helpful assistance.

For my first introduction to nature carving, I would like to thank Avis Brown.

My thanks to the Kurmans for provinding me space for completion of this book.

A very special thank you to my children, Jason and Jenna Daisey and to my friend, Buddie Kurman, for helping with the photography and for their encouragement and enthusiasm for this project.

My sincerest thanks to Lyn Kelley, Nancy Schiffer and Ellen Taylor of Schiffer Publishing for their much needed assistance and for providing such a warm atmosphere in which to work.

Rosalyn Leach Daisey

Contents

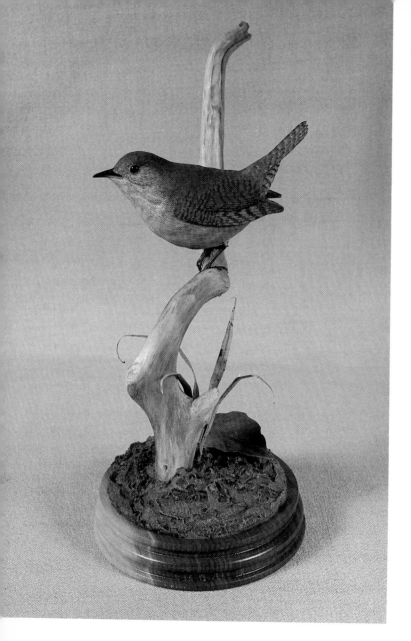

Introduction

The format of this book is a photograhic, illustrated and step-by-step instruction for the carving, texturing and painting of five songbird projects. Each project is completed by the construction and painting of the habitat. Techniques are provided for the following: accurately measuring and depicting the species; realistically shaping and carving; precisely defining individual feather groups; executing burning and stoning techniques for varied naturalistic effects; constructing feet; and painting with depth, softness and color accuracy.

To insure anatomical understanding and realism in the finished bird, there are accurate measurement charts of each project, as well as many illustrations with accompanying text on bird anatomy. There is an entire chapter on how to change the attitude and position of a bird carving. There are specific color illustrations, a step-by-step photographic exposition and instructions for the entire painting procedure of each bird.

Since bird carving is a developmental art, the projects increase in complexity from the first through the fifth. It would be advantageous to preview all the chapters before undertaking the more complicated projects, even though each is complete unto itself.

The close proximity of songbirds makes them ideal subjects for study. It is intriguing to watch a titmouse, holding a sunflower seed under its toes, while hammering the shell with its beak. Songbirds' physical characteristics and habits are fascinating areas for study and observation.

It is with great enthusiasm that I share with you all of the information in this book.

Rosalyn Leach Daisey

Song Bird Basics

To recreate anything, one must know its configuration—that involves study. If one were to ask any bird carver about knowing the birds, the first thing he or she would say is to spend time watching the birds. A feeder is helpful in bringing the birds into view, but a visit to a park, refuge or even a fast food place will give you a "bird's eye" view. Of course not all birds are the same but there are many similarities. Each bird generally has the same basic feather groups though they may be of different shapes, lengths and/or colors.

The more you become involved with bird carving the more you will find yourself delving into this fascinating subject of birds. Each time you do a new species, you will find out something you did not know about that bird. Make it a habit to research a new bird thoroughly to find out its habits, habitat, range and diet. But no matter how much you research, nothing will replace first-hand observation. Field study cannot be emphasized too highly.

GENERAL ANATOMY

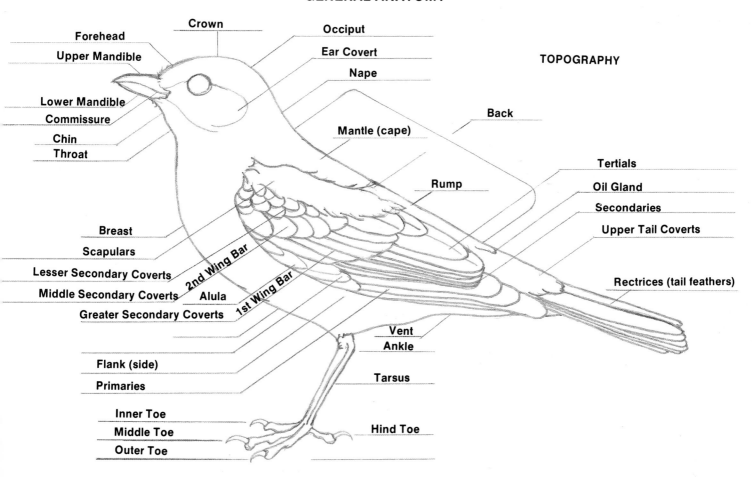

TOPOGRAPHY

Figure 1. All the feathers of a bird have developed to make powered flight possible. Being warm-blooded, birds flourish even in the colder regions. Lightness is the most important feature of a bird's anatomy, though their skeletons have similarities to other vertebrates. The larger bones are hollow with internal struts for strength and the other bones such as the skull, are very thin to decrease the amount of weight and enable a bird to get its body off the ground for flight. Their bodies are stream-lined and aerodynamic so as not to restrict airflow.

When thinking of anatomy, consider the points of origin: that is, where the parts originate. If you are having difficulty with the tail, for example, consider where the tail attaches to the body. Most people have a difficult time realizing that the tail begins far into the body. Some people want to bend a tail right at the upper tail coverts, but that is not correct anatomically.

HEAD

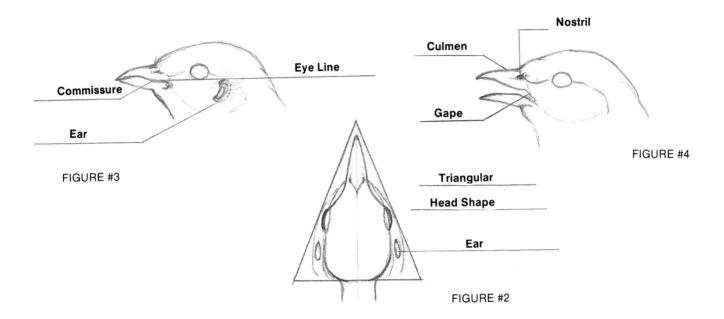

Eye Line

Commissure

Ear

FIGURE #3

Culmen

Nostril

Gape

FIGURE #4

Triangular

Head Shape

Ear

FIGURE #2

Figures 2, 3 and 4. When looking at the topside or underside view of a bird, you realize the head is basically wedge-shaped because the skull is that shape. With the addition of feathers, there will be some rounding of the contour, but the basic shape will not change. The upper surface of the head consists of three parts: the forehead or front of the head, the crown or top of the head, and the occiput or back of the head. The chin is the area underneath the beak. There is an ear opening on each side of the head which is covered by a patch of ear covert feathers (Figure 3). Exact eye placement will be covered specifically in each project chapter, but generally the bottom of the eye rests on an imaginary line drawn through the middle of the beak and extended to the back of the head (Figure 3).

The lower mandible has more movement, although the upper mandible does have slight upward movement. The gape is the space between the upper and lower mandibles when they are opened (Figure 4). The commissure is the line where the mandibles meet when they are closed (Figure 3). The top ridge on the beak is the culmen (Figure 4). The nostrils, one on each side of the culmen, are located at the base of the beak (Figure 4) and, sometimes they are exposed and sometimes they are covered by bristly feathers called rictal bristles.

Figure 5. The upper and lower mandibles which make up the beak are composed of a horny covering similar to human fingernails. Each bird's beak has adapted over the years to the kind of food it eats.

Black-capped Chickadee ___

Tufted Titmouse ___

Goldfinch _____

Cat Bird _____

House Wren _____

10

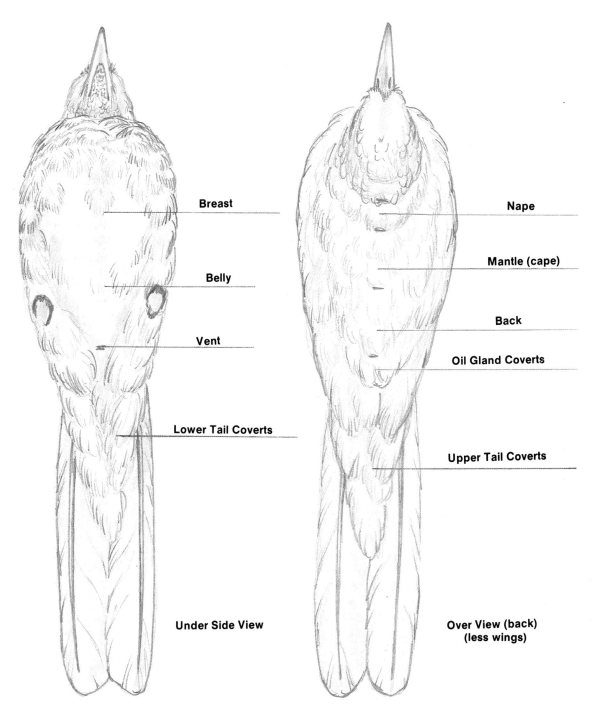

Breast

Belly

Vent

Lower Tail Coverts

Under Side View

Nape

Mantle (cape)

Back

Oil Gland Coverts

Upper Tail Coverts

Over View (back)
(less wings)

FIGURE #6

Figure 6. The back of the neck is called the nape. The base of the neck is attached to the trunk at an imaginary line drawn across the back at the level of attachment of the wings to the body. When the neck turns, the feathers covering the base of the neck travel with the movement— there is no spiralling of the feathers.

The upper back is covered by a group of feathers called the mantle (cape feathers). The lower back is covered with the oil gland coverts when they are present.

The breast is the upper portion of the underneath side. The area behind the breast is the belly, which extends to the vent (cloaca). The lower tail coverts are in the area between the vent and tail feathers on the underneath side. The lower tail coverts can be a totally different color than the belly and/or underneath surface of the tail feathers, such as in the catbird. The upper tail coverts cover the area between the body and the tail on the topside of the bird.

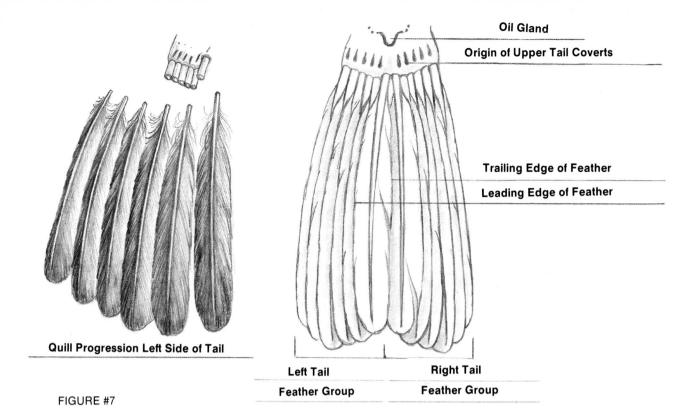

Oil Gland

Origin of Upper Tail Coverts

Trailing Edge of Feather

Leading Edge of Feather

Quill Progression Left Side of Tail

Left Tail
Feather Group

Right Tail
Feather Group

FIGURE #7

Figure 7. In all birds, the tail is used as a rudder for steering and for braking and in song birds is composed of two groups of six feathers. When a bird spreads or extends its tail, one group will fan to the right and the other group will fan to the left. A bird will generally lose and regrow all of its feathers at least once a year. When losing tail feathers at molting, a bird will usually lose the same feathers on both sides. An uneven number can be attributed to an accidental loss. Notice the location of the quills on the tail feathers. The outside feathers have their quills near the leading edges, or windward side. The closer a feather is to the midline the more the quill is in the middle of the feather.

Figure 8. The joint of the leg that is visible as a bird stands is often improperly called the knee joint. Actually it is similar to the ankle joint in humans. The tarsus (the foot bone) is sometimes covered by scales for protection. On the back of the tarsus, a sheathed tendon is sometimes scaled depending on the species.

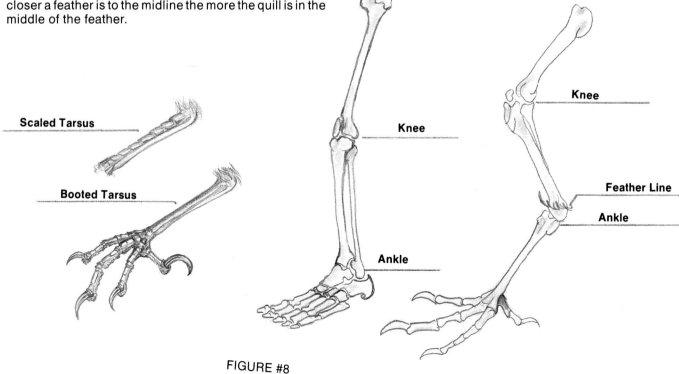

Scaled Tarsus

Booted Tarsus

Knee

Knee

Feather Line

Ankle

Ankle

FIGURE #8

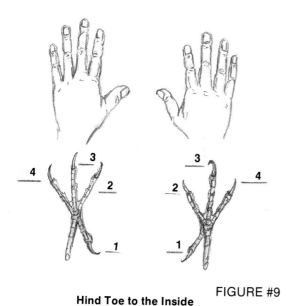

Figure 9. The toes are numbered 1 or hind toe, 2 or inner toe, 3 or middle toe, and 4 or outer toe and have that respective number of joints, including the joint at the base of the claw. Notice that the hind toe (similar to the human thumb) is not directly behind the tarsus but more toward the inside.

Figure 10. The wings are similar to human arms, but the structure of the joints in the wing assembly only permits movement in the plane in which the wing is folded. The primaries are attached to what is comparable to the human hand. The alula or thumb is joined at the wrist. The secondaries originate from the forearm. It is important to know the origin point so that when a wing is partially or fully extended you can place the feathers and quills properly. Always anticipate the placement of feather groups when designing the project.

Hind Toe to the Inside

FIGURE #9

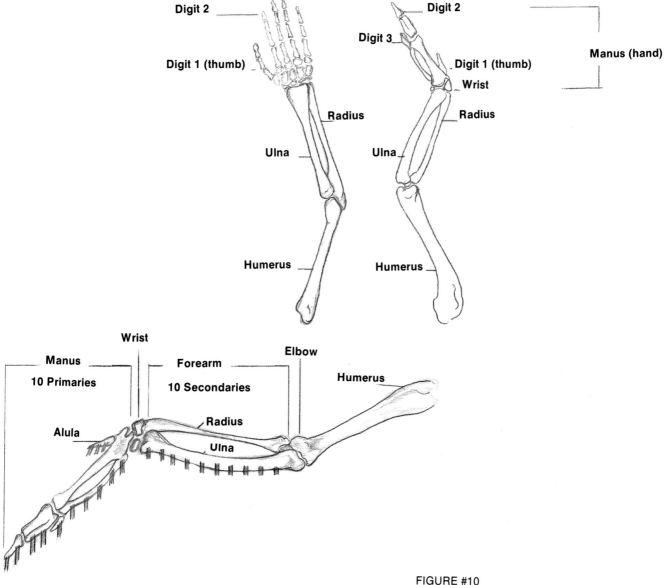

FIGURE #10

13

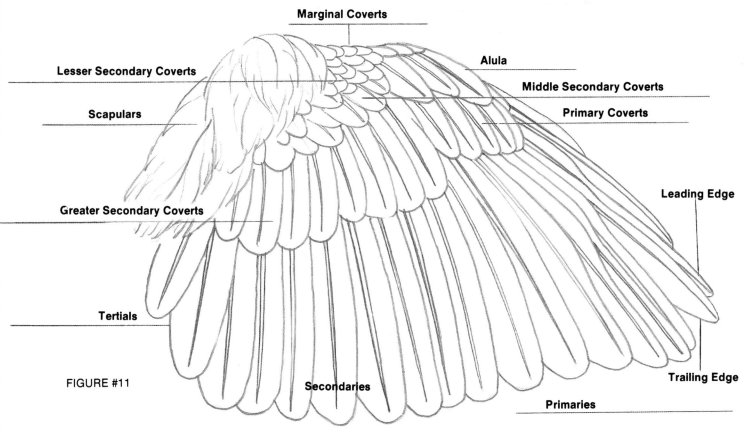

Marginal Coverts

Lesser Secondary Coverts

Alula

Middle Secondary Coverts

Scapulars

Primary Coverts

Greater Secondary Coverts

Leading Edge

Tertials

Secondaries

Trailing Edge

Primaries

FIGURE #11

Figure 11. As with the tail feathers, quill placement in the primaries is close to the leading edge in the first primary and is located almost center on the tenth primary.

The scapulars are the feather group that makes the bird's wing more aerodynamic in flight. When a bird is at rest with wings folded, the scapulars are usually not fully prominent, depending on the exact position of the body and wing.

Figure 12 Feathers provide a streamlined and smooth exterior to a bird, reducing wind drag and resistance. On the surface there are a number of feather tracts with areas of bare skin (or apteria) in between, which sometimes contain down for warmth. The areas of bare skin are not noticeable when the bird is fluffed up, but there may be some indentation in these areas, an important point to remember when contouring feathers.

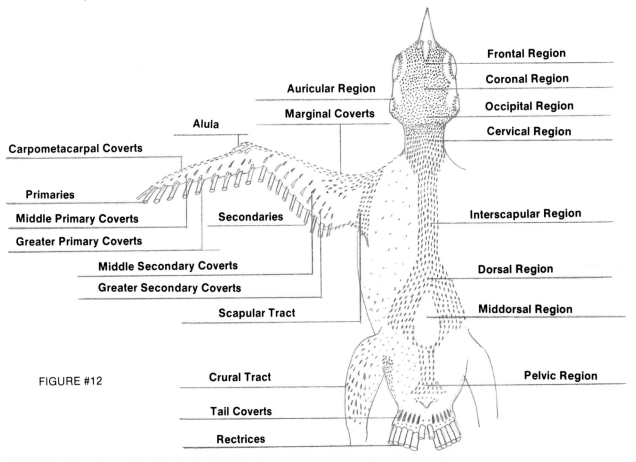

Frontal Region

Coronal Region

Auricular Region

Occipital Region

Marginal Coverts

Cervical Region

Alula

Carpometacarpal Coverts

Interscapular Region

Primaries

Middle Primary Coverts

Secondaries

Greater Primary Coverts

Dorsal Region

Middle Secondary Coverts

Greater Secondary Coverts

Middorsal Region

Scapular Tract

Crural Tract

Pelvic Region

FIGURE #12

Tail Coverts

Rectrices

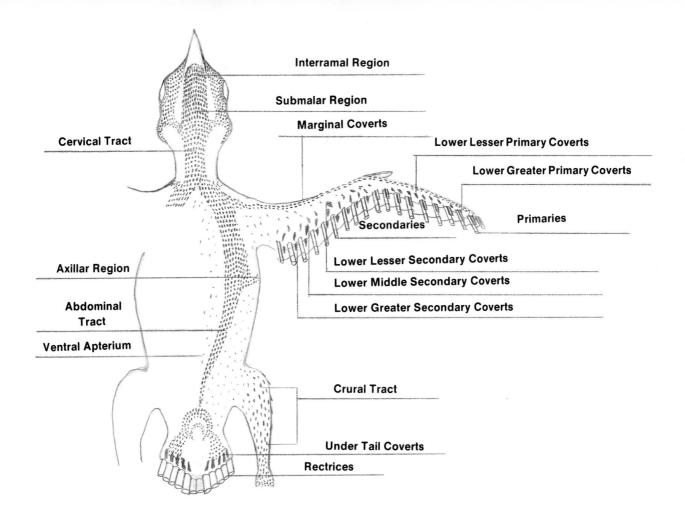

Interramal Region

Submalar Region

Marginal Coverts

Cervical Tract

Lower Lesser Primary Coverts

Lower Greater Primary Coverts

Secondaries

Primaries

Axillar Region

Lower Lesser Secondary Coverts

Lower Middle Secondary Coverts

Abdominal Tract

Lower Greater Secondary Coverts

Ventral Apterium

Crural Tract

Under Tail Coverts

Rectrices

It is *ILLEGAL* to have a dead song bird in your possession unless you have a Federal Non-Migratory Salvage Permit. If you should find a dead bird, check in your area for a natural history museum that might be interested in obtaining such a specimen. Most museums and some universities are usually happy to have donated specimens in good condition for their collections of study skins.

Before you dispose of or take the specimen to a museum or university, examine it closely. Study the feathers paying particular attention to the size, shape, color and location. Spread the tail feathers and notice what happens to the upper and lower coverts. Spread the wing, and look at all the different groups within the wing to see where they go in different wing positions. Open the beak and sketch the tongue and the inside configuraton of the upper and lower mandibles. Study the head, therin lies the life and expression of every carving and bird. Move the leg in different positions—notice where it comes out of the body feathers. Study and sketch the tarsus and toes—note the color and presence or absence of scales.

Keep a chart on each bird. Record notes on each bird that you examine and/or carve. Keep a folder of every species that you are interested in carving. The folder should contain notes from any specimen or study skin that you have examined, charts of measurements and any pictures that you have taken or obtained from magazines or brochures.

Before you finish with the specimen, take some measurements similar to those on the charts preceding each project. Hold or lay the bird in a natural position (head straight on, wing folded, tail straight). Measure the overall length, and width at the widest point of the breast. Remember that a dead bird does not have its lungs filled with air. When carving any bird, remember that there can be a 10% differential longer or shorter in every measurement. Do not become so exact on measurements that you get frustrated. They should only give you an idea about the relationships of the different parts. You can use artistic license. Not all birds of a species have all the same dimensions, but if you measure a bird, **you** will know that at least one bird in nature had that length of tail, width of bill, etc. You will be in the ballpark with your own measurements.

Some field guides and bird books have length measurements. These are usually longer than a bird will appear in nature because of the way a bird is measured. For this measurement, a bird is layed on its back in a stretched out position. *Birds of North America* by Robbins, Bruun and Zim (Golden Press, Western Publishing Co., Inc.) uses measurements of a bird in its natural position. All of the length measurements in this text were obtained with the bird in a natural upright position.

Some natural history museums will allow you to measure, photograph or sketch study skins at their facility if you are a member. It might be helpful to check out this possibility at your local facility.

Figure 13. Goldfinch Male

A study skin is a bird whose inner parts have been removed and, after preservatives have been applied, is stuffed with cotton and allowed to dry. Once a study skin has dried, its parts (such as the wing, tail, head, legs and feet) are not moveable. The length of a study skin would not be the same as the living bird in a natural upright position. You will not be able to get an accurate width or height measurement from a study skin; these you have to judge optically. The measurements from a study skin that can be used with confidence are the wing length and all of its parts, length, width and height of the beak, length of tarsus and tail length. The most important benefit of study skins is the coloration of the bird for painting. Some colors will fade slightly over the years, but if kept in darkness, this can be kept to a minimum.

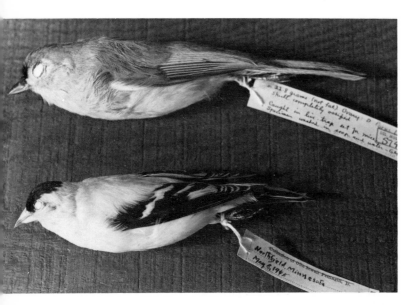

Figure 14. Titmouse and goldfinch study skins from the Delaware Natural History Museum of Wilmington, Delaware.

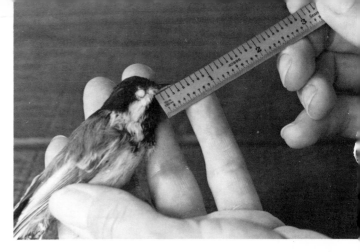

Figure 15. Measuring a chickadee beak on a study skin.

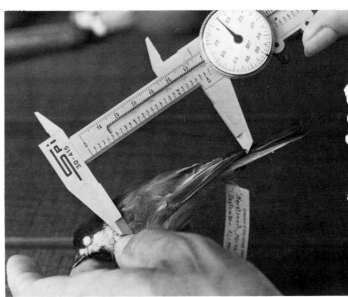

Figure 16. Measuring a chickadee's wing length (wrist to end of longest primary).

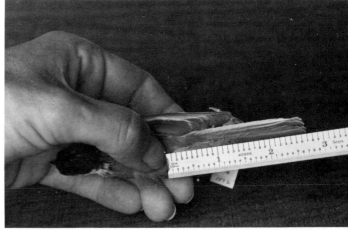

Figure 17. As study skins are dry and brittle, gently feel the base of the tail feathers and measure from the base to the end of the longest feather for the tail length dimension.

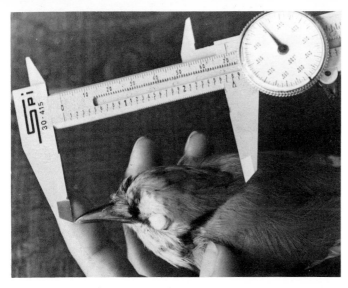

Figure 18. On crested birds (such as this bluejay) obtain a head measurement from the tip of the beak to the end of the crest.

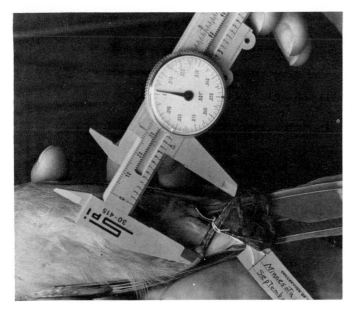

Figure 19. To obtain a tarsus dimension, measure from the ankle to the base of the toes.

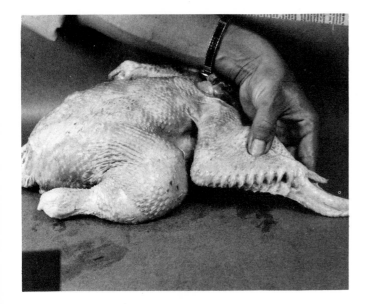

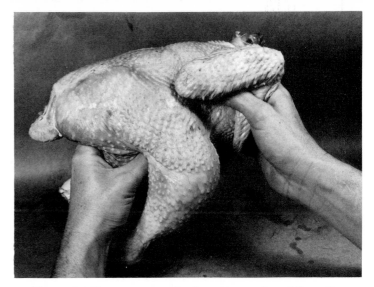

Figure 21. Here you see the insertion point of the tail. The upper tail coverts originate directly above the tail feathers and the lower tail coverts just underneath. If you observe the skin closely you can see the insertion points of the body contour feathers.

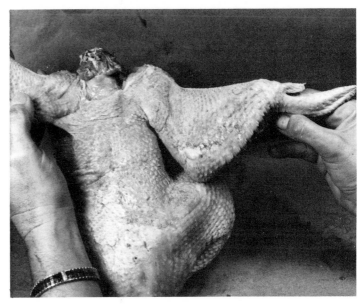

Figure 22. With the wing outstretched, you can readily see the shoulder, elbow, wrist and digits. At the shoulder joint of a bird, there is only to and fro or up and down movement—unlike man, whose shoulder has rotary motion.

Figure 20. Much information about bird anatomy can be obtained from observation and examination of a turkey or roasting chicken such as you see here. The tarsus, the ankle at the end of the drumstick, has been cut-off. You can also see the insertion points of the secondaries on the forearm. Note the position of the thumb or winglet where the alula originates.

Supplies and Tools

There are no hard and fast rules for what tools to use: the only criterion is that the task be accomplished. For example, in removing wood, there is no difference whether hand or power tools are used, only that the wood is removed. Different people work differently with different tools. The implements used, although important, are not the distinguishing factor between an excellent carving and a poor one.

Bird carving is an art you can accomplish with minimal expense. As you grow in knowledge and techniques, you can enlarge your tools as needed. To my way of thinking, I would rather spend more money for a good tool that, with care, will last a lifetime and will do whatever job is required. A good knife, usually only slightly more expensive, will hold its edge longer and cut the wood easier than one of inferior steel. By talking to other carvers and suppliers at wildfowl competitions and exhibitions, you can keep abreast of the new tools and supplies that are continually being developed.

KNIVES AND CHISELS

There are many knives on the market that are particularly well-suited for small bird carving. (Some are made by the Warren Tool Company, X-Acto and Cheston Knotts.) Remember when selecting knives and knife blades that comfort in the handle is important and that the size of the blade should be in proportion to the size of the carving. It is extremely difficult, though not impossible, to carve a chickadee bill with a 2½ inch blade. The smaller the area to be carved, the smaller the knife blade should be.

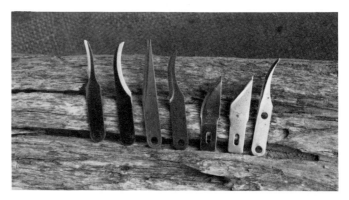

Figure 2. Although there are a variety of blades available, check for blade and handle compatibility. Blades are not always interchangeable between manufacturers.

Figure 3. You want knives and chisels that hold a keen edge for a long time. Knives that have thin blades with a long bevel, are ideal for cutting soft wood. From left to right: Cheston Knotts #8a, #11a, #9, #5 and #4.

For roughing out a song bird body, a 2-inch round-bladed knife (such as Knotts' #9) can clear away waste wood quickly. When you get down to finer detail, a shorter, round-bladed knife (Knotts' #8a) will do the job nicely.

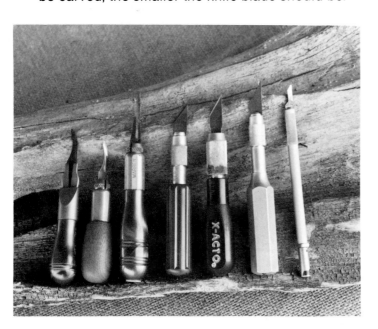

Figure 1. The three knives on the left are made by the Warren Tool Company. The four on the right are made by the X-Acto Company. Knives are used extensively. Find one that fits comfortably in your hand.

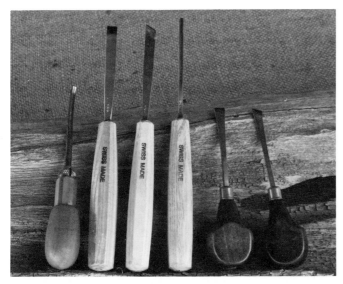

Figure 4. From left to right: Warren Tool's small v-tool, 2 Swiss Made chisels, a small v-tool from Woodcraft Supply, and 2 palm-handled chisels.

When cutting feathers in on the wings and tail, a small v-tool is useful for cutting the drawn outline. Chisels (straight, skew and fishtail) are useful for working the feathers to a rounded contour. A v-tool will not leave cut-lines which are difficult to texture and will draw the paint. For those of you who favor power tools, ruby carvers on a flexible shaft machine will accomplish the task of cutting out feathers similarly.

FLEXIBLE SHAFT MACHINE

Wood removal can be accomplished with power tools as well as chisels and knives.

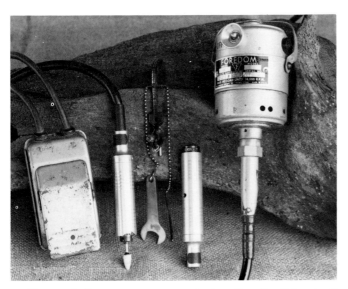

Figure 5. For many carvers today, the flexible shaft machine is the main tool in their workshop. It can take a lot of waste wood away quickly with a carbide bit.

There are a variety of handpieces available that will hold bits, burrs, mandrels or drills from the smallest wire drill available to large ¼ inch shank tools. The variable speed feature is controlled by either dial or foot pedal, depending on the model selected. The Foredom tool shown here has variable speeds from 0-14,000 RPM.

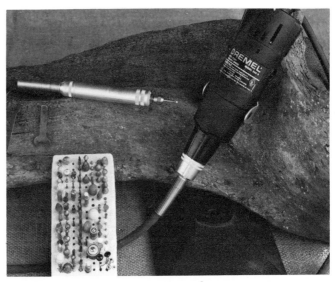

Figure 6. The Dremel Moto-Flex is another flexible shaft machine, though smaller in power and bulk. It has only one handpiece with various collets that hold the smallest wire drill to ⅛ inch shank tools. The handpiece is lightweight and small in diameter, making it very easy to use for long periods of time. There is a single speed model (Model 232) and a variable speed model (Model 332) that varies from 7,500-24,000 RPM with a twist of the dial. The single speed model can be connected to a rheostat dial or foot control, making it a variable speed tool.

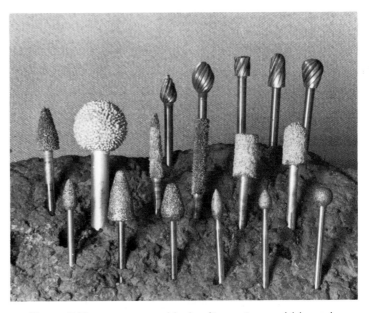

Figure 7. There are many kinds of tungsten carbide and tool steel bits available. Remember that the smaller the project the smaller the bit should be. Before purchasing every size and shape that you can find, you should buy one of each of the basic shapes (taper, ball nose, cylinder and sphere) in one of the smaller sizes. Use these for several projects and then proceed to add others as your needs dictate.

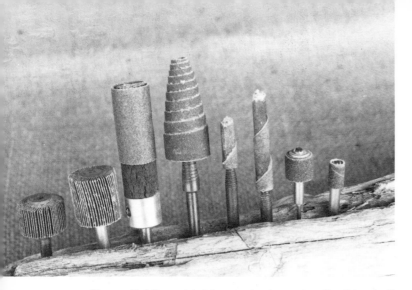

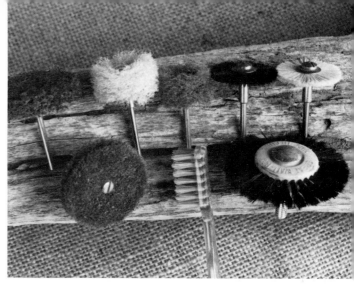

Figure 8. After a bird is rough shaped, a flexible shaft machine is very useful for handling the task of sanding out the knife marks or rough spots from the coarse cutters. For sanding, the cartridge roll sander ("tootsie roll") or small flap sander is helpful. The "tootsie rolls" and flap sanders come in a variety of diameters and lengths. Choose one that fits the size of the area to be sanded.

Figure 11. A natural bristle toothbrush or a bristle laboratory brush on the mandrel of a flexible shaft machine is ideal for cleaning up any fuzziness left on the wood after the stoning. A "defuzzer" (a round abrasive pad on a mandrel, left in the photo) on a flexible shaft machine can also be used to clean up any remaining fuzz. Both the bristle brush and the defuzzer must be run with the grain at a **slow speed** to prevent roughing-up or burning the soft wood.

BANDSAW

Though not essential for small bird carving, a bandsaw is helpful in expediting some of the initial steps. Naturally, it is useful for cutting out the pattern profile. It can save you time by quickly eliminating the waste wood on the plan view (the topside view) part of the blank. Also, a bandsaw is handy when making driftwood fit your base or the carved bird.

If you do not own a bandsaw, perhaps you know someone who could cut out the profile pattern for you. If not, large lumber yards, cabinet maker's shops or millwork shops will do it for you for a small fee.

Figure 9. Always carve, sand and stone with the grain of the wood; that is, downhill. Unusual wood types or block cuts may have inconsistent grain changes. A strong, one-directional light source will allow you to see the fuzz created by sanding against the grain.

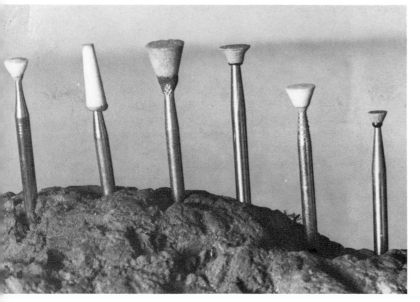

Figure 10. Some areas of the birds will be textured using a small mounted abrasive called a grinding stone.

The process is called "stoning" in this book. Some people may call it "grinding". Grinding stones come in three basic hardnesses: (1) green or silicon carbide which leaves a coarse texture on soft wood, (2) red or aluminum oxide which leaves a medium fine texture on soft wood, and (3) white or another form of aluminum oxide with a vitrified white bond which leaves a fairly fine and clean texture. The most important technique for stoning texture is working with the grain. Stones come in a variety of shapes and sizes. The texturing is accomplished with the sharp corner of the stone running along the surface, leaving a v-like indentation in the wood. The carver can vary the depth of the indentation.

BURNING TOOLS

Three wood burning systems are shown here: the Feather Etcher, the Detailer and the Detail Master. All three have a rheostat which controls the heat. The higher the number, the hotter the tip gets. Very little heat is used when texturing synthetic wood and red hot is used when burning channels for inserting separate feathers.

Figure 12. The Feather Etcher has tips made of Nichromewire. Extra wire can be ordered to fashion your own tips or you can use the handpiece with the standard tip.

The Detailer is another sophisticated burning system. One model has a handpiece with tips of various shapes. Another model has a handpiece in which you change the tips to suit the styles needed.

The Detail Master has many handpieces available with varied tip shapes and because of its solid state construction the heat is evenly distributed and controlled.

The tips of all burning tools will dull after many hours of use. A flat file can be used lightly to sharpen it. Be sure to file a short bevel on the edge. You need a sharp burning edge to obtain fine lines. Occasionally carbon will build up on the tip causing the burn lines to widen. To rid the tip of this carbon, run the edge lightly on a piece of sandpaper attached to a board, or run the edge on a piece of hard wood such as a scrap of walnut or cherry.

SANDING

All the sanding needed can be accomplished by hand, but as mentioned earlier, it is very helpful to rough sand with a flexible shaft machine with either a tootsie roll or a flap sander.

Figure 13. A small amount of hand sanding will be necessary and for this, strip abrasive cloth (80-100 grit) is very handy. Because of its flexibility, a strip 10-12 inches long can be held between the thumb and fore-finger of one hand and pulled across the grain with the other thumb pressing the strip lightly to the wood. This two-handed sanding method is a quick way to sand a broad area. For smaller areas, the strip of abrasive cloth can be used in the conventional back and forth method.

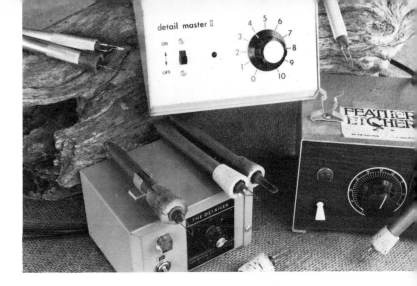

Figure 14. For sanding the beak, an emery board (the kind used for filing fingernails) is very helpful. It can be cut to any shape to facilitate sanding. By cutting one end to a shallow taper you can get into tight corners of the beak area. The emery board's narrow width and stiffness allow it to be used in restricted areas.

EYES

The correct size and color for the eyes are listed with each project.

The eyes can be purchased in two ways. (1) The black pupil with a clear iris can be bought. With these you paint the iris whatever color you need. (2) The black pupil with the iris already colored can be bought. This type is usually slightly more expensive. (For example, today clear eyes average 50¢ a pair, while the colored eyes usually costs less than $2.00 a pair for small birds.) Better quality eyes usually cost more and give more life to the carving.

The life of the eye determines the life of the carving. The eyes create the expression and bring the bird to life. Buying the best eye you can afford and paying particular attention to this area of the carving will help give a more life-like appearance.

Most perching birds have dark brown eyes. Often, carvers insert a black eye because the bird's eye looks dark, but the real eye is dark brown.

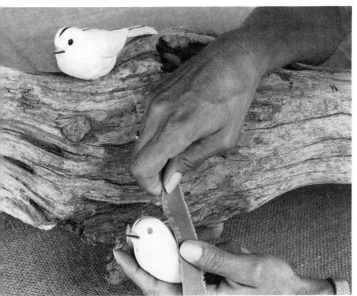

CAST FEET

Most competitions specify that cast feet are unacceptable. Therefore, if you are making a bird for competition, you will have to construct the feet. This construction will be covered in a later chapter.

Notched Joints

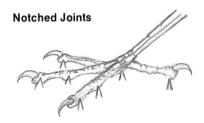

Figure 15. For those of you not making competition birds, cast feet are appropriate. Usually you will need to remove excess casting material from the sides of the tarsus (foot bones) and toes with a knife. At the heavier joints you will need to make small notch cuts with a knife in order to bend them in order to position the bird properly. The smaller or lighter joints usually will bend with finger pressure.

Replacing Tendon for Strength

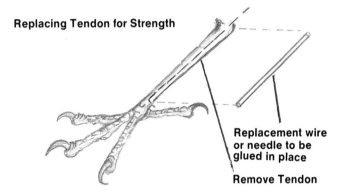

Replacement wire or needle to be glued in place

Remove Tendon

Figure 16. Often, with very small birds, the tarsus of cast feet and legs may not have sufficient strength to support the bird. The tarsus shoud be perfectly straight. To remedy this you can file or cut off the small back tendon and apply super glue and the appropriate length of tempered wire or a shortened sewing needle of the appropriate diameter as the excised tendon.

RIBBON EPOXY PUTTY

Figure 17. Ribbon epoxy putty can be used when setting the eyes, doing the tufts at the top of the feet or constructing your own feet. This putty comes in a ribbon of blue and yellow material which should be cut straight across to get equal amounts of each color. Cut away the small area where the two colors meet, since this part has often hardened already. Mix the equal amounts of the colors to get an even green mixture.

When working and shaping the epoxy putty, you will need a small amount of oily clay (Plastilene and Plasticene are two brand names, although any oily clay will do). Before shaping the putty, lubricate your tool by sticking it into the clay. Then you can push the putty around until the putty starts sticking to the tool. Again stick the tool into the clay for lubrication.

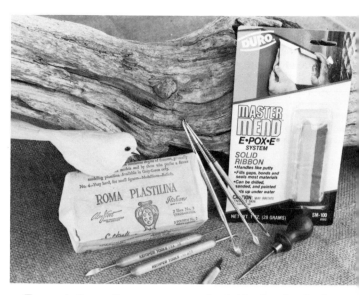

To work the putty, you can use dental tools, clay tools, knife blades or tools you make yourself from flattened or shaped pieces of wire glued in the end of a dowel.

SYNTHETIC WOOD AND ADHESIVES

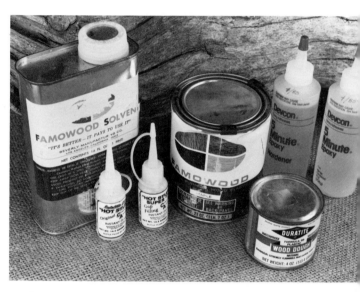

Figure 18. When making a repair, inserting feathers, or inserting an entire wing, it is often advantageous to help hide the joint with synthetic wood (Wood Dough or Famowood are brand names). You will need an old paint brush and a supply of acetone or solvent to smooth the synthetic wood and eliminate as much sanding as possible.

After curing, the synthetic wood can be textured using a burning pen on **very low heat.** If the burning pen is too hot, the material will melt and bubble. After texturing, the synthetic wood should be sealed with shellac.

Instant Glue, Hot Stuff and Super Glue are just a few of the brand names by which cyanoacrylate esther is known. Whichever you choose, I do not think I would like to carve any birds without this type of adhesive. It is very useful to harden fragile areas, insert feathers and make general repairs.

After shaping and rough sanding a beak, use the super glue to coat the area and then resand. This process gives the beak a hard and bony appearance. You should be

very careful in handling cyanoacrylate esther, as it bonds fingers together as well as wood.

Another adhesive you will need is 5-minute epoxy which is very useful in attaching cast feet to the bird and the bird to the branch or mount. You should always wash your hands after handling 5-minute epoxy, as it is very caustic.

MAGNIFIERS

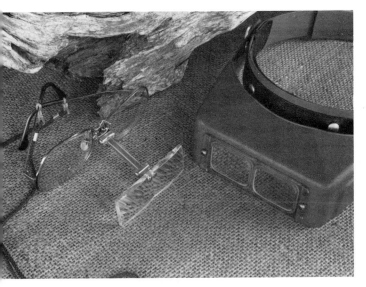

Figure 19. No matter how good your eyes are, you will appreciate some magnification when you burn tiny lines in small detail work. Magnifiers can be found in several forms. One kind fits around your head (headband fashion) and will fit over eyeglasses. Another kind attaches to your regular eyeglasses by a little wire bracket. A third kind has eyeglass frames with magnification lenses.

MEASURING AIDS

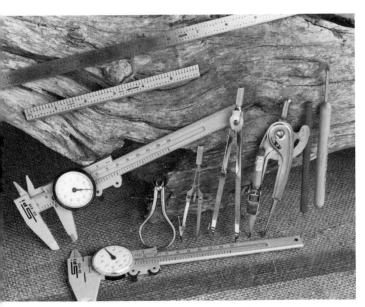

Figure 20. Rulers and calipers measuring in **tenths** of inches will be needed. Tenths units facilitate the halving and doubling of measurements. Most hobby stores, drafting supply stores and general tool suppliers carry these. Dividers (in center of photo) are useful in transfer-

ring dimensions from the pattern to the bird. A compass is needed when radiating the beak and head dimensions when you turn the head of a bird in the wood. A pointed-end clay tool or dissecting needle is helpful in retaining a measurement mark when cutting away wood.

SAFETY PRECAUTIONS

Goggles or safety glasses and a face mask are necessary whenever you operate any power equipment. Wood dust is particularly irritating to your eyes, nose, throat and lung tissue. "Being safe rather than sorry" is an old adage that should be a part of every bird carver's thinking.

DRIFTWOOD

Driftwood for mounting the song birds can be found on many beaches, at rivers, or creeks and in woods. Sometimes driftwood contains its own residents which you can eliminate by spraying a broad spectrum insecticide into a plastic bag and inserting the wood. Fasten the bag tightly and leave it alone for several days. After the bugs have departed, you can proceed to clean the piece of driftwood with a bristle or small round wire brush on a flexible shaft machine. **Always wear goggles or safety glasses and a face mask** when you clean the wood, as many little particles of wood usually come flying off at breakneck speed. If a sheen on the driftwood is desired, you can polish the piece with shoe polish or any good paste wax and buff it with a brush or cloth thoroughly.

WOOD

Basswood is probably the most popular wood for carving birds because it is readily available from most suppliers. It is a wood that works well with both hand and power tools. Because it has a tight, close grain, basswood takes detail well. Basswood, though technically a hardwood (coming from the deciduous linden tree), is soft enough to cut easily with a knife, although occasionally you may have a piece that is particularly hard.

Water tupelo (or tupelo gum) is a soft wood which is becoming more popular as it becomes more readily available through suppliers. The carving wood comes from the lower trunk which is usually underwater, since this tree grows in southern swampy areas. Some carvers prefer to carve it green (not dried) with hand tools such as knives and chisels. Dried stock is best worked with power tools. This wood can be stoned beautifully, leaving a crisp, clean texture that needs very little de-fuzzing.

Jelutong is another very soft wood that is used by many songbird carvers. More carving suppliers and specialty shops are beginning to carry this wood. Jelutong is best worked with power tools, since it is so soft that all but the very sharpest knife blade will "bunch" it up rather than cut it.

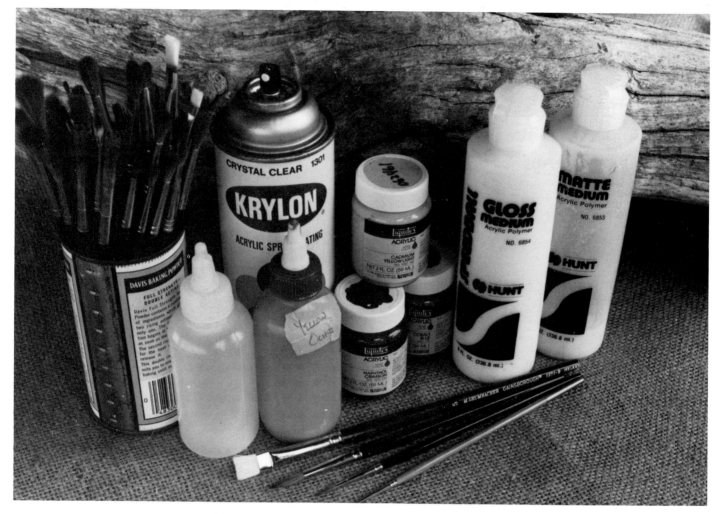

Figure 21. Before you begin to apply paint, spray each
bird **lightly** with Krylon 1301, which will seal your carving
from any moisture raising the grain.

After the Krylon dries, each bird will need two light coats of dry-brushed gesso, which will ensure that the color paint coats will have good adhesion. Also, the gesso will whiten the burned texture to produce a uniform white surface upon which to apply your paints. The gesso will reflect light through the many washes to be applied.

Liquitex **jar** acrylics, made by Binney Smith, are formulated differently than all other tubed colors. **They dry to a matte finish.** All other acrylics dry glossy which can leave your birds shiny. Originally the jar acrylics were made for air brush users, since they often need large quantities of matte finish. Now you can buy Liquitex jar acrylics in small 2 oz. jars, the same size as the standard tubed colors. Jar acrylics are not as pasty as tubed paints; their consistency is that of runny pudding. The colors you will need for each bird will be listed in each project chapter.

You will need a small jar each of matte and gloss medium. Matte medium is used to give a soft sheen

to beaks. Gloss medium is used to give a shiny appearance to larger quills and claws.

You will need a stiff bristle brush for dry-brushing gesso like #5 Grumbacher Gainsborough, a #3, #5 and #7 Grumbacher Beau Arts 190 or equivalent, and a scroll or liner brush.

Beau Arts 190 brushes are not the most or the least expensive brushes you can buy; a #3 will average $6.00, the #5 $9.00 and the #9 about $16.00. They are easy to work with, hold a sharp point or fan out nicely and break in quickly. It is far easier to paint any bird with good brushes than with less expensive ones.

Unlike good knives, good brushes will not last a lifetime, even with the best of care. Wood is a very abrasive substance upon which to drag a paint brush. However, good brushes will last longer if you take good care of them, which means washing them with warm water and mild soap after every hour or two of painting. Pay particular attention to keep the body of the brush clean, since once paint has dried there, the brush will never be the same.

Black-capped Chickadee

(Parus atricapullus)

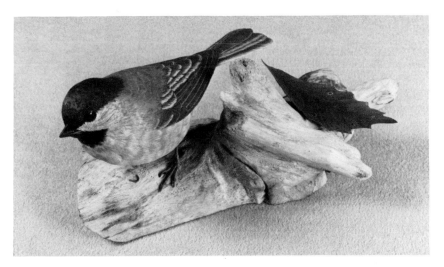

Before I ever carved a bird, I went snowshoeing through the woods in the wilds of the Adirondack State Park in upper New York. From out of nowhere came dozens of little flying creatures, black-capped chickadees, chirping their "chicka-dee-dee-dee" and buzzing all around! It was as though there were a mighty pillow fight and one of the pillows had sprung a leak! The chickadees did not seem the least bit afraid of human presence—in fact, they seemed glad for the company on that 30° *below zero* afternoon. Since that magical experience, chickadees have been my favorite birds. I love to watch their animated and acrobatic antics. Other birds come to the feeder and gorge themselves— but the little chickadee eats just one seed at a time.

The black-capped chickadee, a member of the titmouse family, is also known as the Eastern chickadee or black-capped titmouse. It prefers to inhabit the edges of woods and suburbs where there is sufficient cover from its predators, Northern shrikes, hawks and falcons. The chickadee builds its nest two to eight feet above the ground in dense undergrowth, evergreens, ivy or cavities of dead trees. Its nest is composed of hair, fur of smaller mammals, downy feathers of the parents, dry grass, mosses and soft lichens.

The black-capped chickadee is the northern counterpart to the Carolina chickadee. While they are similar, there are some noteworthy differences. The black-cap is 1/2 to 3/4 of an inch longer than the Carolina. The black-cap's body and feet are slightly longer, while other parts are generally of the same size as its southern relative. With a smaller black bib, the black-capped chickadee shows more white in its wing feather edgings (the secondary or wing bar coverts).

Physical Characteristics

There are ten primary feathers and each usually can be seen when the wing is extended. This is not to say that every chickadee has ten primaries on each wing at all times. For different reasons a bird might lose one or two primaries and can be in the process of regrowing them. Also, during the molting season the bird may have less than ten. In a closed or folded wing carving, of course, not all ten will show anyway. There may only be four or five primary edges or feather tips exposed at the most.

In a folded wing bird carving one of the most important and yet one of the trickiest parts to execute is the stack of primaries. The secondaries as a group are also a stack of feathers. At the side of a song bird carving, one should only see the *edges* of these feathers, not half of an exposed feather. By looking down upon the back of the bird one should see a portion of the top surface of the secondaries or primaries. The same principle holds true for the tail. The bird's tail is composed of two groups (stacks) of feathers. When a bird extends (fans out) these two groups, one group will spread off to the left and the other group to the right. However, when one looks at the profile of a bird (or carving), he should only see the *edges* of these feathers, not the broad expanse of any of them.

As with all song birds, the beak is a five-sided, small, conical bill. On the chickadee the nostrils are concealed under a group of bristly feathers (rictal bristles) that originate between the beak and the front portion of the eye.

The chickadee's tail is slightly rounded with the innermost feather of the two groups being the longest and each feather progressing laterally a little shorter. The greatest difference from the longest to the shortest is .3 of an inch. The entire tail length is 2.7 inches. The tail originates much further into the bird than most people realize. The chickade's tail is usually the same length as the wing.

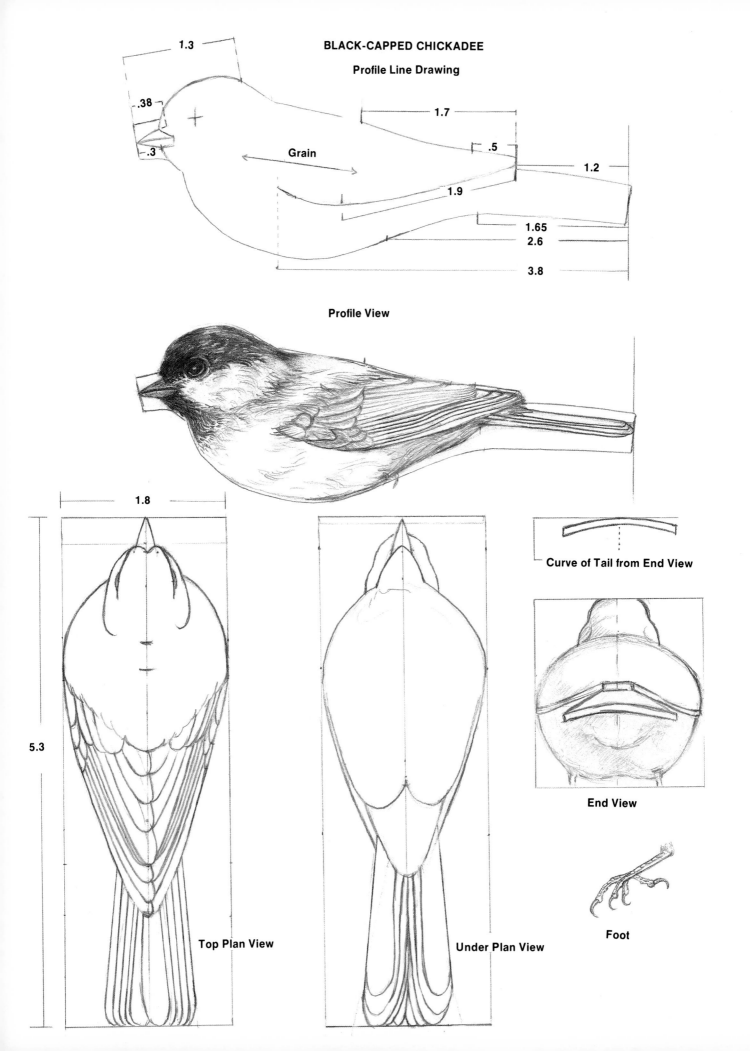

BLACK-CAPPED CHICKADEE

Profile Line Drawing

1.3

.38

.3

Grain

1.7

.5

1.2

1.9

1.65

2.6

3.8

Profile View

1.8

5.3

Top Plan View

Under Plan View

Curve of Tail from End View

End View

Foot

Life Size Wing

Top Side

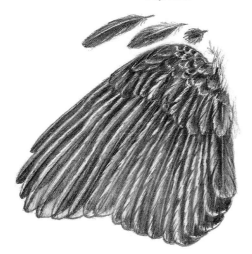

Under Side

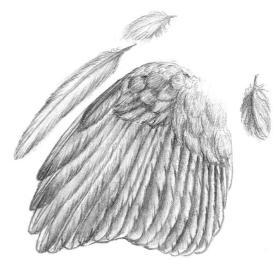

Life Size Tail

**Center Left
Tail Feather
Length 2.6**

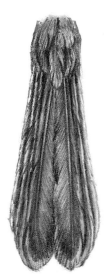

**Third Right
Tail Feather
Length 2.6**

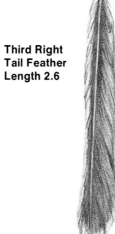

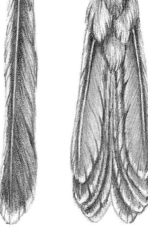

Top Tail

Under Tail

Head on View

Top Plan View

Profile

DIMENSION CHART

1. **End of tail to end of primaries** — 1.2 inches.
2. **Length of wing** — 2.6 inches.
3. **End of primaries to alula** — 1.9 inches.
4. **End of primaries to top of 1st wing bar** — 1.7 inches.
5. **End of primaries to bottom of 1st wing bar** — 1.9 inches.
6. **End of primaries to mantle** — 1.7 inches.
7. **End of primaries to end of secondaries** — .5 inch.
8. **End of primaries to end of primary coverts** — 1.65 inches.
9. **End of tail to front of wing** — 3.8 inches.
10. **Tail length overall** — 2.7 inches.
11. **End of tail to upper tail coverts** — 1.7 inches.
12. **End of tail to lower tail coverts** — 1.65 inches.
13. **End of tail to vent** — 2.6 inches.
14. **Head width at ear coverts** — .8 inch.
15. **Head width above eyes** — .6 inch.
16. **End of beak to back of head** — 1.3 inches.
17. **End of beak to back of crest** —
18. **Beak length: top** — .38 inch; **center** — .4 inch; **bottom** — .3 inch.
19. **Beak height at base** — .21 inch.
20. **Beak to center of eye (eye 5 mm)** — .65 inch.
21. **Beak width at base** — .22 inch.
22. **Tarsus length** — .6 inch.
23. **Overall body width[1]** — 1.8 inches.
24. **Overall body length** — 5.3 inches.

[1]At widest point.

TOOLS AND MATERIALS

TOOLS:

Bandsaw (or coping saw)	Flexible shaft machine
Carbide bits	Tootsie roll sander on a mandrel (120 grit) or a mounted bullet-shaped abrasive stone
Ruby carvers	Knives, small chisels, shallow gouge (optional)
v-tool (optional)	Ruler measuring tenths of an inch
Calipers measuring tenths of an inch or dividers	Pointed clay tool or dissecting needle
Emery board (kind used for fingernails)	Burning pen
Abrasive cloth (120 and 320 grits)	Variety of small mounted stone
Defuzzer on a mandrel	Laboratory bristle brush on a mandrel
Natural bristle toothbrush	Variable speed electric drill
Drill bits	

MATERIALS:

Basswood	Tracing paper
Super-glue	Clay
One pair of brown 5 mm eyes	Duro epoxy ribbon putty
Clay or dental tools	Driftwood for mount
Pair of cast feet for chickadee	5-minute epoxy

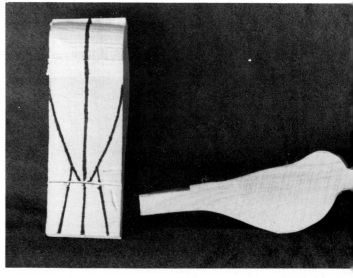

Figure 1. The chickadee blank on the left is the plan view. The one on the right is the bandsawed profile. Both blanks are basswood. On the plan view blank, draw your center lines on the top and underneath side. Take your measurements from the line drawing plan view for the wings and tail.

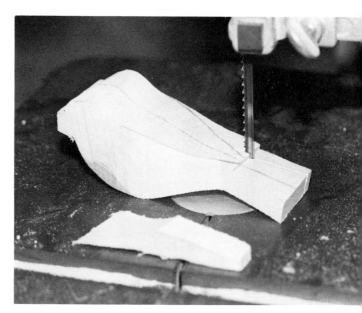

Figure 2. With the bandsaw, coping saw or carbide bit on a flexible shaft, take off the excess wood from the tail and wing plan view.

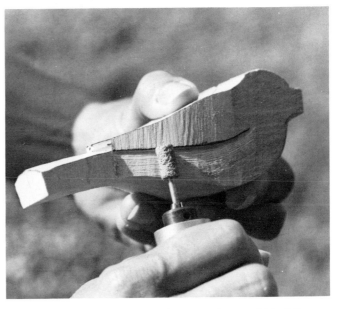

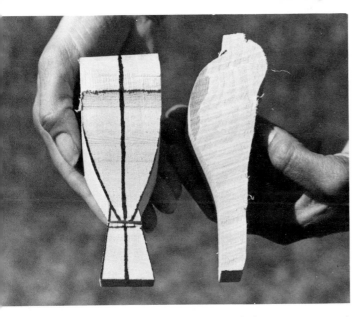

Figure 3. Here you see the blank with the excess wood from the tail and wings removed.

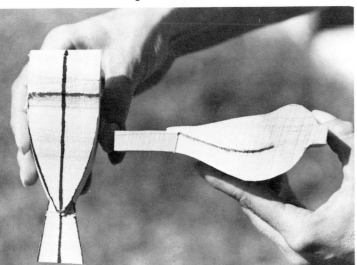

Figure 6. The small cylinder tungsten carbide bit on a flexible shaft machine is a nice way to relieve the wood from the flank area underneath the lower edge line of the wing. A v-tool and chisel can be used to obtain the same effect. The same tungsten carbide bit may be used to make the tail slightly convex or rounded. Remove the wood on the edge of the tail down to the .1 of an inch line and gently round to the center line. By looking straight onto the end view of the tail, you can check the balance of both sides.

Figure 4. With a knife or chisel, remove the little triangles (as seen in Figure 3) at the point where the primaries lie on the tail.

Figure 5. Draw the lower edge line of the wings as taken from the profile pattern. On both sides of the tail, draw a line .1 of an inch from the top edge.

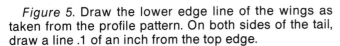

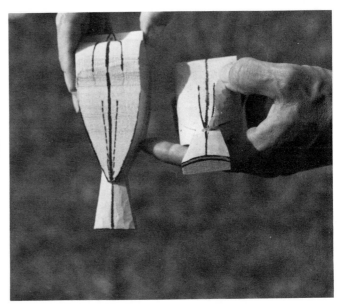

Figure 7. Draw a line on the wings .2 of an inch on each side of the center line and taper to the centerline with all three lines converging at the tips of the primaries.

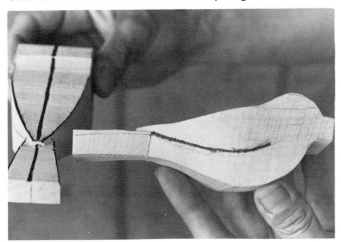

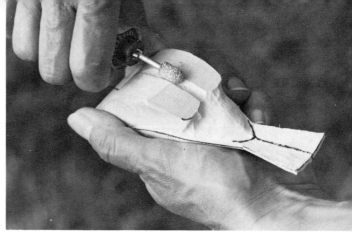

Figure 8. With a knife or carbide bit on a flexible shaft machine, gently round the wings from the lower wing edge line up to the .2 of an inch line on both sides of the center line. Check for symmetry of both sides by looking straight on the end view.

Figure 11. Flow the underneath covert area toward the base of the tail and round over from side to side. You can use a tungsten carbide bit on the flexible shaft machine or a knife. Take care not to nick the lower wing edges.

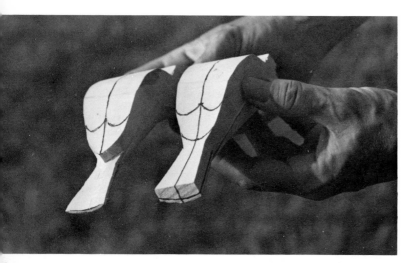

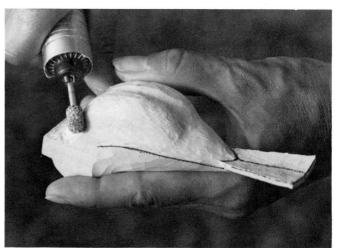

Figure 9. Transfer the measurements for the lower tail coverts and vent from the underneath plan view pattern. Draw the lower tail covert and vent area lines. On the tail, draw lines .1 of an inch long on all three sides of the tail. The same sharp-edge cylinder tungsten carbide bit used on the flanks is a good tool to use to remove the excess wood under the tail up to the lower tail coverts. From the end view of the tail, you should see a symmetrical convex surface on the top of the tail and a concave surface underneath.

Figure 10. With a ball-nosed cylinder tungsten carbide on a flexible shaft machine, trace around the vent lines and form a shallow channel on the centerline to approximately the bottom of the breast/top of the belly.

Figure 12. Gently round both sides from the lower wing edges to the midline channel. Check to make sure both sides are balanced by looking at both of the end views, front and back.

Figure 13. Begin working on the head by marking the widest dimension of the head which is the ear coverts on both sides of the center line. There should be a total .8 of an inch, or .4 of an inch on each side of the center line. With a tungsten carbide bit on the flexible shaft machine or a knife, make scooping cuts on both sides of the head beginning above the shoulder area and flowing toward the top of the head. When you start getting close to the dimension marks, begin checking for balance; you want equal halves of the head on each side of the center line.

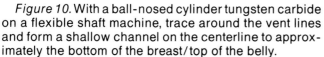

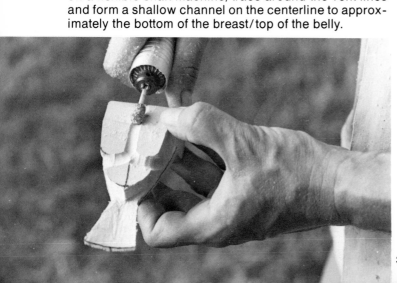

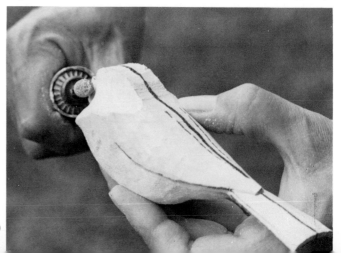

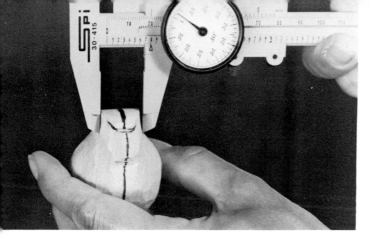

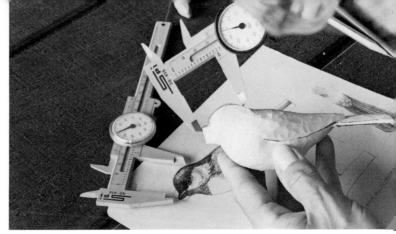

Figure 14. Keep working the ear coverts down, a little on one side and then a little on the other side, until you have .8 of an inch. Gently round the shoulder area toward the breast and flow the ear covert areas down towards the shoulder region.

If you measure from the end of the primaries to the alula on both wings and hold the bird at these points between the thumb and forefinger, you will be holding the bird at the widest part of the body. At this point, the body will narrow slightly until it rounds at the breast and the body will taper more acutely toward the tail. The body itself (excluding the tail) resembles an elongated teardrop with the widest point approximately midwing.

Figure 17. From the profile line pattern dimensions, check the dimensions from the end of the beak to the back of the head. It should be 1.3 inches on the carving. Adjust the carving if needed by taking small chips from the back of the head and the tip of the beak.

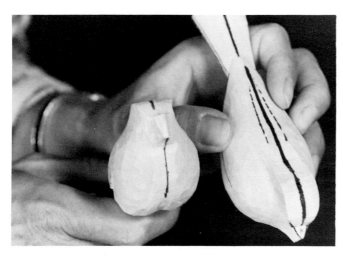

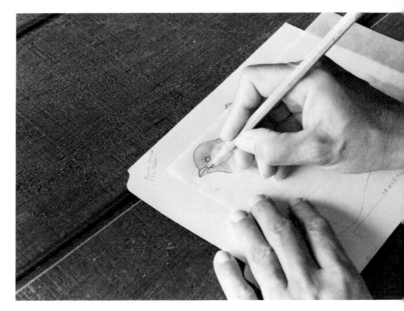

Figure 15. Here you can see the breast rounded. There is a gentle flow from the point where the wings insert under the breast and shoulder feathers to the ear covert area (the cheeks).

Figure 16. The chickadee on the left shows where you are at this point. Note that the planes of the head and beak should be flat at this point of the carving process.

The bird on the right demonstrates the results of the next steps of the beak carving process as obtaining: (1) the top dimension and contour, (2) the width, (3) the underneath dimension and contour, and (4) the details.

Figure 18. Trace the head and beak from the profile pattern with tracing paper.

Figure 19. With a pointed clay tool, dissecting needle or a sewing needle glued into a dowel, pinprick the beak lines and the eye center right through the paper onto the carving. Keep in mind that the tracing was done from a flat surface and you will be putting it onto a contoured surface, so that some adjustments of the tracing paper may be necessary. Prick both sides of the head, making sure that the marks are even. Draw in the beak lines. Check the balance of both sides by looking at the bird from the head-on view.

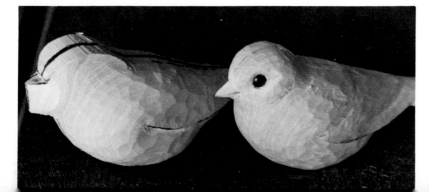

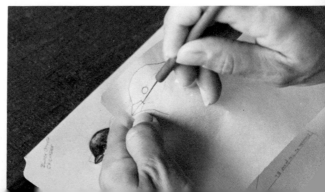

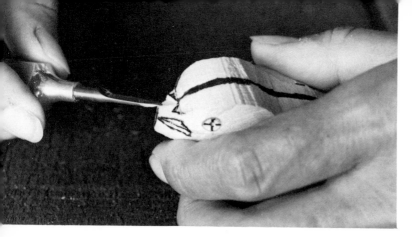

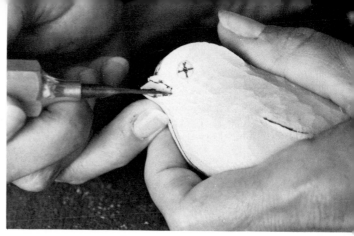

Figure 20. Mark the top dimension of the beak from the tip to the forehead (.38 of an inch). Make a v-shaped stop cut on the top of the beak with the point of the "v" at the measurement mark. Make sure to keep your knife blade perpendicular to the top surface of the beak. Carefully cutting back to the stop cut, remove the excess wood until you get down to the top profile pattern line traced and pinpricked onto the beak.

Figure 23. With the point of a knife, carefully trace the **outside** lines (not the commissure lines) on both sides of the beak. Make sure the knife blade is perpendicular to the surface of the beak; **do not undercut.**

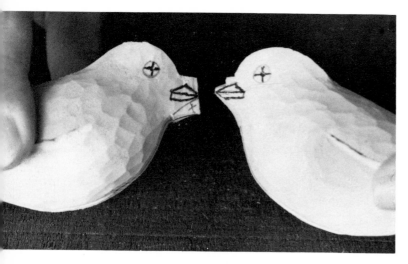

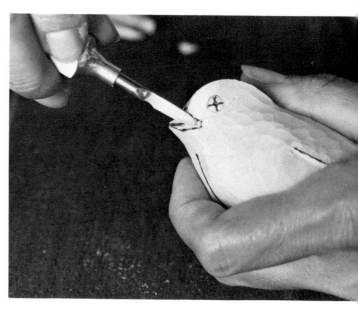

Figure 21. Here you can see the edge of the v-cut on the top of the beak beginning to be recessed to the top of the beak line.

With scooping cuts, carefully remove some of the waste wood under the chin, making sure that you leave enough wood to do the details under the beak.

Figure 22. The top of the beak has been taken down to the line and shaped. As you can see, the beak is much too wide at this point.

Figure 24. With a small knife, remove small chips from the sides of the base of the beak on both sides. Work carefully, taking off little chips and cutting back toward the tracing stop cuts.

Figure 25. The bird on the right shows that some wood has been removed on both sides of the base of the beak. Keep the beak symmetrical by checking the head-on view to see that there is an equal amount of wood on both sides of the beak center line.

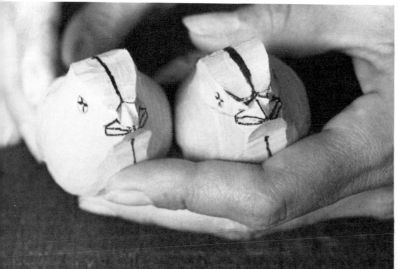

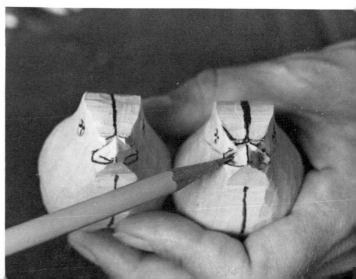

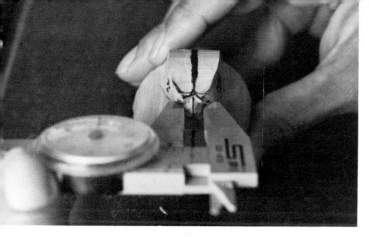

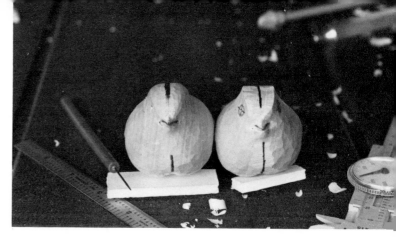

Figure 26. Keep checking the width at the base of the beak until it measures .22 of an inch.

Figure 29. Check the dimension across the head above the eye (the crown), which should measure .6 of an inch. If necessary, take scooping cuts with a knife until you get the proper dimension. Make sure you keep the head symmetrical. Gently round the head on both sides from the base of the beak to the back of the neck.

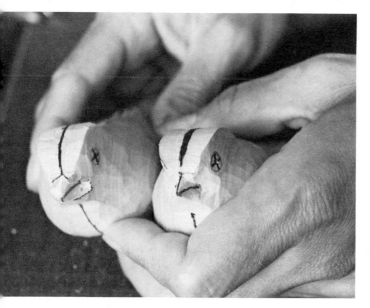

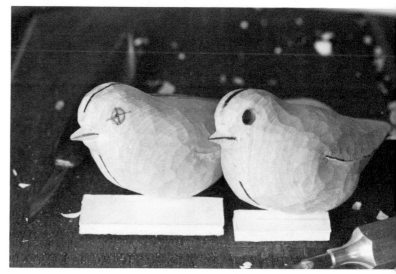

Figure 27. Redraw the commissure line. Carefully flow the area in front of the eye and the forehead down to the base of the beak. Continue to keep the planes of the head flat and squarish.

Figure 28. Mark the under beak measurement on the carving (.3 of an inch). Draw a semi-circular line on both sides from the .3 of an inch mark back to the base of the beak on the sides. Make a perpendicular stop cut on this line. From the tip of the beak, cut back to the stop cut on the underside of the beak. Carefully flow the chin area up to the beak.

Figure 30. Recheck the end of the beak to the center of the eye (.65 of an inch). Check the balance of the center of each eye from the head-on view, as well as the topside plan view. Drill a 5 mm eye hole on each side. There should be a slightly concave area for each eye to sit in.

Figure 31. With an emery board cut to a point, sand the beak and round its contours slightly.

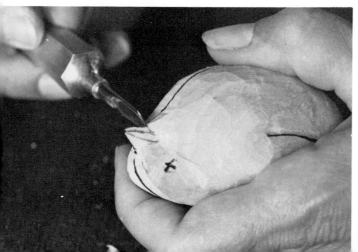

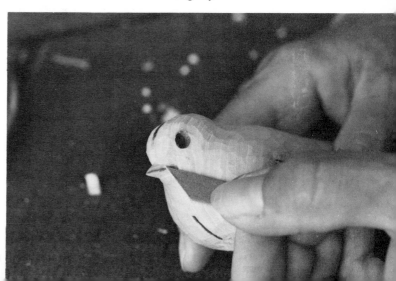

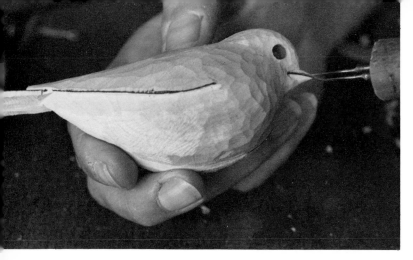

Figure 32. With the burning pen at a 90° angle to the side of the beak, burn in the commissure lines.

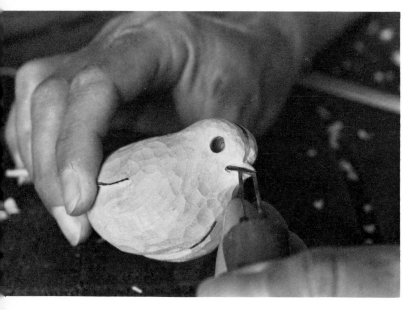

Figure 33. With the burning pen at a 30° angle, burn up to the previous burn line so that you have the effect of the lower mandible fitting up into the upper mandible. The angled burn line creates a bevel on the lower mandible.

Figure 34. Put super-glue on the beak. After it hardens, fine sand the beak with a folded piece of 320 grit abrasive paper.

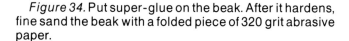

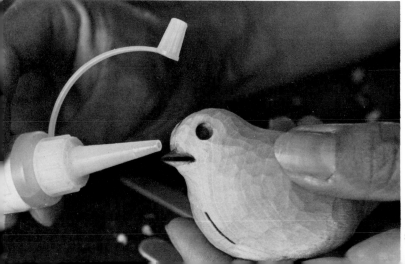

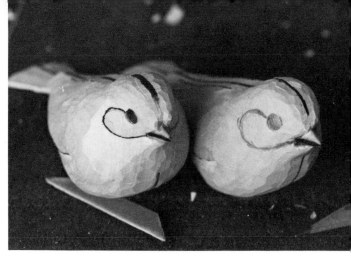

Figure 35. Draw or trace and pinprick the ear coverts onto the cheek area using the profile line pattern. With a v-tool or ruby carver, make a shallow channel on the line. Flow the side of the neck to the bottom of the channel.

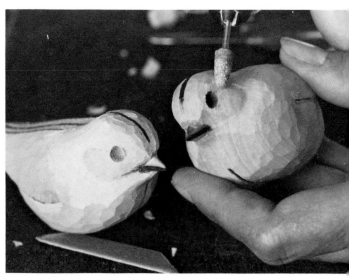

Figure 36. Flow the ear covert down to the bottom of the channel on both sides. This will create a gentle rounded contour to the ear coverts/cheeks.

Figure 37. Putting clay in both eye holes, temporarily set in a pair of 5 mm dark brown eyes, making sure that they do not protrude too much and cause a bug-eyed look. Check for evenness of the eyes from the head-on view as well as the top plan view. Recheck the symmetry of the entire head, especially the eyes, and adjust the eyes if necessary. Notice how putting the eyes in gives a lifelike appearance to your carving.

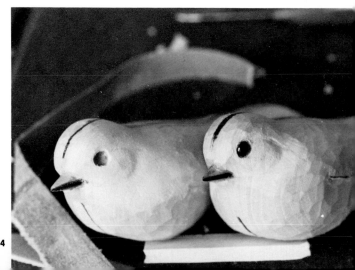

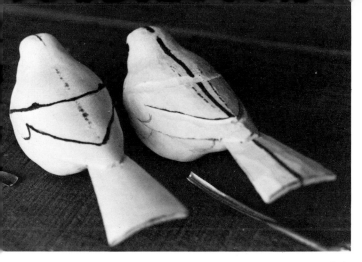

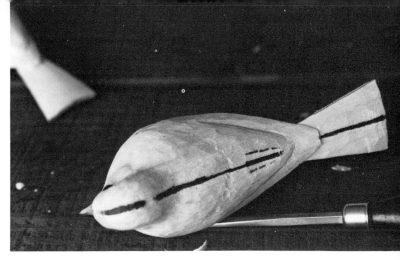

Figure 38. From the profile pattern, trace and pinprick or draw the mantle line and the line separating the secondaries from the primaries up to the alula. With a shallow gouge or ruby carver, make a shallow channel on the mantle line. Using a v-tool or working a ruby carver deeper, make a sharper angled channel on the secondary/primary line.

Figure 41. Gently flow the mantle down towards the wings and round over the secondaries.

Figure 42. On the breast, belly and lower tail coverts, you can see the high and low points of feather contouring (also known as feather landscaping or "lumps and bumps"). Close observation of a bird reveals that there is variation in the flow of the groups of feathers as well as of individual feathers within the groups. There is no definite pattern of this feather contouring. If you have a bird (dead or alive) and blow on the breast and belly feathers, they will fall into different patterns with different high and low points each time you puff away. Every time a bird fluffs his body contour feathers, they will fall into different patterns with varying high and low points. Also remember that the wind will affect the flow and the patterns.

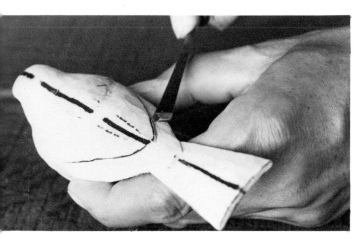

Figure 39. Flow the primaries from the bottom of the channel out to the edges of the wings on both sides.

Figure 40. From the bottom of the channel on the mantle line, flow both of the entire wings out towards the secondaries.

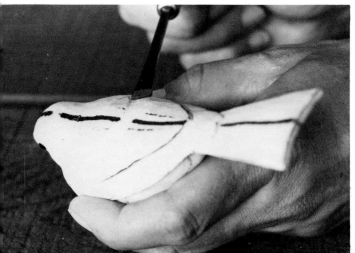

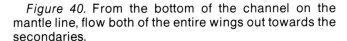

35

Every feather grouping will have a high point, flowing out to the lower areas. Every feather also has a definite contour; that is, it is convex on the top surface and concave underneath. If you closely examine a body contour feather, you will see that it not only has curvature from side to side, but also from top to bottom.

There is no one right way to do feather landscaping. You can use your imagination and artistic license to exaggerate and enhance the motion, fluidity and naturalness of your feather contouring. When laying out your feather landscaping, think in big sweeping curves and shapes to heighten interest in the breast, belly and lower tail coverts. Think in terms of high points and low points. One thing that you will want to avoid is the fishscale or brickwall type of contouring. Anything regular or fixed becomes rigid and monotonous. Feathers do tend to flow in rows, but not to the point of predictability. Vary the direction of the flow to create motion and fluidity. Also remember that each side of the bird should "read" differently; that is, do not have the high and low points the same on both sides.

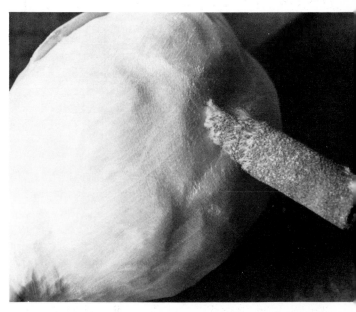

Figure 44. For further shaping and smoothing, a bullet-shaped stone or small, worn tootsie roll in a flexible shaft machine is useful. Remember, when smoothing contours, to run the stone or tootsie roll with the grain. When a carving has been bandsawed with the grain running the length of the body, there is a grain change that occurs at the upper belly or lower breast where the flat grain becomes end grain. Whether you are sanding or stoning, some fuzzing will occur in this tricky area. Turn the bird around end for end so that you are sanding or stoning in the opposite direction. Less fuzzing will occur if you work downhill.

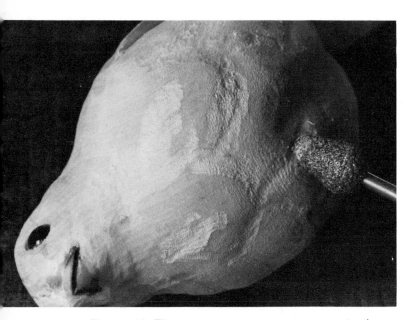

Figure 43. There are many ways to execute these feather contours. After drawing in large, sweeping feather groups on the breast, belly and lower tail coverts, you can use a knife, ruby carver, gouge or tootsie roll to lower the areas you have selected to be low points. There should be a variety of high and low points of differing depths, keeping in mind that each feather group comes out from underneath the preceeding one, progressing from the head back to the under tail coverts. Using a single light source helps to create shadows and highlights when working on the feather contouring as well as when stoning.

After you have channeled the main feather flow lines, round over each high area and flow to the bottom of the channel.

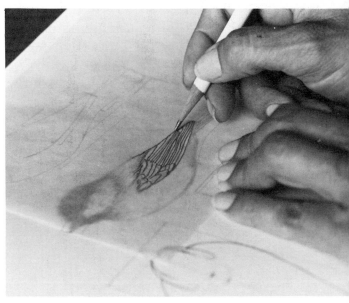

Figure 45. Trace the feather layout of the wings from the profile pattern.

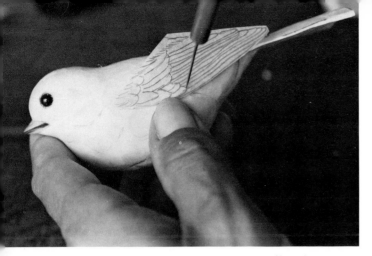

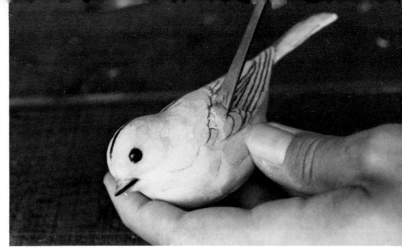

Figure 46. Hold the tracing up to the side of the bird and trace the middle and greater secondary coverts, the alula, primary coverts, and the edges of the secondaries and primaries.

Figure 49. Flow out the channel that you cut on the middle secondary covert line towards the greater secondary covert area. As you can see in the photo, a small fishtail skew chisel can be used. If you prefer a power tool, a ruby carver on a flexible shaft machine can also be used. By cutting out the groups of feathers and flowing the channel out toward the next group, the carver can create the effect of one group laying on top of another group, just as in a real bird.

Each side of the bird does not need the same number of feathers exposed in each group. You may use artistic license and imagination in creating asymmetry as long as the main groups are in the proper location. In fact, each carving should and will be slightly different—yours, mine or someone else's.

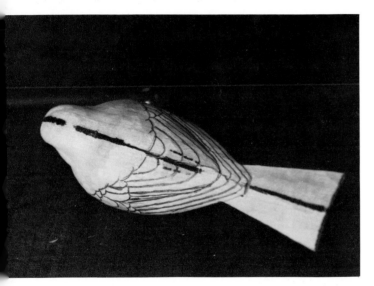

Figure 47. Trace (from the line drawing of the plan view) and pinprick the tertials and the tips of the primaries. Draw in all the feathers and edges that you pinpricked.

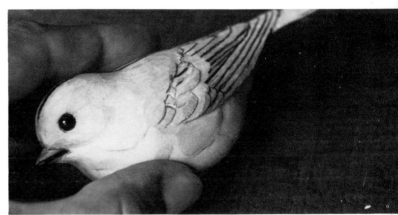

Figure 48. Using a v-tool or ruby carver, begin cutting out the feather groups and individual feathers of the wings by starting at the front of the wing, working back toward the end and down toward the lower wing edge. The first group to cut out is the middle secondary coverts.

Figure 50. Next, channel around and flow out the greater seconday coverts (first wing bar). Cut around the individual feathers within the group.

Figure 51. Procede to cutting out the tertials and secondaries, starting at the top (the point closest to the head) and remembering that the secondaries are a stack of feathers with just the edges showing in a folded wing position.

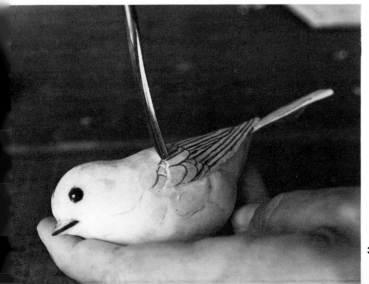

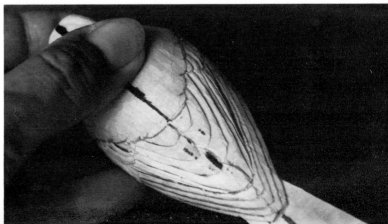

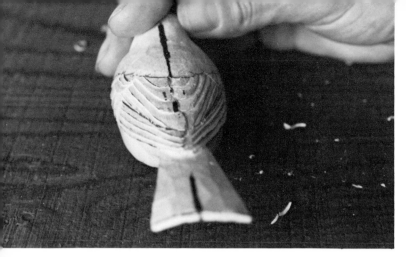

Figure 52. Using the same procedure, cut around the alula, primary coverts and primaries, beginning with the ones on top.

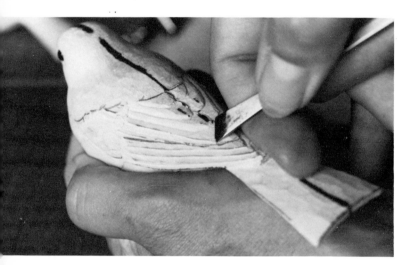

Figure 53. With a chisel, sharp knife or ruby carver, round over the sharp edges created by cutting out the individual feathers. Remember that each feather has a rounded contour.

Figure 54. Draw or trace and pinprick the feathers on the upper surface of the tail. Using a v-tool or ruby carver, cut out the centermost feather first and procede to cut out the remaining ones, working your way to the outermost feathers.

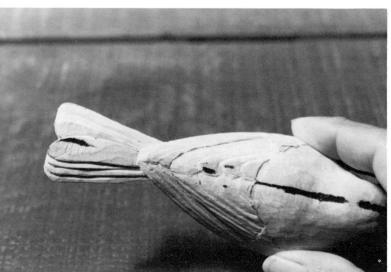

Figure 55. With a chisel, knife or ruby carver, shave off the corners of the ledges to make each feather have a rounded contour.

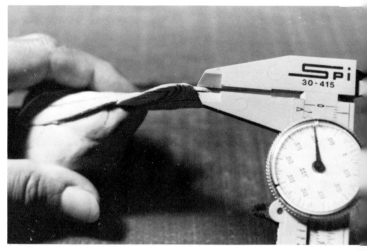

Figure 56. The middle of the tail thickness at its end should be slightly less than .1 of an inch. If yours is thicker, thin it down from underneath.

Figure 57. Draw or trace and pinprick the feathers on the underneath surface of the tail. With the burning pen, separate the feathers on the very end of the tail so that the top and bottom of each feather align—that is, the outside edge of a feather on the top of the tail matches the inside edge of the same feather underneath.

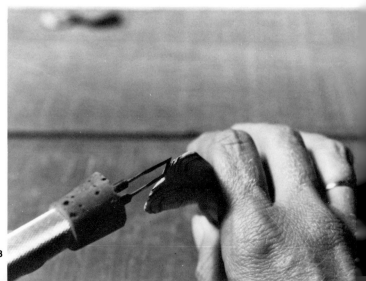

Figure 58. With the burning pen on a medium heat, trace the pencil line of each underneath tail feather with the pen at a 30° angle.

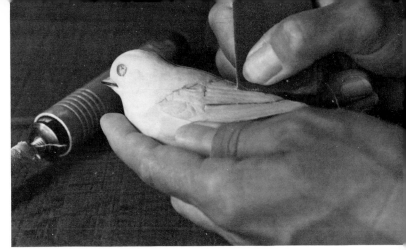

Figure 61. Use a folded piece of abrasive cloth to sand the wing and tail feathers and other areas that the tootsie roll cannot reach.

Figure 59. With a knife or burning pen, carefully remove the small triangular-shape piece of wood underneath the lower wing edge.

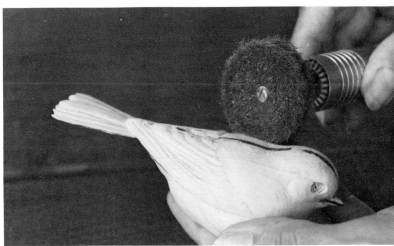

Figure 62. Preparation for the following final steps is important. After you have finished sanding your carving, use a defuzzer abrasive pad on a flexible shaft machine to rid the carving of any fuzz. With a strong, one-directional light source you will be able to see any imperfections in the wood. Any chips, fuzz or rough surfaces will likely show up in the texturing and/or stoning procedures. The end product will most certainly reflect the amount of preparation. A clean, crisp bird at this point will yield a clean, crisp completed piece.

Figure 60. Remove the eyes temporarily for the sanding and stoning, so that the eyes are not scratched. You can use a dissecting needle or sharply pointed clay tool to pop the eyes out. Using a worn tootsie roll (120 grit), sand the body and the head, making sure you sand with the grain. A strong, one-directional light will enable you to see if you are creating more fuzz than you are removing.

Figure 63. Layout the feather patterns and their flow to be stoned on the under tail coverts, belly and breast (the entire underneath surface of the bird). Do not make the feathers all the same size, as this will create a stiff effect. You want variation and sweeping flows that keep your eye traveling over the surface.

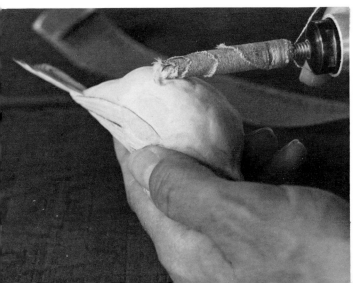

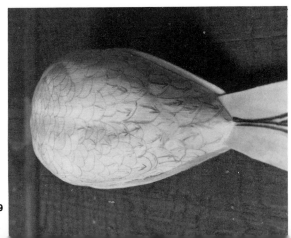

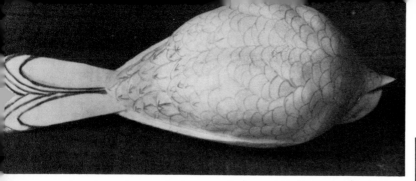

Figure 64. It may take several attempts to obtain a "look" that is pleasing and natural. Keep drawing and erasing until you come up with a fluid, sweeping configuration.

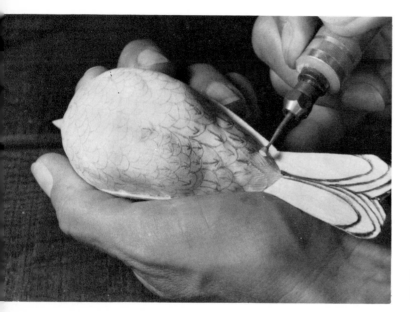

Figure 65. There are many stones on the market today that will do an excellent job. Try several shapes until you find one that you are comfortable with. If you have never stoned before, work on a practice board until the motion seems comfortable.

No matter what shape of stone you decide to use, it is crucial to get as fine a line as possible by using the sharp edge of the stone. Textured lines placed as close as possible will give a softer appearance.

You want to accomplish the texturing with as little fuzz as possible, stoning in the direction of the grain. With most birds being bandsawed out with the grain running the length of the body, there will be a definite grain change at the upper belly/lower breast as the flat grain becomes end grain. Again, a strong, one-directional light source will enable you to see how much fuzzing is occuring. Do not be afraid to experiment on the practice board, because you may develop techniques that can be used on this or other birds. No two people texture the same way—keep it yours! Try not to get locked into just one way of doing anything—you will continue to grow as you become more familiar with the birds and carving procedures. There is no one right way.

Holding the Dremel or Foredom handpiece like a pencil (this may seem awkward at first but will become more comfortable with practice), draw it toward you in short, curvy strokes. On larger feathers it is easy to keep curvature to your strokes. As the feathers become smaller, it will take a more concentrated effort to get in that curvature.

Begin stoning at the lower tail coverts at the base of the tail, and work your way up the belly stoning each overlapping feather as you go. Working up the bird's body enables you to overlap the feathers just as they are on a bird.

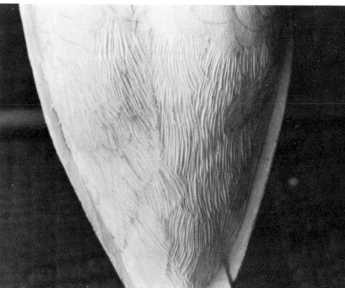

Figure 66. Stone as close to the wing edges as possible without getting so close to the lower wing eges that you nick them. The unreachable areas can be textured with your burning pen later.

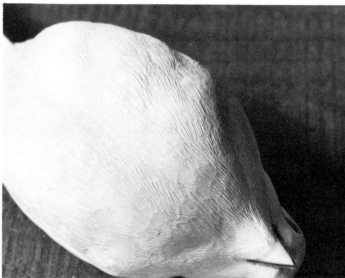

Figure 67. When you get to the grain change at the upper belly/lower breast, turn your bird end for end so that you are actually working backwards. This may seem awkward at first, but with some practice, it will begin to become more comfortable.

When you get to the upper breast and neck area, the feathers become very small, and it is difficult to get much curvature to the stoning strokes. You can still create motion and fluidity to the area by varying the flows of your groups of feathers as well as individual ones.

Stone as close to the beak as you feel comfortable; do not, however, get so close that you nick the beak. This area can be textured with the burning pen.

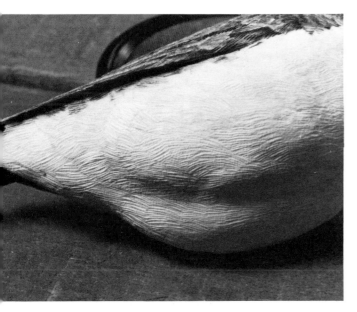

Figure 68. Here you can see how the combination of feather contouring and stoning enhance the fluffy look on the breast and belly.

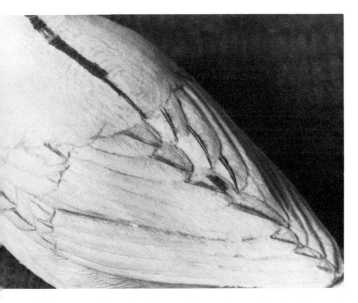

Figure 69. Draw in the quills on the major feathers of the wings. With the burning tool, burn the quills, keeping two burn lines very close together and even running together the last 1/4 inch at the very tip of the feather. Quills can be burned starting at the base of the feather and working toward the tip or starting at the tip and working toward the base of the feather. Try both directions to see which seems best for you.

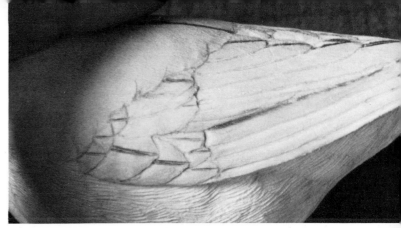

Figure 70. On smaller feathers, just a single burn line is sufficent to indicate the quill. Quill lines, whether single or double lines, should not be straight, but should have some curvature, if only a little.

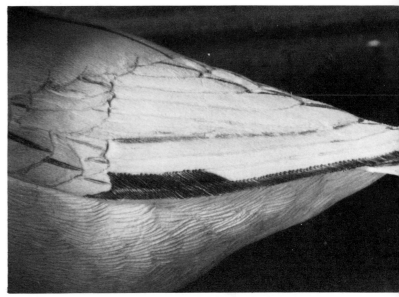

Figure 71. Begin burning the barb lines at the lowest exposed primary. Keep your burn lines as close and fine as possible on this little chickadee. The smaller the bird, the finer the burning and stoning should be.

Figure 72. Work your way up the primaries and forward with your burning. When beginning each stroke, get as close to the feather above it as possible. Again, you want to curve the burning stroke as you draw it away from the feather above and draw it down the edge a little, toward the tip of the feather.

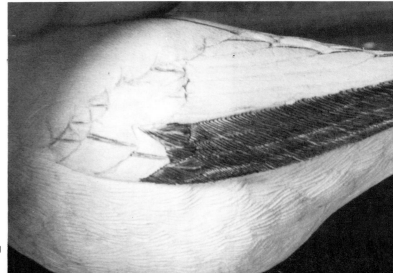

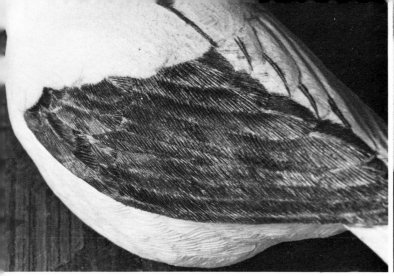

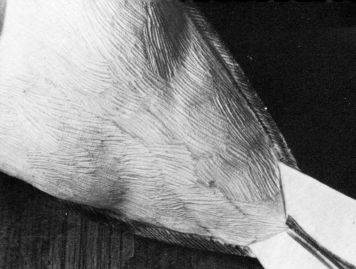

Figure 73. Here you can see the wing, that is underneath in the folded wing position, completed.

Figure 76. With the burning pen, burn in the barb lines on the underside of the exposed lowest primary on both wings.

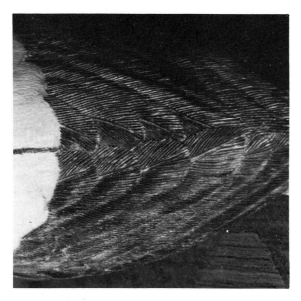

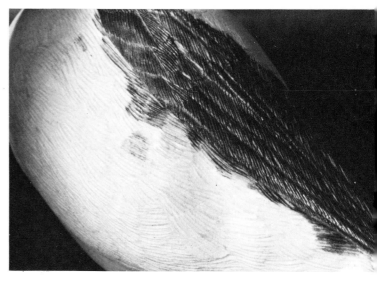

Figure 74. Begin burning in the barb lines on the uppermost wing by starting at the lowest primary and work forward and upward on the wing feathers. Burning in this way enhances the reality of one feather laying on top of another.

Figure 77. The area along the sides of the bird near the lower wing edges can now be burned. To blend the stoning and burning, carry the burn lines into the stoning so that you will not have a sharp line between the stoning on one side and burning on the other.

Figure 75. Randomly go back over a few pre-selected barb lines, making them a little deeper and wider to create feather splits. Smaller feather splits will be painted in later. Do not have a pattern to these splits, but keep them spontaneous and unpredictable; a definite pattern would create rigidity and monotony.

Figure 78. Draw in the feather pattern on the mantle, upper back, neck and head. Remember to vary the amount of the exposed feather—the feathers should not all be the same shape and size. You want to keep the patterns free-flowing and natural looking. Feathers tend to follow each other in rows, but do not get carried away with this to the point of corn rows all over the back of the bird. You want to vary the rows, patterns and flow directions.

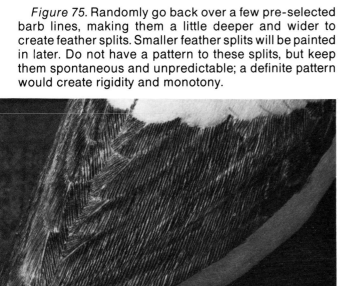

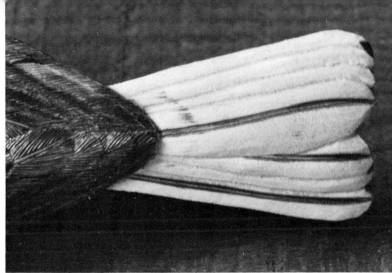

Figure 79. Begin burning the barbs in the mantle feathers at its lowest point just above the beginning of the exposed wings. Work your way up the mantle and upper back, burning the lower feather first.

Figure 82. Draw and burn in the quills on the upper tail, keeping your two burn lines very close together to create a narrow quill. As with the major feathers on the wing, the two lines should join approximately 1/4 inch from the tip.

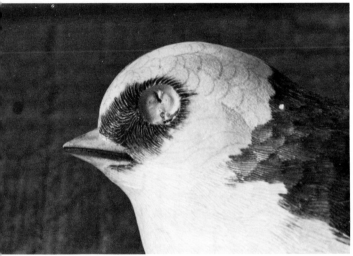

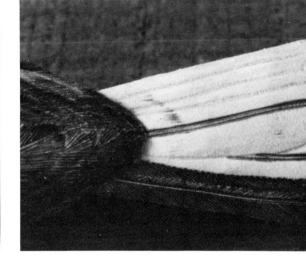

Figure 80. When you have burned the barbs of the feathers on the nape of the neck, proceed to burn the detail area around the eye. Notice how the feather edges originate in the front corner of the eye and flow toward the beak, curving up toward the forehead and crown and down toward the area below the eye and the ear coverts.

At the shoulder region where the burning and stoning meet, carry the burning slightly into the stoning so that the two blend.

Figure 81. Finish burning the barbs of the ear coverts on both sides, and proceed to completing the feathers on the remainder of the head. As with the stoning, when the feathers become smaller, it is more difficult to obtain much curvature to the burn strokes. To compensate for the rigidity that short, straight strokes create, vary the feather flow itself.

Figure 83. Begin burning the barbs on the upper surface of the tail, starting at the outermost feather and working towards the center. This will enhance the effect of one feather laying on top of the next.

Figure 84. Here you can see that all of the barbs on the upper tail surface have been burned. The burning should be kept fine and close. Notice the actual burn strokes curving when they approach the edge. Examine a real tail feather and pay particular attention to the angle that the barbs come away from the quill and curve as they approach the edge. (This curvature at the edge is caused by wing resistance during flight).

The randomly placed splits were effected by going over a few of the barb lines a little deeper and wider. As with the wing feather splits, smaller splits can be accomplished with painting. Do not overdo feather splits as this can lead to a ragged look.

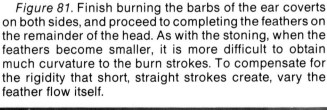

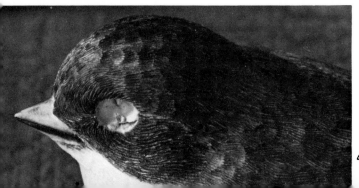

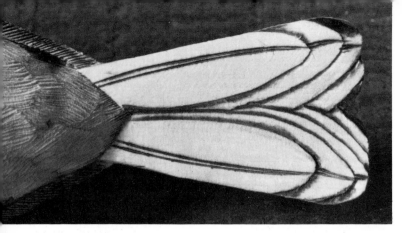

Figure 85. Draw and burn in the two major quills exposed on the under surface of the tail, using two strokes to raise the quill. On the lesser exposed feathers, a single line for the quill is sufficient.

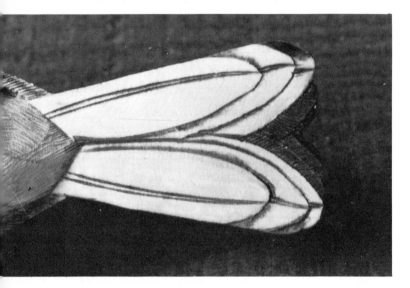

Figure 86. Begin burning the barbs on the underneath tail feathers by starting in the center of the tail and working your way to the outer ones.

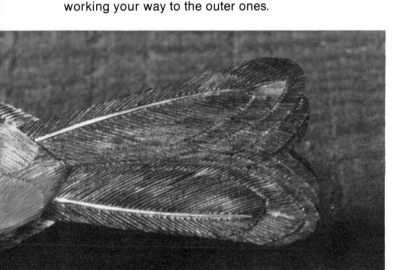

Figure 87. Here you see the feathers on the underneath surface of the tail completely burned. The same time and effort should be taken to keep the barb lines tight and clean on the underneath tail surface as on the upper surface.

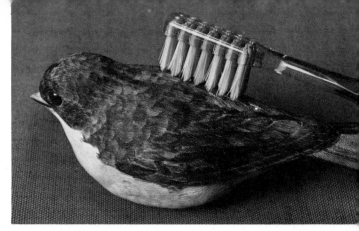

Figure 88. All of the burned surfaces should be cleaned with a natural bristle tooth brush.

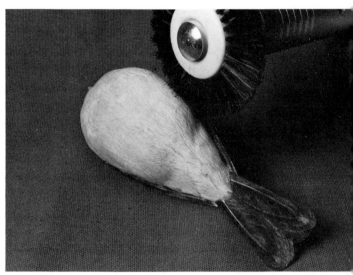

Figure 89. The stoned surfaces should be cleaned using a laboratory brush on the flexible shaft machine. Make sure that you run the brush with the grain—your one-directional light source will enable you to see in which direction to run the brush so that the existing fuzz is removed.

Occasionally you will get a piece of basswood that is particularly prone to fuzzing. If the first brushing does not remove all the fuzz, spray the stoned areas with Krylon Clear 1301 and let it dry. Use the bristle brush on the flexible shaft machine again, running it with the grain. Sometimes it might be necessry to do the spraying and brushing a couple of times. Be careful not to fill up the stoned lines with the Krylon. It will begin to build up and fill in the texture if sprayed too heavily.

Figure 90. Reset the eyes back into their holes after you have sanded and stoned the area. You may need to replace a small amount of the clay. Recheck the eyes for balance from both the head-on and top views.

Figure 91. With a pointed end clay tool or dissecting tool, clean out any excess clay around the perimeter of the eye that would keep the ribbon putty from adhering to the eye or the wood surrounding it.

When you set eyes in birds, remember that the eyes are an integral part of the head with only a fractional part of the eye actually exposed. The eyes should not be so bulbous that the bird looks pop-eyed, and not so deep that you have to look down into the head to see them.

The life of the bird is captured in the head, but more particularly in the eyes. Taking the time and effort to execute a lifelike look about the eyes and head is well worth it. When viewing a carving, your own eye will travel to the head first and more specifically to the eyes.

Figure 92. Mix up the Duro epoxy ribbon putty. Remember to cut out the little piece where the two colors meet since the chemical reaction may have already taken place and the putty may have hardened.

Roll a small piece of the putty between the fingers of one hand and the palm of the other to make a small snake. Using a clay tool, dental tool or dissecting needle, push the thin snake into the crevice around the eye. When working with the putty, peridically push whatever tool you are using into the oily clay which will keep the putty from sticking to the tool. The eye ring around the eye is oval, not round. Push the clay with the tool to form the eye ring and remove any excesss putty as you are working. Gradually blend the putty into the surrounding grooves, the inner eye ring will start to become more prominent. If you find you have more than .1 of an inch of putty to blend into the burned area, remove some. You want as little putty outside the eye as possible. If an edge of the drilled eye hole begins to show, cover it up now or it will show when the bird is painted. If the putty eye ring starts hugging the eye itself too tightly, pull it away with your tool. The eye ring is not smooth, but has a little bumpy texture similar to wrinkled skin.

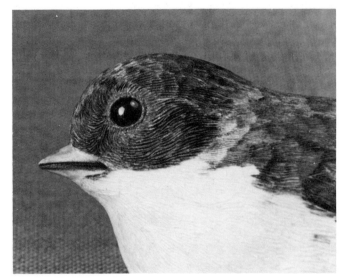

Figure 93. Here you see the eye with the putty applied. Notice that the eye ring is not greatly prominent—it is just slightly raised.

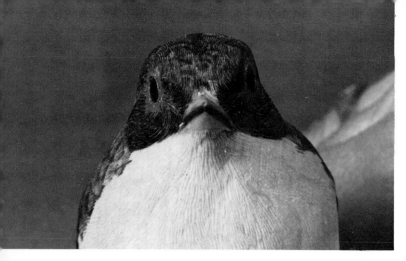

Figure 94. Proceed applying the putty to the other eye, making sure that you do not obliterate the putty around the first eye. Again, check the eyes for balance from the head-on and the top plan views. If something is amiss with the eyes, it is easier to reset one or both at this point than after the bird has been painted.

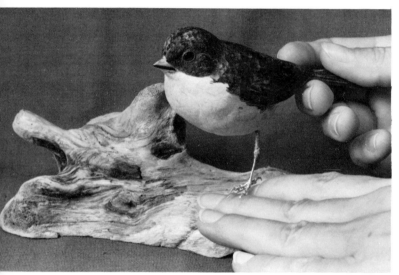

Figure 95. Select the piece of driftwood for the mount. Using the laboratory bristle brush on a flexible shaft machine, clean the driftwood. Brushing not only cleans the driftwood, but also burnishes it to a nice patina. If you want even more sheen, you can wax it with a good furniture paste wax and buff it with a cloth or brush. If you want to change the color of the driftwood, you can paint it with acrylic washes or apply some shoe polish and then buff.

Often the driftwood will have to be altered with the bandsaw or flexible shaft machine. If there is a branch that juts out in front of the bird's head, saw it off and rough up the stump using a propane torch and wire brush on the flexible shaft. If the wood does not sit evenly or firmly, rub the bottom of it along a piece of abrasive cloth on a flat surface, or, if it is far out of place, take a saw or flexible shaft machine to it.

Cast feet may have to be trimmed of excess casting material on the toes and tarsus. Any sharp knife will cut this off. Make sure that the hind toe extends out from the inside of the tarsus.

Studying live birds will enable you to learn in what positions the feet come out of the body. Nothing will replace time spent observing bird activities and behavior.

Hold the bird, one cast foot and the driftwood together in your desired position. Mark the point at which the nub of the casting is to be inserted into the body. Drill this hole into the body, using a drill the same size or slightly larger than the nub on the casting.

Place the foot casting into this hole and proceed to mark and drill the hole for the other foot.

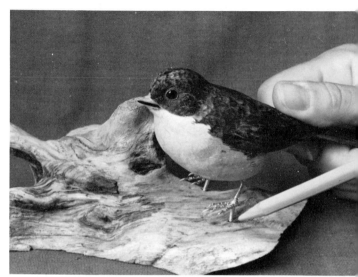

Figure 96. After inserting the second foot, hold the bird over the driftwood. Check to make sure that the bird will be balanced over the feet and on the driftwood. Gauge the angle that you will need to hold the drill and proceed to drill two holes into the driftwood the same size or slightly larger than the nubs that come out underneath the toes.

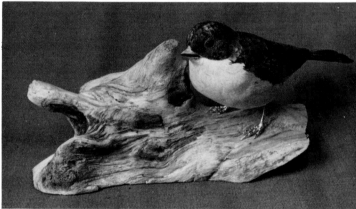

Figure 97. Place the feet into the holes drilled and check for balance. Do not be surprised if you have to change the holes; with some birds and mounts it is difficult to obtain the right balance and position. You may have to alter the angle the feet come out of the body. It may be easier to bend the cast feet if you cut a little notch at the point that is to be bent.

On small bird's cast feet, there may be a problem with the tarsus bending. The tarsus should be straight. If necessary, the tendon on the back of the tarsus can be filed or cut away and replaced by a piece of tempered wire the appropriate diameter joined to the tarsus with super glue. The wire will probably provide the necessary strength to support the bird.

Figure 98. The bird's balance and position is checked from the profile view.

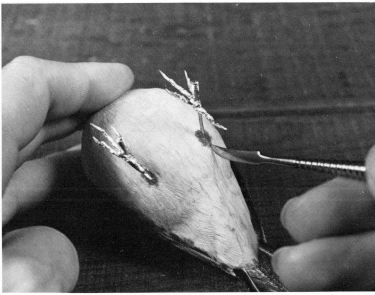

Figure 101. Pull the putty down into the adjacent stoned areas around the insertion point. You want a smooth transition area. Allow the putty to harden before proceeding. Use an **unheated** burning pen, a dull knife blade or a dental tool to texture the bristly little feathers of the leg tufts. Allow the putty to harden before proceeding to paint.

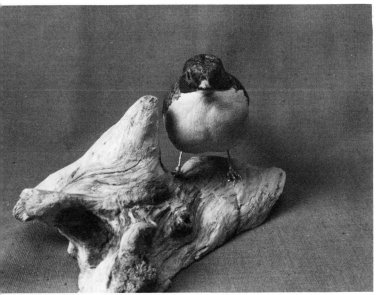

Figure 99. The bird's balance and position is checked from the head-on view. In this position, the bird's body should sit level. If you are mounting a bird on the side of a branch, the pattern should be altered to an angle that will make the carving look alive. The body does not always have to sit level, but the head is usually level except when the bird is cocking its head. Studying live birds will give you insight into the normal and acrobatic antics.

After you are satisfied with the bird's position, glue the castings into the *body* with 5-minute epoxy. Do *not* glue the castings into the *driftwood* until after the bird has been painted! When using 5-minute epoxy, try not to get any on the belly; but if you should, it can be stoned off after it has dried. After the glue is placed in the holes in the body and the castings are inserted, place the bird in the proper position on the driftwood and wait for the glue in the body to dry. This will assure that the feet will dry in the proper position you have selected.

Figure 100. After the glue is dry, mix a small amount of Duro epoxy ribbon putty between your fingers until you have an even green color. Place a small amount of the putty where each casting comes out of the body of the bird. Use only enough putty to encircle each casting. Do not use a glob to simulate the leg tuft.

INTRODUCTION TO PAINTING

There is no one, right way to paint a bird. Everyone sees and interprets color differently. Perfect eyesight is not the key, since there are several decorative bird carvers who are color blind. However, an observation of form is essential to carving a realistic bird, observation of color is equally essential in painting a realistic bird.

For the bird carver, studying colors is every bit as important as studying form. Pick up a leaf or a rock and for a moment, forget the form. Just "see" the colors, and actually focus on their character. Ask yourself questions to spark the learning process: "What colors could I mix to get a particular color?, or "What happens when I put one color next to another one or on top of another one"? Take these and other questions, along with your patience and enthusiasm, to your painting area. Begin by trying to reproduce certain colors. Trial and error experience is a marvelous teacher; Painting does not come to your magically, you have to work at it.

Though you will be painting on a three-dimensional surface, the techniques and methods of flatwork should be utilized as though you were painting on a two-dimensional one. Think in terms of the value of a color: light, medium or dark. The darker values should be used in areas that you want to recede or deepen. The lighter values are used to highlight or elevate areas. The medium value bridges lights and the darks. Values are the important consideration whether you are painting a rock or a fluffy feather.

Base coats

Base coats are the initial coats of paint that begin to demonstrate the predominant color of an area of the bird. Keep your paint thin so that it does not obscure the texture lines. Several thin coats should be applied rather than a thick one.

Wash Technique

To obtain a wash effect, or cover mix a small amount of color pigment with a large amount of water and apply to the bird. You may hear an artist occasionally refer to a "dirty water wash" which indicates that the wash is so watery it appears as dirty water with a very small amount of the desired color. On a textured surface, a wash technique will deposit a small amount of color on the low points (valleys) of the texturing.

Dry Brush Technique

To get a dry brush effect, mix the color needed, load your brush with paint and then wipe most of the paint on a paper towel, leaving only a small amount actually on the brush to be applied on the bird. On a textured surface, this dry brush technique will leave a small amount of color on the high points (peaks) of the texturing.

Wash and dry brush techniques are ways of subtly changing the colors of a given area. For example, if a bird's tail is a brownish charcoal, the base coats may consist of burnt umber, black and a small amount of white. After you have applied several base coats, you may decide that you did not apply enough burnt umber to your base coat colors, since black seems to greatly absorb the burnt umber. You should apply several watery washes of burnt umber with a small amount of white until you begin to see the burnt umber becoming more apparent. If the edges are a slightly lighter color than the centers of the feathers, load up a brush with the appropriate edge color and deposit most of the paint on a paper towel. Using short, flicking strokes, deposit a small amount of paint on the edges of the feathers.

Blending

Often on a bird, there is an area of dark colored feathers adjacent to an area of light ones, or even within a single feather there is a light edge next to a dark area. To get a naturalistic blend of the contrasting colors, you can use a stipple, dry brush or wet-blend technique.

Stipple is an effect obtained by dotting or flicking the tip of the loaded paint brush on the surface. To stipple, you will need a short, stiff bristled brush such as used in oil painting. Working the light and the dark colors separately, stipple the light color into the dark one, let dry and then stipple the dark one into the light. Keep the paint on your brush to a minimum by wiping it on a paper towel, and hold the brush vertically so only the tips of the bristles come in contact with the wood surface.

To dry brush a blend line, use a soft, sable brush, leaving most of the paint on a paper towel. Work the light color into the dark one, using short flicking strokes with the brush held at an angle allowing approximately one-third of its bristle length to be used. When the light color has dried, load the dark color on the brush, wipe most of the color on a paper towel and flick a scant amount of the dark color into the lighter one. It may be necessary to repeat this procedure several times to effect a natural blend line.

To wet-blend, keep both the light and the dark colored paint wet. Quickly clean your brush. Work the light color into the dark one, wiping your brush off between strokes. Pull the wet color into the light one, again cleaning your brush between each stroke.

Feather Edges

The leading edge of a quilled feather is the outside edge. The trailing edge is the inside edge. Often a trailing or leading edge is a different value or color from the remainder of the feather.

Few people are born with the innate ability to paint. Painting is developed, in time, by experimentation, innovation, study, observation and practice. Just as a professional decorative bird carver is a novice who never quit, a professional painter is a beginner who never quit. Let's get started.

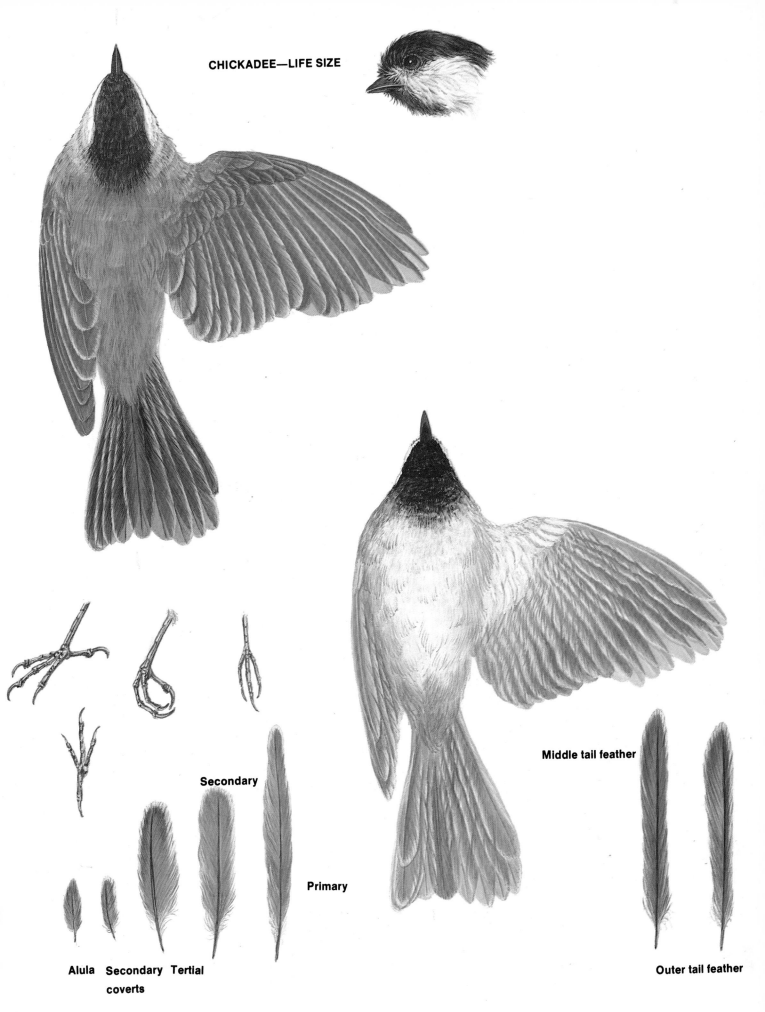

CHICKADEE—LIFE SIZE

Secondary

Primary

Middle tail feather

Alula Secondary Tertial

coverts

Outer tail feather

49

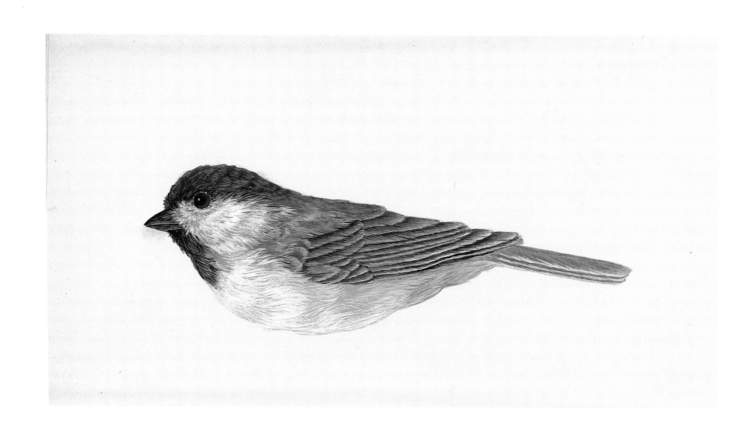

Black

Burnt umber

Raw umber

Payne's gray

Burnt sienna

Cerulean blue

White

BLACK CAPPED CHICKADEE

Head—beak, cap, bib

Black
Burnt umber

Mantle *Upper back*

Raw umber
Cerulean blue
White

Highlights: *mantle, upper back*

Raw umber
Raw sienna

Cerulean blue
Burnt Umber
White

Tail, wings—base coat

Burnt umber
Black
White Cerulean blue

Base coats: *belly, cheeks, lower tail coverts*

White
Burnt umber
Payne's gray

Sides

Raw sienna
Burnt umber
White

Edges for: *belly, cheeks lower tail coverts*

White
Burnt umber
Payne's gray

Flank washes—softens the appearence

Raw sienna

Watery wash on *belly* and *flanks:* to soften appearence

White
Raw umber

Edges: *wings and tail*

White
Raw umber
Payne's gray

Under tail, under lower wing edges

Burnt umber
Black
White

Feet

Burnt umber
Black
White

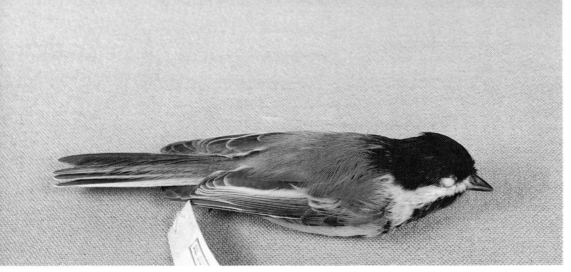

Figure 1. Here you see the black-capped chickadee study skin. Notice the dominant light edgings of the tertials and partially exposed greater secondary coverts.

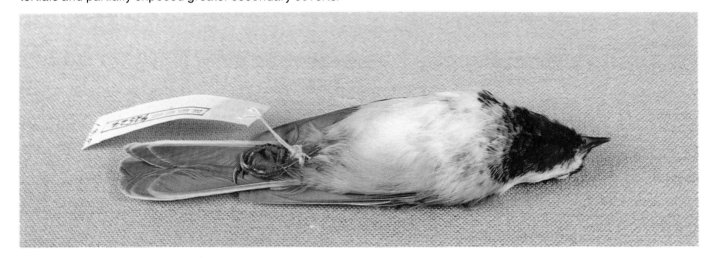

Figure 2. The area that the black bib seems to encompass in the study skin is deceptively large. Remember, the study skin is stretched out with its head pulled back. In reality, the black-capped chickadee's bib is much smaller since the feathers on the chin would compress with the bird in a natural, upright position.

A similar occurrence appears on the belly of the study skin. When the bird is in a natural position, with the feathers fluffed and lungs filled with air, there will be a larger whitish area on the belly between the buffy sides.

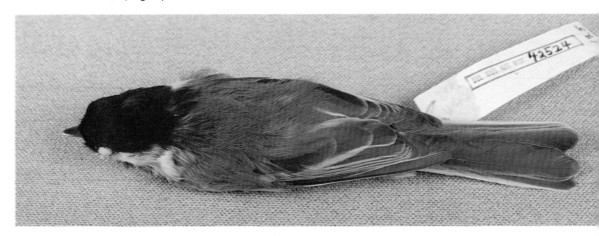

Figure 3. Notice the subtle coloring in the mantle and upper back areas. With the bird in a natural, upright position, the black cap would not extend as far down the upper back as it appears in the study skin, but it does extend to the base of the neck.

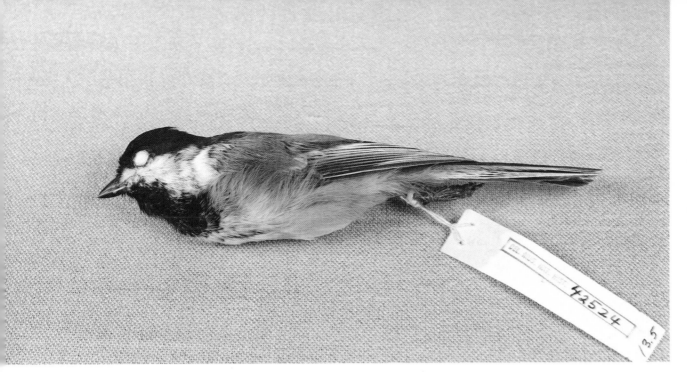

Figure 4. Notice the area that the black cap encompasses on this profile view of the study skin.

Figure 5. Applying gesso to the bird provides an even colored painting surface over the burned and stoned areas. Since gesso is a type of primer, it also ensures good adhesion for the application of subsequent layers of acrylic paint.

Using a stiff bristle brush such as a Grumbacher Gainsborough #5 (or equivalent), begin applying the gesso, working small areas at a time. Scrub the gesso down into the texture lines, rather than paint it on. Use a dry brush technique, leaving most of the gesso on your paper towel. Be careful not to leave any globs, especially on the edges of the tail and wings. Too much gesso will actually fill and obliterate the texture lines. Keep your brush damp, but do not use too much water, as it lessens the adhesive quality of the gesso. Dry brush the entire bird with the gesso including the areas around the eyes and the feet. Usually two coats of the gesso are sufficient. You can use a medium heat setting of a hair dryer to dry the bird between applications.

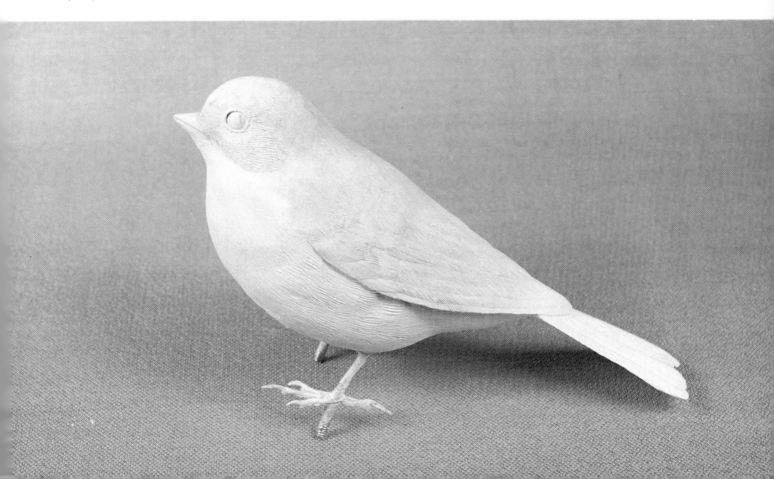

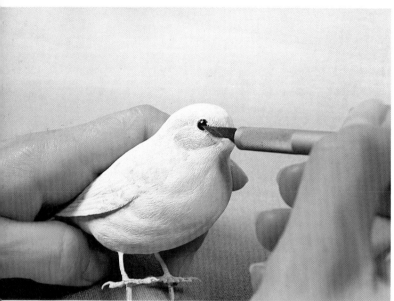

Figure 6. After the bird is thoroughly dry, CAREFULLY scrape the gesso off of the glass eyes, using the point of a sharp knife held at an angle. Cleaning the eyes periodically during the painting process enhances the lifelike quality of the carving allowing a more realistic application of colors.

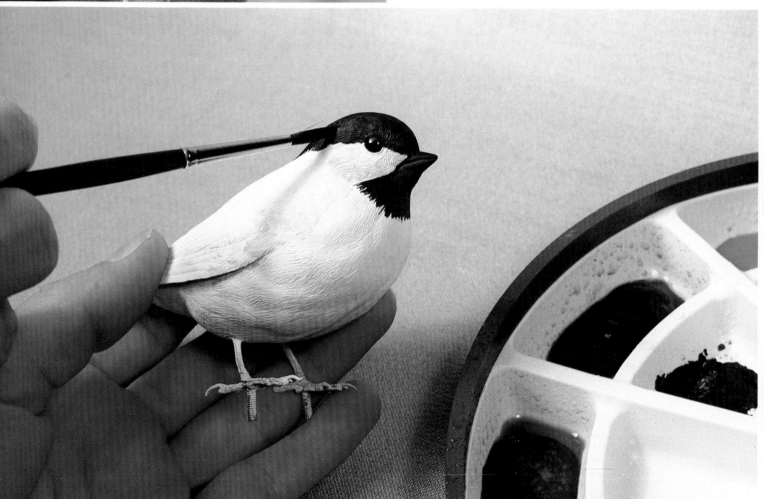

Figure 7. Mixing burnt umber and black to a warm black, paint the beak and layout the cap and bib areas. Feather out the edges of the dark areas so that you do not have straight lines, for example, across the bottom of the bib. Covering these dark areas will likely take two or more applications of the color depending on the consistency of the paint. Keep the paint thin, so you do not fill up the texture lines.

After the dark base coats have dried, mix a small amount of white in the dark base coat color. Using this lighter mixture, go back over the cap and bib with a dry brush technique to highlight the edges of some of the feathers. When the highlights are dry, use a watery burnt umber wash over the entire cap and bib.

Figure 8. Mixing burnt umber, black and a small amount of white to create a medium charcoal color, begin applying the base coats to the wings and upper tail surface. It will take several applications of this color to cover the surface. Keep your paint thin so that it does not fill in the texture.

After your base coats have dried, alternate watery washes of burnt umber and cerulean blue over the wings and upper tail, drying each one before applying the other. Your eye will mix these two optically, creating a soft blend of color.

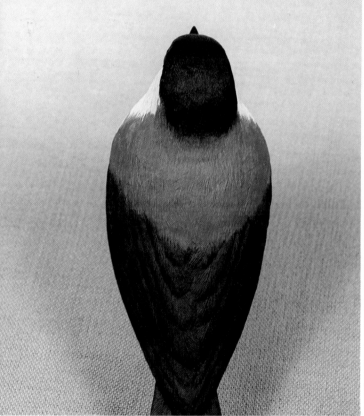

Figure 9. Blending raw umber, cerulean blue and white to a soft, medium gray, begin applying the base coats to the mantle and upper back. On each thin base coat, vary the proportion of the different colors. At the point where the black cap merges with the lighter color of the upper back, feather the light color into the darker area and the dark color (used on the cap) into the lighter area until you have achieved a soft, blended area.

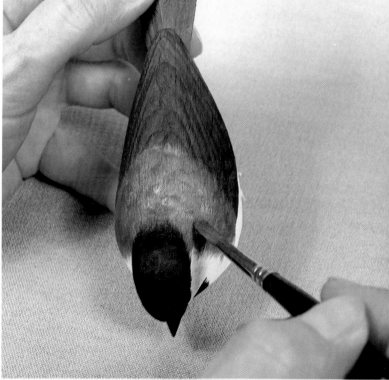

Figure 10. Blending raw umber, raw sienna and a small amount of white, feather out the edges of the mantle and upper back color in the shoulder area. With a dry brush technique, highlight various areas within the upper back and mantle, especially the edges of the mantle where it flows over the wings.

After the highlights are dry, add a large amount of water to the raw umber, raw sienna and white mixture. Using a small liner or scroll brush, outline the edges of the feathers on the mantle and upper back with the watery highlight mixture.

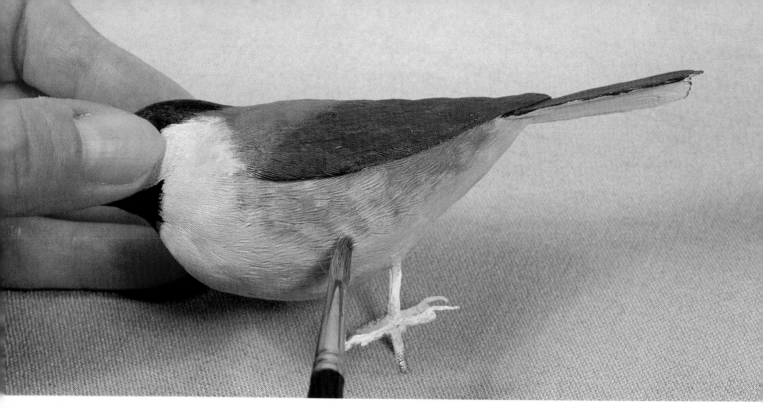

Figure 11. Combining white, burnt umber and payne's gray, creating a light gray. Apply the base coats to the cheeks, breast, belly and lower tail coverts. Feather this light color into the dark area of the bib and bring some of the dark color (burnt umber and black) down into the light color of the breast until you have a soft, feathery look at the bottom of the bib.

Blending raw sienna, white and a small amount of burnt umber, apply the base coats on both sides of the bird. Feather this color into the lighter color of the belly, and carry some of the light gray of the belly into the darker, buffy color of the flanks. This creates a soft transition from one color to another.

Figure 12. To do the edgings of the feathers on the underneath side of the chickadee, mix a very small amount of burnt umber and payne's gray with white. The two colors added to the white keep it from being so stark. Using a #4 or #5 Grumbacher Beau Arts 190 brush, (or the equivalent) begin to dry brush the edges of the feathers on the breast, belly, sides, lower tail coverts and cheeks with the white mixture. Edgings can be executed by drawing the brush from the center of the feather towards the edge or from the edge towards the center of the feather. Try both directions to see which works best for you. Remember to keep only a scant amount of paint on your brush.

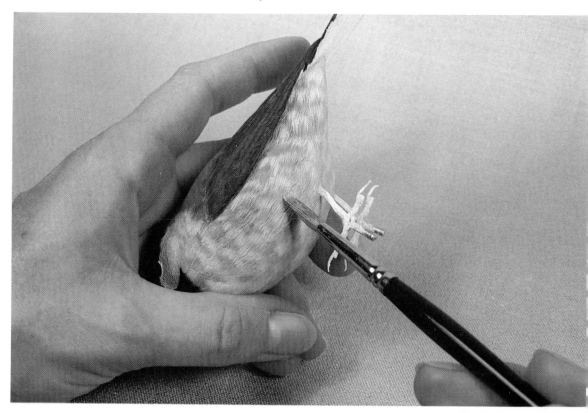

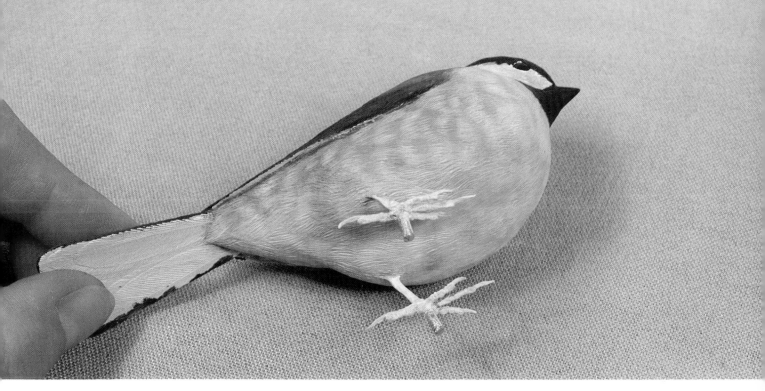

Figure 13. After the edgings are dry, apply a watery raw sienna wash over the buffy color on the sides. This wash will soften the edgings.

On the cheeks, breast, belly and lower tail coverts, apply a watery wash of white and just a hint of raw umber.

Figure 14. For the base coats of the under tail and the underneath surface of the lower wing edges, mix burnt umber with small amounts of black and white to produce a medium gray. Be careful not to get any of the gray mixture on the upper surface of the tail feathers when you are doing the edges of the underneath area of the tail—paint sometimes has a way of going around edges.

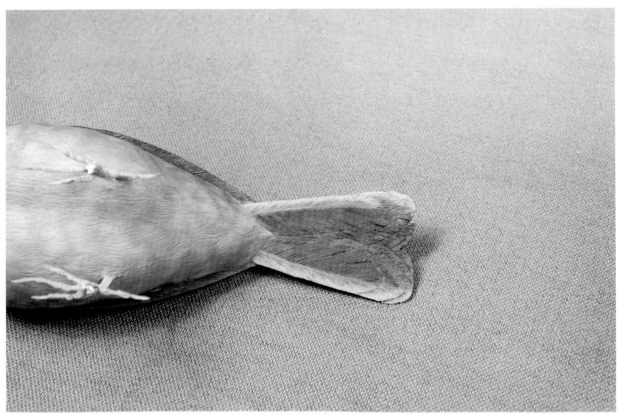

Figure15. Blending a small amount of the medium gray mixture with white, lighten the outer edges of the underneath tail feathers. After the edges are dry, make a watery wash with a small amount of burnt umber and a large amount of white. Apply the light watery wash to the entire underneath tail and the underneath surface of the lower wing edges. The light wash over the medium gray base coats creates the silvery effect of the underneath surface of dark feathers. To create feather splits, use the medium gray base coat and a small liner or scroll brush.

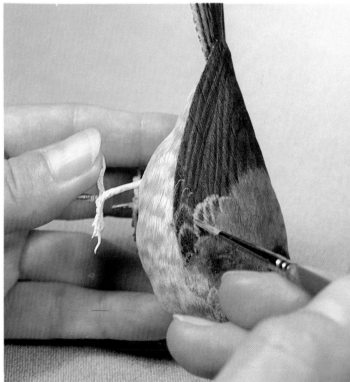

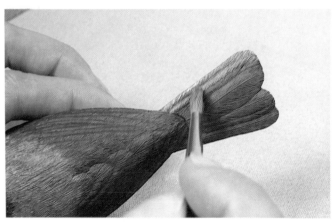

Figure 16. For the edgings on the wing and tail feathers, blend small amounts of raw umber and payne's gray into a large amount of white to effect a light gray. Begin dry brushing this mixture on the edges of the tail feathers. You will notice on the photos of the study skin (Figures 1 and 3) that the outer tail feathers have wider light edgings. It may take several dry brush applications of the light gray mixture to create the realistic light edgings.

Figure 17. A small liner or scroll brush can be used to apply the light gray edging mixture on the wing feather edges. Again, refer to the study skin photos for reference. You will notice that the tertials, secondaries and secondary coverts have progressively wider, lighter edges.

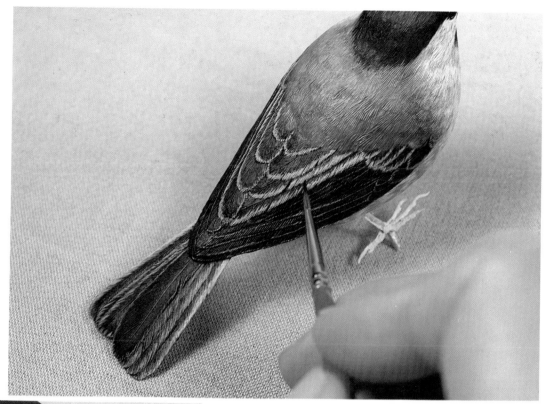

Figure 18. Mix a small amount of payne's gray with a large amount of water. Paint in the feather splits on the wings and tail with a small liner or scroll brush.

Figure 19. If you find that your feather edgings have gotten too wide, use the small liner or scroll brush to pull some of the medium charcoal base coat (burnt umber, black and a small amount of white) from the center of the feather towards the edge.

Figure 20. Using a very watery wash of burnt umber and payne's gray, soften the starkness of the edgings by applying the wash on the wings and tail.

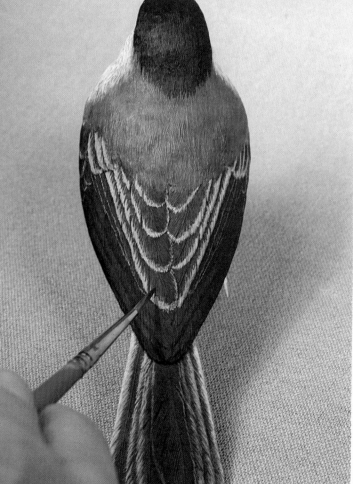

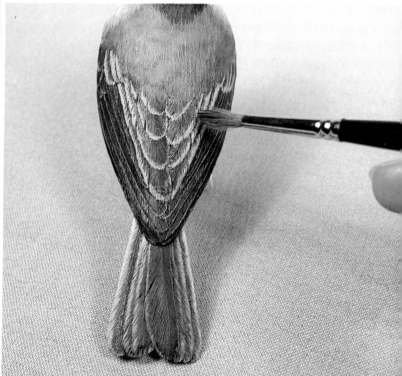

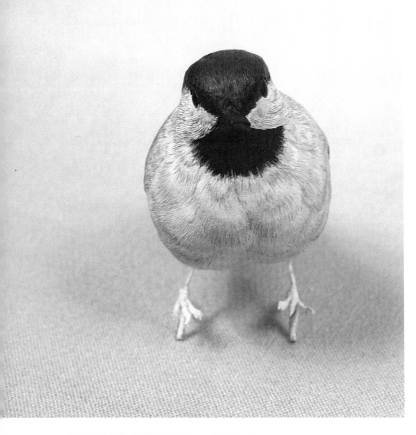

Figure 21. Now that the bird is basically painted, you can go back over the entire bird, section by section, highlighting and subduing different areas. On the upper breast, you can use some of the base coat color (white and small amounts of burnt umber and payne's gray) to optically recess your low areas of the feather contouring. You can optically raise the high points of the feather contouring by lightening them.

To further blend the dark area of the bib with the light breast area, add a small amount of burnt umber to a puddle of water. Again, using the small liner or scroll brush, paint in small hair-like lines where the dark and light areas meet at the bottom and sides of the bib. Use this technique around the edges of the dark cap as well.

Figure 22. With a small liner or scroll brush, paint the inside of the eye lids with watery black paint so that no white of the gesso can be seen. Adding a small amount of white to the black, paint the eye ring itself a dappled charcoal color. When this area has dried, **carefully** scrape any remaining paint off of the eye.

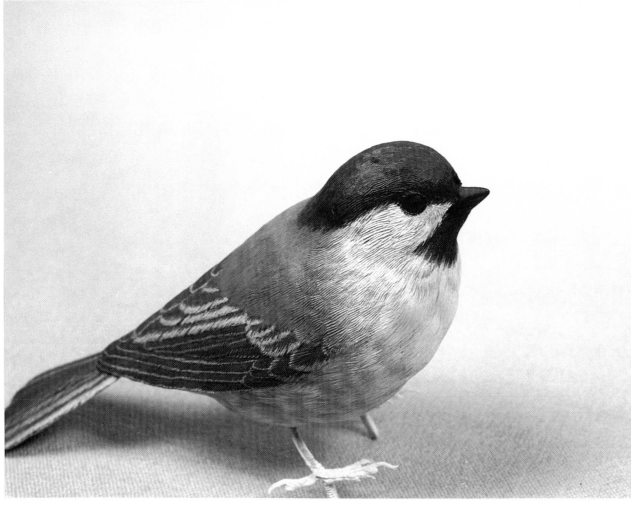

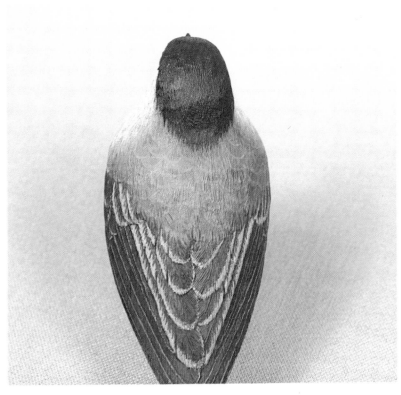

*Figure 23.*With watery payne's gray paint, enhance the feathery look of the edges of the mantle by darkening the hair-like splits.

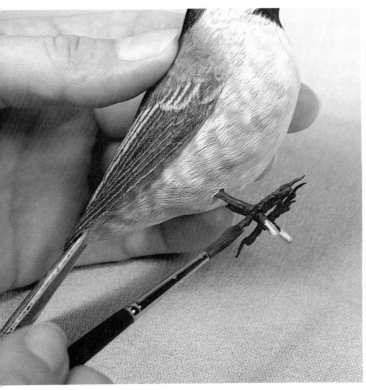

Figure 24. For the color of the feet, mix burnt umber with small amounts of black and white. Apply at least two coats to the feet, being careful not to fill in the texture of the castings.

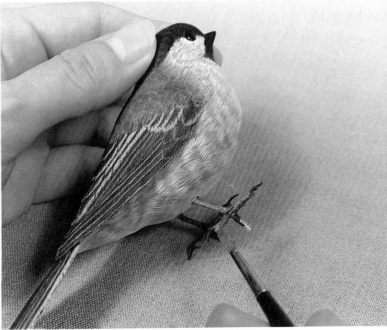

Figure 25. To accentuate the texture of the castings, apply a very watery wash of white and a small amount of burnt umber to the entire foot except the claws.

Figure 26. Brush the entire surface of both feet with a small amount of gloss medium added to a puddle of water. This leaves a slight sheen to the feet. Apply stright gloss medium to all surfaces of the claws. Both gloss and matte mediums appear milky-looking when wet, but both dry clear.

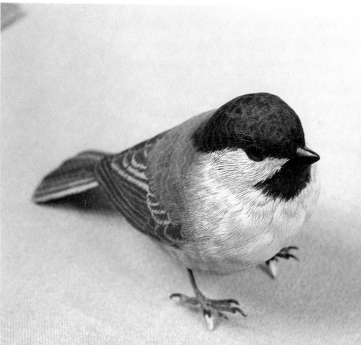

Figure 27. Using a small liner or scroll brush, apply straight gloss medium to the quills of both wings and to the quills of the upper and lower surfaces of the tail feathers.

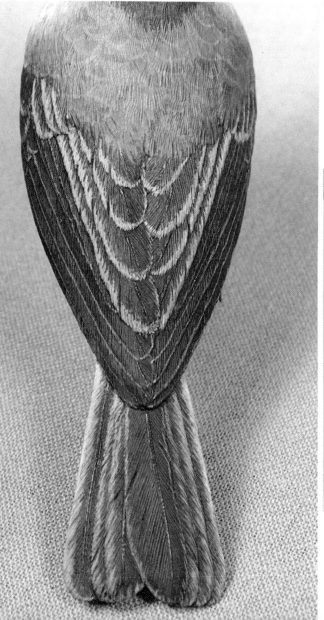

Figure 28. Apply a half and half mixture of matte and gloss mediums to the beak, creating a satin gloss.

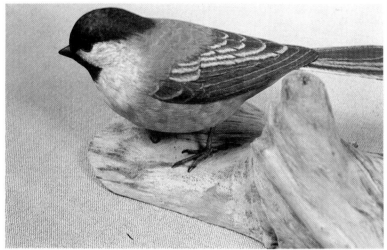

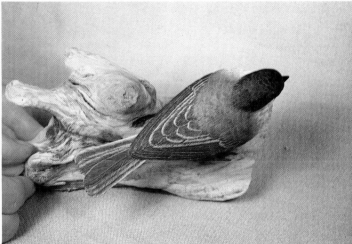

Figure 29. After the mediums have dried, you are ready to mount the completed carving onto the prepared driftwood. Mix up a small amount of 5 minute epoxy and glue the feet in their respective holes. If any of the glue should seep out of the holes onto the surrounding driftwood, you can touch up this area with acrylic paint after the glue has hardened.

Figure 30. Top view of the completed chickadee.

Figure 31. The completed project.

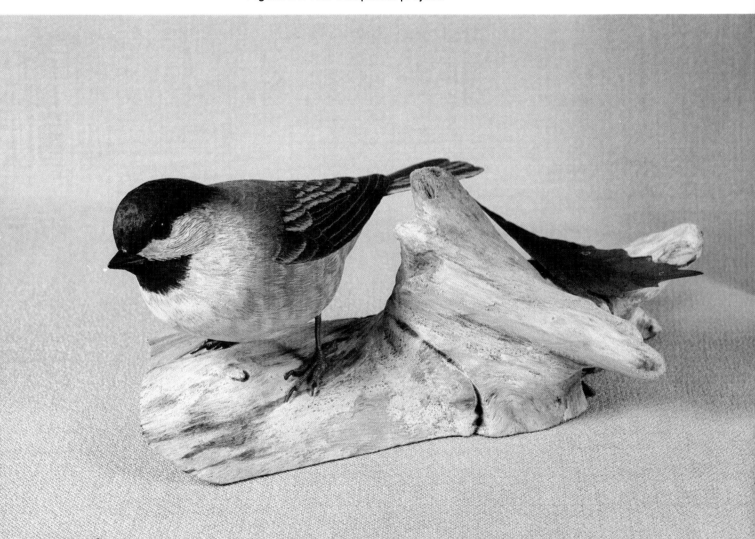

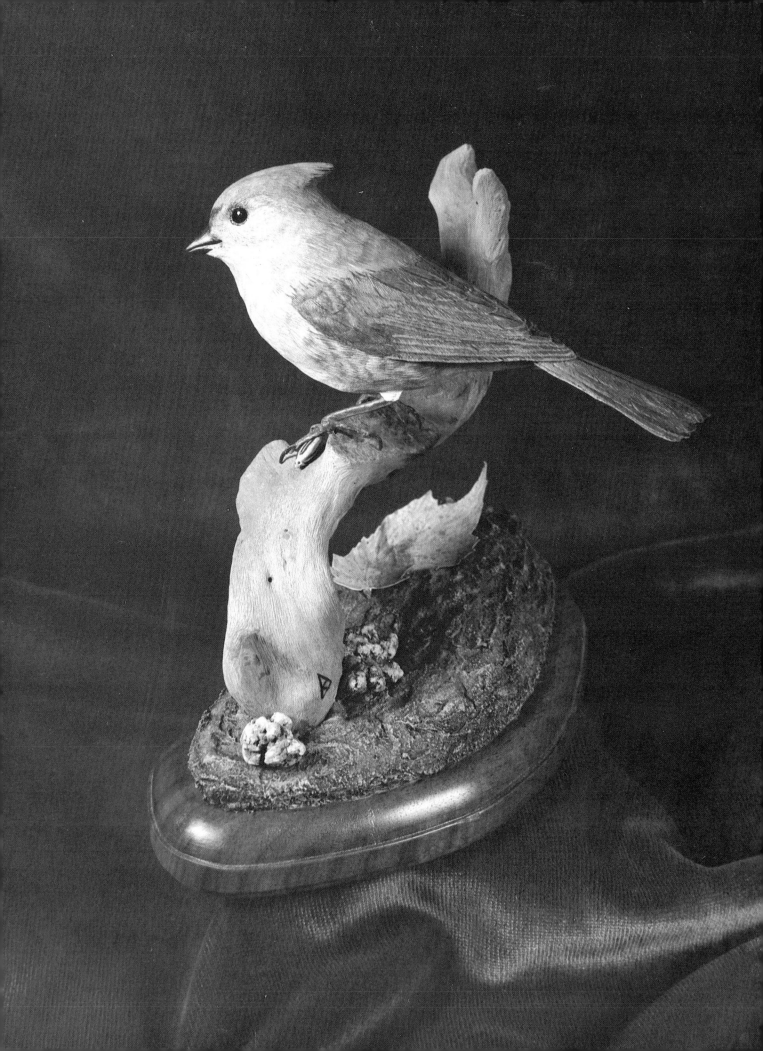

Tufted Titmouse

(Parus bicolor)

In this project you will be turning the bird's head, which will give a more natural, flowing motion to the carving. With the tufted titmouse you have a bird with a light, airy crest. The head will be cut off in the neck area and turned. The grain will be running along the crest for strength and ease of carving.

The tufted titmouse is the largest North American titmouse (5½-6 inches) and is a frequent inhabitant of the eastern deciduous forests and suburbs. His soft gray plummage allows him to hide easily among the branches, but his active voicebox will let you know he is nearby. The titmouse often travels in flocks (even with chickadees) except during the breeding season. A pair will usually next in a hole or crevice in a tree or fencepost, 2-8 feet above the ground. In the nest, which is made of dry grasses, moss, downy parent feathers and even mammal hair or fur, the male will feed the female while she is incubating the eggs.

Physical Characteristics
The titmouse has a 5-sided conical bill with both the bottom and top outlines slightly convex. The nostrils, at the base of the bill, are covered by a group of bristly feathers, called the rictal bristles.

With a folded wing position, you will not see all 10 of the titmouse's primaries, only 3 or 4 will be exposed. Remember, that from the side profile view, you will only see the edges of these feathers. It is from the top or plan view that you will see the broad expanse of the primaries in a folded wing position. The first three primaries are considerably shorter than the longest ones which are the fourth and fifth. The titmouse has a rounded wing shape when the wing is extended.

The tail of the titmouse is slightly rounded with the outermost feathers being shorter than the inner ones. The greatest difference from the longest tail feather to the shortest is .2 of an inch. There are usually 12 tail feathers but not all will be visible unless the tail is widely fanned.

The crest is flattened and extends to the extreme back of the head (occiput). The titmouse can raise or lower the crest as a group.

DIMENSION CHART

Tools:

Bandsaw (or coping saw)	Flexible shaft machine
Carbide bits	Ruby carvers
Tootsie roll sander on a mandrel (120 grit) or a mounted bullet-shaped abrasive stone	v-tool (optional)
Knives, small chisels, shallow gouge (optional)	Ruler measuring tenths of an inch
Caliper measuring tenths of an inch or dividers	Pointed clay tool or dissecting needle
Emery board (kind used for fingernails)	Burning pen
Abrasive cloth (120 and 320 grits)	Variety of small mounted stones
Laboratory bristle brush on a mandrel	Natural bristle toothbrush
Defuzzer on a mandrel	Variable speed electric drill
Drill bits	Needle-nose pliers
Wire cutters	Alligator clips
Paste flux	Solid wire solder
Soldering gun or pen	Small, triangular-shaped file
Awl	

MATERIALS:

Basswood	Tracing paper
Super-glue	Pair of brown 5mm eyes
Duro epoxy ribbon putty	Clay or dental tools
1/16 of an inch diameter copper wire (16 gauge)	Copper wire (20 or 22 gauge)
Yellow wood glue	Acetone
Pair of cast toes for titmouse	Permanent ink marker
Krylon Crystal Clear 1301	Driftwood for mount

TOOLS AND MATERIALS

1. **End of tail to end of primaries — 1.4 inches.**
2. **Length of wing — 3.3 inches.**
3. **End of primaries to alula — 2.2 inches.**
4. **End of primaries to top of 1st wing bar — 2.0 inches.**
5. **End of primaries to bottom of 1st wing bar — 2.2 inches.**
6. **End of primaries to mantle — 2.0 inches.**
7. **End of primaries to end of secondaries — .5 inch.**
8. **End of primaries to end of primary coverts — 2.1 inches.**
9. **End of tail to front of wing — 4.5 inches.**
10. **Tail length overall — 2.7 inches.**
11. **End of tail to upper tail coverts — 1.9 inches.**
12. **End of tail to lower tail coverts — 1.7 inches.**
13. **End of tail to vent — 2.7 inches.**
14. **Head width at ear coverts — .9 inch.**
15. **Head width above eyes — .65 inch.**
16. **End of beak to back of head — 1.21 inches.**
17. **End of beak to back of crest — 1.75 inches.**
18. **Beak length: top — .4 inch; center — .5 inch; bottom — .3 inch.**
19. **Beak height at base — .22 inch.**
20. **Beak to center of eye (eye 5 mm) — .8 inch.**
21. **Beak width at base — .27 inch.**
22. **Tarsus length — .8 inch.**
23. **Body width[1] — 1.8 inches.**
24. **Overall body length — 5.8 inches.**

[1]At widest point.

TUFTED TITMOUSE

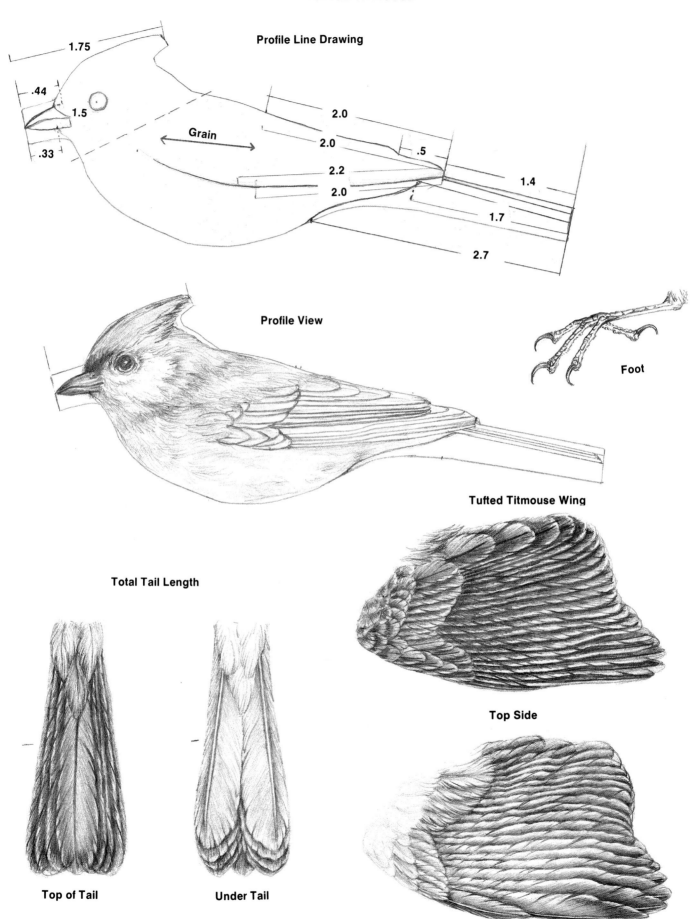

Profile Line Drawing

1.75

.44

.33

1.5

Grain

2.0

2.0

.5

2.2

2.0

1.4

1.7

2.7

Profile View

Foot

Tufted Titmouse Wing

Total Tail Length

Top Side

Top of Tail

Under Tail

Under View

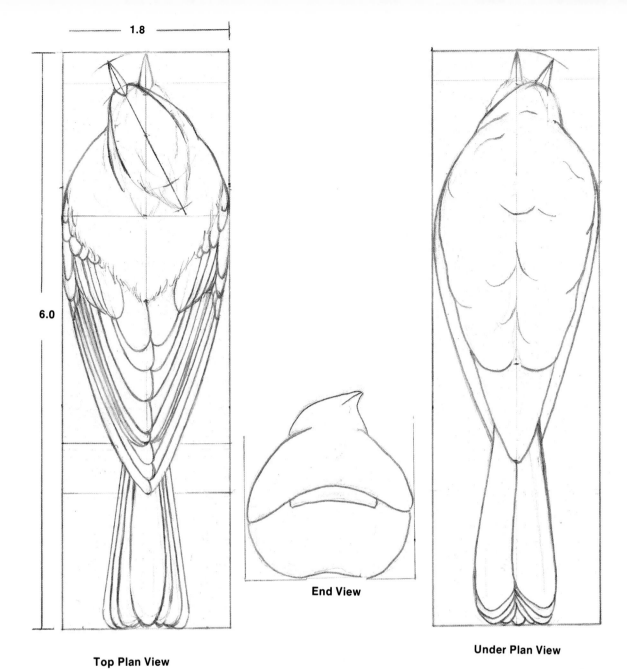

1.8

6.0

Top Plan View

End View

Under Plan View

Head on View

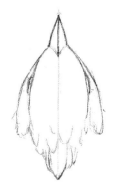

Top Plan View

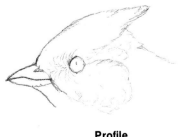

Profile

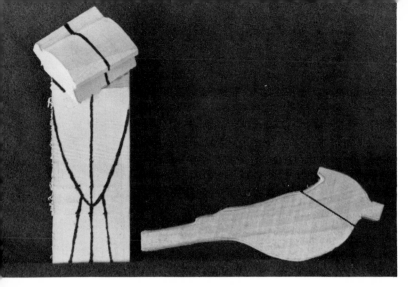

Figure 1. The titmouse on the right shows the profile pattern cut-out. The one on the left shows the plan view with wings and tail drawn out ready to be bandsawed.

Figure 4. After finding the center of both pieces, drill 1/16 inch holes. Insert a piece of 1/16 inch wire. Using yellow wood glue, put the two sections together with the head turned. Hold in place with hand pressure or rubber bands until the glue begins grabbing. Let it dry for approximately two hours or until handling does not disturb the joint.

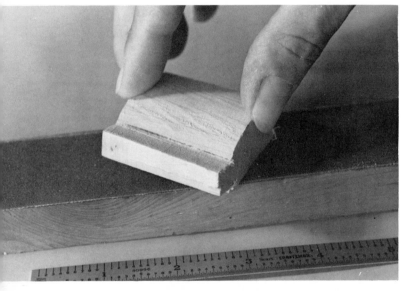

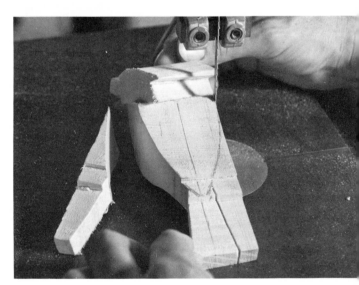

Figure 2. Bandsaw the neck line according to the pattern. Glue a strip of medium grit (100-120) sandpaper to a flat strip of wood. With an even pressure, push both the head and body sections across the sandpaper until the surface is perfectly flat and smooth.

Figure 3. With a straightedge check both sections for light leaks and low spots. The better the fit, the less trouble it will be to cover the seam. If the seam is extremely tight there may be no patching necessary.

Figure 5. With a bandsaw or coping saw, remove excess wood on wings and tail according to plan view. Check for proper tail to the end of wing dimension which should be 1.4 inches.

Figure 6. Cut triangles off the wing edges that lay on top the tail.

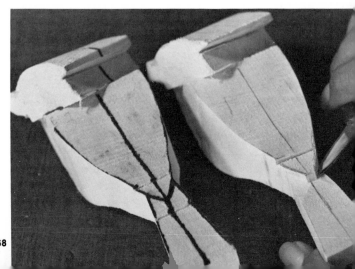

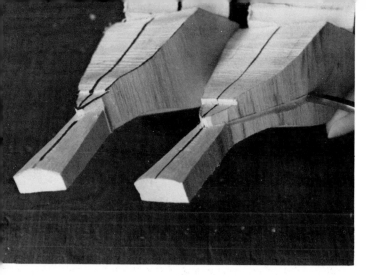

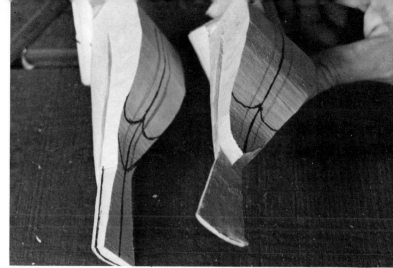

Figure 7. Slightly round the top tail surface. Draw the lower wing edge on both sides as seen in the profile pattern. With square-edged carbide bit or v-tool, cut along the lower wing edge line.

Figure 10. Draw a line .1 of an inch from the top edge all the way around the tail. Measure and draw in the lower tail coverts (1.7 inches from the end of the tail) and vent area (2.7 inches also from the end of the tail). Remove excess wood on the under tail up to the lower covert line. The tail should have a convex shape on top and concave underneath.

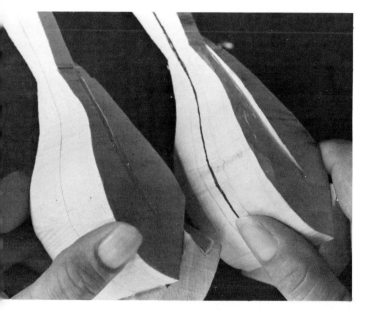

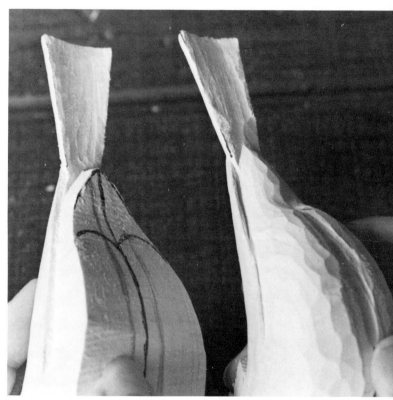

Figure 8. Remove the excess wood on the sides of the bird to the bottom of the v-cut and below the wing from the v-cut edge to the belly. Work carefully so that the lower wing edges are not nicked.

Figure 9. Gently round the wings from .2 of an inch on both sides of the center line to the lower wing edges.

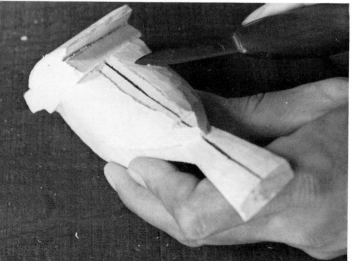

Figure 11. Using a knife (scooping cuts) or carbide cutter, make a channel on the vent lines around to the flanks. Round the belly and flanks down to the bottom of the channel and flow lower tail coverts to the base of the exposed tail feathers. Make a shallow depression on the center line up to the lower breast area. Gently round the belly and sides from the lower wing edges to the center line channel.

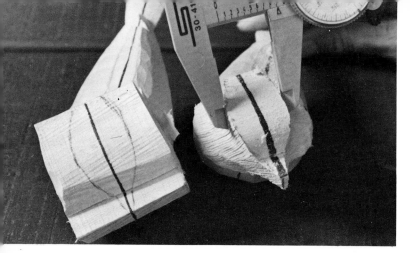

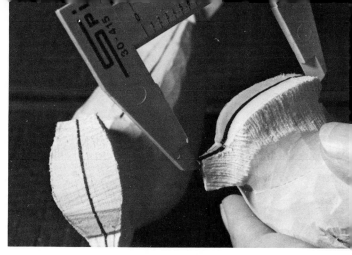

Figure 12. The widest dimension of the head is the ear coverts which are .9 of an inch wide. Mark this on the bird and draw the plan view allowing a little extra wood. Take scooping cuts with a knife or carbide cutter from the shoulder area to the ear covert width lines drawn on the top of the head. As you start getting close to the width line marked on the top of the head, check the head for balance on each side of the center line. Keep removing wood symmetrically until you get the .9 of an inch dimension.

Figure 14. Make sure you have the proper end of the beak to the end of the crest measurement (1.75 inches). Adjust if necessary by taking equal amounts of wood from the end of the crest and beak.

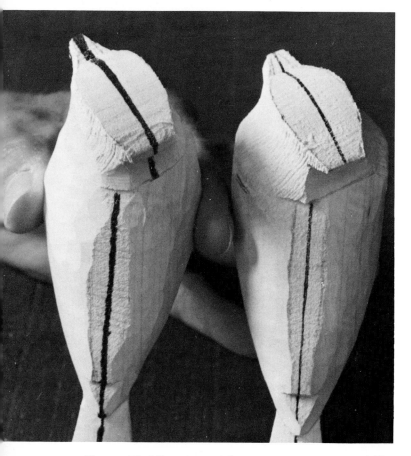

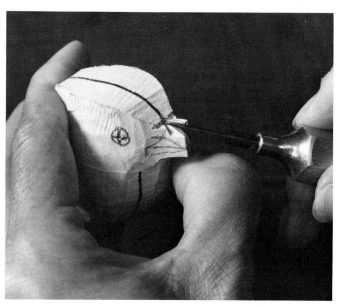

Figure 13. After you get the proper ear covert width, round the shoulder area and flow the upper back to the neck area. Work carefully around the glue joint to avoid "chunking" out any pieces. Round the breast and check the overall shape of the body of the bird so it has an elongated teardrop shape. The body should round gently from a mid-wing point and flow more acutely towards the tail.

Figure 15. Trace the beak and eye positions from the profile pattern line drawing and pinprick onto the wood making sure that both sides are equal and balanced. Mark the top dimension of the beak from the tip to the forehead (.4 of an inch). Make a v-shaped stop cut on the top of the beak. Cutting back to the stop cut, remove the excess wood until you get down to the profile pattern tracing top line.

Figure 16. With a sharp knife, trace a stop cut on the **outside** lines of the beak profile view (not the commissure line). Make sure that the cut is perpendicular to the beak surface and not undercut.

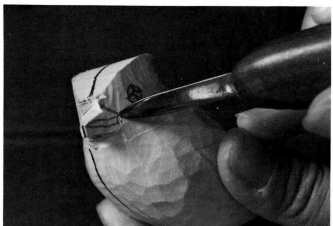

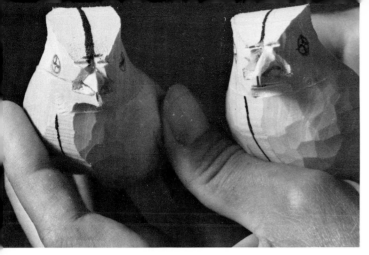

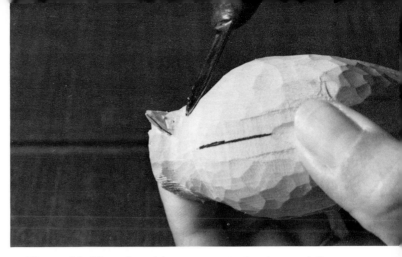

Figure 17. Cut the sides of the beak back to the stop cut, carefully taking little chips off of each side. Keep the beak balanced with the center line. The width of the base of the beak at the head should measure .27 of an inch. Flow the sides of the beak into the pyramid-shaped top surface.

Figure 20. Flow the chin area up to the base of the lower mandible underneath.

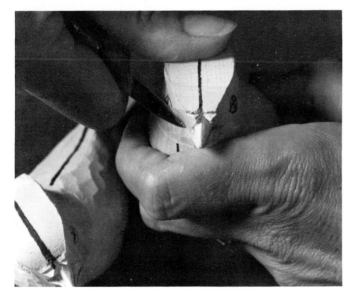

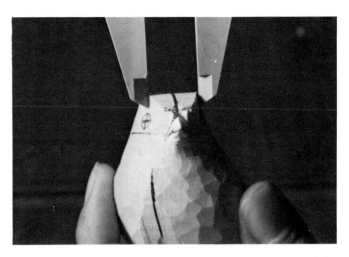

Figure 18. Flow the head down to the base of the beak, shaping the region immediately behind the beak towards the upper mandible.

Figure 19. Measure .3 of an inch on the underneath base of the beak. Draw a semi-circular line from the sides of the beak to the .3 of an inch mark. Make perpendicular stop cuts along this line. From the tip of the beak, carefully cut back to the stop cut until you reach the bottom beak line traced from the profile pattern.

Figure 21. When looking at the head from a straight head-on view, the widest dimension is between the ear coverts, which measures .9 of an inch on the titmouse. The ear coverts then flow towards the area around and behind the eye, gradually becoming more concave. The width of the head above the eye (crown) measures .65 of an inch in the titmouse.

Recheck the end of the beak to the eye center measurement (.8 of an inch). Pinprick the eye center deeply with an awl or dissecting needle. The distance across the top of the head above the eye should be .65 of an inch. If necessary, cut away any excess, keeping both sides of the head balanced. Leave a slightly concave area for each eye to sit in.

Figure 22. Gently round the top of the head from the forehead (at the base of the beak) to the back of the neck. Drill 5 mm eye holes keeping them balanced from the top or plan view and the head-on view.

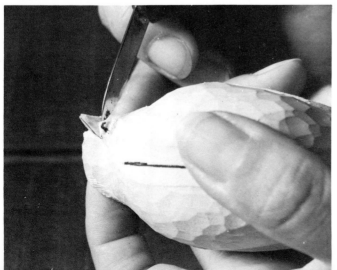

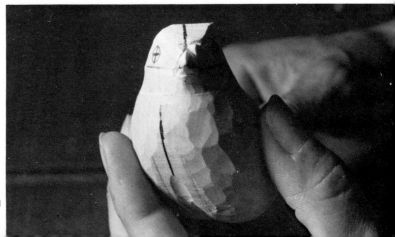

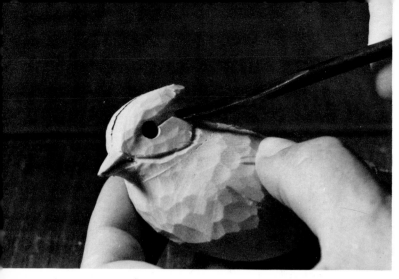

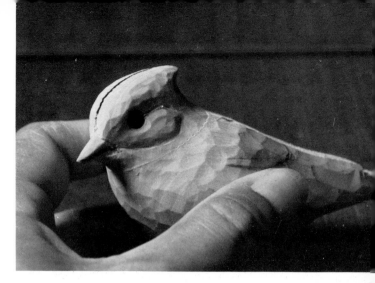

Figure 23. Draw or trace and pinprick the ear coverts onto the cheeks using the profile line pattern. With a v-tool or ruby carver, make a channel on the ear covert line.

Figure 26. Recheck the area around the eye—you may have to recess the area around the eye so that the eye sits in a slightly concave area (not a channel or groove but a flattened area).

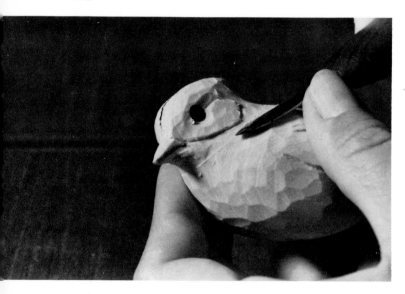

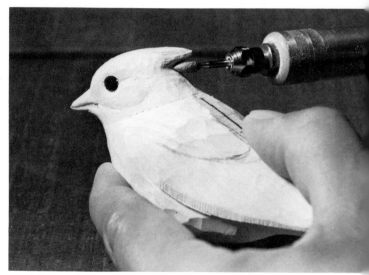

Figure 24. Flow the neck area to the bottom of the ear covert channel.

Figure 27. With a ruby carver, round up the area under the crest.

Figure 28. With the burning pen, burn the commissures line on the beak, keeping the pen perpendicular to the beak's surface. To create the effect of the lower mandible fitting up into the upper mandible, lay the burning pen on its side and burn up to the perpendicular commissure burn line—this creates a bevel on the lower mandible.

Figure 25. Flow the ear coverts down to the bottom of the channel. This creates the fullness and roundness that is needed in the cheek/ear covert area.

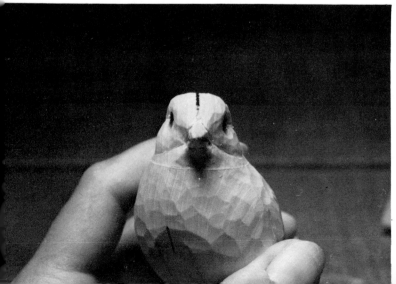

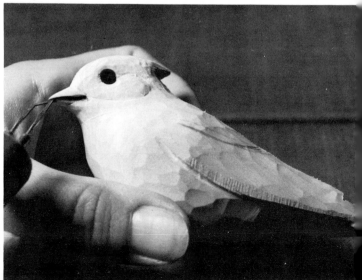

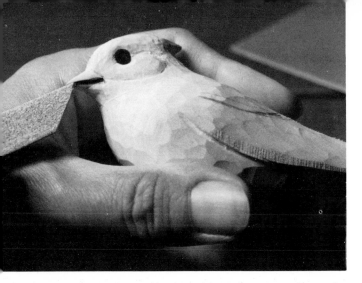

Figure 29. Sand the beak with an emery board, gently rounding any sharp contours. Apply super-glue and let harden. When the glue has dried, fine sand.

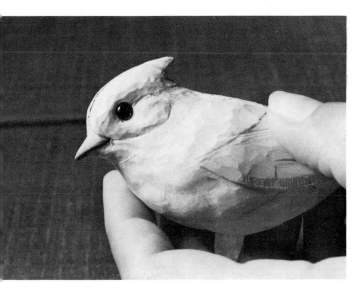

Figure 30. Put a small ball of clay into each eye hole. Place a 5 mm dark brown eye into each hole, checking for balance from the head-on view as well as the top plan view. Notice how inserting the eyes gives a lifelike appearance to your carving!

Figure 31. Every feather has a definite contour (convex on the top surface and concave underneath). Looking at a body contour feather, you will see that it not only has curvature from side to side but also from top to bottom.

On the breast and belly, close observation of a bird reveals high and low points of feather contouring as well as varying directions of feather flow. You will hear this referred to as "lumps and bumps", feather landscaping or feather contouring. The pattern of this feather contouring is not definite or fixed. Every time a bird fluffs his body contour feathers, they will fall into different patterns. The wind will also affect the patterns and the flow.

There is no one right way to do feather contouring. You can exaggerate and use artistic license on feather landscaping to increase motion and fluidity and to heighten interest in any particular area. One thing you will want to avoid is the fish scale or brickwall type of pattern. Feathers tend to flow in rows, but not to the point of rigidity or predictability. Vary the direction of the feather flows as well as the length of each exposed feather. Also remember that the two sides of the bird's breast and belly should be different to avoid monotony.

There are many ways to accomplish these feather contours. After drawing large sweeping feather groups on the breast and belly, use a knife, ruby carver, gouge or tootsie roll to recess the lower areas. There should be a variety of high and low points of varying depth, keeping in mind that each feather group comes out from underneath the preceeding one (progressing from the head back to the under tail covets). A single light source is helpful to create shadows when working on the contours as well as well as when stoning.

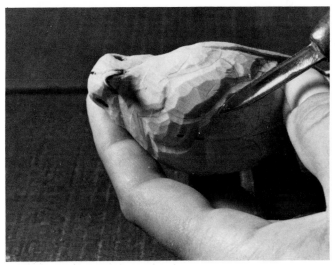

Figure 32. After you have channeled the main feather flow lines, round over each high area to the bottom of the channel.

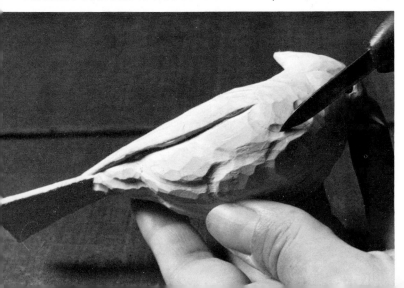

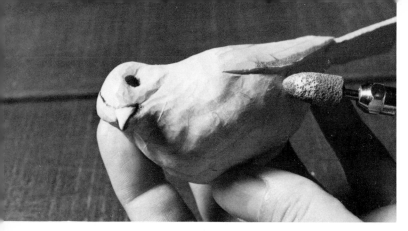

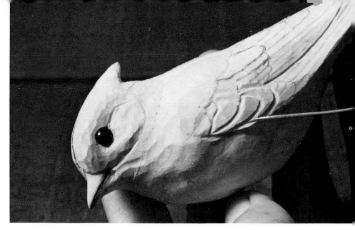

Figure 33. For further shaping and smoothing, a bullet-shaped stone in a flexible shaft machine is helpful. Remember to run the stone with the grain. If the bird has been bandsawed out with the grain running along the length of the bird, be aware that there usually is a grain change at the upper belly or lower breast where the flat grain becomes end grain. Should the wood start becoming fuzzy, turn the bird around end for end so that you are sanding or stoning in the opposite direction. There is usually less fuzz if you work downhill.

Figure 36. Trace and pinprick the feather groups of both wings. The exposed feathers on the top of the wings can be traced from the line plan view pattern, and those on the sides can be traced from the profile pattern. Starting at the front of the wing, begin cutting out the feathers and progress back towards the tail and down towards the lower wing edge. A v-tool or ruby carver can be used. Leave the secondaries uncut at this point as their edges will be burnt in with the burning tool after the bird has been sanded.

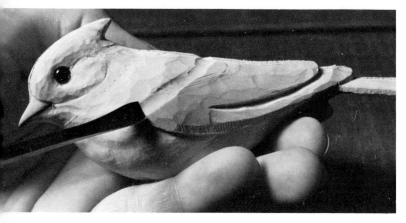

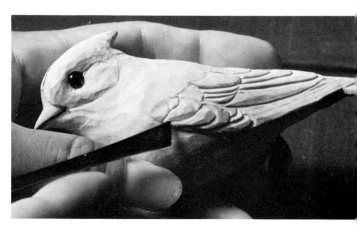

Figure 34. From the profile pattern draw the mantle line and the line dividing the secondaries from the primaries. With a shallow gouge or ruby carver, make a shallow channel on the mantle line. Using a v-tool or working a ruby carver deeper, make a sharper-angled channel on the secondary/primary line.

Figure 37. Keep in mind that each feather has a rounded (convex) contour and flows out from underneath the preceeding one. With a ruby carver, knife or chisel, round over the feather edges and flow each one out from underneath the preceeding one.

Figure 35. Flow the mantle down to the bottom of the channel and flow the wing out from underneath the mantle. Round over the secondary area and flow the primary group out from the bottom of the channel to the wing edge. In the folded-wing bird, the secondaries are a separate stack of feathers resting on top of the primaries.

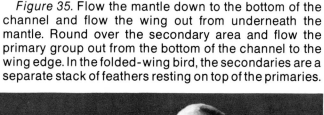

Figure 38. Sand the wing feathers with a folded piece of abrasive cloth (120 grit) or a bullet-shaped stone on a flexible shaft machine.

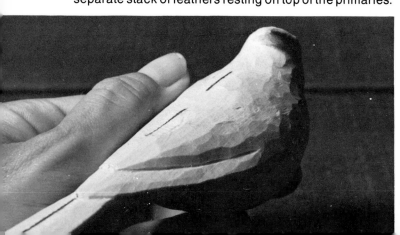

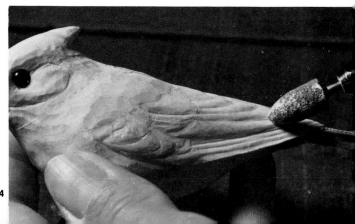

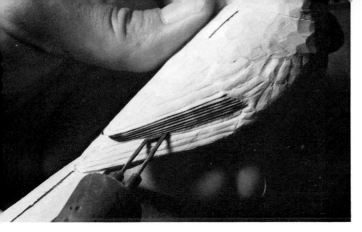

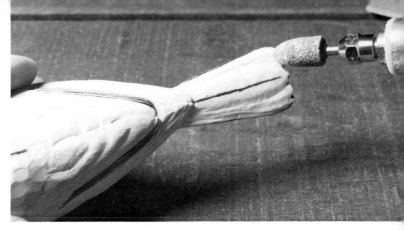

Figure 39. In this type of folded wing position, the secondaries should appear as a stack of feathers. From a profile view, only the edges of the feathers will be prominent. Draw in the secondary edges. With a burning pen at a 90° angle, burn in the secondary edges.

Figure 42. With abrasive cloth or a bullet-shaped stone on the flexible shaft, sand out rough spots and gently round the fully exposed feathers on the top and underneath tail.

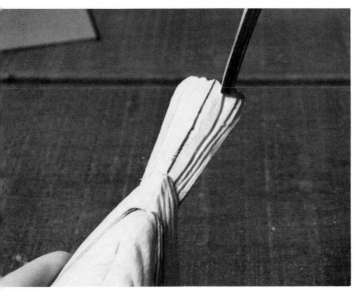

Figure 40. Not every tail feather will necessarily show in every tail position (except for an extremely fanned tail). If you desire, you can vary the tail feather layout. Trace the tail layout and pinprick onto the carving. With a v-tool or ruby carver, begin cutting out tail feathers by starting with the centermost or fully exposed feather and proceed outward on both sides. Round over the sharp edges.

Figure 41. Trace the underside tail feathers from the line pattern and transfer to the carving. Relieve around the outermost feathers first and proceed towards the center ones. Line up the end edges of the topview and the bottomview. Use a burning tool to match up the top and bottom edges on the very end of the tail. Round over the exposed edges on the underneath tail feathers.

Figure 43. With a knife, carefully cut the triangular-shaped strips of wood from underneath each of the lower wing edges along the entire length of the primary. This creates the effect of the body going up, around and underneath the wings. Work very carefully so as not to nick or split out the lower wing edges.

Figure 44. Whenever you have to do any work on the head, whether it is sanding, stoning or burning, temporarily remove the eyes. A dissecting needle or clay tool is helpful in popping them out. With a tootsie roll, sand the body of the bird, always going with the grain or going downhill. As you are sanding, use a strong, one directional light source and check the overall effect of your feather flows and contours. Use a folded strip of abrasive cloth to reach areas that the tootsie roll cannot sand.

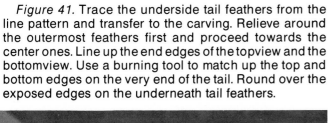

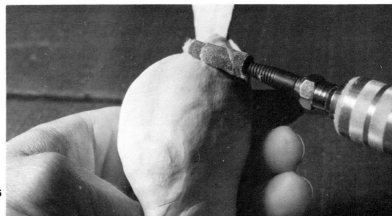

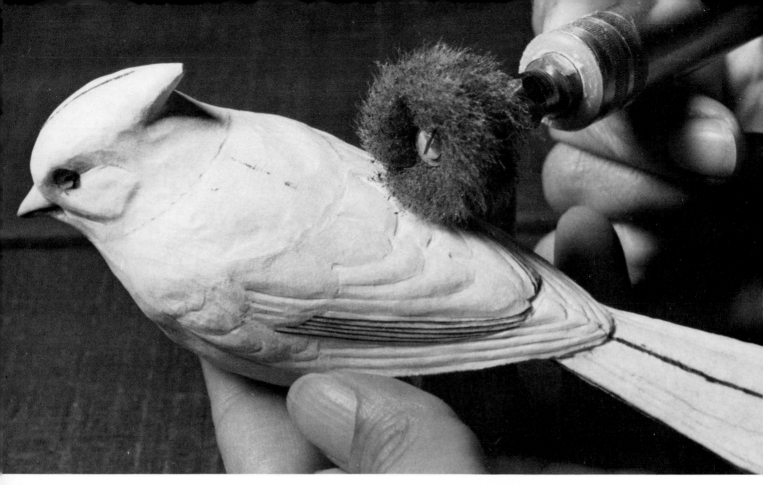

Figure 45. To remove the fuzz that is sometimes left from sanding, go over the entire bird with the defuzzer, still going with the grain.

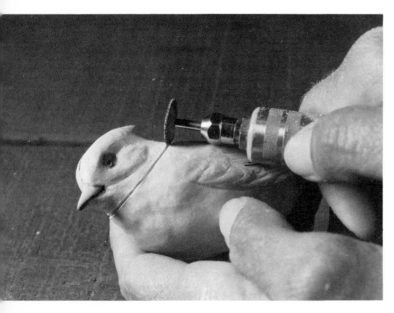

Figure 46. With a channel cutter or ruby carver, make .1 of an inch channel into the entire glue joint around the neck. If your joint is absolutely tight, this step may be unnecessary. The glue line cannot be burned satisfactorily with the burning tool, but it can be carefully stoned.

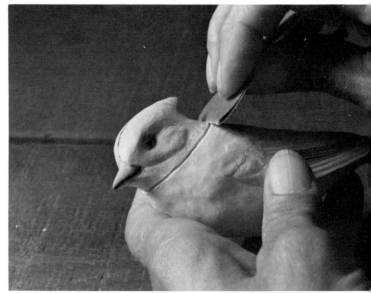

Figure 47. Remove any rough spots along the channel edges with a folded piece of abrasive cloth.

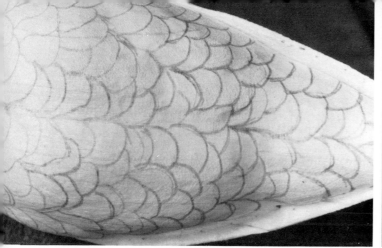

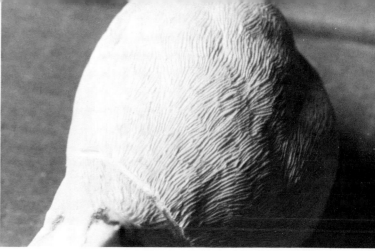

Figure 48. Layout the feather patterns on the lower tail coverts, belly and breast (the entire underneath surface of the bird to be stoned). Vary the length of the exposed feathers as well as the directional flow. Remember that feathers tend to flow in rows, but not to the point of corn rows that would indicate rigidity. Think big sweeping curves and flows when drawing in the feathers.

your light so that the texture and/or fuzz is best illuminated. You will want the light coming across the surface at a low trajectory so that the hills and valleys of your texturing will be vividly apparent.

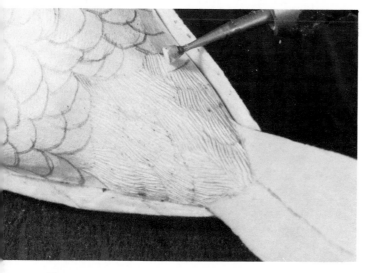

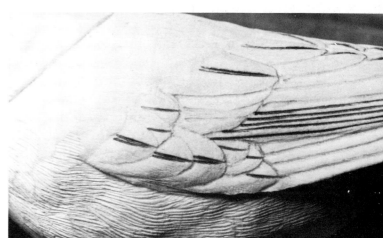

Figure 49. Begin stoning at the lower tail coverts nearest the base of the exposed tail feathers and work your way up the belly. Try getting as much curvature in your stoning strokes as possible. Remember that the feathers lay on top of the ones underneath and below. Carry the strokes of the upper feather over the beginning strokes of the one underneath so you do not have any blank spaces. Since you have already practiced stoning, you will have decided whether the inverted cone stone or the cylindrical stone is more suited to your style.

Figure 50. Work your way up the belly, breast and underneath the beak, getting as close to the wing edges as possible without nicking them up.

As you are stoning the belly and lower breast area, there is one particular area where fuzzing will occur more than any other—that is, the upper portion of the belly and the lower portion of the breast where the grain changes from flat grain to end grain. When you get to this area of fuzzing, turn the bird around so that you will be stoning in the opposite direction, upside down. Stoning this way may seem awkward at first, but with practice, it will become easier. A strong one-directional light source will enable you to see the fuzzing easier. Keep moving

Figure 51. Draw out the quills on the major feathers of the wings, as well as the edges of the secondaries. With the burning tool, burn the quills, keeping two burn lines very close together and even running together the last ¼-½" at the tip of the feather, depending on the size of the feather. The quills can be burned starting at the base of the feather and working towards the tip or going in the opposite direction—try both ways to see which way seems best for you.

Figure 52. Begin burning the primaries with the burning pen. Start with the lowermost feather and work your way up the wing. Burning from the bottom to the top enhances the reality of one feather laying over top of the one underneath. Work from the bottom to the top of each particular group and from back to front.

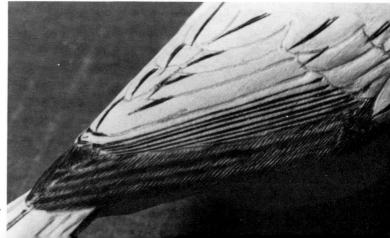

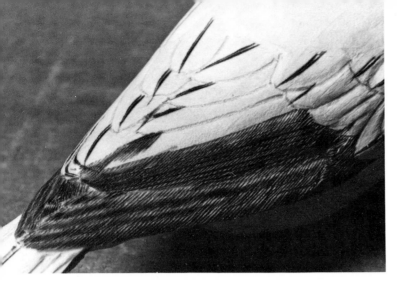

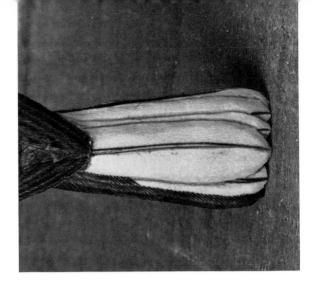

Figure 53. Burn the barb lines of the secondary edges. You can see how the secondary group appears as a stacked group of feathers with only the edges exposed.

Figure 56. Begin burning the barbs on the outermost tail feathers, working your way towards the center ones.

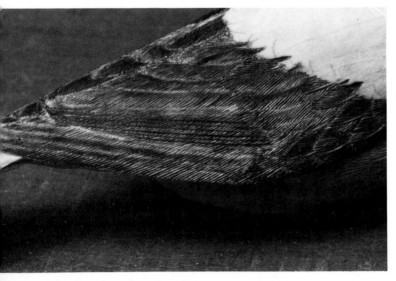

Figure 54. The feathers of both wings are completely burned. Randomly put in a few feather splits by going back over a few of the barb lines burning a little heavier than the original burn lines. On a little bird such as a titmouse, you can actually paint in a few more of the smaller splits. Do not overdo splits, as this can lead to a choppy or raggy look. Avoid any kind of pattern with the splits, as this leads to a rigid look. Keep your splits spontaneous and natural looking.

Figure 55. Draw in the quills that are exposed on the upper tail. With the burning pen, burn two lines very close together, having them meet approximately ¼" from the tip of the feather.

Figure 57. Here you can see the upper surface of the tail feathers fully burned with a few randomly spaced more heavily burned splits.

Figure 58. Draw in and burn in the two major quills on the under surface of the tail. With the burning pen, burn in the two quills. Begin burning the barbs of the feathers in the middle of the tail and work your way to the outmost ones.

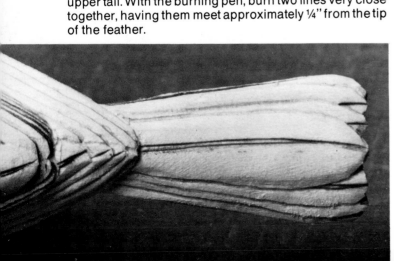

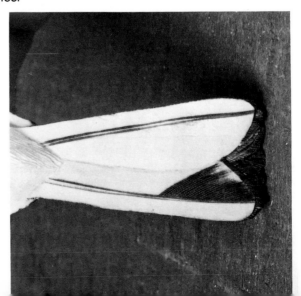

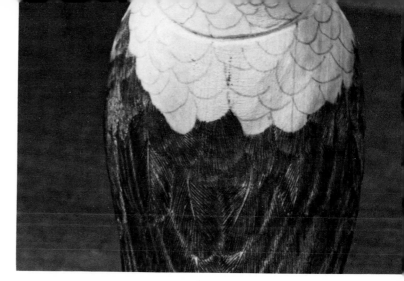

Figure 59. Here you see the under surface of the tail fully burned. Do not take any short cuts by not burning as fine as you did on the top surface. Just because this area is underneath does not mean it will not be viewed. You will be surprised how many people will check out every nook and cranny.

Figure 60. With your burning pen, burn the barb lines on the underneath edge of the primaries.

Figure 61. Next burn in the barbs of the feathers underneath the lower wing edge where the stone could not texture when you were stoning the sides of the belly.

Figure 62. Draw in the feather pattern on the mantle, upper back and head. Remember to vary the amount of the exposed feather. Do not have all the feathers the same size and shape, as this becomes too monotonous and boring. Feathers tend to follow each other in rows, but do not carry this to an extreme. You will want to vary the patterns and the flow to create motion and fluidity, not rigidity.

When you get to the neck joint, just imagine that area solid. Work right through this, carrying your flows in different directions and varying your patterns. Do not have all the feathers beginning nor ending at the joint line.

Begin burning the barbs at the lowermost portion of the mantle and work your way up the upper back and around to the stoned portions of the side of the breast areas. Try to get as much curvature in your burn strokes as possible.

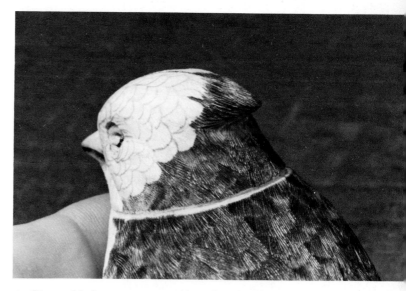

Figure 63. As you progress burning the feathers of the mantle, back and neck, the feathers become smaller, and it becomes more difficult to get much curvature to the burn strokes. This can be compensated for by varying the flow of the individual feathers and groups.

Starting at the bottom of the crest feathers, burn the barbs of the edges of the feathers, so it appears as a small stack of feathers.

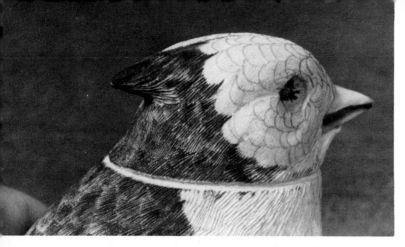

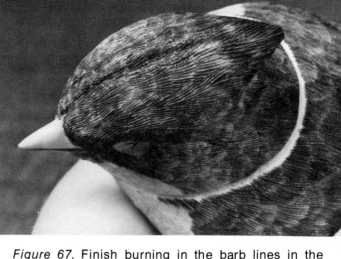

Figure 64. Here you can see the edges of the crest feathers with their barbs burned in. Burn heavier in a few random areas to create splits that will give the crest an airy look.

Figure 67. Finish burning in the barb lines in the feathers on the forehead and crown, again working from back to front so that one feather flows over the one underneath it.

Figure 65. Because you see only the edges of the feathers between the eye and the base of the beak, begin burning at the front corner of the eye, carrying the sweeping motion up towards the top of the forehead and down towards the area below the eye and the ear coverts.

Figure 66. Continue burning the barbs of the ear covert feathers. Here you also can see the shoulder area where the burning and the stoning meet. Blend the two operations by carefully burning into the stoned area so that you do not have a definite line where the burning stops and the stoning begins. You want the burning to flow smoothly and unobtrusively into the stoning.

Figure 68. Carefully burn the areas around the beak where the stone could not reach.

When your burning is complete, clean all the burned areas using a natural bristle toothbrush. Also reinsert the eyes and check the overall look. You may want to make changes not that would take proportionately more time later on.

Figure 69. For patching the neck joint of the titmouse, mix up a small amount of the Duro epoxy ribbon putty, making sure you cut out the little piece where the two colors meet. Keep your oily clay handy to dip your tool in to prevent the putty from sticking to it.

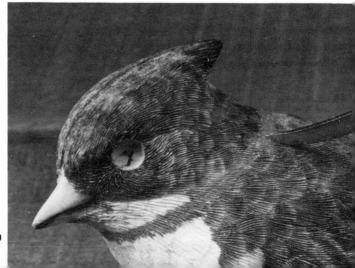

Roll a small "snake" in the palm of your hand and place it in the channel. Begin to pull the putty into the surrounding burn lines using a dental tool, dull knife blade or unheated burning tool.

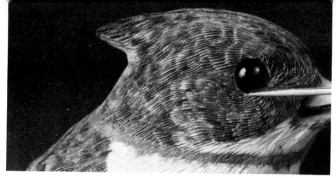

Figure 72. Carefully clean up the area around the eyes with a sharp-pointed clay tool or dissecting needle. You do not want any excess clay around the outside channel of the eyehole.

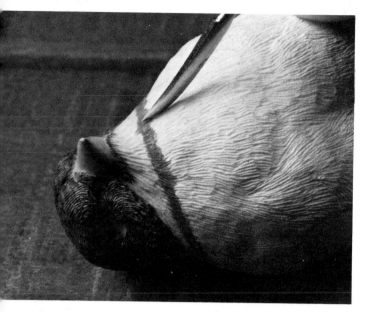

Figure 70. Work around the channeled joint, pushing the rolled putty into the channel. Pull the putty down below the joint line and push it above.

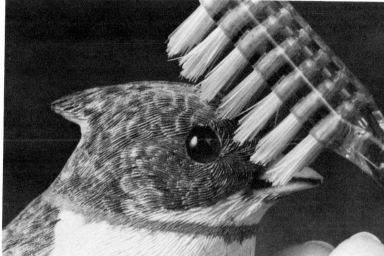

Figure 73. Using the natural bristle toothbrush, clean the area around the eye so that no remnants of clay are there.

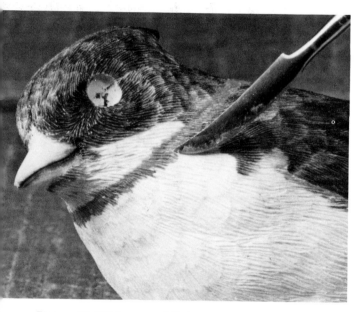

Figure 71. With a good light source, go over the joint again to make sure that you do not have any ridges of the joint showing through the putty as they will show up even after the painting if not smoothed down at this time. Allow the putty to harden. If you examine it after it has dried and suddenly find an area that you wish you had remedied, use a small inverted-cone stone on the flexible shaft machine. This can be used even if the area to be fixed is in the burned area. A small nub here and there can be fixed with the stoning, but do not leave large areas of careless work to be remedied with the stone. You will end up with a finer piece of work by taking the time to texture the putty when it is still workable rather than fixing it with stoning.

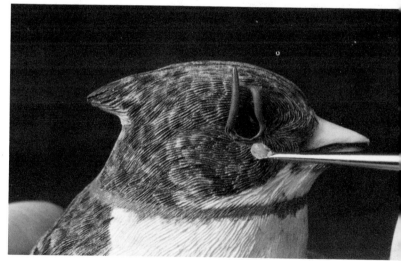

Figure 74. In setting the eyes in birds, remember that the eyes are an integral part of the head with only a fractional part of the eye actually exposed. The eyes should not be so bulbous that the bird looks popeyed and yet not so deep that you have to look down into the head to see them.

Check the positioning of the eyes in your carving. Look at them from every angle to make sure that they are not too deep nor too shallow and that they are balanced.

The life of the bird is captured in the head, but more particularly in the eyes. Taking the time and effort to execute a lifelike look about the eyes and head is well worth it. When one is viewing a carving, his/her own eye will travel to the head first and more specifically to the eyes.

When you are satisfied that the eyes in your carving are balanced and the right depth, mix up a small amount of the Duro epoxy ribbon putty, again cutting out the little piece where the two colors meet. Roll a small piece of the putty between your fingers of one hand and the palm of the other to make a small "snake". Using a clay tool, dental tool or dissecting needle, push the roll of putty into the crevice around the eye.

When working with the putty, periodically push whatever tool you are using into the oily clay to keep the putty from sticking to the tool. Remember that the eye ring around the eye is oval, not round. Pushing the clay around with the tool, form the eye ring. Remove any excess putty as your are working.

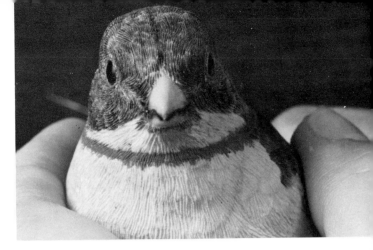

Figure 77. Proceed to apply the putty to the other eye, when you are satisfied with the first. Be careful, when working on the second eye, not to obliterate the putty around the first eye.

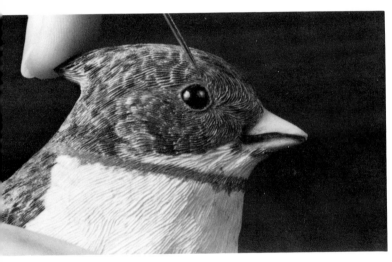

Figure 75. Gradually blend the putty into the surrounding burning. As you pull the putty into the grooves, the inner eye ring will start to become more pronounced. It should not become too prominent, just slightly elevated above the surrounding area.

Figure 76. If you find that you have too much putty to blend outside on the burned area (more than .1 of an inch), remove it. You want as little putty outside of the eye as possible. If an edge of the drilled eye hole begins to show through, cover it up, as it will show even when the bird is painted. If the putty eye ring starts hugging the eye itself too tightly, pull it away with your tool. The eye ring is not smooth, but has a little bumpy texture similiar to wrinkled skin.

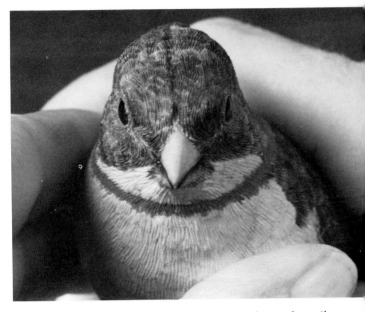

Figure 78. Again, check the eyes for balance from the head-on view as well as the top plan view. It is easier to reset one or both at this point than after further steps are completed.

Figure 79. After the putty around the eyes has hardened, spray the stoned areas (lower tail coverts, belly, breast, underneath neck and chin) with a light coat of Krylon Crystal Clear 1301. Let this dry a few minutes.

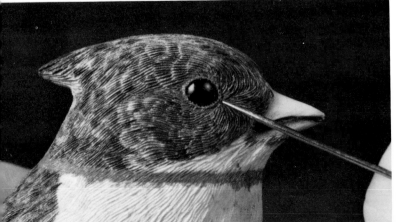

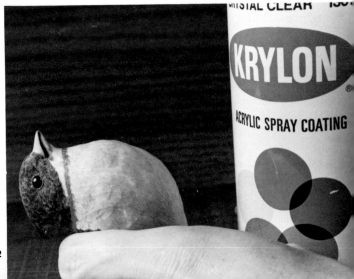

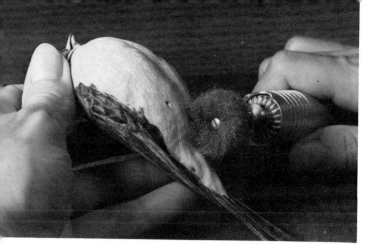

Figure 80. Using a defuzzer pad on the flexible shaft machine, **lightly** go over the stoned areas. This should rid the stoned areas of any fuzz. The Krylon hardens the fuzzies so the defuzzer can whisk them off easily.

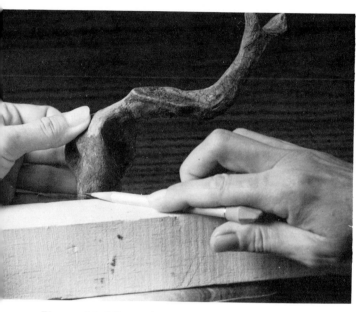

Figure 81. After selecting the piece of driftwood on which to mount the carving, it is best to attach the driftwood to a "working" base so that any procedures that you do for the feet do not ruin any ground or permanent base that you might prepare. You will want the driftwood to attach to the working base in the same position and angle that it will be attached to a permanent base or ground.

Holding the piece of driftwood in the exact position and angle that you have decided will enhance the carving. Mark the wood to be sawed off or eliminated with a carbide bit on the flexible shaft.

Figure 82. Using a laboratory bristle brush on a flexible shaft machine, clean up the driftwood. Notice that the

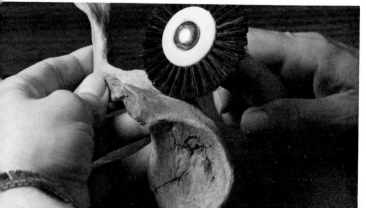

brushing not only cleans the driftwood up, but also burnishes it to a nice patina. For even more sheen, you can use paste wax and buff with a cloth or brush. If you want to change the color, you can paint with acrylic washes or apply a desired color of shoe polish and then buff.

Often the piece of driftwood will have to be altered with the bandsaw or flexible shaft machine. If there is a branch that juts out at an inappropriate place, saw it off and rough up the stump using a propane torch and wire brush on the flexible shaft machine.

Be creative and imaginative with driftwood by fashioning interesting additions to it, such as a fascinating knot, knothole or an entire added branch. It is easier to make a knothole if you have one in another piece of driftwood that you can use as a model. Using a carbide bit, make the hole in the piece of driftwood to be used for the carving. The area around the hole can be textured using ruby carvers, stones or cutters on the flexible shaft machine—the burning pen can also add interesting textures. After you are satisfied with the hole's contours, paint the area using acrylic washes.

To make an added branch, use a wire armature to which you add plastic wood, autobody (the kind used to fill dents in cars) or ribbon epoxy putty if it is a small addition. After contouring, paint the branch to match the existing driftwood using acrylic washes.

There are many ways you can alter existing driftwood: painting, contouring, sandblasting, wire brushing, etc. There are no limits; use your imagination. You can even create your own driftwood by carving it yourself. It is easier if you have other pieces of driftwood from which to model it, but it is not mandatory.

Figure 83. Now that the driftwood you have selected has been altered to fit the working base and has been brushed, drill two 1/16 inch diameter holes in the driftwood. Insert two short pieces of 1/16 inch diameter wire. Using two pieces of wire will prevent the driftwood from turning or twisting on the base or in the prepared ground. Press the two pieces of wire in the base of the driftwood into the soft wood of the working base. Drill 1/16 inch diameter holes at these marks. Using a small amount of super-glue or glue from a hot-melt glue gun, attach the driftwood to the working base.

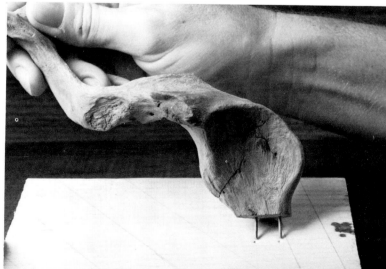

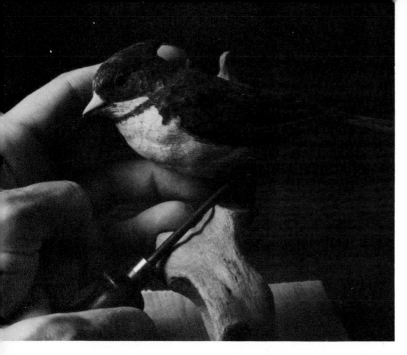

Figure 84. Holding the carving in the desired position above the piece of driftwood, mark the spot on the belly where the tarsus will exit. Studying live birds will enable you to learn in what positions the feet come out of the body feathers at different points. Nothing will replace first-hand knowledge from time spent observing bird activities and behavior.

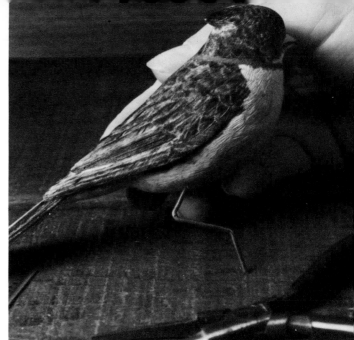

Figure 86. Using needle-nose pliers, make the appropriate bends in the wire—at the ankle joint and the bottom joint where the toes attach (the point at which the wire goes into the driftwood). Proceed to do the other tarsus using these same techniques.

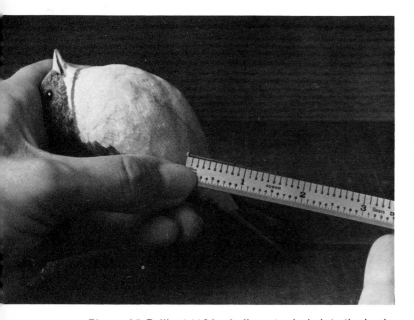

Figure 85. Drill a 1/16 inch diameter hole into the body of the bird at the mark. The hole should be approximately ½ inch deep into the body. Insert a long piece of 1/16 inch wire into the hole. Holding a rule along the wire, mark the tarsus length (.8 of an inch for a titmouse) from the ankle joint. At the bottom joint of the tarsus where the toes attach, allow about ½ inch extra to go into the piece of driftwood. You can use a permanent ink marker or a file to identify these spots.

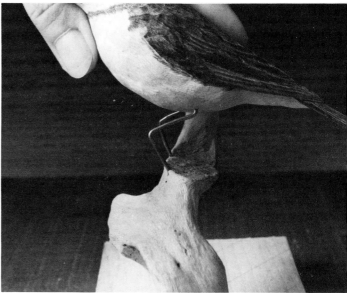

Figure 87. After both of the wire tarsi are bent to shape, hold the bird above the driftwood. Using a pencil, mark the points of insertion into the driftwood.

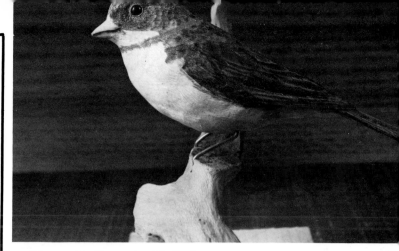

TIPS ON SOLDERING

Materials necessary:

1. soldering gun or pen
2. solid wire solder
3. paste flux
4. surgical clamps, alligator clips, or stapler
5. fine abrasive cloth
6. alcohol or acetone

1. Some metals have a surface coating or film that must be sanded off with fine abrasive cloth. Clean the metals with a degreaser such as alcohol or acetone. Do not touch the cleaned metals with your fingers.

2. The pieces to be soldered must be held motionless during the soldering procedure. A device such as a surgical clamp, or alligator clips is most effective, however, stapling the metals to be soldered in place on a scrap piece of wood is also successful.

3. Spread the flux on the area to be soldered to prevent oxides from forming on the metallic surfaces while they are being heated. Oxides form on the surfaces even in the short time between cleaning and heating to a soldering temperature. Oxides will prevent a strong soldered joint.

4. Using a soldering gun or pen, heat the metals to be joined and apply the solder to the heated workpieces, permitting melting to occur through heat conduction. Apply a small amount of solder to the tip of the gun or pen; this will act as a heat conductive bridge allowing the heat to flow from the tip to the workpieces. Continue holding the pen to the metals until the solder has flowed to all the areas you desire. Let the areas cool before handling.

Figure 89. Place the bird's feet wires into the holes. Check the bird for balance from all viewpoints. Now is the time to change the position, if necessary. You may have to go back and alter one or more of the bends in the wires. Keep working with it until you have a well balanced bird.

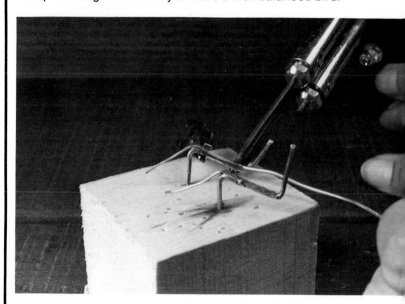

Figure 90. Using a smaller diameter wire for the back tarsus tendon, cut two pieces (one for each tarsus) the appropriate lengths. Sand lightly both tarsus wires and both tendon wires. Drill 1/16 inch diameter holes in a block of wood to hold the tarsi for soldering. Place the tarsi upside down in these holes. Using alligator clips to hold the tendon in place, apply flux and solder.

Figure 91. Clean each tarsus with acetone to remove any remaining flux or impurities that might keep the gesso or paint from adhering.

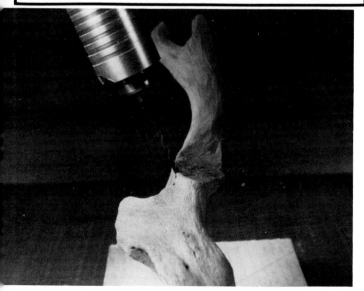

Figure 88. Use a drill bit one size larger than the diameter of the wire to allow easier insertion and removal. Drill 5/64 of an inch diameter holes into the driftwood at the same angle as the bend of the feet wires.

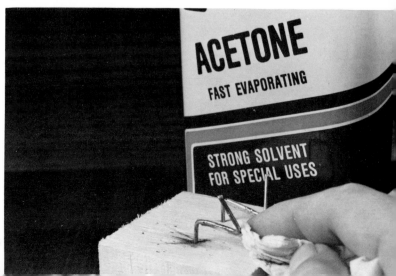

Figure 92. Referring to the line drawing of the foot, file the scales of the tarsus using a small triangular-shaped file.

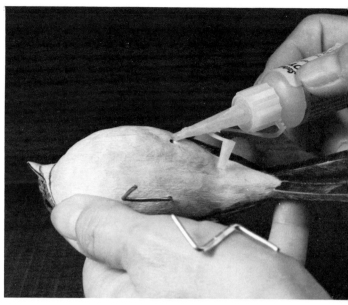

Figure 94. Place super-glue in the holes in the bird's body. Work quickly but carefully to place the tarsi in their respective holes. Quickly place the bird's feet wires in the holes in the driftwood so that the wires will be in the proper position as the glue dries. Do not glue the feet wires into the driftwood until after the bird is completely painted!

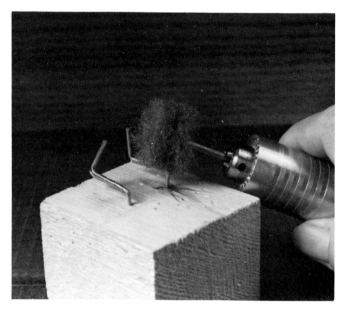

Figure 93. Using a defuzzer pad on the flexible shaft machine, sand off any burrs or irregularities left from the filing.

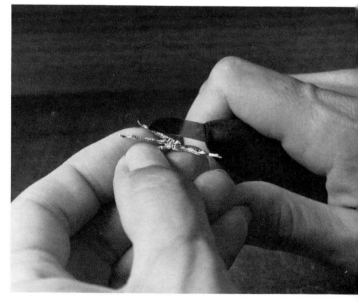

Figure 95. While the glue is hardening, prepare the cast toes. Often, in the casting process there will be extra bits of casting material along the sides of the toes and on the claws. Using a sharp knife, remove these nubs from the purchased set of titmouse toes.

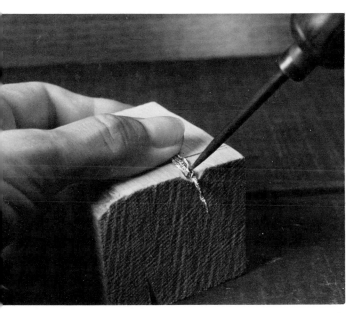

Figure 96. Cut a small v-notch in a scrap block of wood. Holding the cast toes in this notch, make a small hole with an awl in the center of the joint to keep the drill bit from drifting.

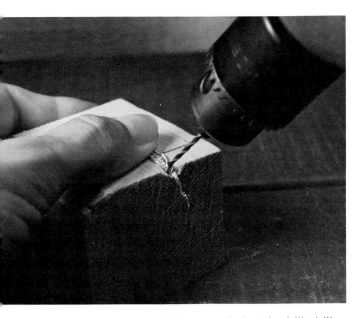

Figure 97. Using a variable speed electric drill, drill a 1/16 inch diameter hole into each set of cast toes. Drill very slowly so that the casting material does not grab the drill bit. If you do not drill slowly, all of a sudden you will find the toes whirring around on the end of the drill bit.

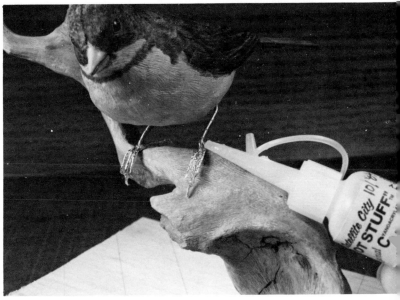

Figure 98. Now that the tarsi have hardened into the body, take the bird off the driftwood. Place the proper set of cast toes on the respective tarsus with the hind toe going on the inside of the tarsus. On the right tarsus, the hind toe should be on the left side of the tarsus, just as on your own right hand, the thumb comes out of the left side of your hand. On the left tarsus, the hind toe should be on the right inside of the tarsus.

With the toes on the proper tarsus, place the bird back on its perch. Making sure each set of toes is placed properly with the middle toes in line with the respective tarsi, super-glue each set of toes to its tarsus. Just a small amount of super-glue is necessary. Be careful not to use so much super-glue that it flows down into the driftwood hole, making it difficult to remove the bird from its perch. Once the super-glue has hardened, you can remove the bird from its perch; you can use more super-glue on these joints, allowing it to harden while the bird is off its perch.

Figure 99. After the super-glue has hardened on the toes, mix up a small amount of the Duro epoxy ribbon putty. After cutting out the section where the two colors meet, massage it between your fingers until you have an overall green color. Place a small amount at the point where the tarsus comes out of the belly. There is a small tuft of feathers at the ankle joints of this and most songbirds. These are called leg tufts.

Figure 100. Work the putty around the joints of both tarsi. If the tarsus position is right up next to the belly, you may need to roll a dissecting needle or clay tool in there to get the putty right up on the tarsus. Remember to dip whatever tool you are using in the clay from time to time so that the putty does not stick to it. A small amount of putty is all that is necessary for the leg tufts.

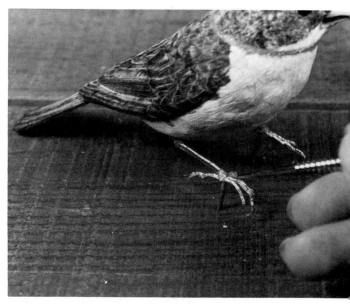

Figure 102. At the tarus and toe joints on both feet, you will need a small amount of the ribbon putty to accomplish a smooth transition. Place a small amount of putty around the entire joint of both sets of toes.

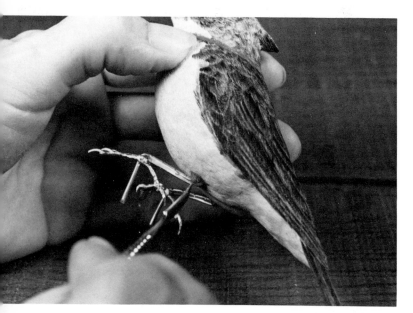

Figure 101. After the putty is placed around the circumference of the insertion point, begin texturing the leg tufts. You will want to accomplish a short, bristly feather effect, using an unheated burning pen, dental tool or the pointed end of a clay tool. Try several of these to see which will achieve the best feathery effect. Pull the putty into the grooves of the stoning surrounding the insertion point creating a smooth transition area.

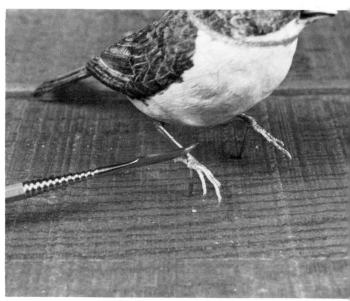

Figure 103. Using a dull knife blade or dental tool, press in the details of the semi-circular scales where the toes will bend on the foot of a live bird. Allow the putty to harden before proceeding.

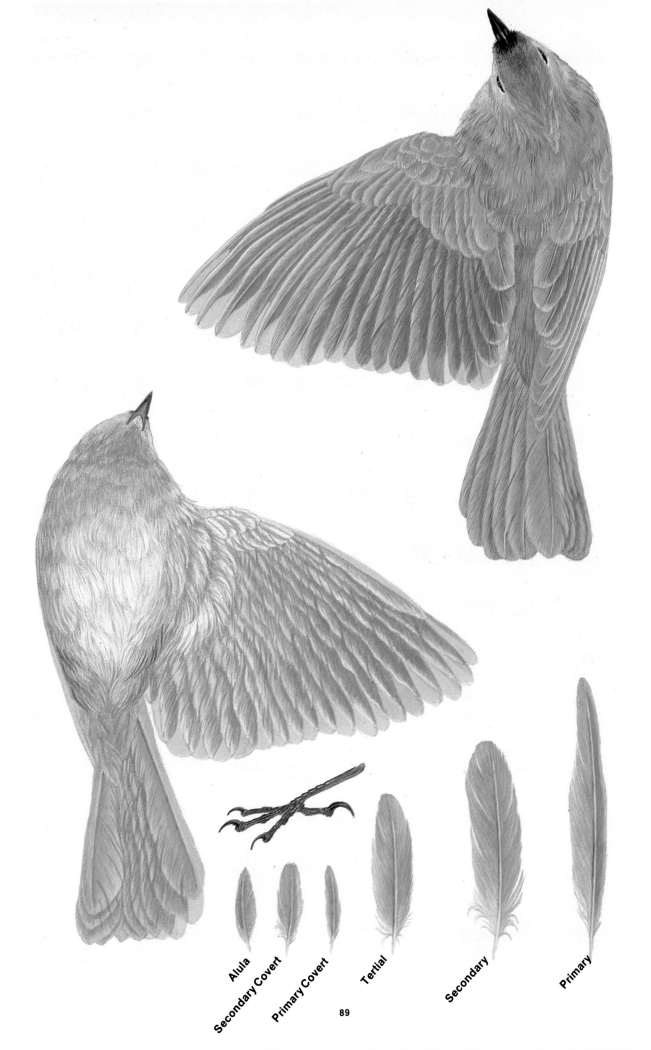

Alula

Secondary Covert

Primary Covert

Tertial

Secondary

Primary

89

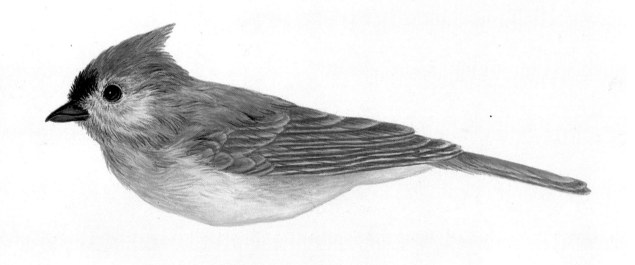

Black

Burnt umber

Raw umber

Payne's Gray

Burnt sienna

Raw sienna

Cerulean blue

White

TUFTED TITMOUSE

Base coats: *head, neck, mantle, wings, tail*

Raw umber
Cerulean blue
White

Payne's Gray
Burnt Umber
White

Highlights: To soften *head* and *mantle*
Dry brush

Burnt umber
Payne's gray
White

Primaries and *tail*

Burnt umber
Payne's Gray
White

Breast, under neck, chin *and cheeks*

White
Burnt umber
Payne's gray

Underneath: *middle belly,* and *lower tail coverts*

White
Raw sienna
Raw umber

Sides, including *flanks*

Burnt umber
Burnt sienna
White

Under tail and *under lower wing edges*

Burnt umber
Payne's gray
White

Wash over with white and burnt umber

Primary edges and *outer tail feathers, upper coverts*—Light gray

Burnt umber
Payne's gray
White

Feet:
Burnt umber
Black
White

Wash with:
White
Burnt umber

Beak

Black
Burnt umber
White

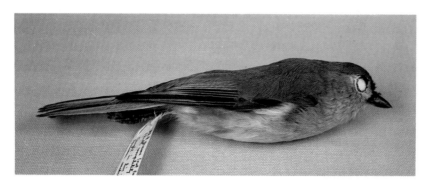

Figure 1. Here you see the tufted titmouse study skin. Notice the delicate edgings of the tertials and secondaries.

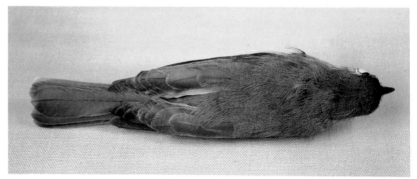

Figure 2. Observe the colors in the mantle and upper back areas.

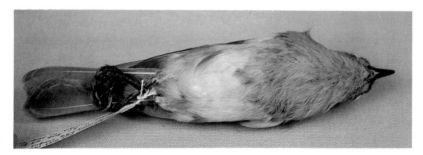

Figure 3. The gray area of the chin and breast seems unusually large. This is a deception of the position of the study skin. If the bird was in a natural, upright position with its lungs filled with air and its feathers fluffed, this gray area would appear smaller and extend a shorter distance down the breast.

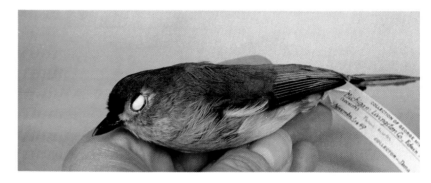

Figure 4. Here you can see the details around the eye and on the forehead. Notice the dark eye ring and the small dark patch of feathers above the eye.

Figure 5. Applying gesso to the bird provides an even colored painting surface over the burned and stoned areas. Since gesso is a type of primer, it also ensures good adhesion for the application of subsequent layers of acrylic paint.

Using a stiff bristle brush such as a Grumbacher Gainsborough #5 (or equivalent), begin applying the gesso, working small areas at a time. Scrub the gesso down into the texture lines with a back and forth motion, rather than merely painting it on. Use a dry brush technique, leaving most of the gesso on your paper towel. Be careful not to leave any excess, especially on the edges of the tail and wings. Too much gesso will actually fill and obliterate the texture lines. Keep your brush damp, but do not use too much water, as it lessens the adhesive quality of the gesso. Dry brush the entire bird with the gesso including the areas around the eyes and the feet. Usually two coats of gesso are sufficient. You can use a medium heat setting of a hair dryer to dry the bird between applications.

Figure 6. After the bird is thoroughly dry, CAREFULLY scrape the gesso off of the glass eyes, using the point of a sharp knife held at an angle. Cleaning the eyes periodically during the painting process enhances the lifelike quality of the carving, allowing a more realistic application of colors.

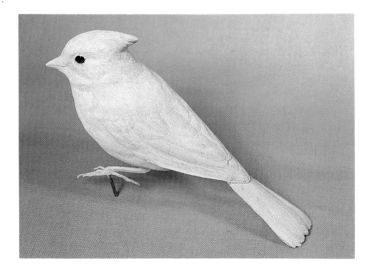

Figures 7, 8 and 9. Here you see the gradual build up of a base coat in an area of a bird that appears as monochromatic from a distance. Upon closer viewing, you see several different colors of varying values. One way to accomplish this effect is by applying two similar but slightly different colors of base coats. Rather than painting each color on top of the other in solid, covering coats, you apply each color in a splotchy, dappled technique. The application of a solid color will make the surface of the carving appear flat, two-dimensional. Thin coats applied using a mottled or dappled technique create the illusion of depth and enhances the actuality of the third dimension. While keeping your paint very thin, build up your colors gradually until there is sufficient depth and intensity.

With the titmouse, one of the base coat colors is a medium greenish gray obtained by blending raw umber, cerulean blue and white. The other base coat color is a medium bluish gray produced by mixing payne's gray, burnt umber and white. Alternate these two colors, drying in between, until you have sufficiently covered the gesso on the tail, wings, mantle, upper back, neck and head including the crest.

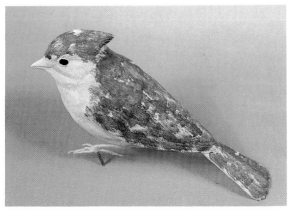

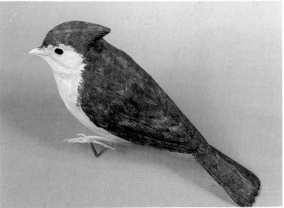

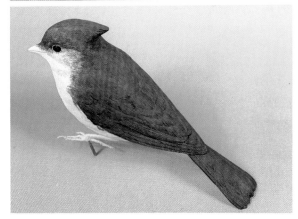

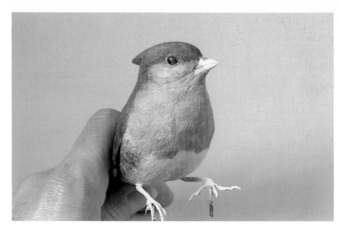

Figure 10. Blending burnt umber and payne's gray with a very small amount of white, darken the primaries and the ends of the tail feathers. Dry brush burnt umber, thinned with water, on the centers of the tertials, secondaries, primary coverts and the alulas of both wings. When these areas are dry, apply a thin, watery wash of payne's gray over both wings and tail.

Figure 13. For the base coats on the breast, neck, chin and cheeks, use a light gray made by blending white, burnt umber and payne's gray. Blend the light gray into the neighboring colors.

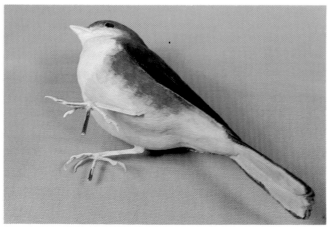

Figure 11. The base coat for the belly and the lower tail coverts consists of white with small amounts of raw sienna and raw umber. The base coat for the sides of the titmouse consists of burnt umber with small amounts of burnt sienna and white. Apple these two base coats to their respective areas. At the points where the two base coat colors meet, blend them by pulling the dark color into the lighter one and the lighter color into the dark one.

Figure 12. When these areas are dry, begin the edgings. The edges of the feathers on the sides require a creamy white, obtained by mixing a small amount of raw umber with white. The edges of the feathers on the belly should be tipped with stark white, created by mixing a very small amount of cerulean blue with a large amount of white.

Figure 14. Adding a small amount of the light gray to white, edge the feathers on the breast, neck, chin and cheek areas.

When these edgings are dry, apply a watery wash of white with a small amount of raw umber to the underneath parts, the cheeks and neck.

Figure 15. Apply the base coats, consisting of burnt umber, and payne's gray and white, to the under surface of the tail feathers and the under surface of the primaries. When the base coats are dry, apply a watery wash of white with a small amount of burnt umber to get the necessary silvery gray.

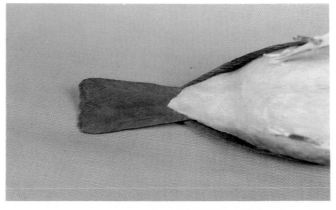

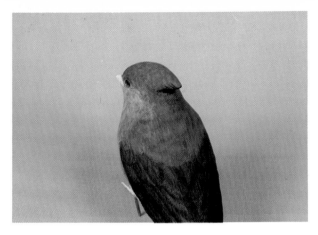

Figure 16. On the mantle, upper back, neck and head, highlight selected areas with dry brush dabs of light gray, produced by mixing payne's gray, raw umber and white. Keep the paint thin and your brush dry with very little paint. Also highlight other selected areas with a light gray made up with burnt umber, payne's gray and white, using the same dry brush dab technique.

When these areas are dry, add a large amount of water to the payne's gray, raw umber and white mixture. Using a small liner or scroll brush, outline the edges of the feathers on the mantle, upper back, neck and head.

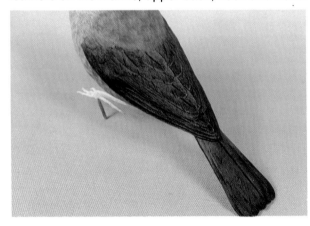

Figure 17. Blending burnt umber, payne's gray and white to create a light gray, paint the leading edges of the primaries and secondaries and both the leading and trailing edges of the exposed tertials. Also lighten the outer edges of the tail feathers near the upper tail covert area.

With a small liner or scroll brush, darken the quills and feather splits on the wings and upper tail using payne's gray and raw umber.

Figure 18. Blending black and raw umber, paint the inside of the eye lids, the feathery eye ring and the little dark patch of feathers above each eye. Clean the eyes and check for any needed touch ups. Using a small liner

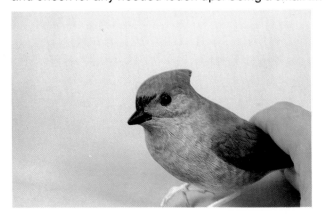

brush, paint the dark patch on the forehead. Adding a small amount of white to the black and raw umber, highlight selected areas of the dark patches on the forehead and above the eye.

For the beak color, combine black and burnt umber with just a hint of white. Keep the paint thin so you do not leave brush strokes on the smooth surface of the beak.

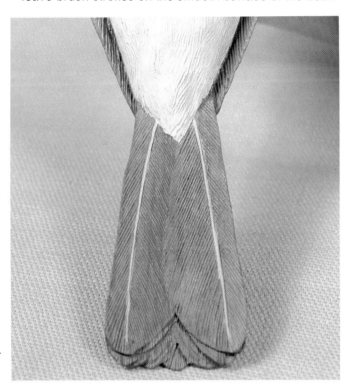

Figure 19. For the quills on the underneath tail, blend white and raw umber. Use a small liner or scroll brush to carefully apply the light mixture. Do not get any of the light color on the barbs of the feathers.

Figure 20. For the color of the feet, mix burnt umber with small amounts of black and white. Apply at least two thin coats to the feet, being careful not to fill in the texture. Add more black to the mixture and paint the claws.

After the base coats have dried, apply a very watery wash of white and a small amount of burnt umber to both feet, excluding the claws. This watery wash will sink down into the texture, accentuating it.

After the watery wash has dried, brush the surfaces of both feet with a small amount of gloss medium added to a puddle of water. This will leave a slight sheen to the feet. Apply straight gloss medium to all surfaces of the claws. Both gloss and matte mediums appear milky-looking when wet, but dry clear.

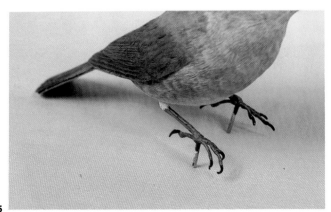

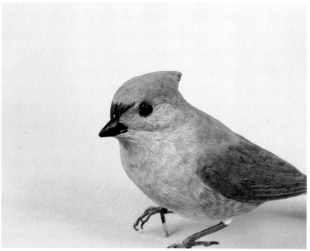
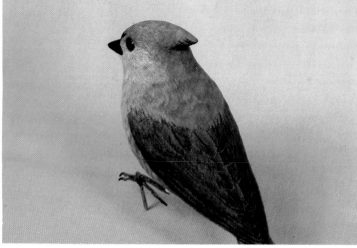

Figure 21. Apply a half and half mixture of matte and gloss mediums to be beak, effecting a satin gloss.

Figure 22. Using a small liner or scroll brush, apply straight gloss medium to the quills of both wings and to the quills of both the upper and lower surfaces of the tail feathers.

Figure 23. After the mediums have dried, you are ready to mount the completed carving onto the prepared driftwood. Mix up a small amount of 5-minute epoxy and glue the feet in their respective holes. If any of the glue should seep out of the holes onto the surrounding driftwood, it can be touched up with acrylic paint after the glue has hardened.

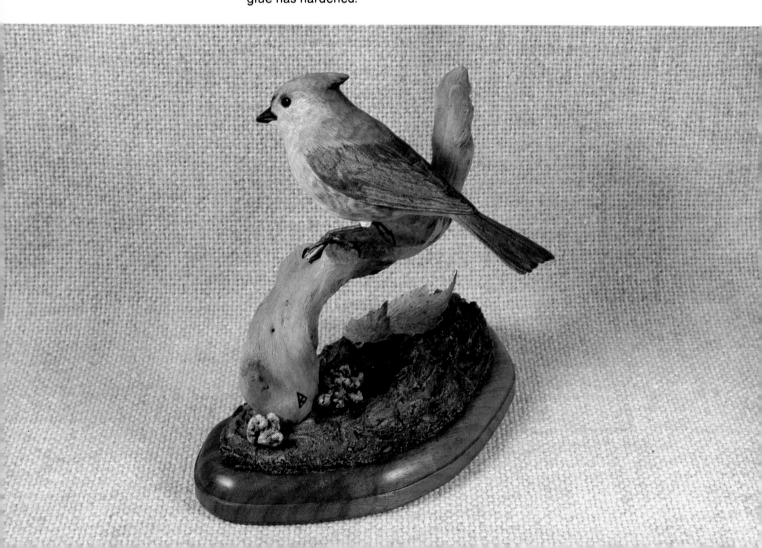

American Goldfinch

(Carduelis tristis)

In this project the head of the bird will be turned but it will not be sawed off as with the titmouse. The head will be turned in the wood. Turning the head of any bird, even slightly, will give more motion and fluidity to the piece.

The goldfinch, a gregarious bird, is found throughout the United States and in southern Canada. Most of the year goldfinches travel in flocks preferring to nest in the suburbs, country hedgerows and fields, and often riverside groves. Only in midsummer do they pair off for the breeding season.

Often called the thistle-bird, the goldfinch uses the thistledown for its nest and the thistleseeds to fill its stomach. Its diet consists of other flower seeds, insects and some berries as well as thistleseeds. Its conical bill is well adapted for cracking the hulls of seeds.

The nest of the goldfinch, rarely higher than 10 feet above the ground, is woven plant fiber and lined with silky thistledown. It has been discovered that the nest is knit so tightly that young birds have drowned when left unattended during heavy rains.

Physical Characteristics

The goldfinch, a blur of yellow and black in motion, is a bird in which the sexes differ somewhat in color. The female is an olive-yellow, which is much more subdued in color than the brighter, lemon-yellow colored male except in winter, at which time his coloring more resembles hers. The male has a black forehead and crown, wings and tail. There are white markings on the edges of the secondary coverts, tertials and secondaries, the upper and under tail coverts and the trailing edges of the tail feathers. The tail, deeply notched, consists of 12 feathers, not all of which are exposed unless the tail is widely flaired.

The 5-sided conical bill, though not extremely sharp, has a slightly curved commissure. The nostrils are not usually exposed but are covered by a group of bristly feathers, called rictal bristles.

DIMENSION CHART

1. **End of tail to end of primaries — .8 inch.**
2. **Length of wing — 2.9 inches.**
3. **End of primaries to alula — 2.1 inches.**
4. **End of primaries to top of 1st wing bar — 1.5 inches.**
5. **End of primaries to bottom of 1st wing bar — 1.9 inches.**
6. **End of primaries to mantle — 1.7 inches.**
7. **End of primaries to end of secondaries — .85 inch.**
8. **End of primaries to end of primary coverts — 1.8 inches.**
9. **End of tail to front of wing — 3.7 inches.**
10. **Tail length overall — 2.2 inches.**
11. **End of tail to upper tail coverts — .8 inch.**
12. **End of tail to lower tail coverts — .8 inch.**
13. **End of tail to vent — 1.8 inches.**
14. **Head width at ear coverts — .8 inch.**
15. **Head width above eyes — .55 inch.**
16. **End of beak to back of head — 1.3 inches.**
17. **End of beak to back of crest —**
18. **Beak length: top — .4 inch; center — .45 inch; bottom — .25 inch.**
19. **Beak height at base — .25 inch.**
20. **Beak to center of eye (eye 4 mm) — .65 inch.**
21. **Beak width at base — .22 inch.**
22. **Tarsus length — .52 inch.**
23. **Body width[1] — 1.6 inches.**
24. **Overall body length — 4.5 inches.**

[1]At widest point.

TOOLS AND MATERIALS

TOOLS:

Bandsaw (or coping saw)	Flexible shaft machine
Carbide bits	Ruby carvers
Tootsie roll sander on a mandrel (120 grit)	Knives, small chisels
Ruler measuring tenths of an inch	Calipers measuring tenths of an inch or dividers
Pointed clay tool or dissecting needle	Compass
Emery board (kind used for fingernails)	v-tool (optional)
Burning pen	Abrasive cloth (120 grit)
1/4 of an inch cushioned sander on a mandrel	Defuzzer on a mandrel
Variety of small mounted stones	Natural bristle toothbrush
Laboratory bristle brush on a mandrel	Variable speed electric drill
Drill bits	Needle-nose pliers
Wire cutters	Awl

MATERIALS:

Basswood	Tracing paper
Pair of brown 4 mm eyes	Super-glue
Clay	Duro epoxy ribbon putty
Clay or dental tools	Driftwood for mount
1/16 of an inch diameter wire (16 gauge)	Permanent ink marker
Pair of cast toes for goldfinch	Krylon Crystal Clear 1301

AMERICAN GOLDFINCH

Profile Line Drawing

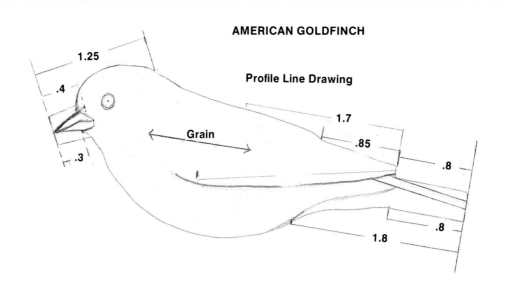

1.25

.4

.3

Grain

1.7

.85

.8

.8

1.8

Profile View

Top Plan View

1.6

4.5

Head Turned in Wood

Under Plan View

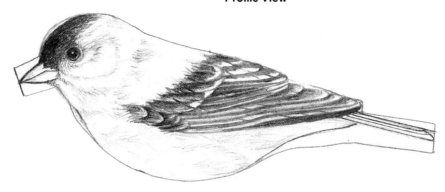

Foot

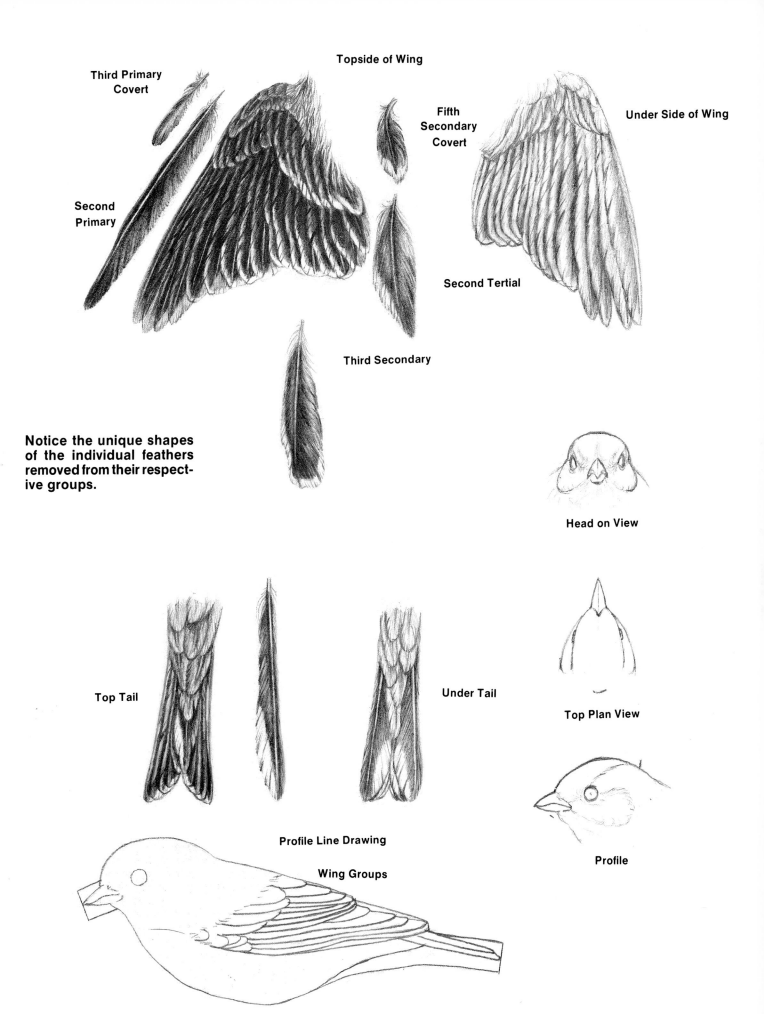

Third Primary Covert

Second Primary

Topside of Wing

Fifth Secondary Covert

Under Side of Wing

Second Tertial

Third Secondary

Notice the unique shapes of the individual feathers removed from their respective groups.

Head on View

Top Tail

Under Tail

Top Plan View

Profile Line Drawing

Profile

Wing Groups

99

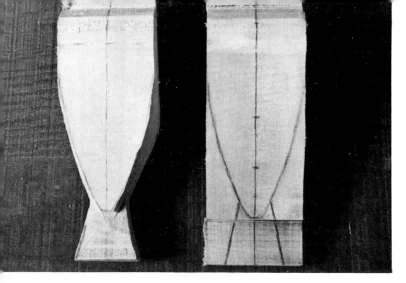

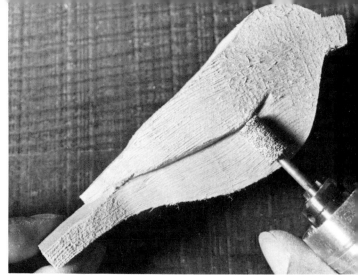

Figure 1. After transferring the profile pattern to your basswood block, bandsaw out your goldfinch. The goldfinch blank on the right shows the center-line and the wings and tail transferred from the plan view pattern. With a bandsaw or coping saw, remove the excess wood from the wing and tail area. This will leave your blank looking like the goldfinch on the left.

Figure 4. The sides of the bird can also be recessed using the flexible shaft machine and a square-edged carbide bit if you prefer power tools. Work carefully so that the carbide bit does not nick up the lower edge of the wing. Lay the carbide bit all the way on its side so that the entire side of the bird's sides are recessed deeper than the lower wing edges.

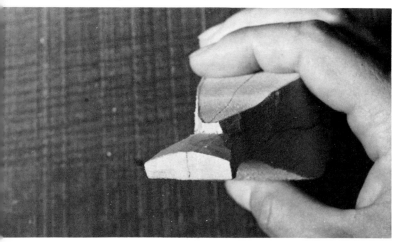

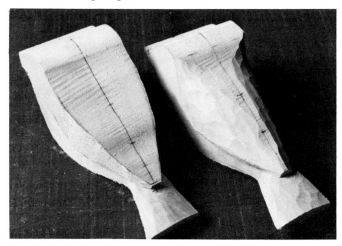

Figure 2. Check the dimension (.8 of an inch) from the tail to the end of the wing. Shorten the wing tips to achieve the proper dimension. Cut the little triangles off the wing edges on top of the tail. Slightly round the top of the tail with a carbide cutter on the flexible shaft machine or with a knife, so that you have a gentle arc.

Figure 3. Draw or transfer with tracing paper and pinpricks the lower wing edge onto your blank. Here you see the side of the bird being recessed along the lower wing edge line. Use a knife or chisel to cut the excess wood from the lower edge of the blank up to the bottom of the v-cut.

Figure 5. On the back (wing area), gently round the wings from .2 of an inch on each side of the center line. Carry the rounded contour down to the lower wing edges. The bird on the right was contoured using a knife.

Figure 6. Here you see the rounding of the wings achieved using the flexible shaft machine and a pencil-shaped carbide bit.

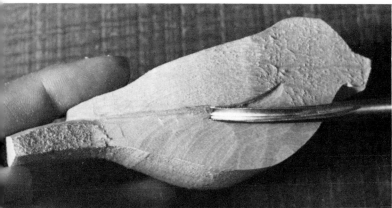

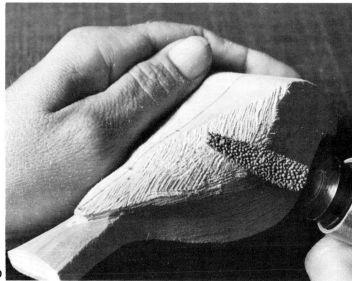

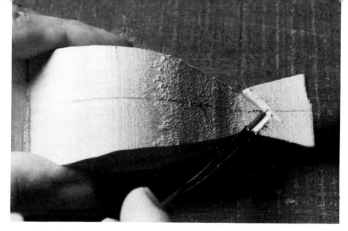

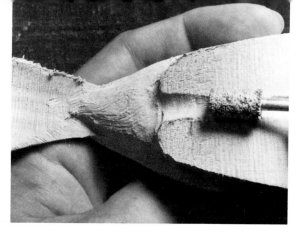

Figure 7. Measure and draw in the lower tail coverts (.8 of an inch from the end of the tail) and the vent (1.8 inches—also from the end of the tail). Draw a line .1 of an inch all the way around the tail. With a v-tool or flexible shaft machine and carbide bit, make a channel on the lower tail covert line. Remove the wood on the under tail up to the bottom of the channel. Keep channeling and removing wood on the under tail until you reach the .1 line initially put all around the tail. The tail should be convex on top and concave underneath.

Figure 10. If you prefer power tools, you can use a flexible shaft machine and carbide bit to taper the lower tail coverts and to shape the vent area.

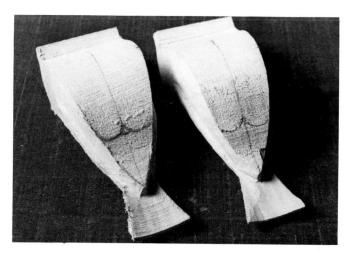

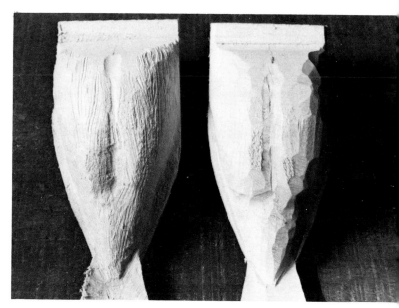

Figure 8. Here are two goldfinches, both have had their tails thinned down to the .1 of an inch line. The one on the left was done with a flexible shaft machine and carbide bit, and the one on the right was done with a v-tool and knife.

Figure 9. Use a knife with scooping cuts to cut around the vent area and the center-line channel. Flow the lower tail coverts toward the base of the tail feathers.

Figure 11. With the flexible shaft machine and carbide bit (for the bird on the left) or knife (for the bird on the right) round the belly from underneath the lower wing edges and down to the midline channel. Work from the lower breast area to the vent.

Figure 12. Measure the distance between the front and the back of the head. This is the approximate point where the head pivots on the neck and body and is the center point of the head. With your compass on the pivot or center point of the head, swing an arc the same distance as the end of the beak, the back of the head and the base of the beak.

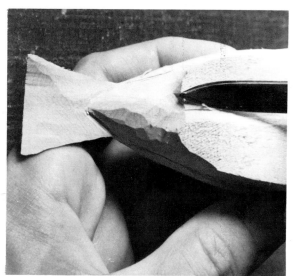

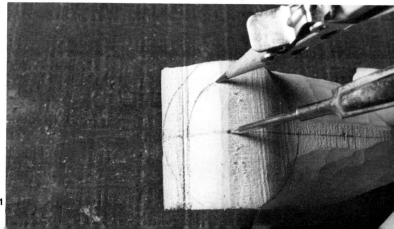

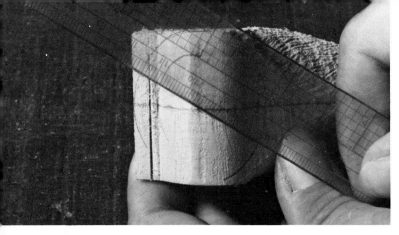

Figure 13. Draw a new centerline, using a ruler, to the degree that you want the head to turn. The points at which the new centerline meets your arcs are the new end of beak, base of beak and back of the head marks.

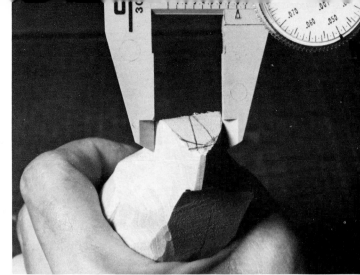

Figure 16. Keep removing small chips until you get a .8 of an inch ear coverts measurement. Remember to keep both sides equal and symmetrical.

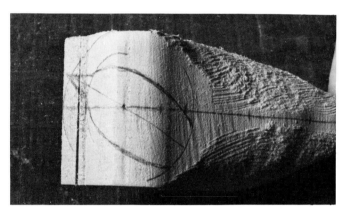

Figure 14. The ear coverts are the widest part of the head when looking from a straight head-on view. The ear coverts dimension on the goldfinch is .8 of an inch. Place a mark .4 of an inch on both sides of the centerline, giving you the proper .8 of an inch ear covert measurement. Using the ear covert dimension as the widest part, draw a rough top view outline of the head including the beak.

Figure 15. Using scooping cuts with the knife, begin cutting away the excess wood on the head. Since the head position is at an angle to the grain, you will be cutting up one side of the head and down the other side (the side to which the head is turned). Occasionally you may find a piece of basswood with grain changes within the head, work carefully, taking off a little at a time. Take off thin shavings until your knife cuts smoothly and cleanly. Too much gusto may find your bird left with large chunks removed in inappropriate places.

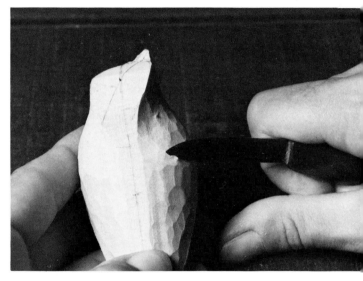

Figure 17. Flow the ear covert and neck areas gently toward the upper back and shoulder.

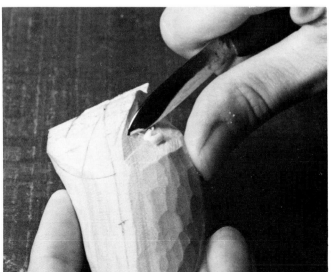

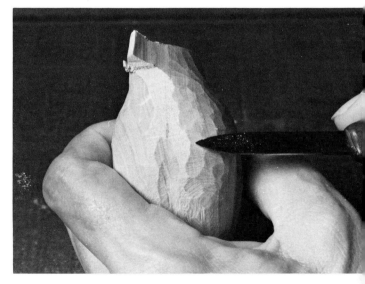

Figure 18. Flow the upper breast toward the neck area.

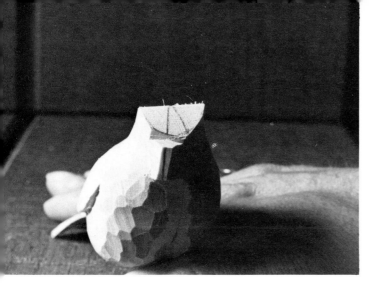

Figure 19. Here you see the gentle contouring of the ear covert, neck and upper breast areas. You will notice when looking straight on towards the beak and head, that you have uneven amounts of wood on the opposite sides of the centerline. Cut the top of the beak down so the top surface is level when looking straight on the head.

Figure 22. Here you can see the quadrants from a different perspective.

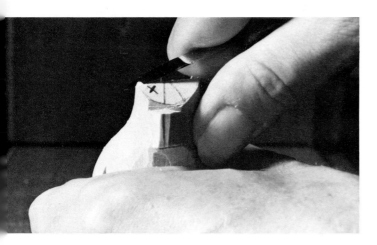

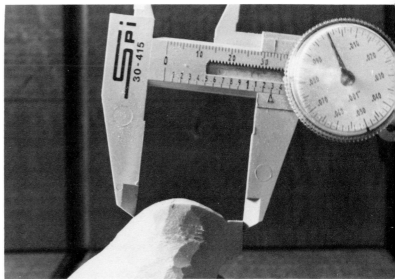

Figure 20. Draw a line perpendicular to the centerline at the center of the head (the pivot point where you placed the compass to draw the arcs). Begin taking **small** chips off the high left front quadrant when looking straight on to the head and beak. Keep the top plane of the head flat at this point. Do not start rounding the crown yet. You will find it easier to cut towards the beak, unless the grain is swirly.

Figure 21. Cut away the high back side of the crown so both sides of the top of the head are on the same plane.

Figure 23. The end of the beak to the back of the head measurement should be 1.3 inches. Adjust yours if necessary, by taking equal amounts from the back of the head and the end of the beak.

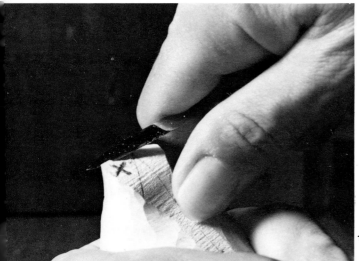

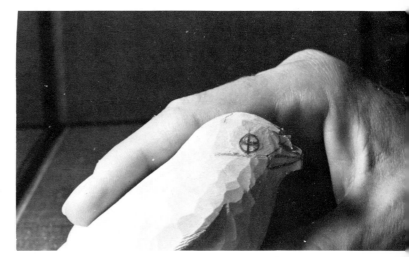

Figure 24. Trace the beak and eye from the profile pattern and carefully pinprick through the tracing paper onto the bird, making sure that both sides are balanced.

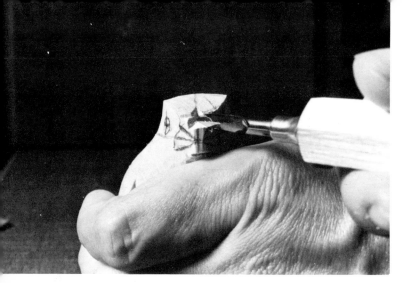

Figure 25. The top of the beak should measure .4 of an inch. On the top surface of the beak, mark .4 of an inch with a pinprick. Draw a "v" with its point at the pinprick. Cutting straight down on the "v", make a stop cut and then cut back to the stop cut, taking small chips off the top of the beak.

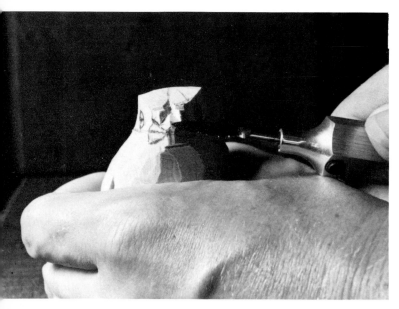

Figure 26. Work carefully on the top surface of the beak, as you will be cutting against the grain on one side.

Figure 27. Continue cutting away the top surface from the base of the beak to the tip until you get down to the line that you pinpricked from the profile pattern.

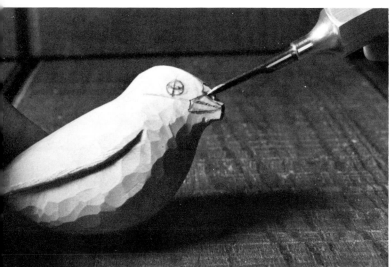

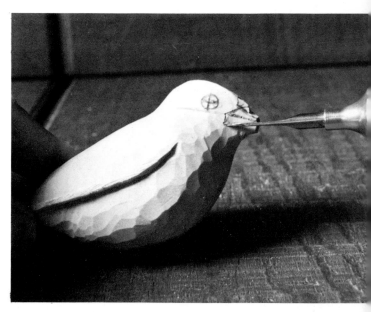

Figure 28. With a sharp pointed knife, trace the **outside** line of the beak (not the commissure line) on both sides. Do not undercut, keep your knife blade perpendicular to the beak surface. Using this perpendicular cut as your stop cut, begin cutting out small chips on both sides of the beak. Frequently check the head-on view to make sure that you are keeping the beak balanced on both sides of its center.

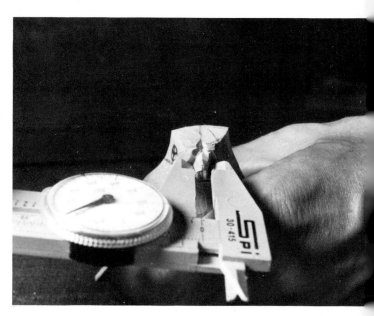

Figure 29. Continue cutting on both sides until you get to the proper width of the base of the beak which is .22 of an inch. The beak may look too narrow, but remember that the only dimension that is accurate to this point is the ear covert measurement, everything else is still oversized.

Figure 30. Redraw the commissure line. Generally shape the top surface of the beak. When working on the beak remember that the base of the beak at the point of attachment to the head is a five-sided, house shape when the beak is closed. Mark and pinprick the lower beak dimension which is .25 of an inch. Draw an arched line from that point on the midline underneath the beak to the base of each side as in the profile pattern. Make a

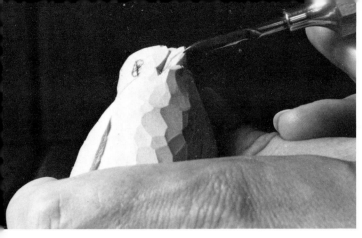

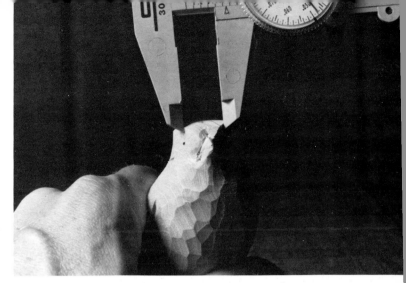

perpendicular stop cut along this line. Carefully cut back to this stop cut on the underneath beak until you get up to the line you traced from the profile pattern.

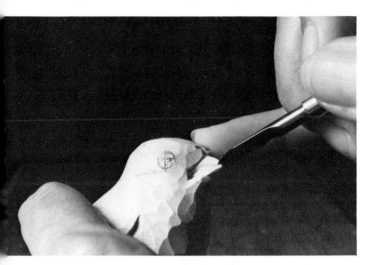

Figure 31. Carefully shape under the beak, rounding the sharp edges. Make a perpendicular stop cut on the commissure line on both sides. Make an angled cut above and below the stop cut so that you have a small "v"-shaped trough along the commissure line.

Figure 32. On the top, sides and underneath, flow the head down to the base of the beak. Work carefully so that your knife does not slip and nick the beak.

Figure 33. Recheck the end of the beak to the eye center measurement which should be .65 of an inch. Pinprick deeply, making sure that the eyes are balanced from a straight-on view as well as looking straight down on the head (the plan view). Check the head width above the eye, which should measure .55 of an inch. Adjust this area if necessary by taking scooping knife cuts on both sides keeping the head balanced on both sides of the centerline.

Figure 34. Carefully cut away the sharp corners of the head, gently rounding the forehead, the crown and the nape of the neck.

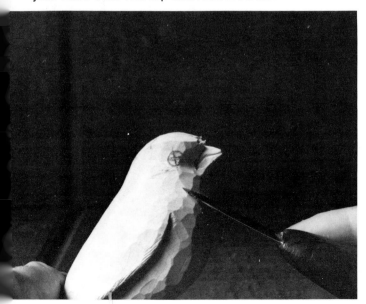

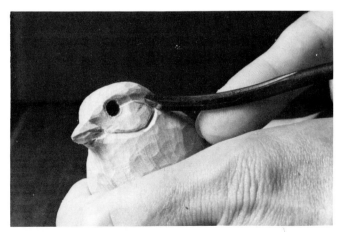

Figure 35. Drill a 4 mm eye hole on both sides and recheck the symmetry of the head, making sure there is a slightly concave area for each eye. Draw the ear coverts. With a flexible shaft tool and a ruby carver or v-tool, make a channel on the ear covert line.

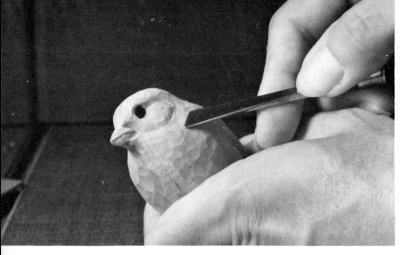

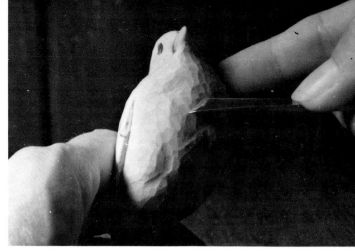

Figure 36. Flow the neck area up to the bottom of the channel and flow the ear covert down to the bottom of the channel. This creates a roundness and fluffiness in the ear covert area.

Figure 39. Draw large sweeping feather groups on the breast and belly. Remember to vary the size, shape and symmetry of these groups, because you do not want both sides of the breast or belly to be the same in configuration. Using a knife, ruby carver, gouge, or tootsie roll, recess the lower areas. There should be a variety of high and low points of varying depth. Keep in mind that each feather group comes out from underneath the preceeding group, progressing from the head back to the under tail coverts. To help in creating and accentuating shadows, use a single directed light source.

After you have recessed your selected low points, round over each of the high areas to the bottom of each channel. Keep using your pencil to experiment with different feather flows and sizes. Remember that there is no single right way to lay out feather contouring. Every bird's feather landscape will vary according to body movement, position and even wind direction.

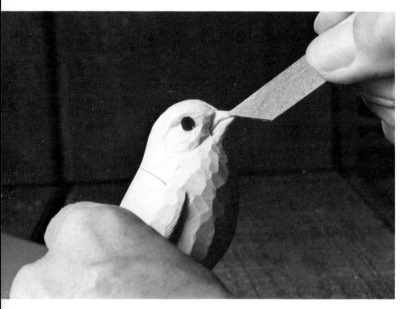

Figure 37. With a tapered emery board, sand the beak, rounding its contours. Apply super-glue and let harden. Fine sand with 320 grit abrasive cloth folded so that it can get into the corners of the beak and hard-to-reach areas.

Figure 38. Temporarily set 4 mm brown eyes making sure that they are balanced both from the straight-on view as well as the plan view. Recheck the entire head for symmetry and proper dimensions.

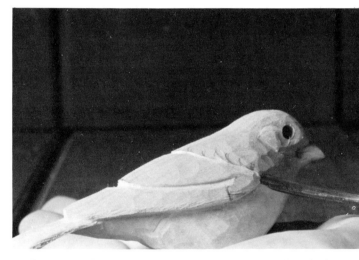

Figure 40. From the profile pattern, trace or sketch the mantle and secondary lines onto the carving. With a v-tool or ruby carver, make a channel on these lines to lower the wings from the mantle and the primaries from the secondaries.

Figure 41. Using a knife or chisel, flow the wings out from underneath the mantle and gently round over the mantle. There should be a smooth transition but with a distinct difference between the mantle and the wings. Flow the primaries out from underneath the secondaries and round them over. These procedures will simulate one feather group laying over another, the mantle over the wings and the secondaries over the primaries.

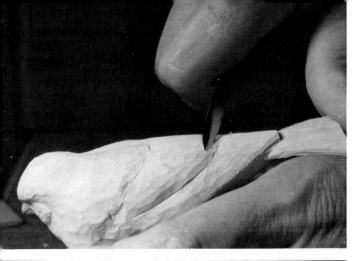

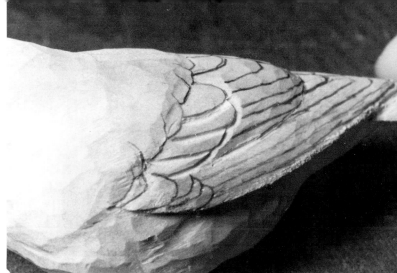

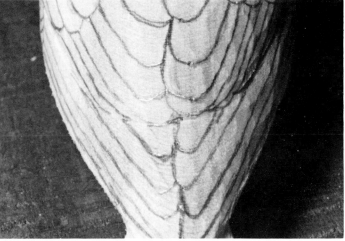

Figure 44. Using a v-tool or ruby carver, begin cutting out individual feathers starting at the front of the wing (shoulder area) with the middle secondary coverts (second wing bar). With this particular feather layout, there is only one exposed feather edge of this group. In other wing positions, however, more middle secondary coverts may be exposed. Using a v-tool or ruby carver to outline the feather edge will allow you to give a convex shape to each feather. Flow the underneath greater secondary coverts toward the middle secondary coverts. Redraw the lines that are cut away. Next, cut around the greater secondary coverts (first wing bar) and flow the channel out towards the tertials and secondaries. Again, redraw any cut away pencil lines.

Figure 42. Draw or trace and pinprick the feather groups of both wings. The exposed feathers on the top surface of the wings can be traced from the plan view pattern.

Figure 43. Those feathers on the sides of the wings can be traced from the profile pattern. Both sides of the bird do not have to have the same number of feathers exposed in each group. Use artistic license and imagination in creating asymmetry as long as the groups are in the proper location with the proper dimension. Each bird will and should be slightly different.

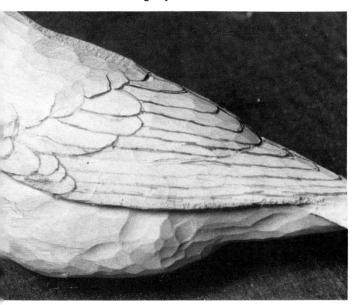

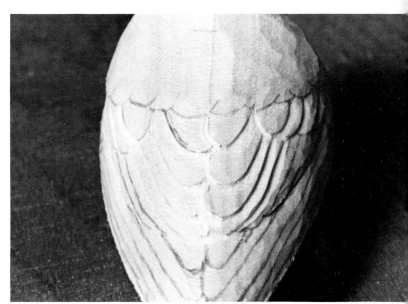

Figure 45. Using the same procedure, cut around each of the exposed tertials. Flow the last tertial channel out toward the outside edge. This is the area of the secondaries whose edges will be burned in using a burning tool after the bird has been sanded. Cut around the alula and the primary coverts on both wings and flow this area out towards the primaries.

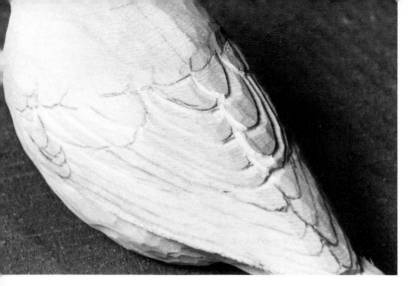

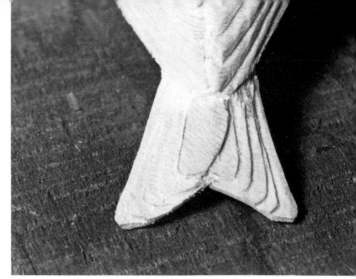

Figure 46. Here you see the small shelf formed on each of the tertials as a result of cutting around the feather outline with a v-tool.

Figure 49. Draw or trace and pinprick the tail feathers on top. Using a v-tool or ruby carver, cut around each of the feathers, beginning with the uppermost center one and proceeding to work each edge progressing to the last outermost one on both sides.

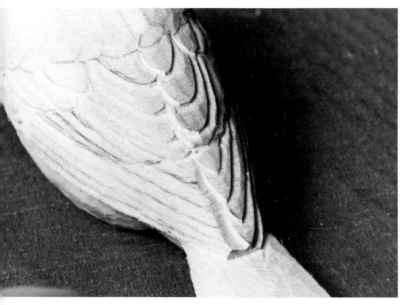

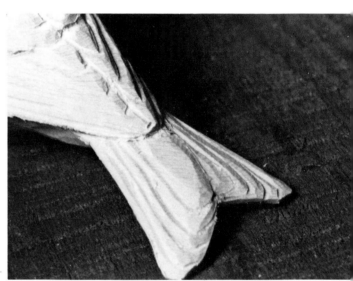

Figure 47. Cut around each of the primaries, beginning with the ones uppermost and fully exposed.

Figure 48. With a knife, chisel or ruby carver, round over the ledge or shelf on each feather, giving a rounded contour and creating the effect of one feather laying on top of the other.

Figure 50. With a sharp knife, chisel or ruby carver, round over each edge on the tail feathers. Work carefully and do not apply a lot of pressure since the tail has been thinned.

Figure 51. With a burning pen, burn the edges on the end of the tail. Draw or trace and pinprick the under side of the tail.

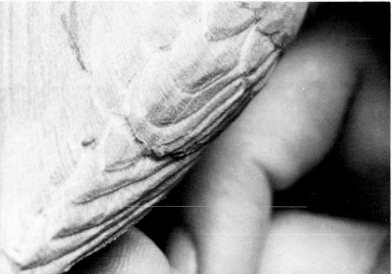

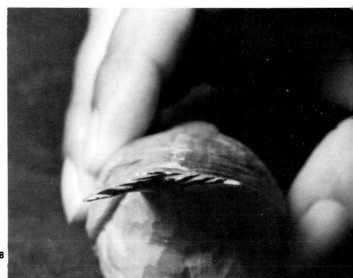

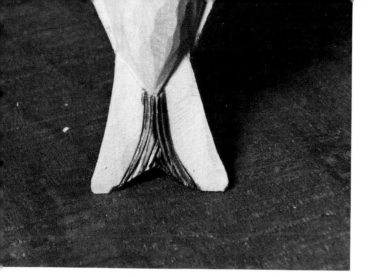

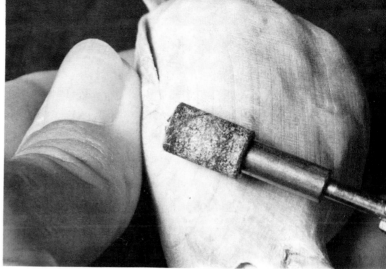

Figure 52. Make sure that the top and bottom tail feathers line up so that the outside top edge of the feather aligns with the inside edge of the feather underneath. Burn or carve the underneath tail feather edges.

Figure 55. A ¼" size cushioned sander is helpful in getting into restricted areas such as underneath the beak.

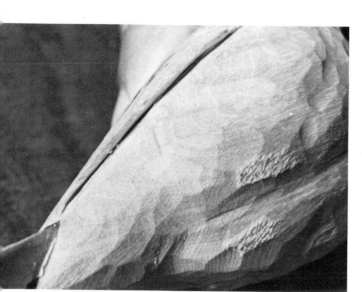

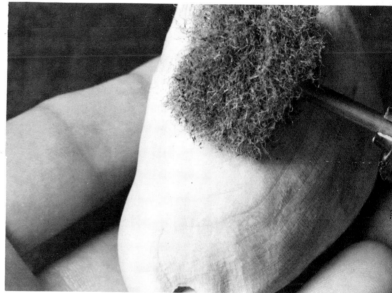

Figure 53. Carefully carve or burn with the burning pen the small triangular piece of wood underneath the lower wing edge on both wings.

Figure 54. Remove the eyes for sanding and texturing. Working with the grain, sand the body of the bird using a tootsie roll or a resin bond spiral band on a rubber cushioned drum as shown in the photograph.

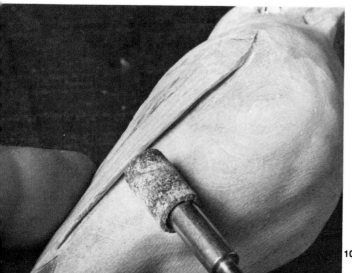

Figure 56. A folded piece of 120 grit abrasive cloth should be used on the feathers of the wings and tail, as well as other areas that other sanders used on a flexible shaft cannot reach. After completing your sanding, go over the entire bird (wings and tail included) with the defuzzer on the flexible shaft. Work with one strong light source so that you are able to see any areas that might need resanding or even reworking.

At any point during the carving, texturing or painting process, you can go back and redo an area that may need changing. Extra time spent checking over your bird for possible errors at this particular stage may save valuable time later.

Pay particular attention to the sanding and defuzzing procedures of any carving. Any chips, fuzz or rough surfaces will likely show up in the texturing and painting procedures and will ultimately affect the overall look of your carving. A clean bird at this point will yield a crisp completed bird. It is easier to paint a fastidiously clean and crisp bird than it is a sloppy, fuzzy bird. The end product will certainly reflect the amount of time taken in preparation.

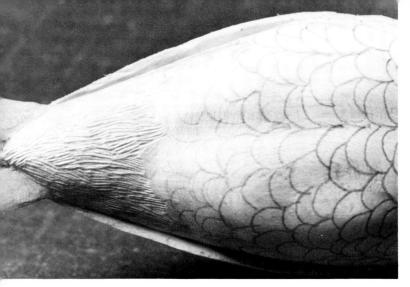

Figure 57. Layout the feather patterns on the lower tail coverts, belly, breast and chin (the entire underneath surface of the bird to be stoned). Varying the sizes and flow of the feathers, remember that a feather lays on top of the one underneath as you progress up the belly of the bird towards the head.

Begin stoning on the bird at the lower tail coverts and progress up the belly towards the head. A small inverted-cone white stone on a flexible shaft machine will leave less fuzz on basswood than one of the green variety.

Figure 59. As you get to this grain change (end-grain), turning the bird end for end will lessen the amount of fuzz produced. It can be tricky stoning in the opposite direction, but with a little practice, it gets easier.

Figure 60. Here you can see the interplay of the light on the feather contouring in combination with the stoning. They produce a fluffy look.

Figure 58. As you are stoning up the belly or sides, there is one particular area where fuzzing will be a problem, the top or anterior portion of the belly and the lower or posterior portion of the breast. This is where the grain changes to end-grain if the blank has been bandsawed out with the grain running the length of the bird. When you notice that more fuzzing is happening, turn the bird around and stone in the opposite direction. With a strong light source, you will be able to see which way will create less fuzz.

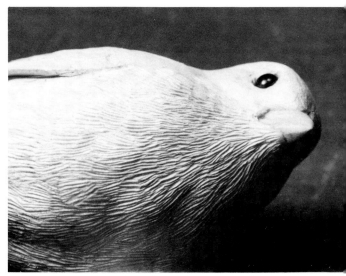

Figure 61. When you stone the smaller feathers of the upper breast and neck area, it is difficult on a small bird, to get much curvature in each stoning stroke, however you can create more motion and fluidity by varying the flow direction of different groups of feathers.

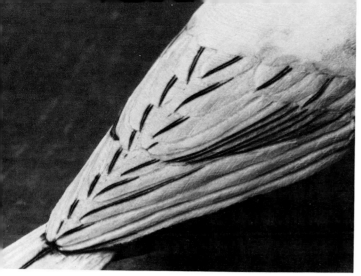

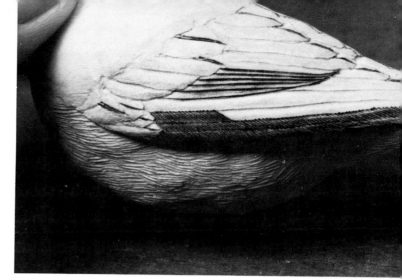

Figure 62. Draw out the quills on the major feathers of the wings, as well as the secondary edges. When burning the quills with the burning tool, burn two lines very close together and actually meeting and running together the last ¼"-½" of the feather, depending upon its size. The quills can be burned starting at the base of the feather and working towards the tip or going in the opposite direction. Try both ways and see which way you seem to like best. Burn the edges of the secondaries, holding the burning pen at a 90° angle to the surface of the bird.

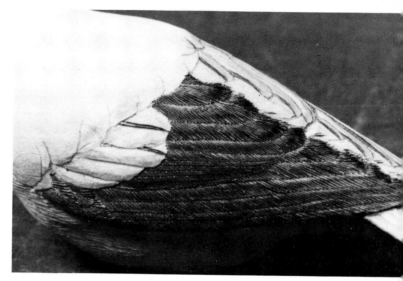

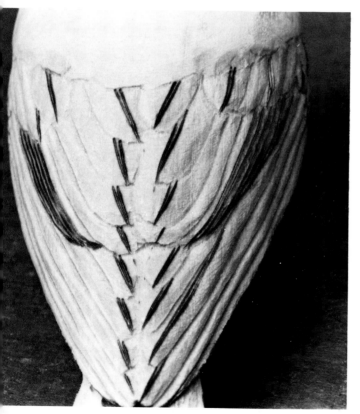

Figure 65. Here you can see the wing being burned from the lowest portion of the wing to the top and from the back to the front.

Figure 66. The burning of the barbs has been completed on both wings, with the wing on top in the folded position left until last. Go back over some of the burn lines making them a little deeper and wider to actually create a feather split. Smaller splits will be painted in. Do not create a pattern so that it becomes rigid. Do not over do.

Figure 63. Here you begin to see the effect of the stacked secondaries with only their edges showing.

Figure 64. Begin burning the barbs of the primaries with the burning pen, starting with the lowermost one and work your way up the wing. Burning from bottom to top allows and enhances the reality of one feather laying over top of the one underneath. Work from bottom to top of each particular group and from back to front.

Figure 67. Draw in the quills that are exposed on the upper tail. With the burning pen, burn two lines very close together, having them join approximately ¼ inch from the end of the feather. Begin burning the barbs on the outermost tail feathers working your way to the center, more fully exposed one.

Figure 70. Here you see the underneath surfaces of the tail feathers fully burned. Keep your burning as clean and as fine as the top surface.

Figure 68. Here you can see the tail feathers fully burned with a few random more heavily burned feather splits.

Figure 69. To burn the underneath tail, begin in the middle of the tail and work your way to the outermost feathers.

Figure 71. The underneath part cf the lower wing edge that is exposed is the next target for your burning pen.

Figure 72. When the lower tail coverts and sides were being stoned, the stone, no matter how small, is too large to get underneath the lower wing edge. With the burning pen, burn the edges that could not be stoned.

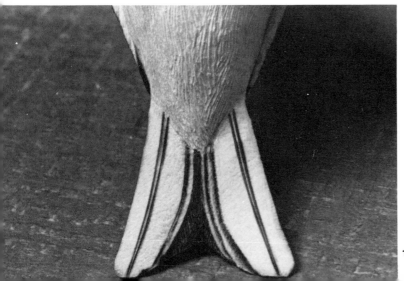

112

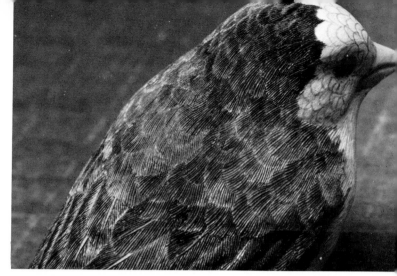

Figure 73. Layout the feather pattern on the mantle, upper back and head. Remember to vary the amount of the exposed feather. Feathers tend to follow each other in rows, but do not carry this to such an extreme that you end up with corn rows. Just as you did with the feather flows on the breast and belly, vary the direction and flow of the feathers to be burned so that there is motion, naturalness and fluidity.

Figure 75. As you progress burning your way up the mantle, upper back, neck and then head, the feathers become gradually smaller, and it will become increasingly difficult to get much curvature to the individual barb lines. You can accomplish more fluidity by varying the flow of the feathers.

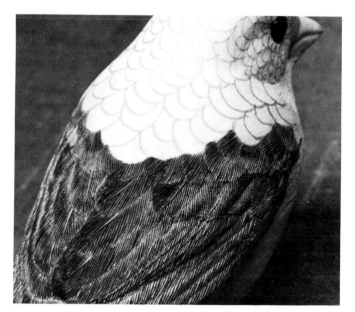

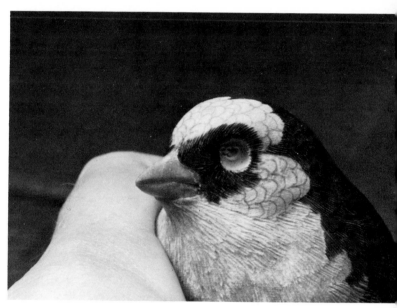

Figure 74. Beginning at the edge of the mantle and working forward and upward, start burning the barbs of the feathers keeping your burning as fine as possible. Try to get as much curvature in your burn strokes as possible.

Figure 76. Here you see the detail around the eye. In the area between the eye and the base of the beak, you actually only see the edges of the feathers, hence the burning pattern you see in the photo.

Figure 77. After the area around both eyes is burned, reinsert the eyes into the clay. Finish burning in the barb lines of the feathers on the crown, forehead and ear coverts.

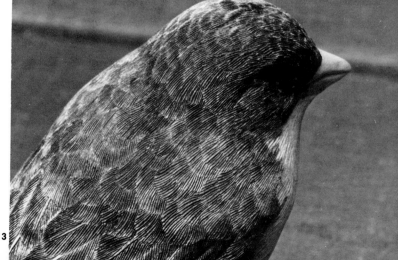

Figure 78. Carefully burn in the feather barb lines on the chin and around the beak that could not be textured with the stoning.

Figure 81. Using the natural bristle toothbrush, clean the area around the eye so that there are no remaining remnants of clay.

Figure 79. In the shoulder area where there is fine burning adjacent to the stoning, blend the two by burning barb lines into the stoned breast feathers.

When the burning is completed, clean all the burned areas using a natural bristle toothbrush.

Figure 80. Carefully clean the excess clay from around the eyes with a sharp-pointed clay tool or a dissecting needle. Any excess clay around the perimeter of the eye will keep the putty from adhering to that area.

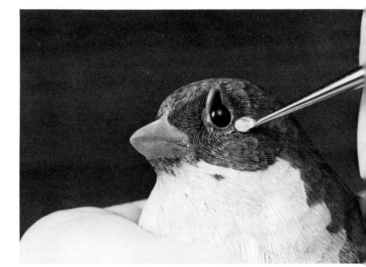

Figure 82. In setting the eyes in birds, remember that the eyes are an integral part of the head with only a fractional part of the eye actually exposed. It is always amazing to see how large the eyes actually are when seeing a study skin being prepared. Even in a small bird, the eye is approximately the same size as a medium-sized blueberry. The eyes in the carving should not be so bulbous that the bird looks popeyed and yet not so deep that you have to look down into the head to see them.

Check the positioning of the eyes in your carving. Look at them from every angle to make sure they are not too deep or too shallow and that they are balanced.

The life of the bird is captured in the head, but more particularly in the eyes. Taking the time and effort to execute a lifelike look about the eyes and head is well worth it. When viewing a carving, one's own eye will travel to the head first and more specifically to the eyes.

When you are satisfied that the eyes in your carving are balanced and the right depth, mix up a small amount of the Duro epoxy ribbon putty. Cut out the little piece where the two colors meet and mix between your fingers until you get an even green color. Roll a small piece of putty between the fingers of one hand and the palm of the other to make a small "snake". Using a clay tool, dental tool or dissecting needle, push the roll of putty into the crevice around the eye. Remember that the eye ring around the eye is oval not round.

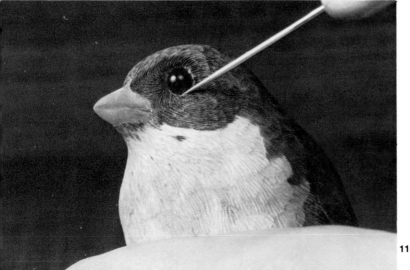

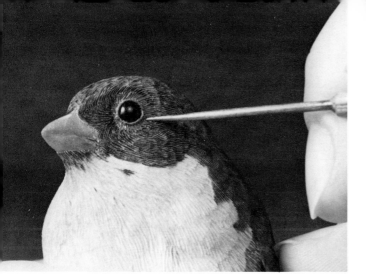

Figure 83. When working with the putty, periodically push whatever tool you are using into the oily clay which will keep the putty from sticking to the tool.

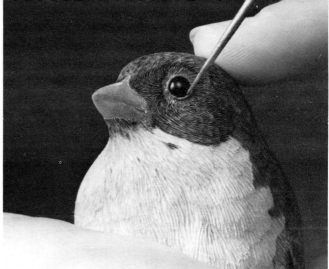

Figure 86. If you find that you have too much putty to blend outside on the burned area (more than .1 of an inch), remove it. You want as little putty outside of the eye as possible. If an edge of the drilled eye hole begins to show through, cover it up, as it will show when the bird is painted. If the putty eye ring starts hugging the eye itself too tightly, pull it away with your tool.

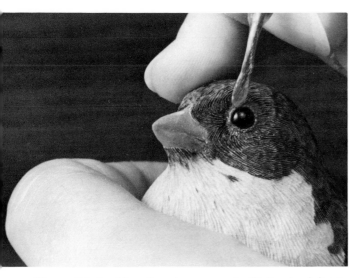

Figure 84. Pushing the clay around with the tool, form the eye ring. Remove any excess putty as you are working.

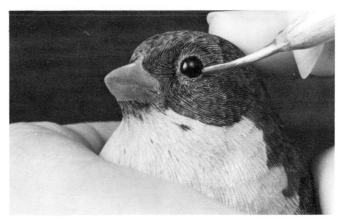

Figure 87. The eye ring itself is not smooth, but has a little bumpy texture similiar to wrinkled skin.

Figure 85. Gradually blend the putty into the surrounding burning. As you pull the putty into the surrounding grooves, the inner eye ring will start to become more pronounced. It should not be too prominent, but just slightly elevated above the surrounding area.

Figure 88. When you are satisified with the first eye, proceed to applying the putty to the other eye. Be careful, when working on the second eye, not to obliterate the putty around the first eye. Check the eyes for balance from the head-on view as well as the top plan view. It is easier to reset one or both eyes at this point than to have to start again at a later stage.

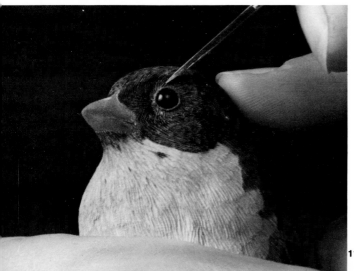

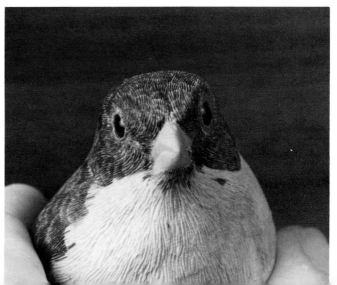

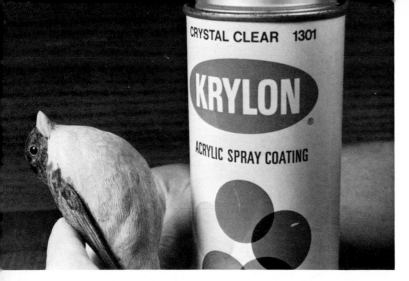

Figure 89. After the putty around the eyes has hardened, spray the stoned areas (lower tail coverts, belly, breast, underneath neck and chin) with a **light coat** of Krylon Crystal Clear 1301. Let this dry a few minutes.

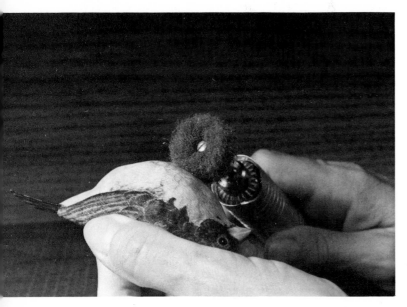

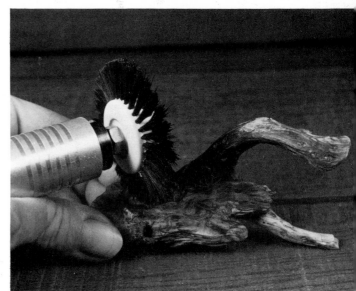

Figure 90. Using a defuzzer pad on the flexible shaft machine, clean up the stoned areas, running the abrasive pad lightly **with the grain.** This should rid the stoned areas of any remaining fuzz. The Krylon hardens the fuzzies and nubbies so that the defuzzer can whisk them off.

Figure 91. After selecting the piece of driftwood to mount the carving on, it is best to attach the driftwood to a "working" base so that any further procedures you do for the feet do not ruin any ground or the permanent base. You will want the driftwood to attach to the working base in the same position and angle that it will be attached to a permanent base or ground.

The piece of driftwood selected for the goldfinch needed flattening so that it would sit in the ground at a particular angle. To flatten a side of the driftwood, you can trim it with a knife, bandsaw, flexible shaft machine and carbide bit, or in this case, a piece of sandpaper on a flat surface.

Figure 92. Using the laboratory bristle brush on the flexible shaft machine, clean up the driftwood. You will notice that the brushing not only cleans it up, but also burnishes it to a nice patina. If you desire even more sheen, you can wax it with a good furniture paste wax and buff it with a cloth or brush. To change its color, you can paint it with acrylic washes or apply some desired color of shoe polish and then buff it.

Often the piece of driftwood will have to be altered with the bandsaw or flexible shaft machine. If there is a branch that juts out at an inappropriate place, saw it off and rough up the stump using a propane torch and wire brush on the flexible shaft machine.

You can be creative and imaginative with driftwood by fashioning interesting additions to it, such as a fascinating knot, knothole or entire added branch. It is easier to make a knothole if you have one in another piece of driftwood to use as a model. Using a carbide bit, make the hole in the piece of driftwood to be used for the carving. The area around the hole can be textured using ruby carvers, grinding stones or cutters on the flexible shaft machine. The burning pen can also add interesting textures. After you are satisfied with the hole's contours, paint the area to blend with surrounding wood with acrylic washes.

To make an added branch, use a wire armature to which you can add plastic wood, autobody (the kind used to fill dents in cars) or ribbon epoxy putty if it is a small addition. After contouring, paint the branch to match the existing driftwood using acrylic washes.

There are many ways you can alter existing driftwood—painting, contouring, sandblasting, wire brushing, etc. There are no limits, let your imagination fly. You can even create your own driftwood by carving it yourself. It is easier if you have other pieces of driftwood from which to model it, but it is not mandatory.

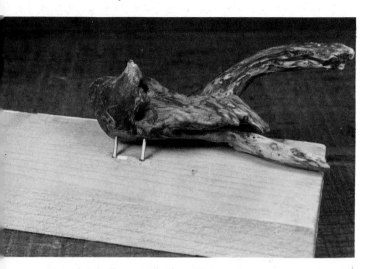

Figure 93. Now that the driftwood you have selected has been flattened to fit the working base and has been brushed, drill two 1/16 inch diameter holes in the driftwood. Insert two short pieces of 1/16 inch diameter wire. Using two pieces of wire, rather than one, will keep the driftwood from turning or twisting on the base or in the prepared ground. Press the two pieces of wire that are in the driftwood into the soft wood of the working base. Drill 1/16 inch diameter holes at these marks. Check to see if the wires of the driftwood fit properly into the drilled holes. Redrill the holes in the working base until you get a proper fit. Using a small amount of super-glue or glue from a hot-melt glue gun, attach the driftwood to the working base.

Figure 94. Holding the goldfinch in the desired position above the piece of driftwood, mark the spot on the belly where you want the tarsus to exit. Do both tarsi this way. Studying live birds will enable you to learn in what

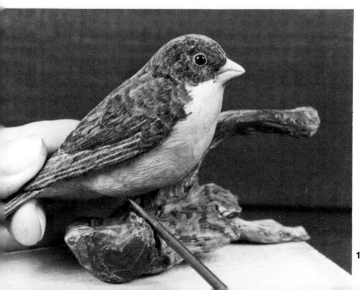

positions the feet come out of the body contour feathers at different points. Understanding the anatomy and functioning of the tarsi is crucial in positioning the bird. Nothing will replace first-hand knowledge from time spent observing and studying bird activities and behavior.

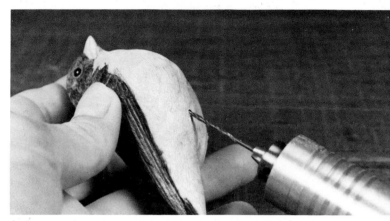

Figure 95. Drill a 1/16 inch hole into the body of the bird at each mark—the holes should be approximately ½ inch deep into the body.

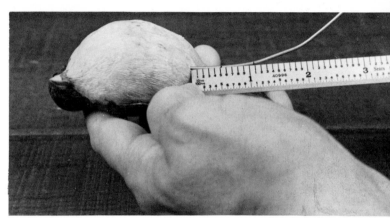

Figure 96. Insert a long piece of 1/16 inch diameter wire into the hole. Holding a rule along side the wire, mark the tarsus length (.52 of an inch for a goldfinch) from the ankle joint. At the bottom joint of the tarsus where the toes attach, allow about ½ inch extra to go into the piece of driftwood. Use a permanent ink marker or a file to identify these spots.

Figure 97. Using needle-nose pliers, make the appropriate angle bend in the wire to go up into the body.

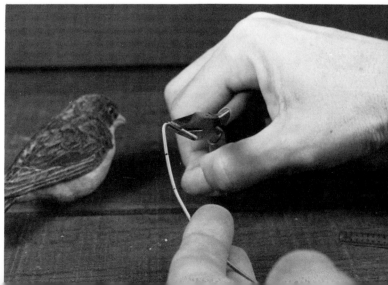

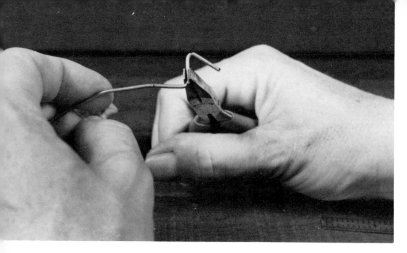

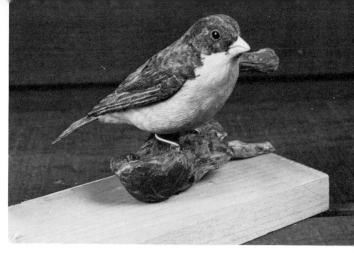

Figure 98. Holding the tarsus with the needle-nose pliers to keep it perfectly straight, make the bend at the toe joint (the point at which the wire goes into the driftwood).

Figure 101. Place the bird's feet wires into the holes. Check the bird for balance.

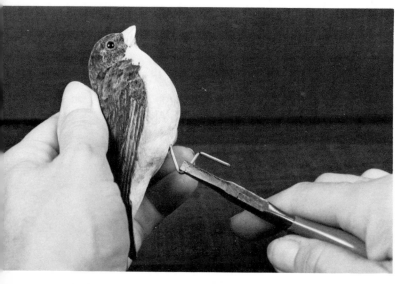

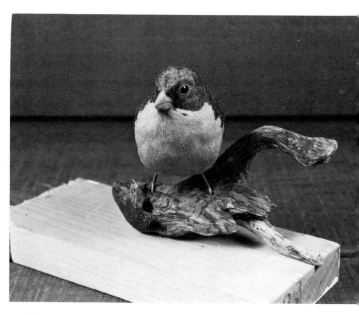

Figure 99. Insert the wire tarsus into the hole in the body. Proceed to do the same with the other tarsus.

Figure 100. Hold the bird above the driftwood. Using a pencil or awl, mark the points of insertion into the driftwood. Drill two 5/64 of an inch diameter holes into the driftwood at the same angle as the bend of the feet wires. Using a drill bit one size larger than the diameter of the wire allows easier insertion and removal from the driftwood.

Figure 102. Check the bird's balance from all viewpoints. Now is the time to change the position, if necessary. You may have to redo one or more of the bends in the wires. Keep working with it until you have a well balanced bird.

Place super-glue in the holes in the bird's body. Working quickly but carefully, place the tarsi in their respective holes, so the wires will be in the proper position as the glue dries. Do not glue the feet wires into the driftwood until the bird has been completely painted!

Figure 103. While the glue is hardening, prepare the cast toes. Often, in the casting process there will be extra bits of casting material along the sides of the toes and on the claws. Using a sharp knife, these nubs and extra bits should be removed from the purchased set of goldfinch toes.

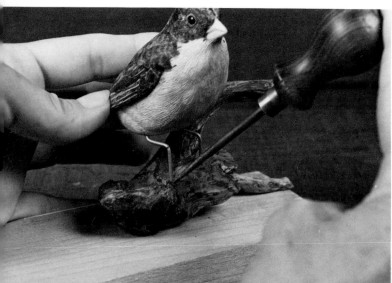

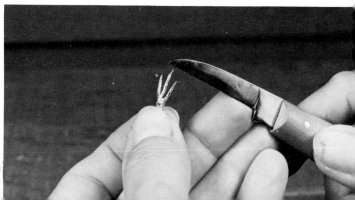

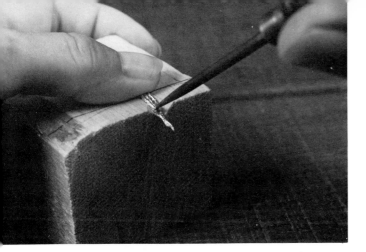

Figure 104. Cut a small v-notch in a scrap block of wood. Holding the cast toes in this notch, make a small hole with an awl in the center of the joint to keep the drill bit from drifting.

own outstretched right hand, the thumb comes off the left side. On the left tarsus, the hind toe should be on the right side of the tarsus.

With the toes on the proper tarsus, place the bird back on its perch. Make sure each set of toes is placed properly with the middle toes in line with the respective tarsi, then super-glue each set of toes to its tarsus. Only a small amount of super-glue is necessary. Too much super-glue will flow down into the driftwood hole, making it difficult to remove the bird from its perch. After this first little bit of super-glue has hardened and the toes are firmly anchored to the tarsus, remove the bird from its perch. More super-glue can be used on these joints, as it is hardening while the bird is off its perch.

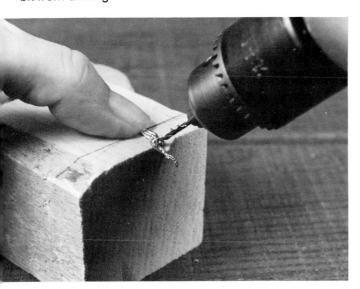

Figure 105. Using a variable speed electric drill, drill a 1/16 inch diameter hole through each set of cast toes. Drill very slowly so that the casting material does not grab the drill bit. If you do not drill slowly, all of a sudden you will find the toes whirring around on the end of the drill bit.

Figure 106. Once the tarsi have hardened into the body, take the bird off the driftwood. Place the proper set of cast toes on the respective tarsus. The hind toe goes to the inside of each tarsus. On the right tarsus, the hind toe should be on the left inside of the tarsus, just as on your

Figure 107. After the super-glue has hardened on the toes, mix up a small amount of the Duro epoxy ribbon putty. After cutting out the section where the two colors meet, mix it between your fingers until you have an overall green color. Place a small amount at the point where the tarsus comes out of the contour feathers on the belly. There is a small tuft of feathers at the ankle joints of this and most other songbirds. These are called leg tufts.

Figure 108. Work the putty around the entire insertion point of both tarsi. If the tarsus position is right up next to

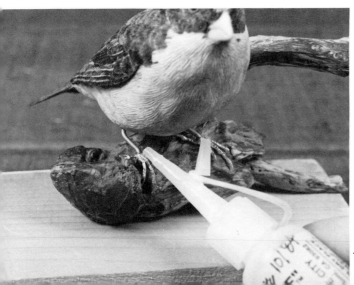

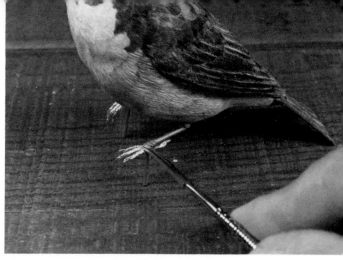

the belly, you may need to roll a dissecting needle or clay tool in there to get the putty right up on the tarsus and a smooth, flowing transition area to the belly. Remember to dip whatever tool you are using in the clay from time to time so that the putty does not stick to it. It is amazing what a small amount of putty you will need for the leg tufts.

After the putty is placed around the circumference of the insertion point, begin texturing the leg tufts. To accomplish a short, bristly feather effect, use an **unheated** burning pen, dental tool or the pointed end of a clay tool. Try several of these to see which you find the best to achieve the feathery effect. Pull the putty into the grooves of the stoning surrounding the insertion point, creating a smooth transition area between the belly and the leg tuft.

Figure 109. At the tarsus and toe joints on both feet, you need a small amount of ribbon putty to accomplish a smooth transition. Place the putty around the entire joint of both sets of toes. Using a dull knife blade or dental tool, press in the details of the semi-circular scales where the toes will bend on the foot of a live bird. Allow the putty to harden before proceeding to paint.

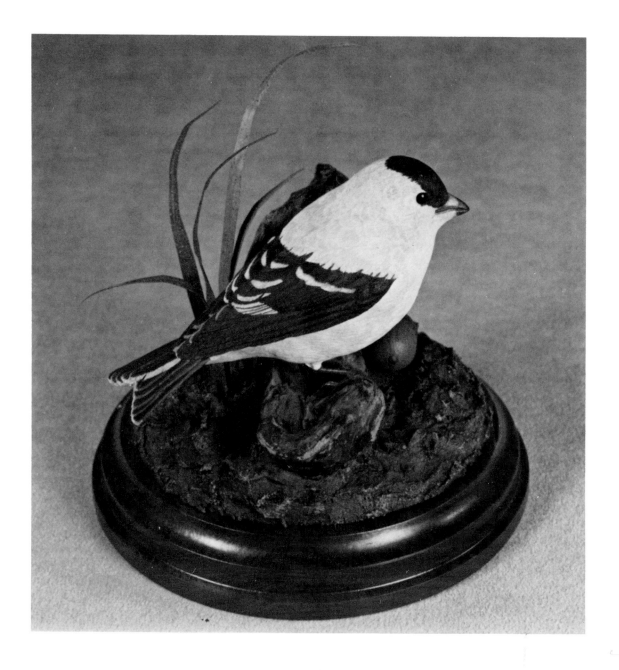

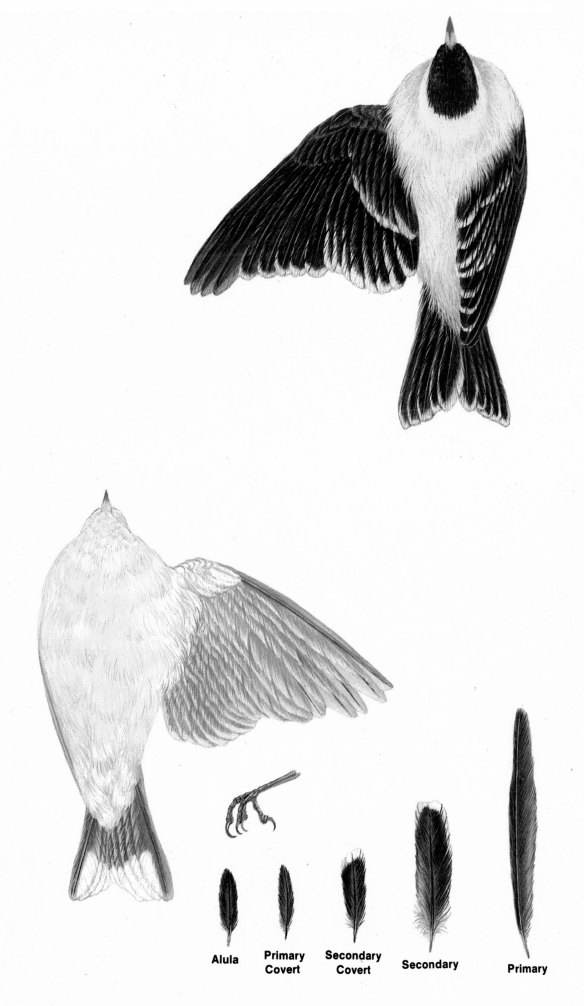

Alula

Primary Covert

Secondary Covert

Secondary

Primary

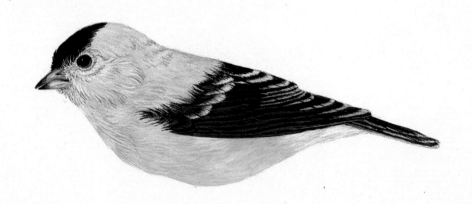

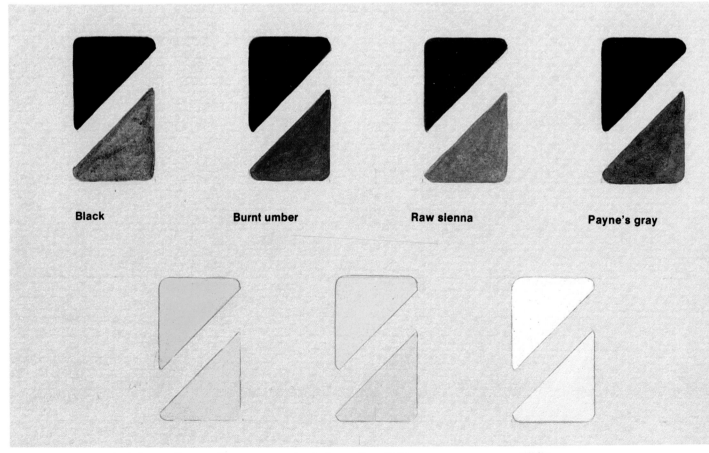

Black

Burnt umber

Raw sienna

Payne's gray

Cadmium yellow medium

Cadmium yellow light

White

Cap, wings, tail

Burnt umber
Payne's gray

Light gray washes
Wing and tail edges

White
Burnt umber
Payne's gray

A. Head, mantle, breast, belly
and *sides*

Cadmium yellow light
White

B. Head, mantle, breast, belly
and *sides*

Cadmium yellow medium
White

Undertail coverts

White
Raw umber
Payne's gray

Undertail and *under lower*
wings

Burnt umber
Payne's gray
White

Edging on head, cheeks, neck,
and *mantle*

White
Cadmium yellow light

Watery wash on white edges of
wings and *tail*

Payne's gray
Raw umber

Beak

White
Cadmium yellow medium

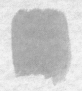

Feet:

Burnt umber
White
Cadmium yellow light

Watery wash
Burnt umber
White

Figure 1. Here you see the goldfinch study skin. Notice that only the edges of the primaries and secondaries are visible from a profile view. The greater secondary coverts are the feathers midwing with the light edgings.

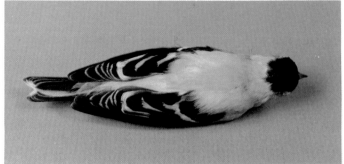

Figure 2. Observe the various shapes and sizes of the light edgings of the tertials, primaries and tail feathers.

Figure 3. Partially obscured by the feet, the lower tail coverts are a light grayish white.

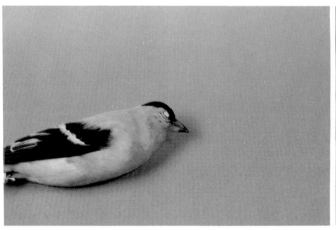

Figure 4. Notice the details around the head and beak.

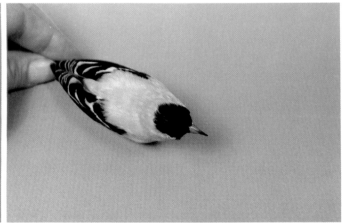

Figure 5. Here you can see the perimeters of the black cap on the goldfinch.

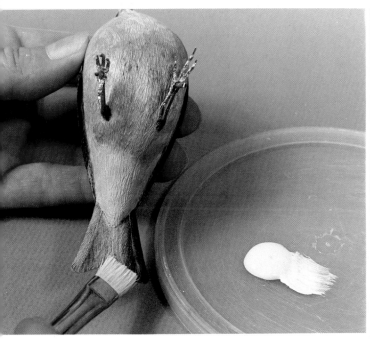

Figure 6. Applying gesso to the bird provides an even areas. Since gesso is a type of primer, it also ensures good adhesion for the application of subsequent layers of acrylic paint.

Using a stiff bristle brush such as a Grumbacher Gainsborough #5 (or equivalent), begin applying the gesso, working small areas at a time. Scrub the gesso down into the texture lines with a back and forth motion, rather than merely painting it on. Use a dry brush technique, leaving most of the gesso on your paper towel. Be careful not to leave any excess, especially on the edges of the tail and wings. Do not use so much gesso that you actually fill and obliterate the texture lines. Keep your brush damp, but do not use too much water, as it lessens the adhesive quality of the gesso. Dry brush the entire bird with the gesso including the areas around the eyes and the feet. Usually two coats of gesso are sufficient. Use the medium heat setting of a hair dryer to dry the bird between applications.

Figure 8. Blending burnt umber and payne's gray to a warm black, begin to lay out the dark areas on the wings, tail and head.

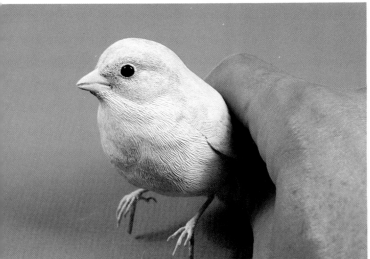

Figure 7. After the gesso is dry, CAREFULLY scrape the eyes, using the point of a sharp knife held at an angle. Cleaning the eyes periodically during the painting process enhances the lifelike quality of the carving, allowing a more realistic application of colors.

Figure 9. It will take three or four applications of the color to thoroughly cover the gesso. Keep your paint thin so it does not fill the texture lines.

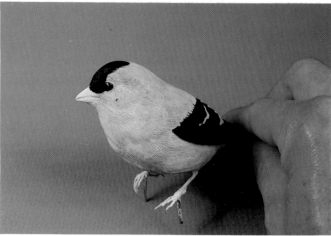

Figure 10. For the light edgings, blend white with small amounts of burnt umber and payne's gray to create a light grayish white. Keep working the light edgings and the dark areas back and forth until you get a clean, crisp, fully covered effect.

Figure 12. With the goldfinch, one of the base coat colors is cadmium yellow light and a small amount of white. The other is cadmium yellow medium and a small amount of white. Alternate these two base coat colors, drying in between, until you have sufficiently covered the gesso on the head, upper back, mantle, belly, sides, breast, neck and chin.

When working on the head, blend the yellow mixtures into the dark cap. Work the dark color (burnt umber and payne's gray) back into the yellow until you get a natural looking blend line.

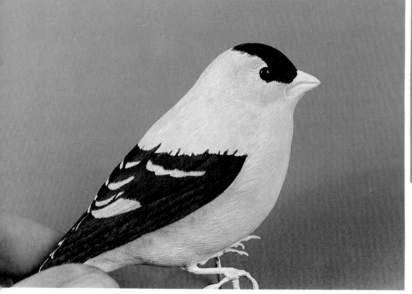

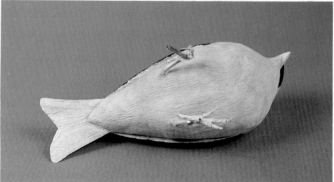

Figure 13. Mixing white with small amounts of raw umber and payne's gray, apply the base coats to the lower tail coverts. Blend the light grayish white with the yellow base coats of the belly at the vent area. Edge the lower tail covert feathers with a dry brush technique and white. When the edgings are dry, apply a very watery white wash to the entire lower tail covert area.

Figure 11. Here you see the gradual build up of a base coat in an area of the bird that appears as monochromatic from a distance. Upon closer viewing, you see several different colors of varying values. One way to accomplish this effect is by applying two similar but slightly different colors of base coats. Rather than painting each color on top of the other in solid, covering coats, you apply each color in a splotchy, dappled technique. The application of a solid color will make the surface of the carving appear flat, and two-dimensional. Thin coats applied in a mottled or dappled technique create the illusion of depth and enhances the actuality of the third dimension. Keeping your paint very thin, build up your colors gradually until there is sufficient depth and intensity of color.

Figure 14. To enhance the contouring of the breast and belly, use a very thinned mixture of burnt umber and cadmium yellow light with a dry brush technique. To highlight some of the feathers on the breast and belly, edge them with white and a small amount of cadmium yellow light again using a dry brush technique.

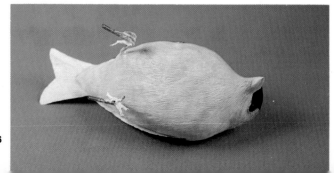

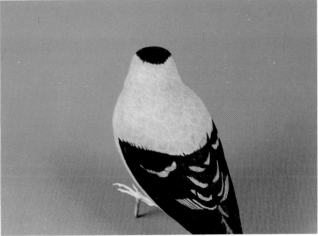

Figure 14. Combining burnt umber, payne's gray and white, apply the base coats to the dark areas on the underneath tail feather surface and the underneath surface of the primaries. For the light areas on the underneath surface of the tail, use a mixture of white with small amounts of raw umber and payne's gray. Work the dark base coat color into the light and the light into the dark until you have a clean, crisp, fully covered effect. When the base coats are dry, apply a very watery wash of white with a small amount of burnt umber to get the silvery gray effect.

Figure 17. To highlight some of the feather edges on the head, neck, cheeks, upper back and mantle, dry brush them with white and cadmium yellow light.
Apply a **very** watery wash of payne's gray and raw umber to the light areas of the wings and tail.

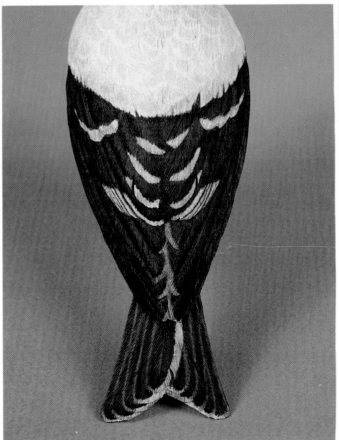

Figure 18. For the color of the feet, combine burnt umber, cadmium yellow light and white. Apply at least two thin coats to the feet, being careful not to fill in the texture. Paint the semi-circular scales on the tarsi with a fine brush and dark gray paint (burnt umber, payne's gray and white). The claws should be painted with burnt umber. When the base coats and details on the feet are dry, apply a watery wash of white with a small amount of burnt umber.

Figure 19. Mixing white with a small amount of raw umber and cadmium yellow medium, paint the entire beak with several base coats. While the last base coat is still wet, draw a small liner brush loaded with burnt umber down both commissure lines. The blackish-brown tip of the beak is accomplished by applying very thin washes using burnt umber and payne's gray. After the beak is dry, apply a **watery** wash to the upper mandible with a mixture of burnt umber and burnt sienna.

Figure 16. For the trailing edges of the primaries and the leading edges on the upper surface of the tail feathers, apply payne's gray, burnt umber and a small amount of white in a watery wash.

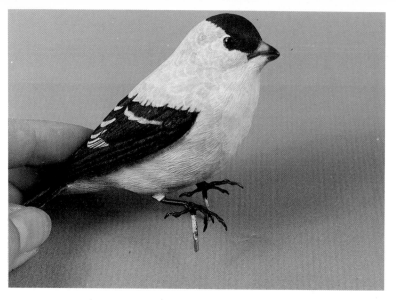

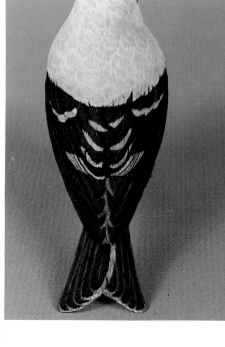

Figure 21. Using a small liner or scroll brush, apply straight gloss medium to the quills of both wings and to the quills of both the upper and lower surfaces of the tail feathers.

After the mediums have dried, you are ready to mount the completed carving onto the prepared driftwood. Mix up a small amount of 5 minute epoxy and glue the feet in their respective holes. If any of the glue should seep out of the holes onto the surrounding driftwood, it can be touched up with acrylic paint after the glue has hardened.

Figure 20. Apply a half and half mixture of matte and gloss mediums to the beak, effecting a satin gloss.

Brush the entire surface of the feet with a small amount of gloss medium added to a puddle of water, leaving a slight sheen to the feet. Apply straight gloss medium to all surfaces of the claws. Both gloss and matte mediums appear milky-looking when wet, but dry clear.

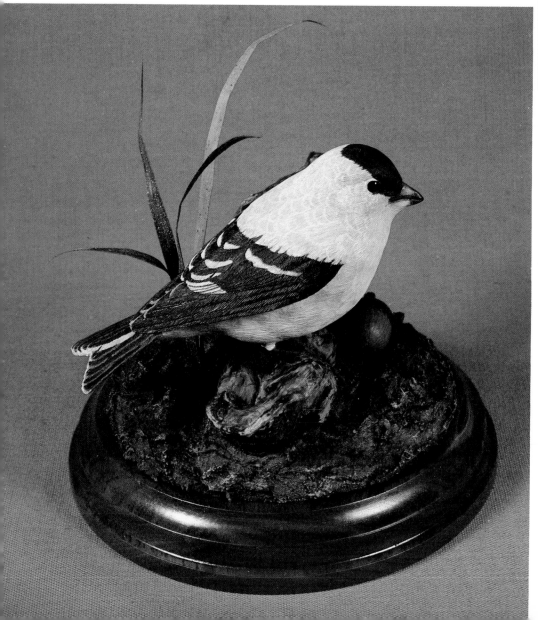

Figure 22. Completed goldfinch project.

Chapter 6
House Wren

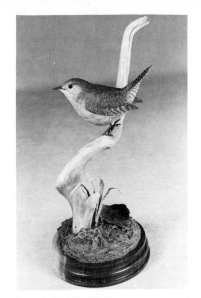

The house wren project, covers cocking the tail up and dropping the wings. The head will be turned in the wood and not sawed off. The position is a characteristic of the wren family.

This is the most common wren in the eastern United States but it is found nationwide. This little songster (it always amazes me that so much noise and song comes out of this little bird) will readily nest in bird houses, old tin cans, hats, flower pots and various nooks and crannies of houses. The wren builds its nest of sticks and twigs with softer lining materials such as fur of small mammals, spider webs and soft feathers. Its diet is mostly insects making the wren an asset for those who enjoy the outdoors.

Physical characteristics

There are 10 primary feathers that are dusky barred. The first primary is slightly less than one-half the length of the longest, which is the third primary. The feathers are barred (from distinct bars on the wings and tail to obscure bars on the back and rump) all over the body except the head and neck. There is a faint light line over each eye.

Slightly shorter than the head—the beak is a five-sided shape at the base. The beak is long and slender with nostrils that are located in small depressions on each side of the culmen. The nostrils are not hidden under bristly feathers, but are fully exposed.

The tail is rounded with the outermost feather on each side .4 of an inch shorter than the longer inner ones. There are 12 tail feathers though not all of them will show except in a widely flaired tail position. The tail is 1.9 inches long. When drawing patterns, it is necessary to take this measurement into account. The bend of the tail begins at 1.9 inches from the end of the tail and not at the considerably shorter upper tail coverts.

DIMENSION CHART

1. **End of tail to end of primaries** — .9 inch.
2. **Length of wing** — 2.1 inches.
3. **End of primaries to alula** — 1.4 inches.
4. **End of primaries to top of 1st wing bar** — 1.25 inches.
5. **End of primaries to bottom of 1st wing bar** — 1.3 inches.
6. **End of primaries to mantle** — 1.4 inches.
7. **End of primaries to end of secondaries** — .5 inch.
8. **End of primaries to end of primary coverts** — 1.2 inches.
9. **End of tail to front of wing** — 3.0 inches.
10. **Tail length overall** — 1.9 inches.
11. **End of tail to upper tail coverts** — .85 inch.
12. **End of tail to lower tail coverts** — .7 inch.
13. **End of tail to vent** — 1.8 inches.
14. **Head width at ear coverts** — .7 inch.
15. **Head width above eyes** — .5 inch.
16. **End of beak to back of head** — 1.3 inches.
17. **End of beak to back of crest** —
18. **Beak length: top** — .48 inch; **center** — .55 inch; **bottom** — .30 inch.
19. **Beak height at base** — .16 inch.
20. **Beak to center of eye (eye 4 mm)** — .75 inch.
21. **Beak width at base** — .20 inch.
22. **Tarsus length** — .6 inch.
23. **Body width**[1] — 1.5 inches.
24. **Overall body length** — 4.3 inches.

[1]At widest point.

TOOLS AND MATERIALS

TOOLS:

Bandsaw (or coping saw)	Flexible shaft machine
Carbide bits	Ruby carvers
Tootsie roll sander on a mandrel (120 grit) or mounted bullet-shaped abrasive stone	Knives, small chisels, gouges (optional)
Pointed clay tool or dissecting needle	Ruler measuring tenths of an inch
Calipers measuring in tenths of an inch or dividers	Compass
v-tool (optional)	Emery board (kind used for fingernails)
Burning pen	Abrasive cloth (120 and 320 grits)
Defuzzer on a mandrel	Variety of small mounted stones
Natural bristle toothbrush	Laboratory bristle brush on a mandrel
Variable speed electric drill	Drill bits
Needle-nose pliers	Wire cutters
Awl	

MATERIALS:

Basswood	Tracing paper
Super-glue	Pair of brown 4 mm eyes
Clay	Duro epoxy ribbon putty
Clay or dental tools	Driftwood for mount
1/16 of an inch diameter wire (16 gauge)	Permanent ink marker
Pair of cast toes for house wren	Krylon Crystal Clear 1301

HOUSE WREN

Profile Line Drawing

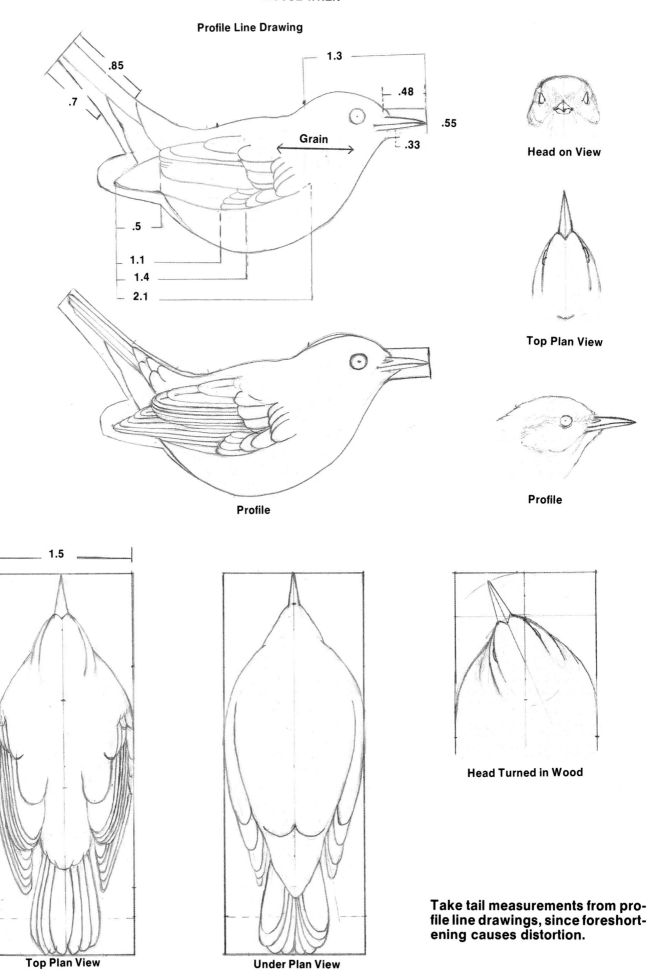

Grain

Head on View

Top Plan View

Profile

Profile

Head Turned in Wood

Take tail measurements from profile line drawings, since foreshortening causes distortion.

Top Plan View

Under Plan View

130

Top Wing

Under Wing

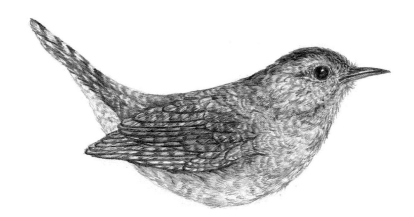

Profile

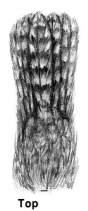

Top

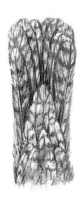

Under

Total Tail Length

Outside

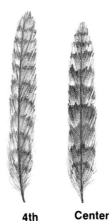

4th **Center**

Actual size individual tail feathers.

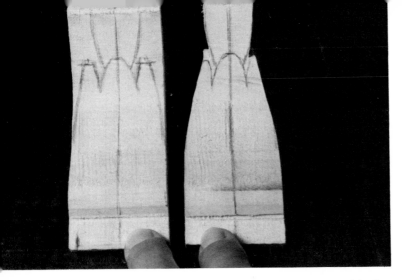

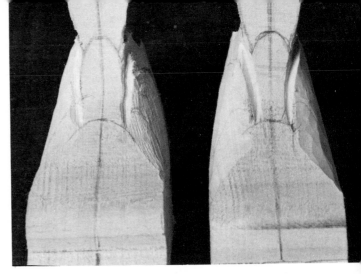

Figure 1. After cutting out the profile view with the bandsaw, draw in the center line all around the bird. Draw or trace and pinprick the line plan view pattern onto the bird, and with the bandsaw or coping saw, cut off the excess wood from the wings and tail.

Figure 4. Using a rounded-end carbide bit on the flexible shaft machine (the bird on the left) or a gouge (the bird on the right), channel along the edge of the tertials and on down toward the tips of the primaries.

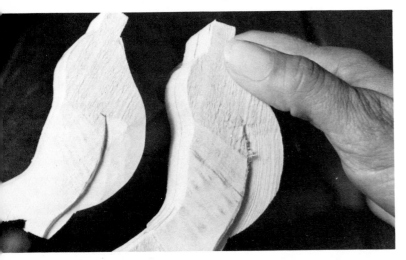

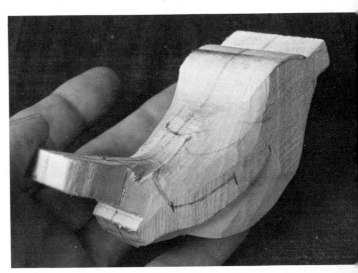

Figure 2. Draw or trace and pinprick the lower wing edges from the line profile pattern. With a sharp-edged carbide bit on the flexible shaft machine or a v-tool and chisel, cut along the lower wing edge line on both wings and remove the excess wood along the sides of the bird all the way to the belly bandsawed edge.

Figure 5. Mark the following measurements on the carving: from the primaries to the secondaries on both sides, .5 of an inch; from the end of the wing to the mantle, 1.4 inches; and from the end of the wing to the alula (on both wings), 1.4 inches. Draw in the secondary line to the alula on both wings.

Figure 3. Draw or trace and pinprick onto the bird the tertials from the line plan view pattern. With a knife or carbide on the flexible shaft, round the wings down to the lower wing edge line. The carving on the left has had its wings rounded using the flexible shaft, while a knife was used on the bird on the right.

Figure 6. Outline the secondaries on both wings with a v-tool or ruby carver on the flexible shaft machine. Using a knife or carbide bit on the flexible shaft machine, flatten the top surface of the tertials and secondaries. Draw in the top surface of the primaries using the line profile drawing as the reference.

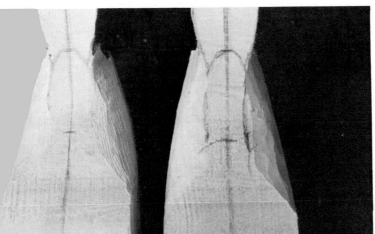

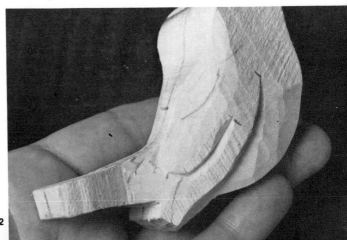

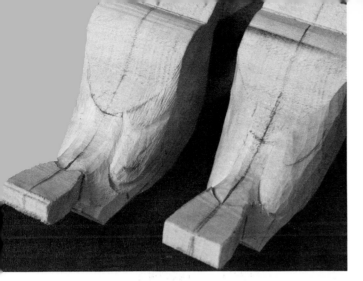

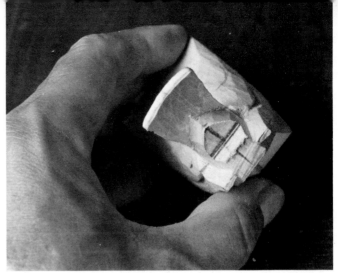

Figure 7. Draw in the upper tail covert line. The end of the tail to the upper tail covert measurement is .85 of an inch. Make a shallow channel on the upper tail covert line. Flow the coverts down to the bottom of the channel. Round the upper tail coverts and the rump area.

Figure 10. Measure and mark the lower tail coverts (.7 of an inch from the end of the tail) and the vent area (1.8 inches from the end of the tail). Draw the lower tail covert line. Using a sharp-edged carbide bit on the flexible shaft machine or a v-tool and chisel, remove the excess wood on the underneath surface of the tail up to the .1 of an inch line around the tail edges and up to the lower tail covert line. Work carefully as the tail runs cross-grain with the blank bandsawed out with the grain running through the beak and the wings. The tail should be .1 of an inch thick at this point, with the top surface convex and the underneath surface concave.

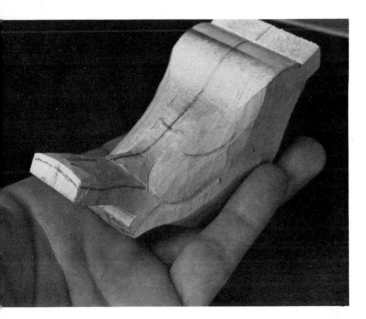

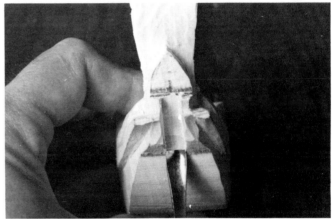

Figure 8. Gently round the top surface of the tail. Draw a line .1 of an inch from the top edge of the tail on all of its sides.

Figure 9. Along the side of the tail, cut down to the top surface of the primaries using a knife or carbide bit on the flexible shaft machine.

Figure 11. Using a shallow gouge or a carbide bit on the flexible shaft machine, carefully make a channel between the primaries of both wings on the underside of the bird.

Figure 12. Replace the vent measurement mark if it has been carved away. Flow the lower tail coverts down to the base of the exposed tail feathers.

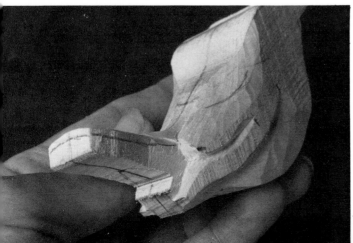

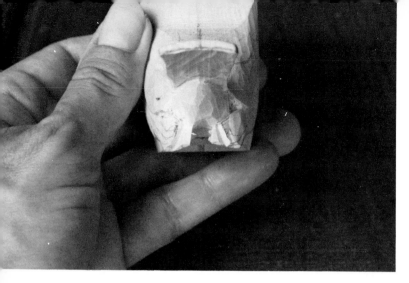

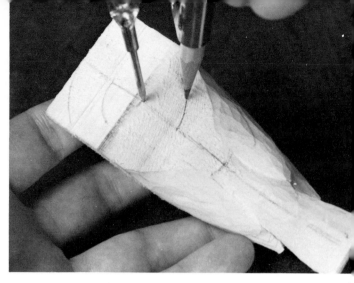

Figure 13. Using a knife, cut away the wood on the top surface of the primaries so that you have an approximately 45° angled top surface. Keep the primaries somewhat blocky at this point due to the fragility.

Figure 16. The "midway point" is that point equidistant from the front and the back of the head.

Directly under the midway point is the pivot point of the head. With your compass at the midway point, swing arcs for the end of the beak, the base of the beak and back of the head.

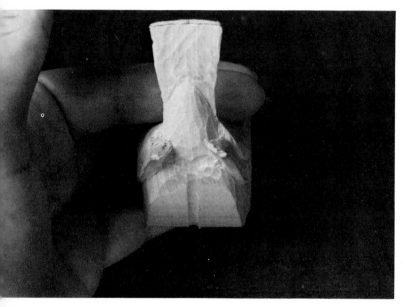

Figure 14. Here you can see the vent area beginning to be carved away. With wings in a dropped position, as in this little wren, the sides of the vent area will be covered up by the primaries on both sides. You can use a shallow gouge, knife or carbide bit on the flexible shaft machine. Work carefully so that you do not nick the lower wing edges. Form the shallow channel along the center line up to the top of the belly and lower breast area.

Figure 17. With a flexible ruler or straightedge, draw a line approximately 25-30° from the center line through the midway point. This is your new center line for turning the head in the wood.

Figure 18. Across the crown, measure and mark the widest point of the head (at the ear coverts) which is .7 of an inch across, being .35 of an inch on both sides of the center line. Draw in a rough outline of the head with the ear covert marks along the line. This is your top plan view of the head. You should allow a little extra wood in the beak area.

Figure 15. Finish contouring the vent area and thin the primary area. Be sure that you carry the same angle underneath the primaries as you have on the top surface. Round the belly area, leaving a shallow depression along the centerline from the vent to the lower breast.

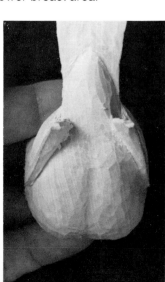

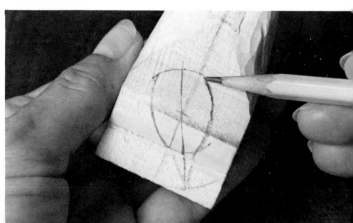

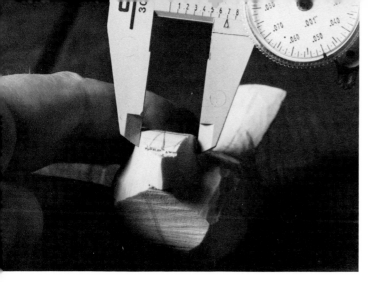

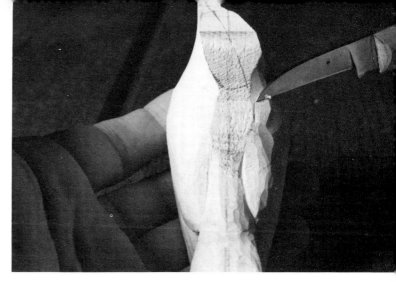

Figure 19. With scooping cuts from a knife or carbide bit on the flexible shaft, take the cheek area down until it measures .7 of an inch. As with the goldfinch, whose head is also turned in the wood, there will be a grain change from side to side on the head. Since the head position is at an angle to the grain, you will be cutting up one side of the head, and on the side to which the head is turned you will be cutting down toward the shoulder. Occasionally you may find a piece of basswood with grain changes within the head. Work carefully, taking away a little at a time. Take off thin shavings until your knife cuts smoothly and cleanly. If you cut into it with too much gusto, you may find your bird with chunks removed in inappropriate places.

Figure 21. Flow the shoulder area toward the breast on both sides and toward the ear coverts. The shoulders should rise gracefully toward the ear coverts and around to the breast area. If you grasp the bird between your forefinger and thumb at the midwing point (the alula on both wings), the bird's body shape should round gently around the breast area and taper back to the tail coverts. The actual body shape without the wings resembles an elongated teardrop.

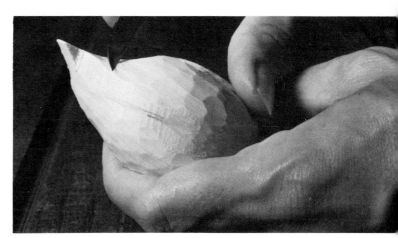

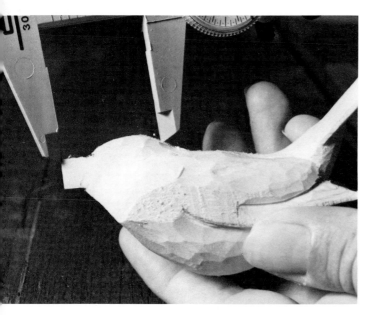

Figure 22. Gently round the breast area to its center line, flowing it toward the already contoured belly.

Figure 23. Draw a line perpendicular to the center line at the center point on the top of the head, dividing the head into quadrants. The two "x"-ed high areas will need to be taken down to achieve symmetry on the top of the head. Turning the head of the bird in the wood throws the top planes of the crown off.

Figure 20. Check the measurement from the end of the beak to the back of the head (1.3 inches). If necessary, take a little off the end of the beak and a little off the back of the head to get the proper dimension.

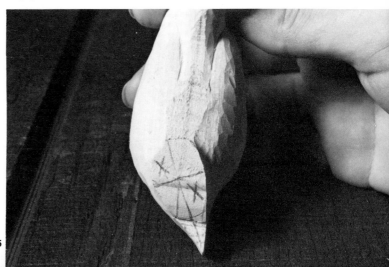

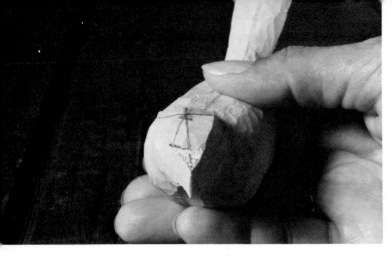

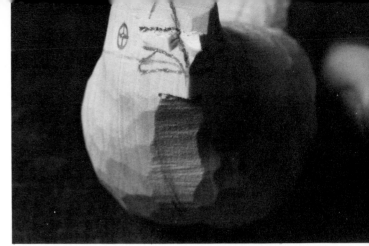

Figure 24. With a knife, carefully take small chips off the "x"-ed areas until the head is balanced from the head-on view (including the forehead, the crown, occiput or back of the head, and the back of the neck). Keep the planes flat at this point.

Figure 27. Mark in the top length measurement of the beak (.48 of an inch). With a sharp, pointed blade knife make a v-shaped stop cut at this mark. Begin taking small slivers of wood back to this stop cut until you get down to the top beak line traced from the profile pattern. Work first one side of the top of the beak and then the other. Redraw the beak center line.

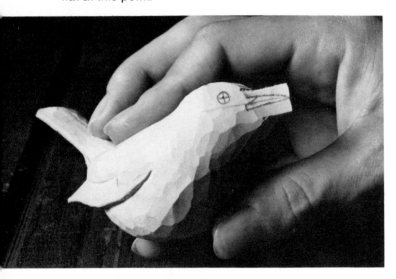

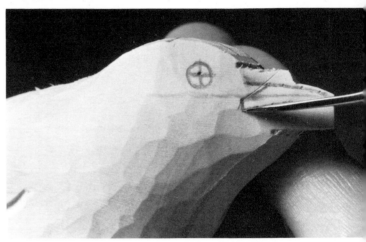

Figure 25. Trace and pinprick the beak and eye on both sides of the head. Make sure, from a head-on view, that the sides of the beak and the eyes are balanced. Draw in the beak and eyes on both sides.

Figure 28. With the tip of a knife, trace the **outside** perimeter line of the beak on both sides. Do not trace the commissure line. Keep the knife blade perpendicular to the side surface of the beak and do not undercut.

Figure 26. Check the balance of the beak and eyes from several views. If you find any discrepancies, remark the beak or eyes. Once you start carving away the excess wood, it may be too late for alterations.

Figure 29. Using the perimeter cut line as a stop cut, begin making the width of the beak narrower by cutting back the sides of the beak on both sides. Take small chips out carefully, and keep checking the head-on view to make sure you are keeping the beak balanced on both sides of its center line.

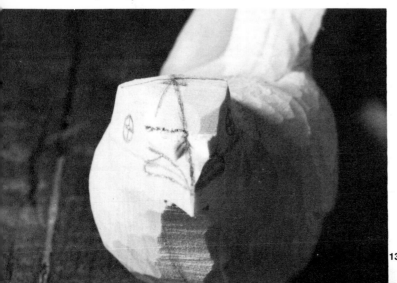

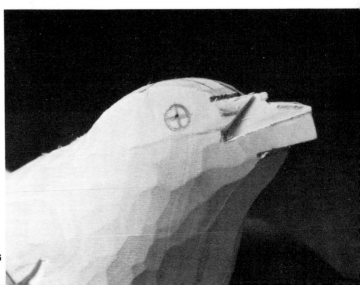

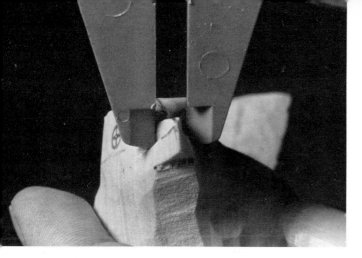

Figure 30. Keep cutting away the sides until the width of the beak measures .20 of an inch. Shape the top pyramidal surface of the beak. Redraw the commissure line on both sides, making sure the two sides match from the head-on view.

Figure 32. Flow the head down to the base of the beak on all sides: the forehead, both sides of the head, and the chin. Work carefully so that you do not nick the beak.

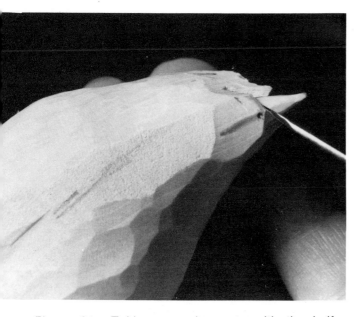

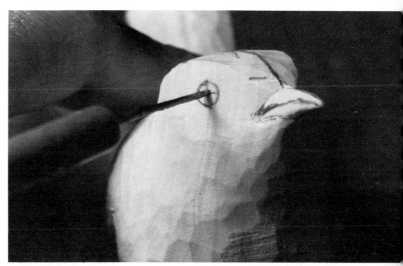

Figure 31a. Taking scooping cuts with the knife, remove the waste underneath the beak. Measure and mark the length of the under beak (.3 of an inch). Draw in the semi-circular shape of the under beak with its longest part at the .3 of an inch mark. The line should go back to both sides of the beak.

Figure 31b. Make a stop cut along this line, making sure that you hold the knife perpendicular to the under beak surface so that it is not undercut. Starting at the tip on the underneath surface of the beak, carefully cut back toward this stop cut, gradually thinning the height of the beak. Trim the area underneath the lower mandible until you get to the line previously traced and marked from the profile pattern line drawing.

Figure 33. Recheck the measurement from the end of the beak to the center of the eye (.75 of an inch). With an awl or pointed clay tool, deeply mark the center of each eye, checking to make sure the eyes are balanced from the head-on view as well as the top plan view.

Figure 34. Working above and through the eye areas, narrow the crown down until you get .5 of an inch across the top of the head above the eye. Take scooping cuts with a knife, just as you did when narrowing the head in the ear covert area. Keep the head balanced with equal amounts of wood on both sides of the center line. Keep checking the head from a head-on view.

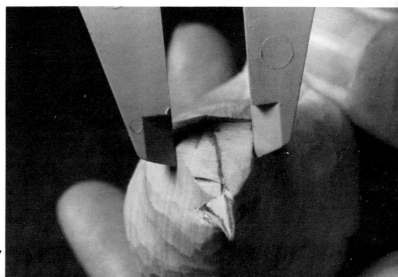

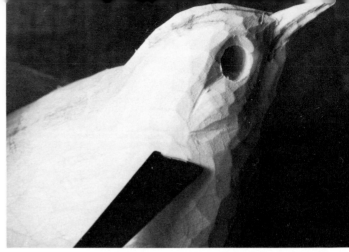

Figure 35. Gently round the top of the head, from the forehead all the way back to and including the back of the neck. Recheck the entire head for symmetry and balance.

Figure 38. Using a chisel or ruby carver, flow both sides of the neck up to their respective ear covert channel, so that you have a gentle contour from the shoulder area, through the neck area and on up to the ear covert area. On the ear coverts themselves, round the sharp edge that the channel created. These two procedures create the fluffy roundness needed in the cheek area. Check the balance of the ear coverts from the head-on view.

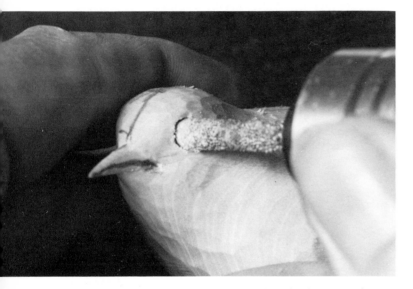

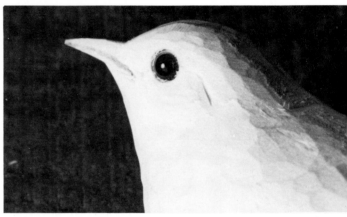

Figure 36. There should be a slightly depressed area for each eye to sit in. Using a carbide bit on a flexible shaft machine or drill, make a 4 mm eye hole hole on each eye center mark. Recheck the eye area, making sure that the eyes are balanced from the top plan view as well as the head-on view. Adjust the eye holes if necessary.

Figure 39. Using clay, temporarily set a 4 mm dark brown eye into each eye hole. Notice how this immediately gives life to your carving. Recheck the entire head and make any necessary adjustments.

Figure 40. Rough sand the beak using an emery board that has been cut on a taper. This allows you to get back to the tight places at the base of the beak on the sides. Redraw the commissure line. With the burning pen, burn the commissure lines holding the pen perpendicular to the surface of the side of the beak. Lay the burning pen on its side and burn a beveled line up to the first burn line. This creates the effect of the lower mandible fitting up into the upper mandible.

Figure 37. Draw or trace and pinprick the ear coverts on both sides of the head. Use the line drawing profile pattern for reference or tracing. Using a v-tool or ruby carver on the flexible shaft machine, cut a channel along the ear covert lines.

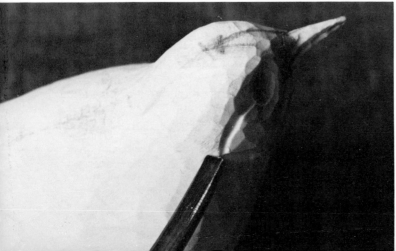

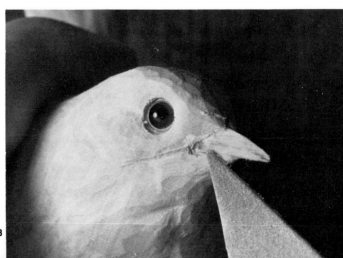

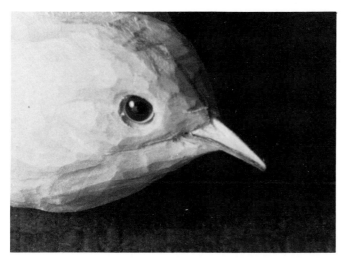

Figure 41. On the top, pyramidal part of the base of the beak, make a small depression with a ruby carver on the flexible shaft machine on both sides. Within this little depression (on both sides of the beak), there is a small flap of cartilagenous material. Using a nail that has had its tip rounded off with abrasive paper or a dental tool, press the detail of this little flap into the depressed area on both sides of the beak. Just beneath the flap on each side is the flattened nostril hole. Using the point of a dull X-Acto knife blade, press in the nostril hole. Put super-glue on the beak. After it has hardened, fine sand the beak with 320 grit abrasive cloth.

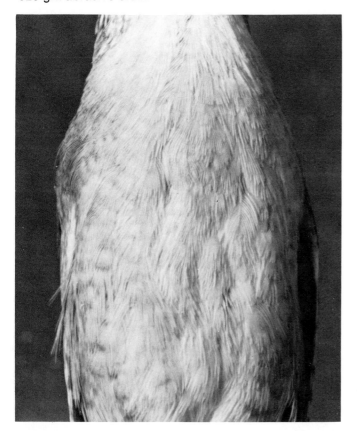

Figure 42. Here you see the breast and belly of the house wren study skin. Notice how you can see the high and low points of the feather contouring (also known as feather landscaping or "lumps and bumps"). Close observation reveals that there is variation in the flow of the groups of feathers as well as of individual feathers within the groups. There is no definite pattern of this feather contouring on the study skin or a live bird. If you have a bird (dead or alive) and blow on the breast and belly feathers, they will fall into different patterns with different high and low points each time you puff. Every time a bird fluffs his body contour feathers, they will fall into different patterns with varying high and low points. Also remember that the wind will affect the flow of the patterns.

Every feather grouping will have a high point, flowing out to the lower areas. Every feather also has a definite contour—that is, it is convex on the top surface and concave underneath. If you closely examine a body contour feather, you will see that it not only has curvature from side to side, but also from top to bottom.

There is no one right way to do feather landscaping. You can use your imagination and artistic license to exaggerate and enhance the motion, fluidity and naturalness of your feather contouring. When laying out your feather landscaping, think in terms of big sweeping curves and shapes to heighten interest in the breast, belly and lower tail coverts. Think in terms of high points and low points. One thing that you will want to avoid is the fish scale or brickwall type of contouring. Anything regular or fixed becomes rigid and monotonous. Feathers do tend to flow in rows, but not to the point of predictability. Vary the direction of the flow to create motion and fluidity. Also remember that each side of the bird should "read" differently—that is, do not have the high and low points the same on both sides.

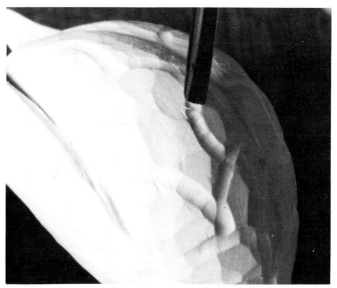

Figure 43. These feather contours can be executed in many ways. Draw in large sweeping feather groups on the breast, belly and lower tail coverts. Keep drawing and erasing until you have a "look" that you deem as natural and fluid. Using a knife, ruby carver, gouge or tootsie roll to lower the areas that you have selected to be low points, proceed to channel along the flow lines. There should be a variety of high and low points of differing depths and heights, keeping in mind that each feather group comes out from underneath the preceeding one, progressing from the head back to the under tail coverts. Using a strong, one-directional light source helps create shadows and highlights when working on the feather landscaping as well as when stoning.

Figure 44. Round the high points of the feather groups and flow down to the bottom of the channels. For further shaping and smoothing, a bullet-shaped stone or small, worn tootsie roll in a flexible shaft machine is useful. Remember when smoothing contours to run the stone or tootsie roll with the grain.

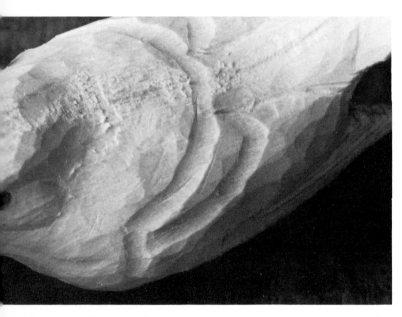

Figure 45. Draw in the mantle line, scapular line and the line where the breast feathers flow over the front portion of the wings. Using a gouge or ruby carver on a flexible shaft machine, make channels on all of these lines on both wings.

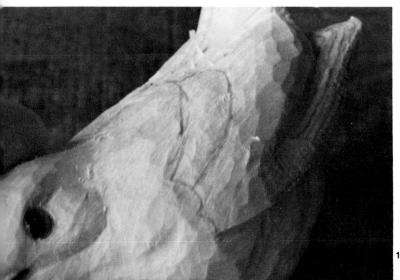

Figure 46. Gently round over the scapulars using a knife or ruby carver. Gently flow the mantle toward the scapulars and the wings so that you are creating the effect of the mantle laying on top of the wings. Flow the wings out from underneath the little patch of breast feathers that are covering the front part of the wings. Round over the patch of breast feathers on both sides.

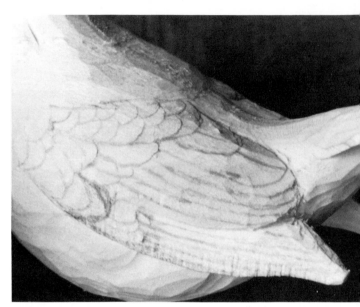

Figure 47. Layout the feathers on both wings. Draw or trace from the profile pattern and pinprick the lesser, middle and greater secondary coverts, the alula, the primary coverts and the edges of the secondaries and primaries. From the top plan view pattern, draw or trace and pinprick the tertials and the tips of the primaries.

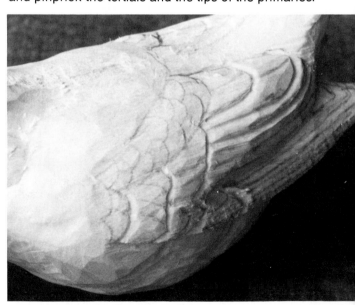

Figure 48. Using a v-tool or narrow ruby carver on a flexible shaft machine, make a shallow channel around the lesser, middle and greater secondary coverts, alula, primary coverts and the three exposed tertials. With a folded piece of abrasive cloth, sand the sharp edge created by the channel. This rounding over of the edges creates fullness and roundness to each of the groups as well as the individual tertials.

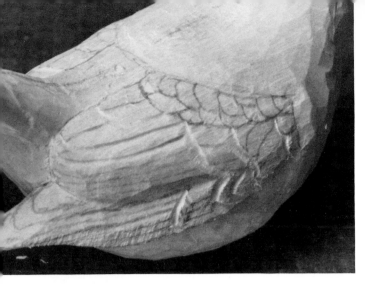

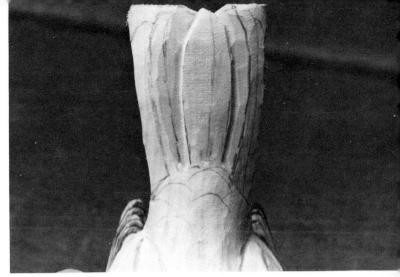

Figure 49. Draw in the individual scapular feathers on both sides within the scapular group.

Figure 52. Draw or trace and pinprick the feather edges on the upper surface of the tail. With a v-tool or narrow ruby carver on the flexible shaft machine, make a channel around the centermost, fully exposed tail feather. Flow the channel out on both sides toward the edges of the tail. Proceed to cut around the remainder of the tail feather edges.

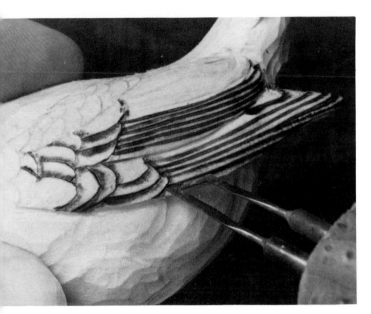

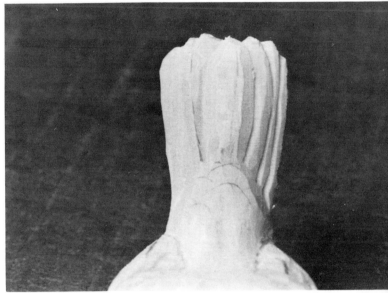

Figure 50. With the burning pen laying down on its side, create a bevel on the lines of the individual feathers on both wings, except the stack of secondaries. You will need to hold the burning pen at a 90° angle to burn in each of the secondary edges.

Figure 51. On the ends of the primaries, use the burning pen to mark the edges as they go around the edge to the underside. Draw the edges of the primaries underneath. Burn in those edges by laying the burning pen on its side.

Figure 53. Round over the sharp edges on the tail feathers. This creates roundness and fullness of the feathers. Work carefully as the tail is crossgrained.

Figure 54. The end of the tail should be .1 of an inch thick. If it is thicker than this, remove the excess wood from underneath.

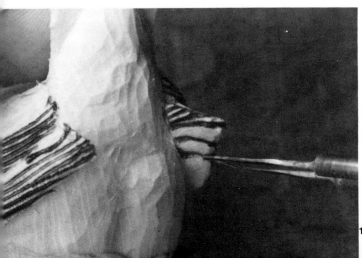

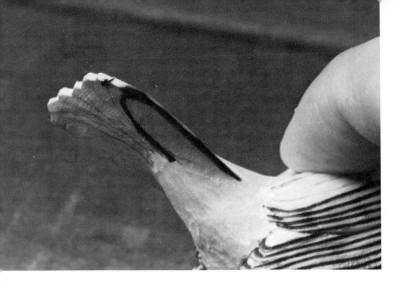

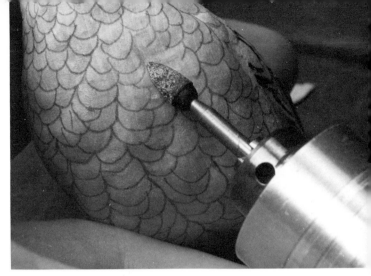

Figure 55. Draw or trace and pinprick the underneath surface of the tail feathers. On this little bird, trace down the side edge of the tail on both sides with the burning pen to create the effect of a stack of feathers.

Figure 58. Remove the eyes temporarily for the sanding and stoning procedures. Sand the body of the bird using a worn tootsie roll (120 grit) or a bullet-shaped stone in a flexible shaft machine. Remember when smoothing the contours to run the stone or tootsie roll with the grain. When a bird has been bandsawed with the grain running the length of the body, there is a grain change that occurs at the upper belly or lower breast where the flat grain becomes end grain. Whether you are sanding or stoning, some fuzzing will occur in this tricky area. Turn the bird around so that you are sanding or stoning in the opposite direction (downhill). Less fuzzing will occur if you work downhill. A strong, one-directional light source will help to highlight areas that might need further sanding.

On the wing and tail feathers, use a folded piece of abrasive cloth to help smooth the edges down and to remove any rough spots. A defuzzer pad on the flexible shaft machine will be helpful in eliminating any fuzz left from sanding. A defuzzer should be run with the grain also.

Figure 56. Here you see the effect of burning a line along the edge of the tail.

Layout the feather patterns on the breast, belly and lower tail coverts. Remember to vary the sizes and shapes of the feathers, since monotony and rigidity will be the result of all the feathers being the same size and shape.

Sometimes after you layout the feather groups and their flows, you become aware that you need a change here or there. Take the time to make the changes, since you will be happier with the bird in the end, and it will likely be a better piece. Using a small, pointed-end stone on the flexible shaft machine, you can alter the contours by going a little deeper in some spots or carve around a few individual feathers within a feather group.

Figure 57. Proceed to burn around the remaining edges of the feathers on the underside of the tail. Lay the burning pen down so that you burn a bevel along the feather edge line.

Figure 59. Here you can see some altering of the contours. The stone is being run downhill (that is, with the grain) so that it does not create any fuzz on the surface. Redraw any area that you may have obliterated.

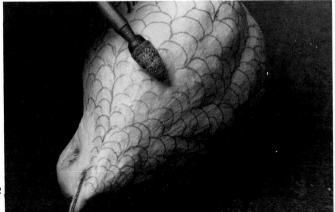

Figure 60. Begin stoning the underparts of the bird, starting at the lower tail coverts at the base of the tail. Work your way up the bird's belly, stoning each overlapping feather as you go. Working up the body enables you to overlap the feathers just as they are on a live bird.

Be aware of the grain change that occurs at the upper part of the belly/lower part of the breast. At this point it becomes necessary to turn the bird around so that you are stoning in the opposite direction. This may seem awkward at first, but with a little practice it will seem easier.

Figure 63. Here you can see the vent area and lower tail coverts fully textured. You can see that each feather progressing up the bird's body appears to be overlapping the one underneath.

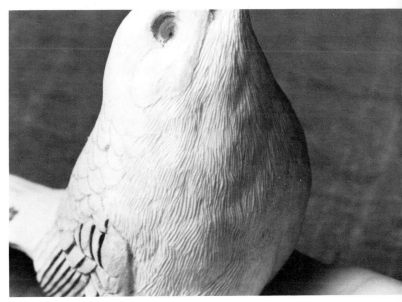

Figure 61. Work your way along the breast with the stoning.

Figure 62. Notice how the combination of the feather contouring and stoning give a fluffy, downy look to the breast area.

Figure 64. As you work your way up the breast and into the neck area, you will notice that the size of the feathers becomes smaller. With the smaller feathers, it is a little difficult to get much curvature to each stoning stroke. You can still create interest in the areas of small feathers by varying the flow of the feathers. On the chin of the bird, the feathers have a hair-like quality.

Figure 65. Draw in the quills on the major feathers of the wings. With the burning tool, burn the quills, keeping two burn lines very close together and even running them together the last quarter of an inch at the very tip of the

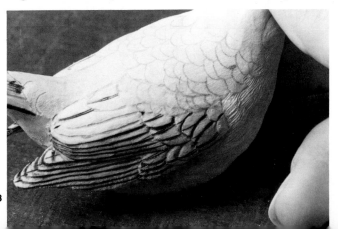

feather. Quills can be burned by starting either at the base of the feather and burning toward the tip or by starting at the tip. Try both ways to see which seems most comfortable for you.

Where you have a small feather or just the tip of a feather as in the primaries of this small bird, a single burn line for the quill is sufficient.

Also burn in the secondary edges holding the burning pen at a 90° angle to the surface.

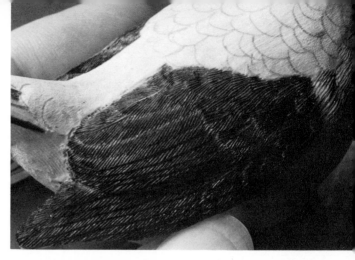

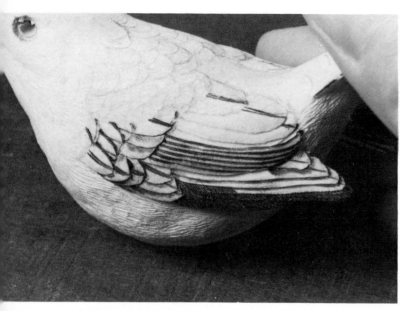

Figure 66. Begin burning the barb lines on the lowest exposed primary. This is such a small bird that the burning should be as fine and close as possible. The smaller the bird, the finer the burning and stoning strokes should be.

Working your way upward and forward on the wing, burn the lowest feather first and then the next one on top. You want to curve the burning stroke as you draw it away from the feather above it, and draw the burning pen down the trailing edge a little, toward the tip of the feather. Study any feather that you might find outside. Pay particular attention to the angle at which the barbs come away from the quill and how the barbs curve toward the tip of the feather along the edges.

Figure 67. Here you can see that the burning has progressed up the wing and forward toward the front of the wing. The secondary edges should be burned with short, curvy strokes that bend towards the tip of the feather.

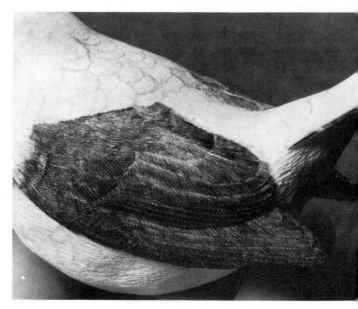

Figure 68. Here you can see the effect of burning in the edges of the secondaries and the short burn strokes. The secondaries appear as a stack of feathers. Notice how the burning was carried into the stoning of the little patch of breast feathers covering the front of the wing.

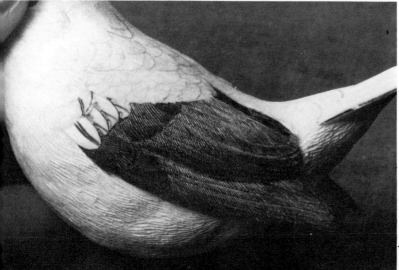

Figure 69. Go back over a few of the barb lines randomly with the burning pen to make them a little deeper and wider to create splits in some of the feathers. Do not overdo feather splits, as this can lead to a ragged appearance. Some of the smaller splits can be painted in.

Figure 70. Draw in the quills on the upper surface of the tail. Just as you did on the major feathers of the wing, burn two lines very close together on the drawn quill line to raise the quill. The two lines should flow together a

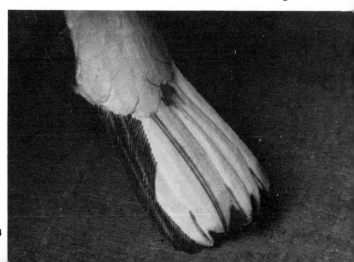

quarter of an inch from the end of the feather. On the tail feathers with just the tips showing, a single burn line will be sufficient to indicate the quill.

Begin burning the barbs, starting at the outermost tail feather and work your way toward the center. Burning the feathers below first produces a smooth.

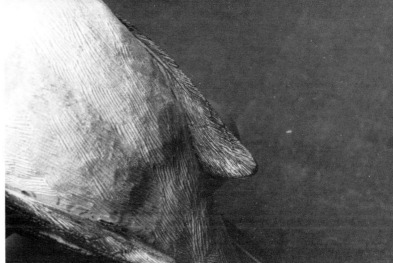

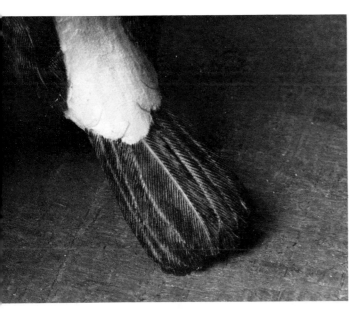

Figure 71. Here you can see the tail completely burned. Keep the burning as fine and close as possible since this is such a small bird.

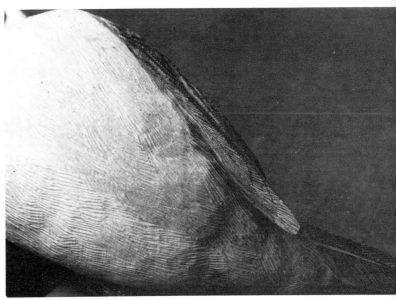

Figure 74. The area along the sides of the bird that could not be stoned because the stone was too large to get up very close can now be burned with the burning pen. Carry the burning into the stoning a little so that there is a blending of the stoning and the burning.

Also burn the edges of the lower tail coverts that the stoning could not reach.

Figure 75. Using a natural bristle toothbrush, clean the burned areas on the wings and tail to see if you need to alter any of the splits or barb lines.

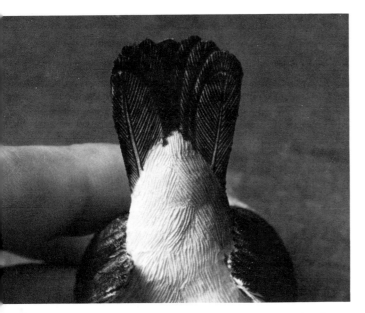

Figure 72. Draw and burn in the quills on the feathers on the under surface of the tail. Beginning in the center of the underneath tail, start burning in the barb lines and work your way laterally towards the outermost feathers on both sides.

Figure 73. Lay the burning pen on its side and burn a bevel on the drawn in feathers of the underside of the exposed primaries. Draw and burn in the quills with two lines burned very close together. Burn in the barb lines of these feathers (on the underside of both wings).

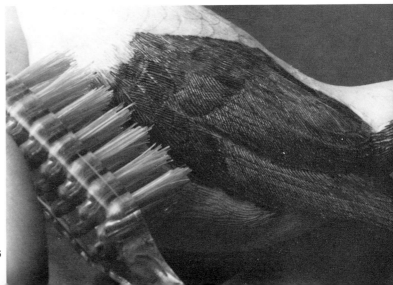

Figure 76. Notice on the top plan view of the wren study skin the variations of the flow of the feathers. Also you can see the broad surfaces of the tertials and primaries, not just the edges.

Figure 78. Proceed to burn in the barbs on the mantle, upper back, neck and back of the head. Notice what a smooth effect you can get from burning over-lapping feathers.

Figure 77. Draw out the feather patterns on the upper tail coverts, back, mantle, neck and head. Remember to vary the amount of exposed feather—the feathers should not all be the same size or shape, which would create rigidity and monotony. You want to keep the patterns free-flowing and natural looking. Use your artistic license and imagination to enhance these areas. Although feathers tend to follow each other in rows, you do not want corn rows on the back of the bird. Rather, you want varied rows, patterns and flow directions.

Begin burning the barbs in the feathers on the top side of the bird at the upper tail coverts at the base of the tail. Proceed to burn the feathers up the back.

Figure 79. At the shoulder and neck areas where you have burning meeting stoning, carry the burning into the stoned areas a little so you do not have a sharp line between them.

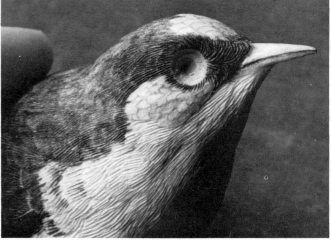

Figure 80. The area between the eye and the side of the base of the beak is textured by burning the edges of the hair-like feathers that appear at the corner of the eye and flow toward the beak. Curve them up toward the forehead and crown, and down toward the area below the eye and the ear coverts.

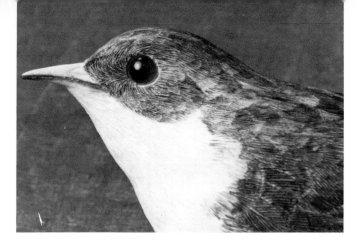

Figure 81. Finish burning the barbs of the feathers of the ear coverts, crown and forehead. These areas contain very small feathers—it is difficult to get much curvature in the burning strokes on these tiny feathers. To create interest and fluidity in these areas, vary the flow of the feathers.

After the area around the eye is textured, replace the eyes—you may have to add a small amount of clay to the holes. Recheck the overall look of the head now that it is fully textured.

Figure 82. Here you see the crown completely textured. Notice how you can see the edges of the individual feathers at this close distance, but that with fine burning, you will not be able to see distinct feathers from farther away.

Clean all of the burned areas with a natural bristle toothbrush.

Figure 83. Carefully clean any excess clay from around the eyes with a sharp-pointed clay tool or a dissecting

needle. Any excess clay around the perimeter of the eye will keep the putty from adhering to that area.

Using the natural bristle toothbrush, clean the area around the eye so that there are no remaining remnants of clay.

In setting the eyes in birds, remember that the eyes are an integral part of the head with only a fraction of the eye actually exposed. It is always amazing to see how large the eyes actually are when seeing a study skin being prepared. Even in a small bird, the eye is approximately the same size as a medium-sized blueberry. The eyes in the carving should not be so bulbous that the bird looks popeyed, and yet not so deep that you have to look down into the head to see them.

Check the positioning of the eyes in your carving. Look at them from every angle to make sure that they are not too deep or too shallow and that they are balanced.

The life of the bird is captured in the head, but more particularly in the eyes. Taking the time and effort to execute a lifelike look about the eyes and head is worthwhile. When viewing a carving, one's own eye will travel to the head first and more specifically to the eyes.

When you are satisfied that the eyes in your carving are balanced and the correct depth, mix up a small amount of the Duro epoxy ribbon putty. Cut out the ends where the two colors meet and discard. Mix with your fingers the blue and yellow putty until you get an even green. Roll a small piece of the putty between your fingers of one hand and the palm of the other to make a small "snake". Using a clay tool, dental tool or dissecting needle, push the roll of putty into the crevice around the eye.

Figure 84. When working with the putty, push whatever tool you are using into oily clay which will keep the putty from sticking to the tool. Remember that the eye ring around the eye is oval, not perfectly round. Pushing the putty around with the tool, form the eye ring. Remove any excess putty as you are working. As you gradually pull the putty into the surrounding burned grooves, the eye ring may become too prominent. It should be just slightly elevated above the surrounding area.

If you find that you have too much putty to blend outside on the burned area (more than .1 of an inch), remove it. You want as little putty outside the eye as possible. If an edge of the drilled eye hole begins to show through, cover it up, as it will show even when the bird is painted. If the putty eye ring starts hugging the eye itself too tightly, pull it away with your tool.

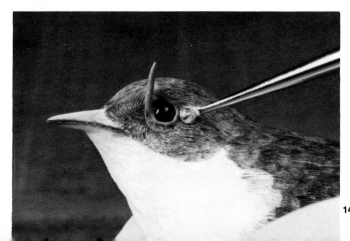

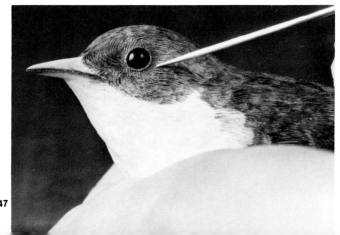

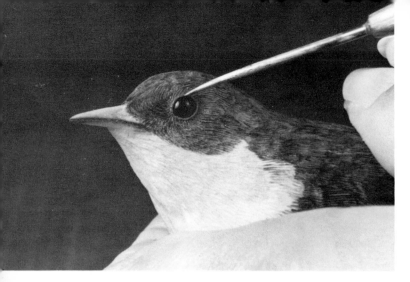

Figure 85. The eye ring itself is not smooth, but has a little bumpy texture similar to wrinkled skin.

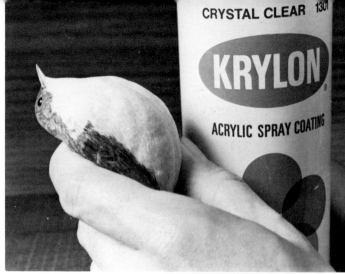

Figure 88. After the putty around the eyes has hardened, spray the stoned areas (lower tail coverts, belly, breast, underneath neck and chin) with a **light coat** of Krylon (Crystal Clear 1301). Let this dry for a few minutes.

Figure 86. Proceed applying the putty to the other eye when you are satisfied with the first one. Be careful, when working on the second eye, not to obliterate the putty around the first eye.

Figure 87. Again check the eyes for balance from several different views. If something is amiss with the eyes, it is easier to reset one or both at this point than to have to dig them out and start again at a later stage.

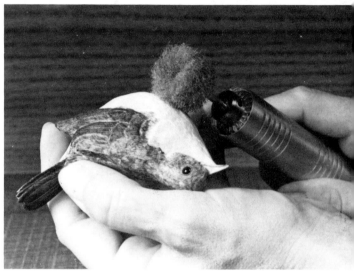

Figure 89. Using a defuzzer pad on the flexible shaft machine, clean up the stoned areas, lightly running the abrasive pad **with the grain.** This should rid the stoned areas of any remaining fuzz. The Krylon seems to harden the fuzz so that the defuzzer can whisk them off.

Figure 90. After selecting the piece of driftwood to mount the carving, it is best to attach it to a "working" base so that any further procedures that you do for the feet do not ruin any ground or the permanent base that you might prepare. You will want the driftwood to attach to the working base in the same position and angle that it will be attached to a permanent base or ground.

The piece of driftwood selected for the house wren needed bandsawing so that it would sit in the ground at a particular angle. To alter a piece of driftwood to fit a base at a particular angle, you can use a knife, bandsaw, flexible shaft machine and carbide bit or a disc or belt sander.

Drill two 1/16 inch diameter holes in the driftwood. Insert two short pieces of 1/16 inch diameter wire. Using two pieces of wire rather than one, will keep the driftwood from turning or twisting on the base or in the prepared ground. Press the two pieces of wire that are in the base of the driftwood into the soft wood of the working base.

Drill 1/16 inch diameter holes at these marks. Check to see if the wires of the driftwood fit properly into the drilled holes—if not, then redrill the holes in the working base until you get a proper fit.

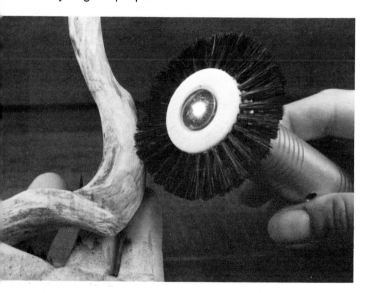

Figure 91. Using the laboratory bristle brush on the flexible shaft machine, clean up the driftwood. You will notice that the brushing not only cleans it up, but also burnishes it to a nice patina. If you desire even more sheen, you can wax it with a good furniture paste wax and buff it with a cloth or brush. If you want to change its color, you can paint it with acrylic washes or apply some desired color of shoe polish and then buff it.

Using a small amount of super-glue or glue from a hot-melt glue gun, attach the driftwood to the working base.

Often the piece of driftwood will have to be altered with the bandsaw or flexible shaft machine. If there is a branch that juts out at an inappropriate place, saw it off and rough up the stump using a propane torch and wire brush on the flexible shaft machine.

You can get creative and imaginative with driftwood by fashioning interesting additions to it, such as a fascinating knot, knot hole or entire added branch. It is easier to make a knothole if you have one in another piece of driftwood that you can use as a model. Using a carbide bit, make the hole in the piece of driftwood to be used for the carving. The area around the hole can be textured using ruby carvers, grinding stones or cutters on the flexible shaft machine—the burning pen can also add interesting

textures. After you are satisfied with the hole's contours, paint the area to blend in with the surrounding wood with acrylic washes.

To make an added branch, use a wire armature to which you can add plastic wood, autobody (the kind used to fill dents in cars) or ribbon epoxy putty if it is a small addition. After contouring, paint the branch to match the existing driftwood using acrylic washes.

There are many ways you can alter existing driftwood-painting, contouring, sandblasting, wire brushing, etc. There are no limits—let your imagination fly. You can even create your own driftwood by carving it yourself. It is perhaps easier if you have other pieces of driftwood from which to model it, but it is not mandatory.

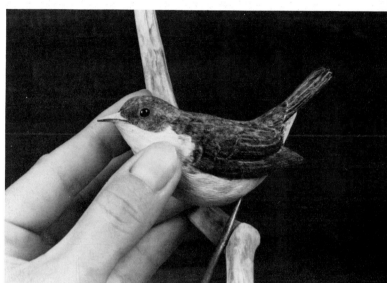

Figure 92. Holding the house wren in the desired position above the piece of driftwood, mark the spot on the belly that you want the tarsus to exit the feathers—do both tarsi this way. Studying live birds outside at your feeder or in the park will enable you to learn in what positions the feet come out of the body contour feathers at different points. Understanding the anatomy and functioning of the tarsi is crucial in positioning the bird. Nothing will replace first-hand knowledge from time spent observing and studying bird activities and behavior.

Figure 93. Drill a 1/16 inch diameter hole into the body of the bird at each mark—the holes should be approximately one half inch deep into the body.

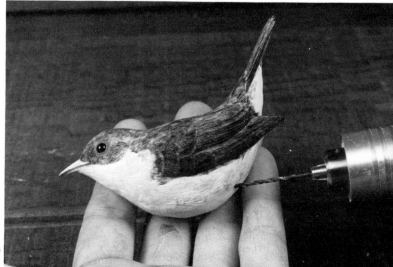

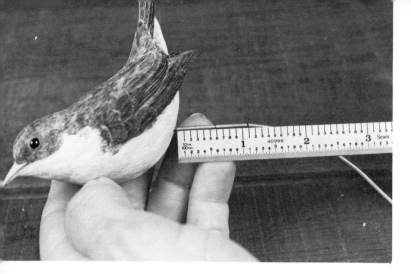

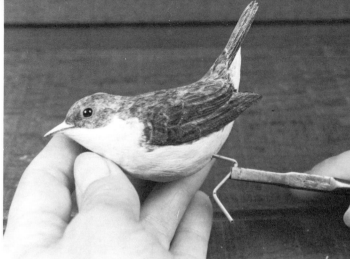

Figure 94. Insert a long piece of 1/16 inch diameter wire into the hole. Holding a rule along side the wire, mark the tarsus length (.6 of an inch for a house wren) from the ankle joint. At the bottom joint of the tarsus where the toes attach, allow about one half inch extra to go into the piece of driftwood. You can use a permanent ink marker or a file to mark these places.

Figure 97. Insert the wire tarsus into the hole in the body. Proceed to do the other tarsus.

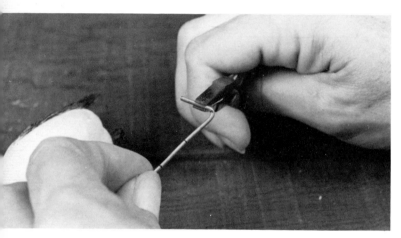

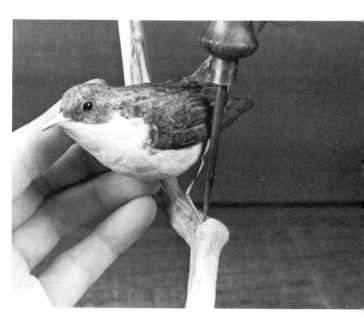

Figure 95. Using needle-nose pliers, make the appropriate angle bend in the wire to go up into the body.

Figure 96. Holding the tarsus with the needle-nose pliers to keep the tarsus perfectly straight, make the bend at the toe joint (the point at which the wire goes through the cast toes and into the driftwood).

Figure 98. Hold the bird above the driftwood in the position that you desire it in. Using a pencil or awl, mark the points of insertion into the driftwood. Drill two 5/64 of an inch diameter holes (using a drill bit one size larger than the diameter of the wire allows easier insertion and removal from the driftwood) into the driftwood at the same angle as the bend of the feet wires.

Figure 99. Place the bird's feet wires into the holes. Check the bird for balance. With the little house wren, the "look" that was desired was one of an anticipatory leap into the air, as if he had just landed on this particular branch for a second and then was going to be off somewhere quickly.

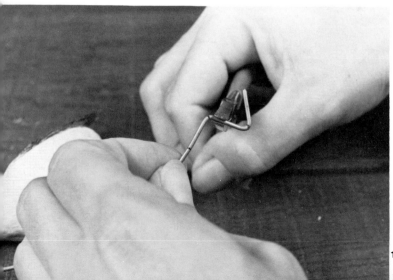

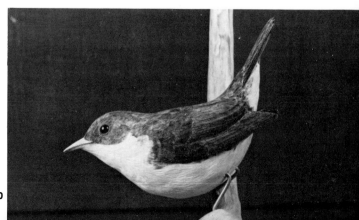

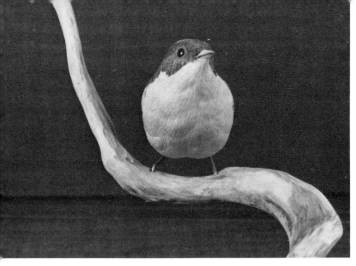

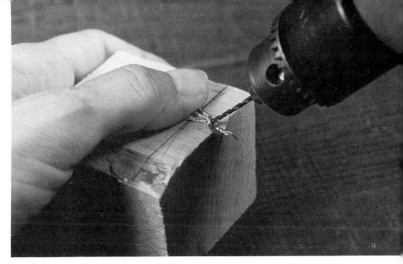

Figure 100. Check the bird's balance from all viewpoints. Now is the time to change the position, if necessary. You may have to redo one or more of the bends in the wires. Keep working with it until you have a well balanced bird.

Figure 103. Using a variable speed electric drill, drill a 1/16 inch diameter hole through each set of cast toes. You must drill **very slowly** so that the casting material does not grab the drill bit. If you do not drill slowly, all of a sudden you will find the toes whirring around on the end of the drill bit.

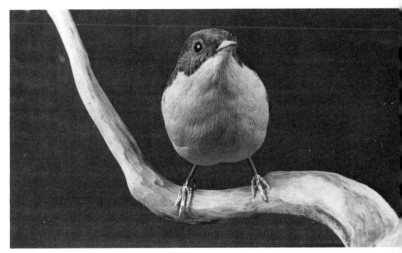

Figure 101. Often in the casting process, there will be extra bits of casting material along the sides of the toes and on the claws. Using a sharp knife, these nubs and extra bits should be removed from the purchased house wren set of toes.

Figure 102. Cut a small v-notch in a scrap block of wood. Holding the cast toes in this notch, make a small hole with an awl in the center of the joint—this hole will keep the drill bit from drifting.

Figure 104. Place the proper set of cast toes on the respective tarsus—the hind toe goes to the inside of the tarus. On the right tarsus, the hind toe should be on the left inside of the tarsus—just as on your own outstretched right hand, the thumb comes off the left side of your hand. On the left tarsus, the hind toe should be on the right side of the tarsus.

Figure 105. With the toes on the proper tarsus, place the bird back on its perch. Making sure each set of toes is

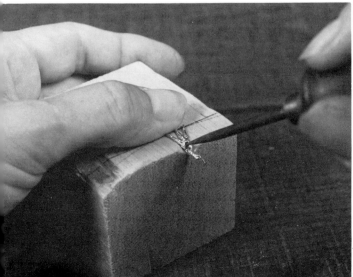

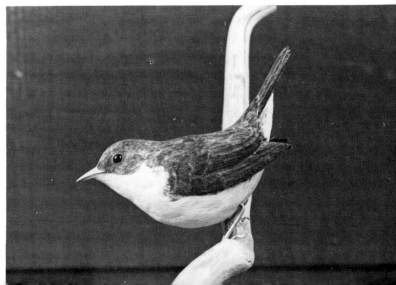

placed properly with the middle toes in line with the respective tarsi, super-glue each set of toes to its tarsus. Just a small amount of super-glue is necessary—you do not want so much glue that it flows down into the driftwood hole, making it difficult to remove the bird from its perch. After this first little bit of glue has hardened and the toes are firmly anchored to the tarsi, remove the bird from its perch; you can use more super-glue on these joints, while allowing it to harden with the bird off its perch.

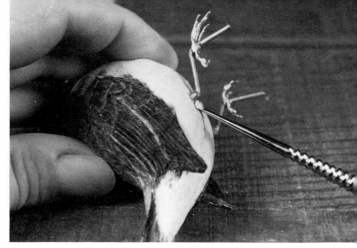

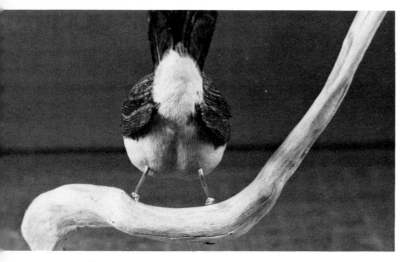

Figure 106. Here you can see the bird's position from the tail-on view.

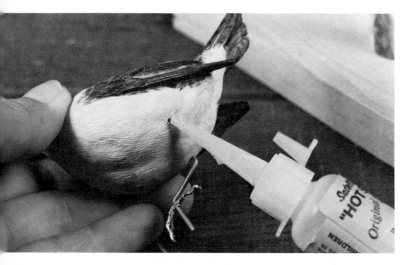

Figure 107. After the glue on the toe joints has hardened, place super-glue in the holes in the bird's body. Working quickly but carefully, place the tarsi in their respective holes in the driftwood, so that the wires will be in the proper position as the glue dries. Do not glue the tarsi into the driftwood until after the bird has been painted.

Figure 110. At the tarsus and toe joints on both feet, you will need a small amount of the ribbon putty to accomplish a smooth transition. Place a small amount of putty around the entire joint of both sets of toes. Using a dull knife blade or dental tool, press in the details of the semi-circular scales where the toes will bend on the foot of a live bird. Allow the putty to harden before proceeding.

Figure 108. After the glue has hardened at the tarsal/body joints, mix up a small amount of the Duro epoxy ribbon putty. After cutting out the section where the two colors meet, mix it between your fingers until you have an overall green color. Place a small amount at the point where the tarsus comes out of the body contour feathers on the belly. There is a small tuft of feathers at the ankle joints of this and most other songbirds. These are called leg tufts.

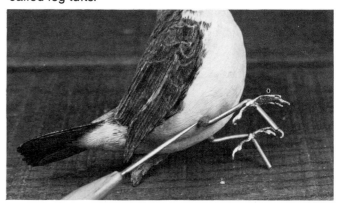

Figure 109. Work the putty around the entire joint of both tarsi. If the tarsus position is right up next to the belly, you may need to roll a dissecting needle or clay tool in there to get the putty right up on the tarsus and a smooth, flowing transition area to the belly. Remember to dip whatever tool you are using in the clay from time to time so that the putty does not stick to it. You will not need a great big glob of putty for the leg tufts—it is amazing what a small amount you will need.

After the putty is placed around the circumference of the insertion point, begin texturing the leg tufts. You will want to accomplish a short, bristly feather effect, using an **unheated** burning pen, dental tool or the pointed end of a clay tool. Try several of these to see which you can use the easiest for the best feathery effect. Pull the putty into the grooves of the stoning surrounding the insertion point—you want a smooth transition area between the belly and the leg tuft.

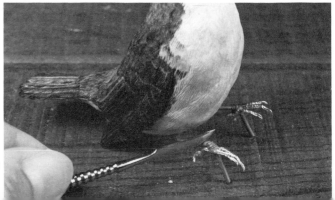

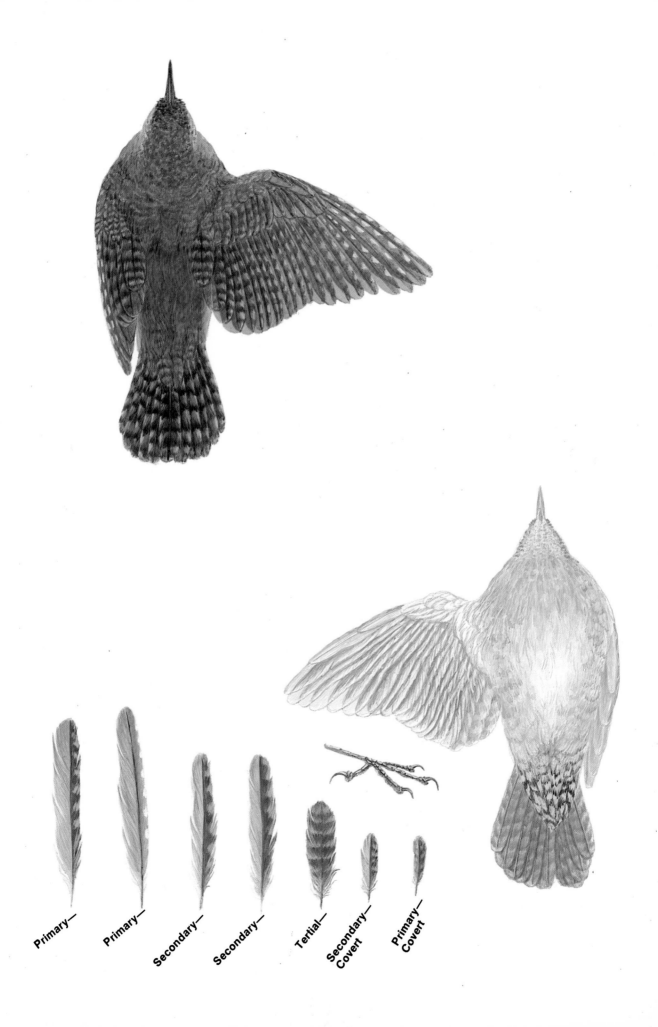

Primary— Primary— Secondary— Secondary— Tertial— Secondary Covert— Primary Covert—

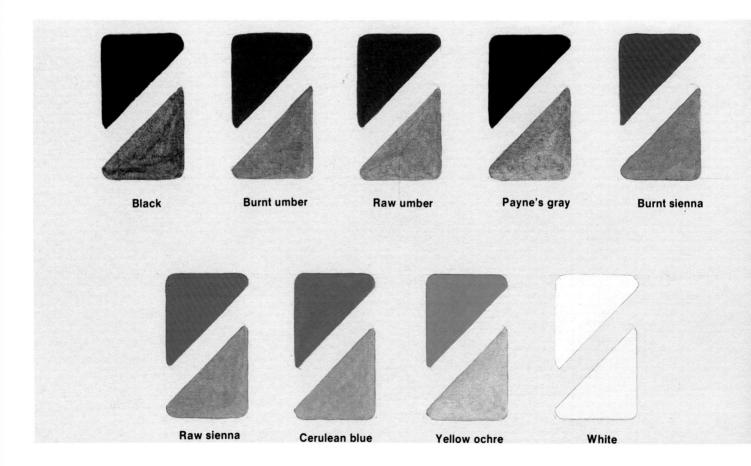

Black Burnt umber Raw umber Payne's gray Burnt sienna

Raw sienna Cerulean blue Yellow ochre White

HOUSE WREN

Head, beak, neck, mantle,
wings, upper tail

Burnt umber
Payne's gray
White

Upper tail coverts and lower
back—washes of:

Burnt umber
White
Burnt sienna
Yellow ochre

Dark bars (keep paint thin)
Burnt umber
Payne's gray

Over the barred areas on the
underneath part of the bird
alternate the following washes.

Burnt umber
White

White
Cerulean blue
Raw umber

Lay out dark bars on wing:

Burnt umber
Payne's gray
White

Wash over with
Raw umber White
Yellow ochre

Dark stripes on upper tail

Burnt umber
Payne's gray

Add the light bars

White
Raw sienna

Dark bars on head, neck,
mantle, scapulars, upper back

Burnt umber
Payne's gray
White

Wash over dark bars—above
Raw umber
Raw sienna

Dark bars under tail.
Burnt umber
Payne's Gray
White

Wash under tail area with
Burnt umber
Payne's gray
White

Beak—upper mandible
Burnt umber
Payne's gray
White

Lower mandible
White Yellow ochre
Raw umber

Area between dark bars on tail

Burnt sienna
Burnt umber
White

Wash entire upper tail (keep
watery) Raw umber
Yellow ochre

Base coats—ear coverts, under
neck, breast, belly, sides, and
lower tail coverts

White
Cerulean blue
Raw umber

Dark bars, sides, lower tail
coverts Burnt umber
White

Sides of head

Burnt umber
White

Black
White

White
Raw umber

Feet

White
Raw umber
Raw sienna

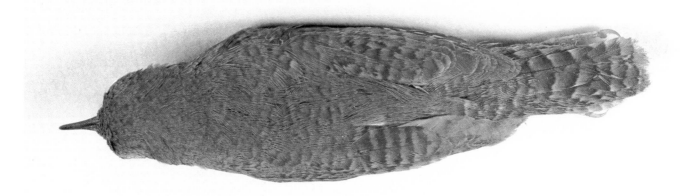

Figure 1. Here you see the house wren study skin. Notice the variations of the lights and darks on the wings and tail.

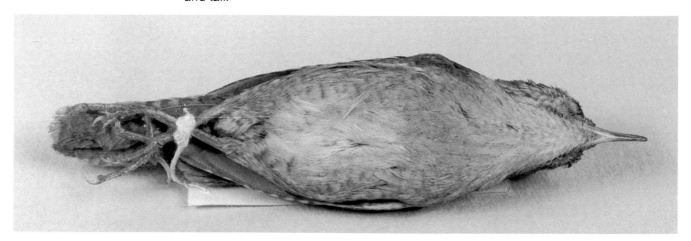

Figure 2. On the breast and belly you see the subtle hint of vermiculations.

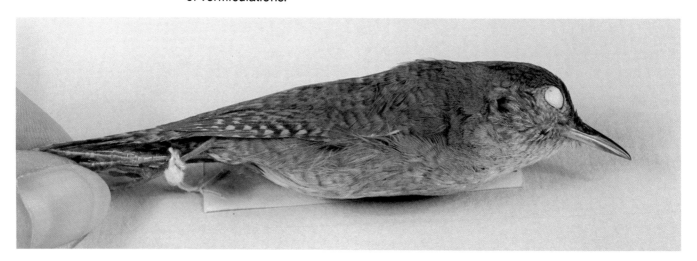

Figure 3. Notice that you only see the edges of the primaries and secondaries from the profile view.

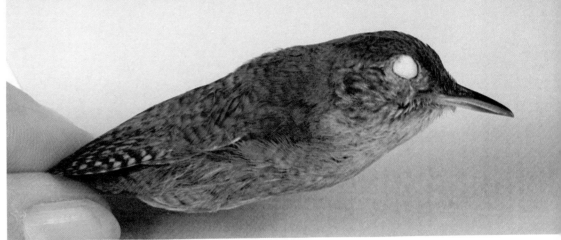

Figure 4. Notice the details of the head and beak.

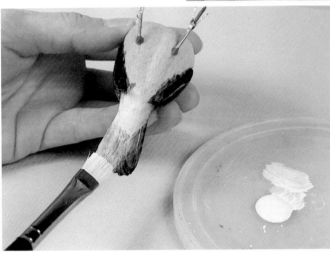

Figure 5. Applying gesso to the bird provides an even colored painting surface over the burned and stoned areas. Since gesso is a type of primer, it also ensures good adhesion for the application of subsequent layers of acrylic paint.

Using a stiff bristle brush such as a Grumbacher Gainsborough #5 (or equivalent), begin applying the gesso, working small areas at a time. Scrub the gesso down into the texture lines with a back and forth motion, rather than merely painting it on. Use a dry brush technique, leaving most of the gesso on your paper towel. Be careful not to leave any excess, especially on the edges of the tail and wings. Too much gesso will actually obscure the texture lines. Keep your brush damp, but do not use too much water, as it lessens the adhesive quality of the gesso. Dry brush the entire bird with the gesso, including the areas around the eyes and the feet. Usually two coats of gesso are sufficient. Use the medium heat setting of a hair dryer to dry the bird between applications.

Figure 6. After the gesso is dry, CAREFULLY scrape the eyes, using the point of a sharp knife held at an angle. Cleaning the eyes periodically during the painting process enhances the lifelike quality of the carving, allowing a more realistic application of colors.

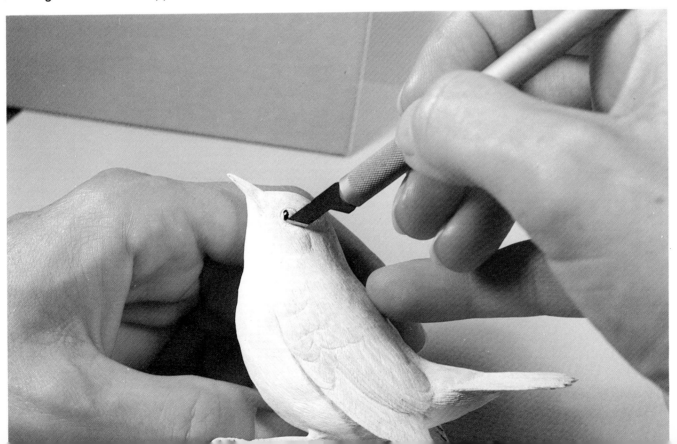

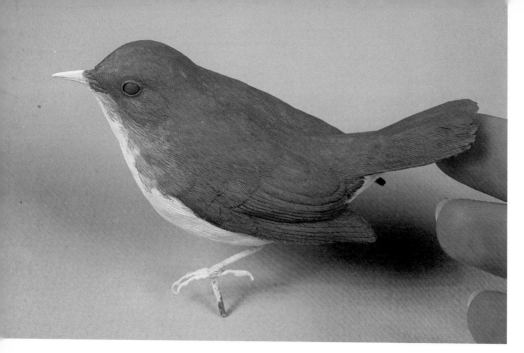

Figure 7 The base coat for the upper tail, back, wings, mantle, neck and head is comprised of burnt umber, payne's gray and white mixed to a medium grayish brown. While the last base coat is still wet, blend a small amount of white into sides of the neck in the shoulder area.

Figure 8. With a heavily patterned bird such as the house wren, it is advantageous to paint the bird in sections, such as the upper tail, back, wings, etc. If you attempt to paint the darks on the entire bird, the project may seem overwhelming.

Using a small liner brush, layout the dark bars on the upper tail with burnt umber and a small amount of payne's gray blended to a deep brown. The edges of the bars are not straight across but are somewhat jagged as in vermiculations.

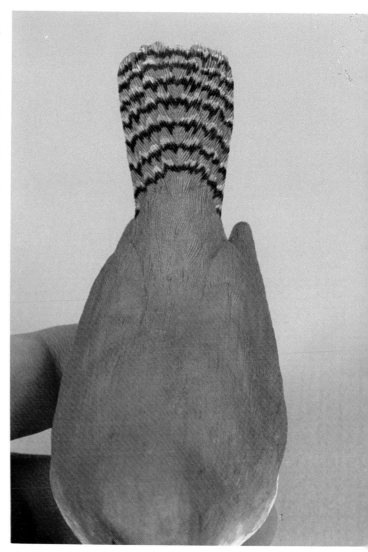

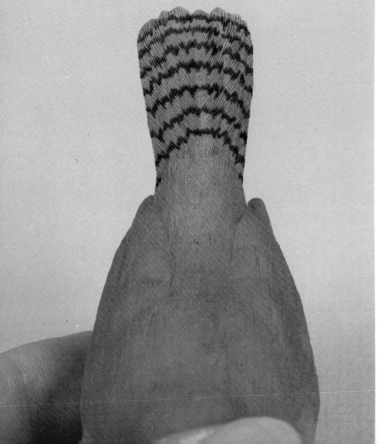

Figure 9. Using white with a small amount of raw sienna blended to a creamy white, paint the light areas on the upper tail.

Figure 11. On the upper tail coverts and lower back, apply several watery washes of burnt umber and small amounts of white, burnt sienna and yellow ochre, bringing the color up slowly. The lightly patterned area of the coverts and lower back is accomplished using the same procedure as with the upper tail, except that the paint is kept very watery so only a hint of the colors appear on the bird.

Figure 10. The areas between the dark bars should be washed with a mixture of burnt sienna, burnt umber and a small amount of white. Using a small liner brush, darken a few areas on the bars using payne's gray. When this is dry, apply a very watery wash of yellow ochre and raw umber.

Figure 12. Layout the dark bars using burnt umber and a small amount of payne's gray blended to a chocolate brown. The light areas (white with a small amount of raw sienna) should be painted next. When these are dry, wash the area with a blend of yellow ochre and raw umber, keeping the wash very watery.

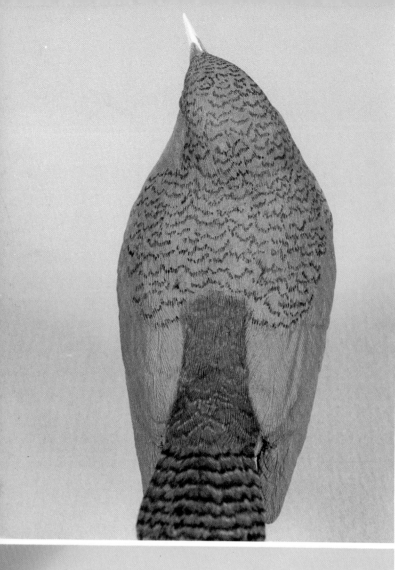

Figure 13. On the mantle, scapulars, upper back, neck and head, paint the dark bars using burnt umber and a small amount of payne's gray and white. Keep your paint very watery so the bars are subtle.

Figure 14. Blending burnt umber and burnt sienna, apply a very watery wash to the entire area.

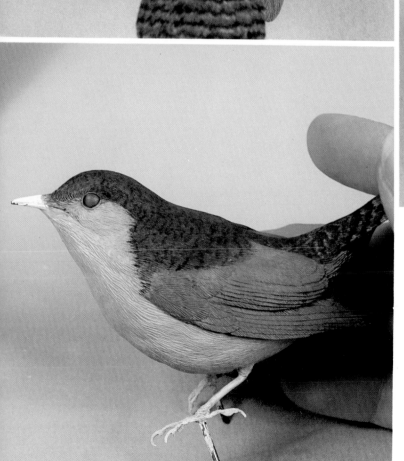

Figure 15. Mixing raw umber and raw sienna, apply another watery wash to the mantle, upper back, neck and head.

Figure 16. Combining white with small amounts of raw umber and cerulean blue to a light gray, paint the base coats on the lower tail coverts, sides, belly, breast, neck and ear coverts. While the base coats are still wet, wet-blend a small amount of white on the lower tail coverts and the middle of the belly.

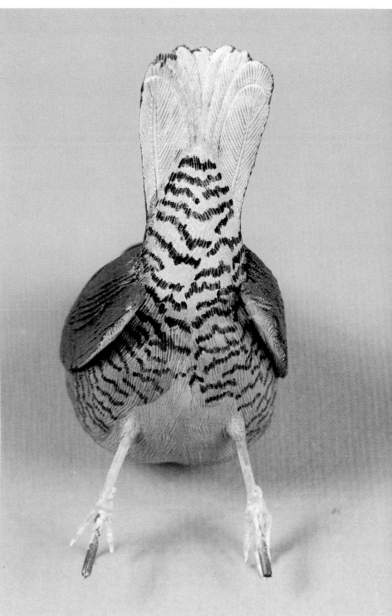

Figure 18. Here you see the dark vermiculated bars on the lower tail coverts.

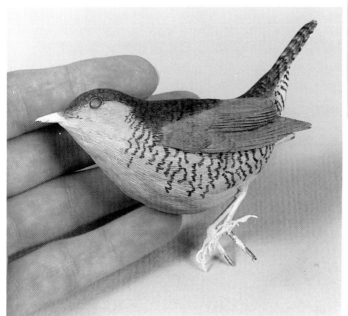

Figure 17. Using burnt umber and a small amount of white, layout the dark vermiculated bars on the sides and lower tail coverts. Keep your paint very thin so only a hint of color is deposited on the bird.

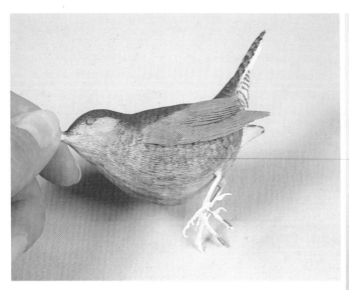

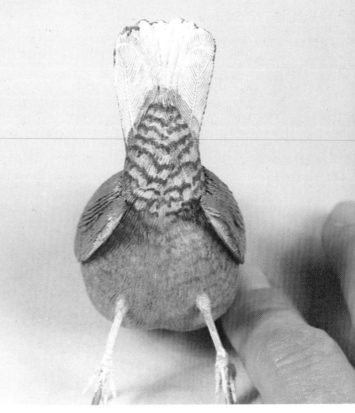

Figure 19. Blending burnt umber and white to a medium brown, apply a **watery** wash over the vermiculated areas. Make a very watery wash of the belly base coat color (white with small amounts of raw umber and cerulean blue) and apply over the vermiculated areas on the underneath side of the bird. Keep alternating the very watery brown and light gray washes until there is only a hint of the darker vermiculated bars on the sides.

Figure 21. Apply a very watery raw umber wash over the lower tail coverts.

Figure 22. On the under surface of the tail, paint in the dark bars using burnt umber and a small amount of white and payne's gray. When the bars are dry, wash over the entire under tail with burnt umber, payne's gray and white to achieve a silvery gray.

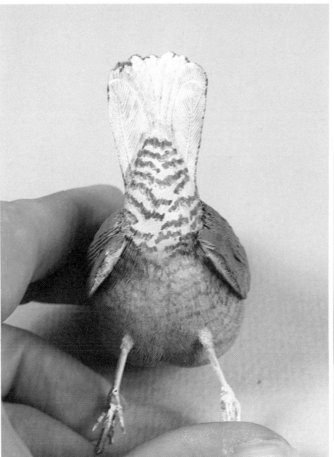

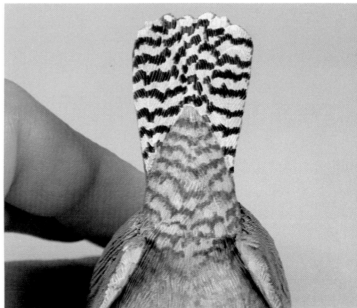

Figure 20. Paint a small vermicualted raw sienna bar next to each dark bar on the lower tail coverts.

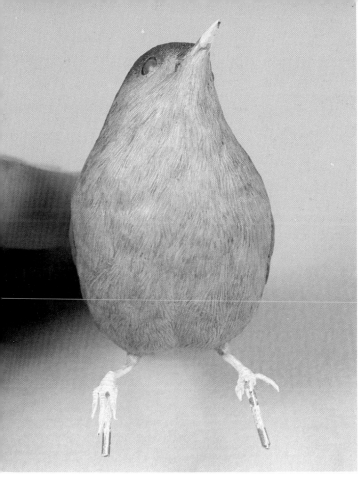

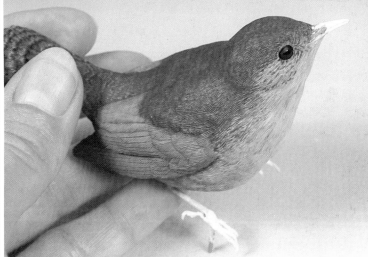

Figure 25. Before painting the head, carefully remove any paint on the eyes.

The lightly speckled area on the sides of the head is created by dry brushing the following colors: burnt umber and white to a medium brown, black with a small amount of white to a dark gray and white with a small amount of raw umber to a creamy white. Work these three colors back and forth until you get a mottled look. If you find the area getting too dark, work more of the light color in. If you find it getting too light, work more of the dark color in. To help blend all the colors, apply a very watery burnt umber wash.

Figure 23. On the breast and under neck, apply a splotchy dry brush effect to the recessed areas of the feather contouring and the bases of some of the feathers, using burnt umber and white blended to a medium brown. Add a little more white to the light gray base coat color, to bring up some highlights in the raised portions of the feather contouring.

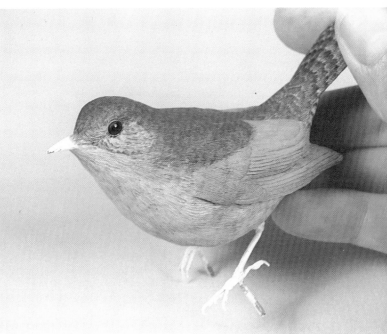

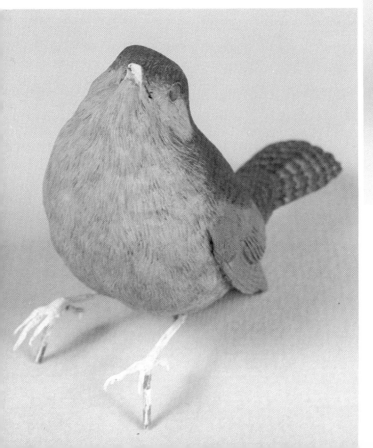

Figure 26. To blend the shoulder area, dry brush the base coat color of the breast (white with small amounts of raw umber and cerulean blue) into the mantle color. Blend the mantle color (burnt umber with small amounts of payne's gray and white) into the side of the breast. Highlight the blended area with dry brushed raw sienna and white.

Figure 24. With a small liner brush, enhance the edges of some of the feathers by lightening them with watery white.

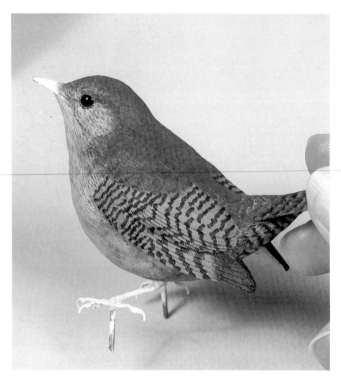

Figure 27. Blending burnt umber with small amounts of payne's gray and white, layout the dark vermiculated bars on both wings and the dark tips of the primaries.

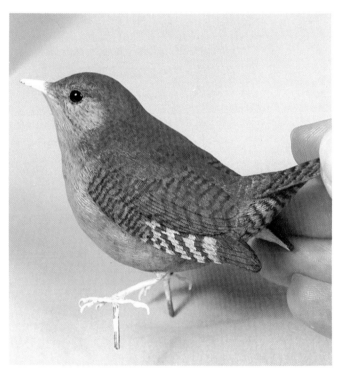

Figure 29. Combining raw umber with small amounts of yellow ochre and white, apply a watery wash to both wings including the primaries. With burnt umber and white, dry brush just a hint of lightness on the trailing edge of the tertials and primaries.

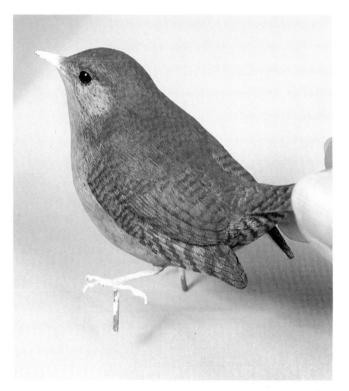

Figure 28. Apply a watery wash of burnt umber over the wings excluding the primaries. Blending white with small amounts of raw umber and cerulean blue, layout the light areas on the primaries between the dark bars.

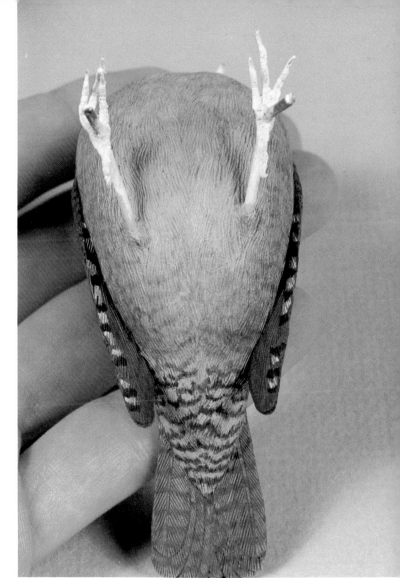

Figure 30. On the underneath side of the primaries, paint the soft gray base coat of burnt umber, payne's gray and white. On the leading edges, paint in the dark bars using burnt umber and payne's gray with just a small amount of white. The light bars can be applied next, using white with small amounts of raw umber and cerulean blue. When these details are dry, apply a white and raw umber wash to subdue and blend all of the colors.

Figure 31. On the upper mandible, apply the base coats of burnt umber and payne's gray with just a small amount of white. Blending with small amounts of raw umber and yellow ochre, paint the base coats on the lower mandible. When both mandibles are dry, wash the upper mandible, the tip of the lower mandible and the commissure lines with burnt umber.

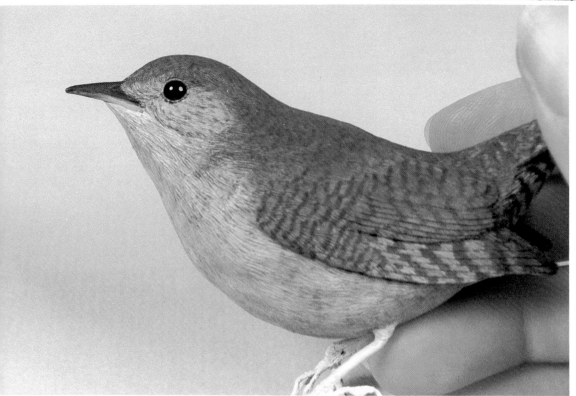

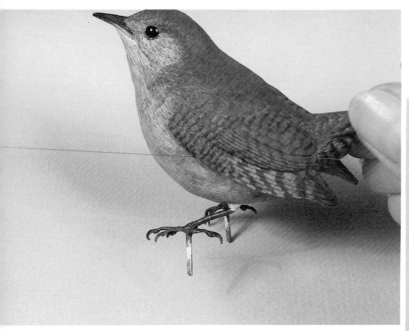

Figure 32. Blending raw umber and raw sienna with a small amount of white, apply the base coats to the feet. With a small liner brush and burnt umber, paint in the semi-circular scales on the tarsi. Brush the entire surface of the feet with a small amount of gloss medium added to a puddle of water. This leaves a slight sheen to the feet. The claws should be painted with straight gloss medium.

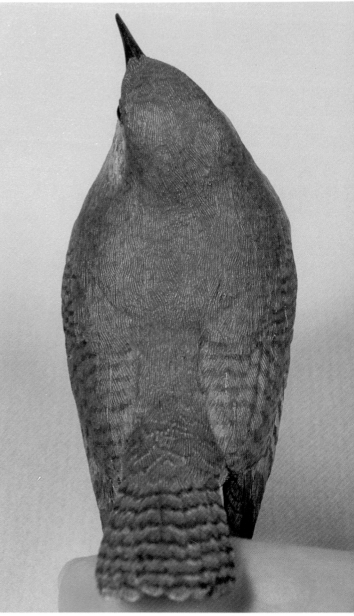

Figure 34. Using a small liner or scroll brush, apply straight gloss medium to the quills of both wings and to the quills of the upper and lower surfaces of the tail feathers.

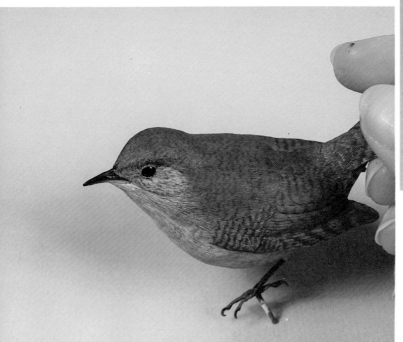

Figure 33. Apply a half and half mixture of matte and gloss mediums to the beak, effecting a satin gloss. Both gloss and matte mediums appear milky-looking when wet, but both dry clear.

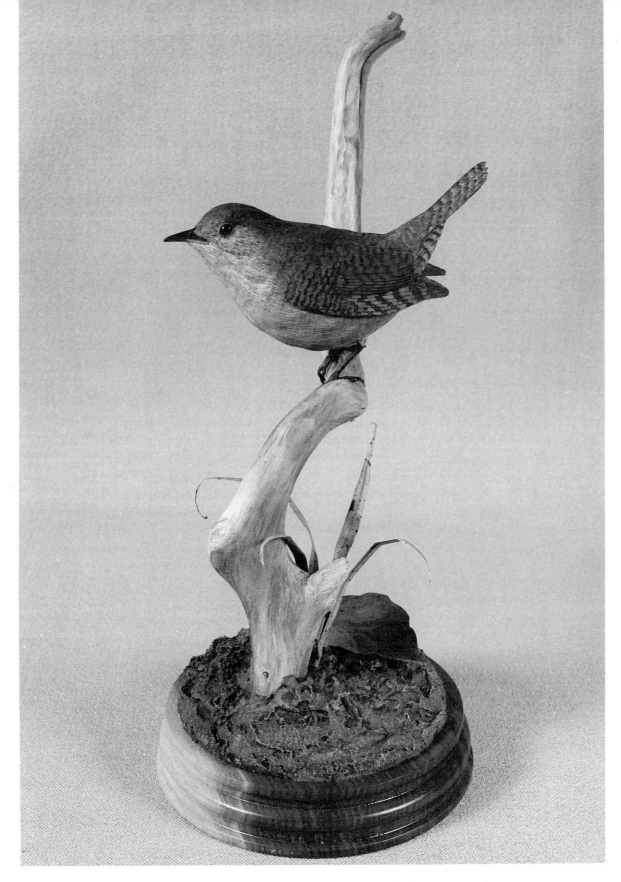

Figure 35. After the mediums have dried, you are ready to mount the completed carving onto the prepared driftwood. Mix up a small amount of 5-minute epoxy and glue the feet in their respective holes. If any of the glue should seep out of the holes onto the surrounding driftwood, it can be touched up with acrylic paint after the glue has hardened.

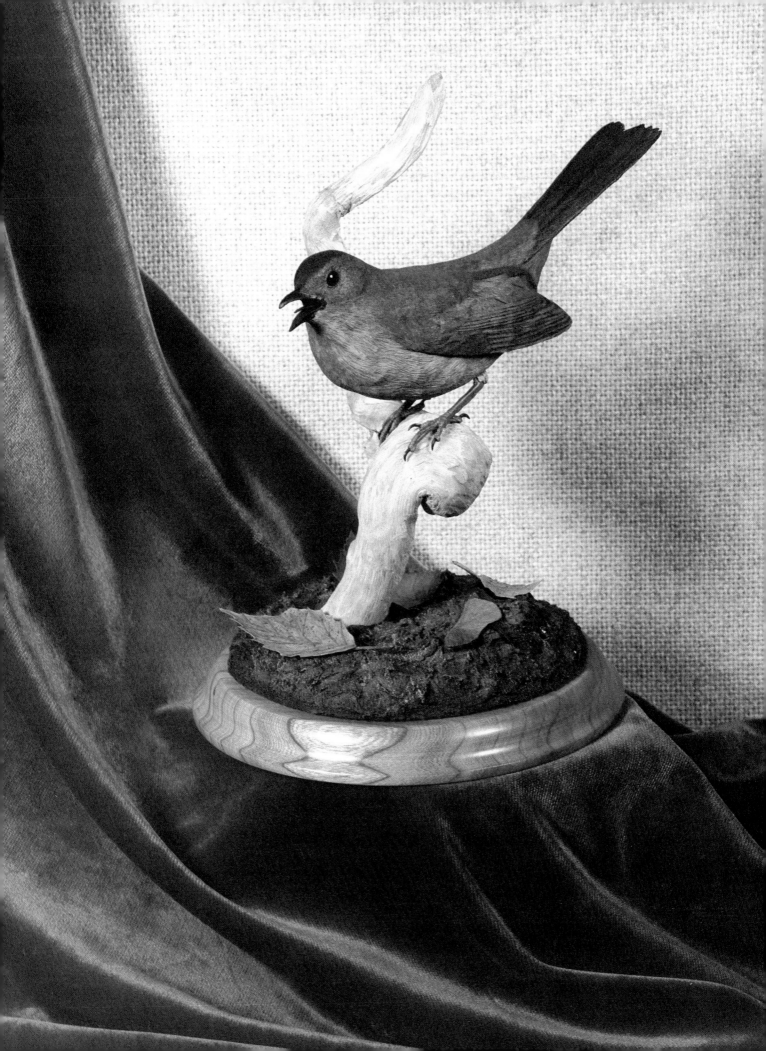

Catbird

(Dumetella carolinensis)

The catbird, found throughout the United States except for the Southwest and the Pacific Coast, is a bird of many songs and mimicries. His cat-like "mew" (from which he is named) is sometimes used to warn of an intruder. In fact, all other birds in the area will scatter after a catbird's warning call.

Preferring the edge of the forest, gardens or borders of roadways, the catbird usually builds its nest in low (3-10 feet) dense shrubbery or bushy trees. It uses small twigs, dried leaves, and strips of bark for the nest with softer grasses and pine needles as a lining.

Adult catbirds dine on insects and berries. They can sometimes be attracted to a feeding station with bits of cheese, crackers, bread or dried fruit.

Physical Characteristics

The catbird is slate grey with a darker head and tail, lighter underparts, and reddish-brown undertail coverts. Both sexes are similiarly colored. The male catbird is 7.75 inches long and the female is slightly smaller.

There are 10 primary feathers on each wing. The first is less than one-half the length of the longest, which is the fourth. All the primaries have light grey leading edges.

The beak, a broad 5-sided shape at the base, is slightly shorter than the head. The nostrils are exposed, rounded openings in small depressions on each side of the culmen. There are usually several rictal bristles on each side of the beak's base that can reach to the nostrils.

The catbird's tail is composed of twelve tail feathers, all of which will be exposed only in a widely fanned tail position. The tail is graduated with the outermost feathers .5 to .7 of an inch shorter than the medial ones.

The middle toe is slightly shorter than the tarsus which is scaled in front and smooth behind. The ornithological term "scutellate-booted" refers to this type of foot.

DIMENSION CHART

1. **End of tail to end of primaries — 2.6 inches.**
2. **Length of wing — 3.4 inches.**
3. **End of primaries to alula — 2.4 inches.**
4. **End of primaries to top of 1st wing bar — 2.1 inches.**
5. **End of primaries to bottom of 1st wing bar — 2.4 inches.**
6. **End of primaries to mantle — 2.2 inches.**
7. **End of primaries to end of secondaries — .6 inch.**
8. **End of primaries to end of primary coverts — 2.0 inches.**
9. **End of tail to front of wing — 6.2 inches.**
10. **Tail length overall — 3.9 inches.**
11. **End of tail to upper tail coverts — 2.5 inches.**
12. **End of tail to lower tail coverts — 1.9 inches.**
13. **End of tail to vent — 3.7 inches.**
14. **Head width at ear coverts — 1.0 inch.**
15. **Head width above eyes — .65 inch.**
16. **End of beak to back of head — 1.8 inches.**
17. **End of beak to back of crest —**
18. **Beak length: top — .6 inch; center — .8 inch; bottom — .5 inch.**
19. **Beak height at base — .22 inch.**
20. **Beak to center of eye (eye 6 mm) — 1.03 inches.**
21. **Beak width at base — .29 inch (closed); .43 inch (open).**
22. **Tarsus length — 1.0 inch.**
23. **Body width[1] — 2.3 inches.**
24. **Overall body length — 7.75 inches.**

[1]At widest point.

TOOLS AND MATERIALS

TOOLS:

Bandsaw (or coping saw)	Flexible shaft machine
Carbide bits	Ruby carvers
Tootsie roll sander on a mandrel (120 grit) or mounted bullet-shaped abrasive stone	Ruler measuring tenths of an inch
Calipers measuring tenths of an inch or dividers	Compass
Pointed clay tool or dissecting needle	Gouge, knives
Awl	Emery board (kind used for fingernails)
Small wire drill (or tempered piano wire)	Burning pen
Abrasive cloth (120 and 320 grits)	Defuzzer on a mandrel
Variety of small mounted stones	Natural bristle toothbrush
Laboratory bristle brush on a mandrel	Tweezers
Surgical clamp (or vise grips)	Needle-nose pliers
Wire cutters	Variable speed electric drill
Drill bits	Staples and a scrap block of wood
Paste flux, solid wire solder and soldering gun or pen	

MATERIALS:

Tupelo	Tracing paper
Super-glue	Pair of brown 6 mm eyes
Clay	Duro epoxy ribbon putty
Cork stopper or heavy cardboard and tape	Clay or dental tools
1/16 of an inch diameter copper wire (16 gauge)	Krylon Crystal Clear 1301
Permanent ink marker	Cast catbird feet (to use as a model)
Driftwood for mount	

CAT BIRD

Profile Line Drawing

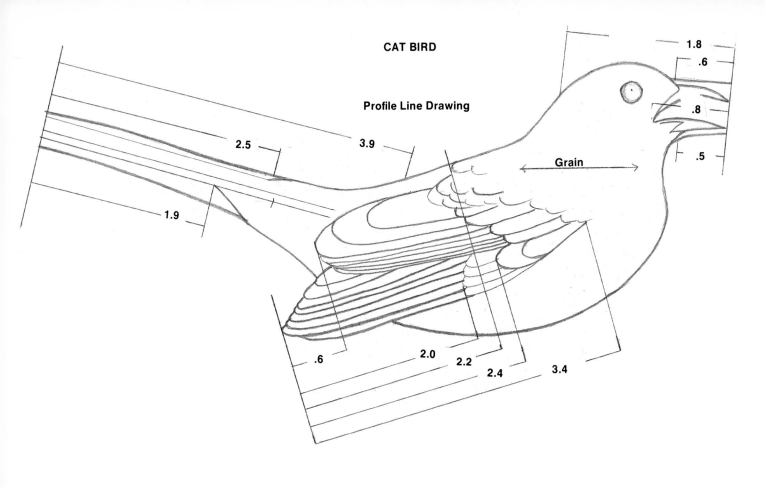

1.8

.6

2.5 3.9

.8

1.9

.5

Grain

.6 2.0 2.2 2.4 3.4

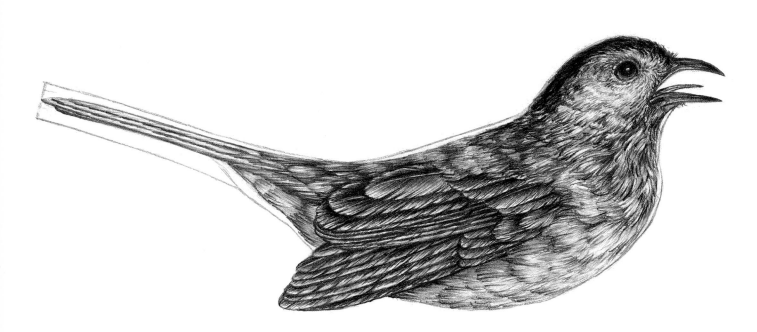

Profile

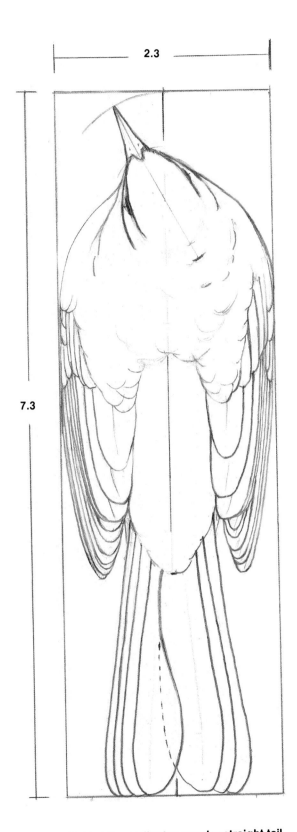

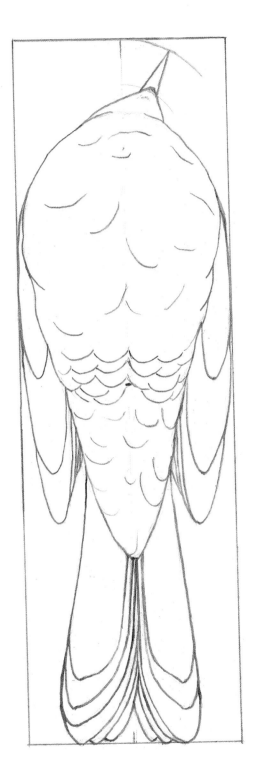

2.3

7.3

Dotted line indicates regular straight tail

Top Plan View

Under Plan View

*Take tail measurements from profile line drawing
since foreshortening causes distortion.

Life Size Wing

Top Wing

Under Wing

Life Size Tail

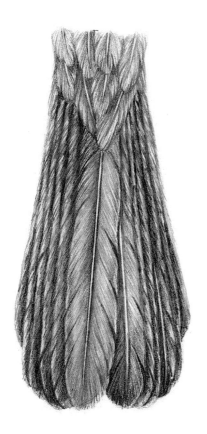

Top Tail

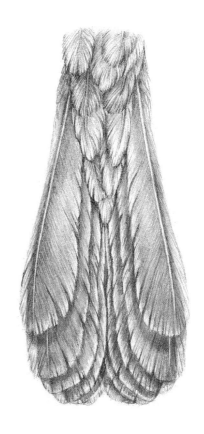

Under Tail

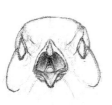

Head on View

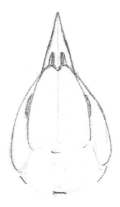

Top Plan View

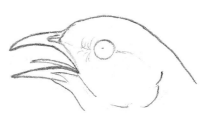

Profile

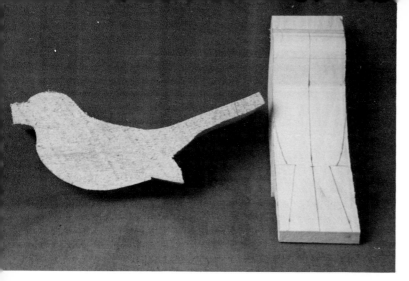

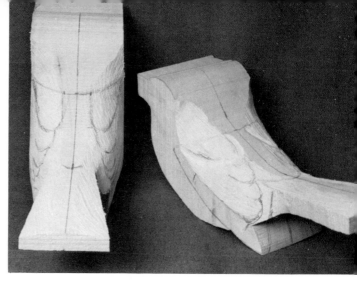

Figure 1. On the left is the blank after being cut by the bandsaw following the profile pattern. The blank should be 2.3 inches wide. Because the beak is so fragile on an opened-beak bird, this blank was sawed from tupelo. Since tupelo is not easily worked with knives (in the dried state), this carving will use primarily the flexible shaft machine.

Using dividers or calipers, transfer the plan view pattern dimensions to the blank, as you see on the bird at the right.

Figure 4. Draw in the lower wing edge lines on both wings, the upper tail coverts, the mantle and the scapular areas. Using a medium-sized taper carbide bit on the flexible shaft machine, slightly round the upper tail coverts and the tail feathers. The outside edges of the tail should be .1 of an inch lower than the center with a gentle arc.

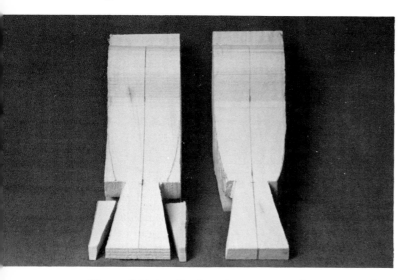

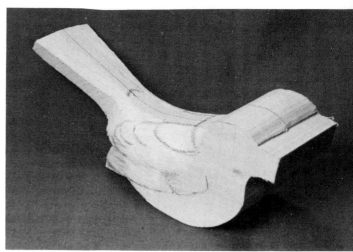

Figure 2. Using the bandsaw or a coping saw, cut just outside the lines of the tail. The excess wood on the wings can be cut off using the bandsaw or the flexible shaft machine with a large carbide bit.

Figure 3. Round the lower back and wing area from the primary / secondary separation to within .3 of an inch on both sides of the center line.

Figure 5. Here you can see the subtle contours of the wings, lower back and tail. The front of the bird is kept as a block. The head carving will be delayed until the remainder of the body has been roughed out since the upper and lower mandibles are so fragile in this opened-beak carving.

Figure 6. With a round-nose carbide bit on the flexible shaft machine, make a channel along the scapular line on both sides.

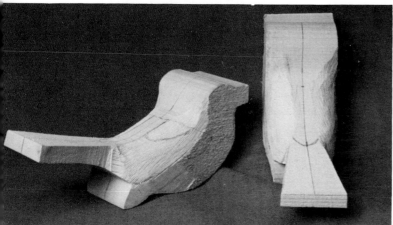

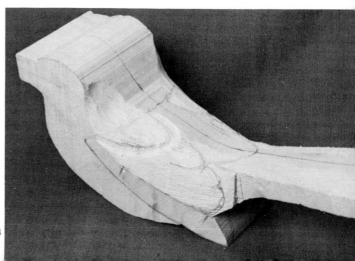

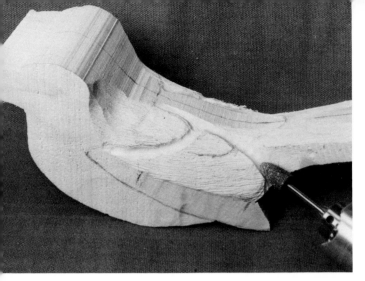

Figure 7. Draw the inner wing edge line (the tertials down to the secondaries). With one of the larger, rounded ruby carvers on the flexible shaft machine, make a channel on the inner wing edge line.

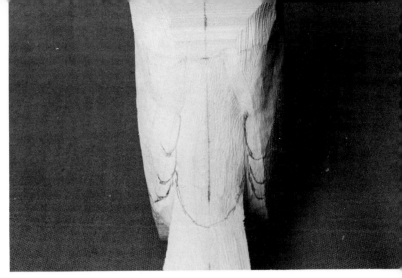

Figure 10. Gently round the scapular areas and flow the wing out from the scapular channel on both wings. Also round the rump and upper tail coverts.

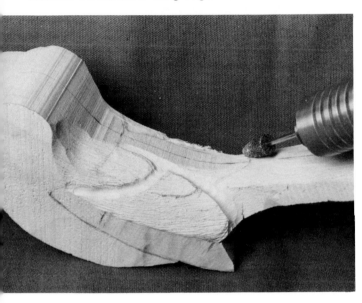

Figure 8. Using the ruby carver again, make a channel on the upper tail covert line. On the tail itself, flow the bottom of the channel out toward the tip of the tail.

Figure 9. Flatten the tertial area on both wings. From the top plan view, you should see the broad expanse of the tertials. From the profile view, the edges of these feathers will be the most prominent.

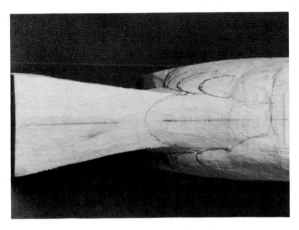

Figure 11. Using dividers, transfer the measurements from the profile view pattern of the tertials on both wings. Remove any excess wood from the side of the tail and the sides of the upper and lower tail covert area on both sides remembering to keep the tail straight into the body.

Figure 12. With a square-edged carbide bit on the flexible shaft machine, relieve the wood under the lower wing edge line on both wings. Keep the plane flat carrying it to the belly edge on both sides. This procedure allows the wings to be wider than the sides of the belly from the head-on and tail-on views. Relieving the lower wing edges creates a shelf along the edge lines on the sides of the bird.

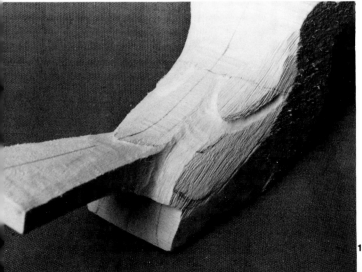

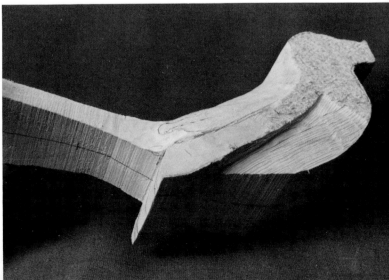

Figure 13. Measure and mark the lower tail coverts (1.9 inches from the end of the tail). Using a carbide bit on the flexible shaft machine, remove some of the excess wood between the sets of primaries under on each side. Measure and mark the vent area (3.7 inches from the end of the tail). Draw in the lower tail covert line and the vent area line.

Figure 16. With a carbide bit on the flexible shaft machine, make a channel in the vent area and along the center line from the vent to the lower breast area.

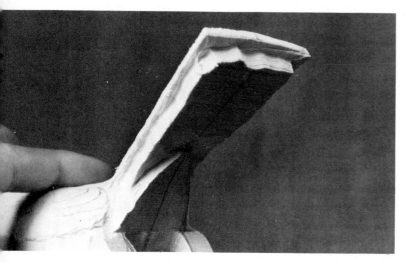

Figure 14. Draw a line .1 of an inch on all 3 exposed sides of the tail. Begin removing the waste wood from the underneath tail area. Work from the end of the tail up to the lower tail covert line.

Figure 17. The underneath part of both sets of primaries should be cut away at a 45° angle. Here you can see the elongated teardrop shape of the body beginning to emerge. The bird's body is tapering back from the upper belly region toward the lower tail coverts at the base of the tail.

Figure 15. Here you can see all the waste wood removed from underneath the tail. Notice that the lower tail coverts and primaries are still blocky at this point. The tail itself now has a convex contour on its top surface, and a concave contour underneath.

Figure 18. Round the lower tail coverts and gently flow them to the base of the tail. Remember that the lower tail coverts are a group of feathers coming out from underneath the feathers in the vent area. Their function is to provide an aerodynamic surface over the quills of the tail feathers actual point of insertion into the body of the bird.

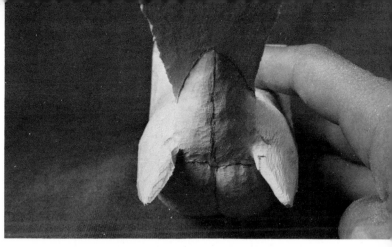

Figure 19. Round the sides of the belly from underneath the lower wing edge lines around to the center line channel. Work carefully under the lower wing edges so that they do not get nicked.

Figure 22. Here you can see the roundness of the belly with a small depression along the center line.

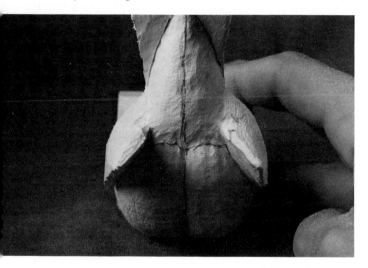

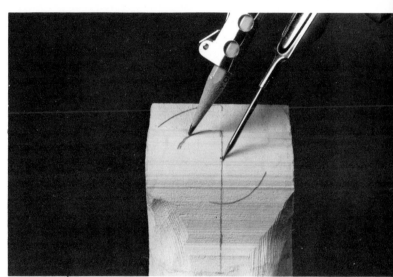

Figure 20. Taper the upper surfaces of the ends of the primaries to correspond with the underneath angle.

Figure 21. Here, the secondaries are not laying flat on the primaries but are draped along the sides of the bird. With the wings in this position, the distance from the end of the primaries to the end of the secondaries will not measure the same as the distance on the folded wing. To get the proper dimension, draw a line .6 of an inch from the end of the primaries up to the area of the secondaries. Draw in the tips of the secondaries on the carving. Cut away the excess wood from the tips of the secondaries. This wood was necessary in the pattern because the wood was needed to allow the tail coverts to be fluffy (refer to the profile pattern).

Figure 23. Find the center of the head by dividing in half the distance from the base of the beak to the back of the head. The center of the head is the pivot point from which to swing arcs with the compass. Swing the arcs for the end of the beak, the base of the beak and the back of the head.

Figure 24. Here you can see the new center line for the head being drawn. The angle of the new center line should not be too great. Remember that this is an open-beak carving. With the beak running across the grain, the strength of the wood supporting the two opened mandibles should be a consideration.

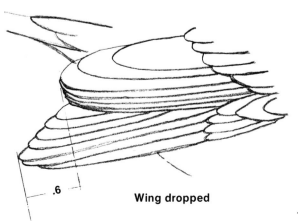

.6

Wing dropped

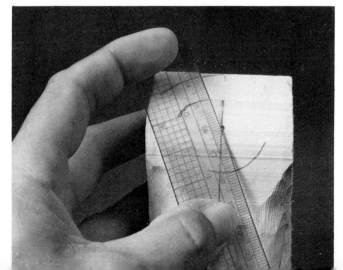

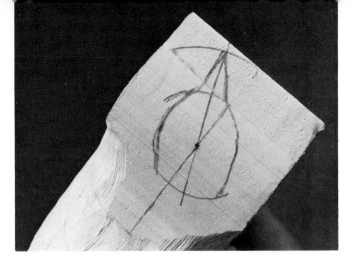

Figure 25. The widest part of the head is the ear coverts—1.0 inches. On both sides of the center line on top of the head, measure and mark spots at .5 of an inch. Roughly draw in the shape of the head including the beak (allow a little waste wood along its sides). You can see in the picture that the side lines of the head include the mark for the ear coverts on each side.

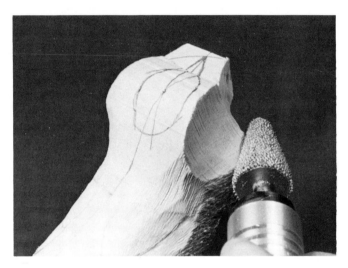

Figure 26. Using a large taper carbide bit on the flexible shaft machine, begin taking wood from the sides of the head, starting at the shoulder area and working up to the ear covert marks drawn on the top of the head. Use the flexible shaft machine just like a knife and take scooping cuts.

Figure 27. Continue taking wood off the sides of the head until you get the proper ear covert dimension (1.0 inches). Keep the side planes of the head relatively straight up. Remember to keep the head balanced on both sides of the center line.

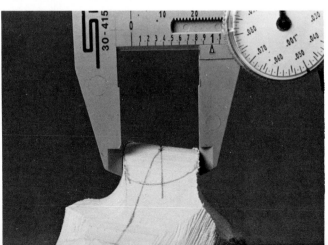

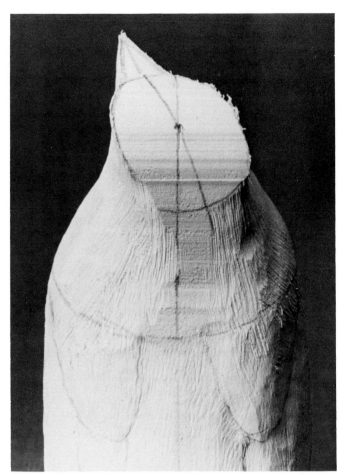

Figure 28. Round the shoulder area on both sides to the breast area. The lower portions of the mantle area on both sides should flow gently up to the sides of the neck.

Figure 29. Remembering that the widest part of the bird is the midwing area on both sides, flow the most forward portions of the wings toward the breast area. You will have to go back and re-edge a small portion of the lower wing edge in front of the alula on each wing. This will give the actual body of the bird the elongated teardrop shape that is necessary. Round the breast area of the bird.

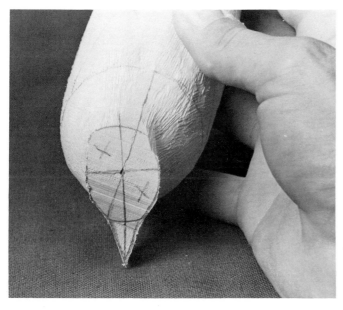

Figure 30. Draw a line perpendicular to the new center line at the center point on top of the head. Here you can see an "x" on the front right and back left quadrants. These are too high as a result of turning the head in the wood. If the head position of the bird were straight on, there would be no high areas but rather a perfectly flat plane on the top of the head. The turned head, however, causes the flat planes of the head to be at an angle with the head-on view.

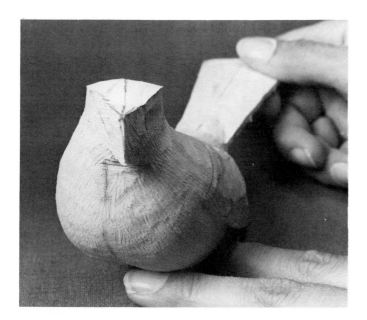

Figure 31. Remove wood from the high areas on the top of the head at the front right and the back left quadrants from the front view. Lowering the high areas will make the head symmetrical from a head-on view. The ruby carver on the flexible shaft machine is a good tool to use for this procedure since it cuts more slowly and smoothly than the carbide bit. Keep trimming and checking for balance until there are relatively flat planes from the forehead to the back of the neck at it approaches the upper back. Do not round off the edges of the head, but keep the edges squared at this point.

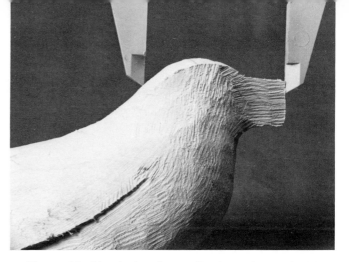

Figure 32. Check the dimension from the end of the beak to the back of the head (1.8 inches). Adjust this if necessary by taking corresponding amounts from the end of the beak and the back of the head.

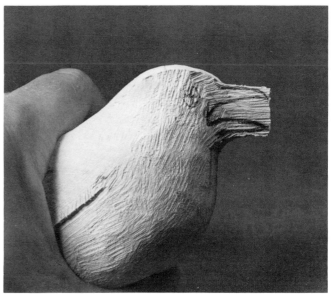

Figure 33. Trace the eye position and the upper and lower mandibles from the profile pattern and pinprick through the paper onto the sides of the head, making sure both sides match from the head-on view. Draw the lines, connecting the pin holes.

Figure 34. Notice the shape and details of the beak of the open mouthed bird.

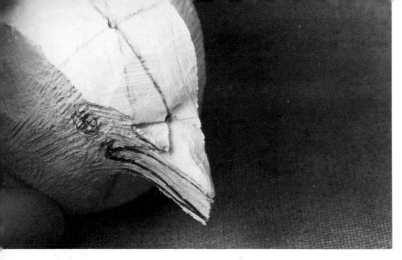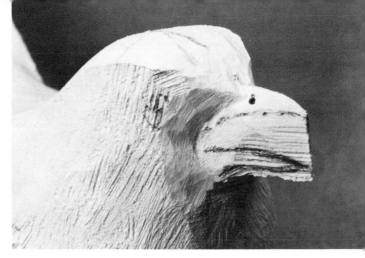

Figure 35. Draw in the measurement at the top of the beak (.6 of an inch). Draw the "v"-shaped line that delineates the top surface of the beak where the forehead flows to the beak. Using a medium-sized pointed teardrop-shaped ruby carver on the flexible shaft machine, make a shallow v-cut on the top of the beak at its base. Take the excess wood off the top of the beak until you get down to the line that you traced from the profile pattern. Shape the top part of the upper mandible into its pyramidal-shape.

Figure 38. Flow the forehead and the area in front of the eye down toward the beak. Finish the final shaping of the upper mandible. With a small, pointed teardrop-shaped ruby carver on the flexible shaft machine, make a small depression at the base of the upper mandible on both sides. The nostrils sit in these depressed areas. With the blunt point of an awl or a slightly worn hard lead pencil, make a small hole on each side of the upper mandible, keeping them balanced on each side of the beak's center line.

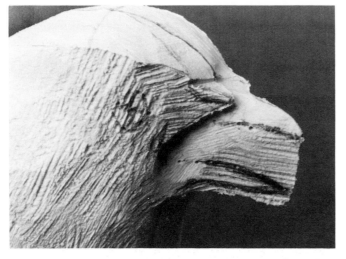

Figure 36. Again with the pointed teardrop-shaped ruby carver, start cutting the sides of the beak. Keep the beak balanced on both sides of the center line and keep taking the sides in until you get a measurement .43 of an inch long.

Figure 37. In taking the sides of the beak down to the proper dimension, work carefully and slowly by taking a little bit from each side and measuring. Make sure that you do not cut away your pinprick marks. Keep the sides of the beak straight.

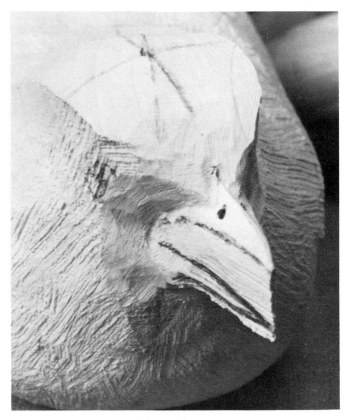

Figure 39. Here you can see how the sides of the beak are kept on a flat plane (straight down).

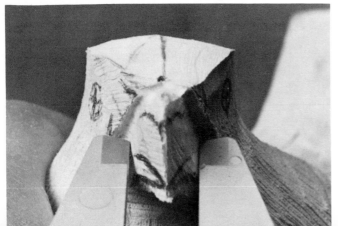

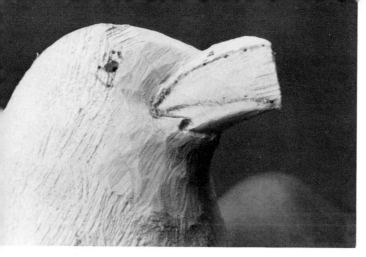

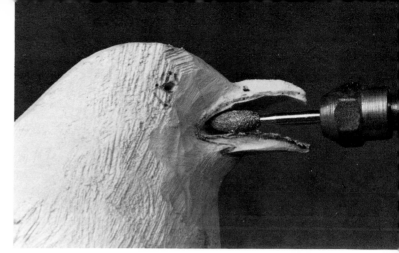

Figure 40. With the small, pointed-end ruby carver on the flexible shaft machine, contour the lower mandible. Measure and mark the bottom beak dimension (.5 of an inch). Work the underneath part of the lower mandible until you reach the lower line traced from the profile pattern. On each side of the lower mandible, recess the lower mandible where the bristly feathers meet the actual beak.

Figure 43. Now that the upper and lower mandibles are contoured, begin taking the excess wood out between the two, using a slender ruby carver. Work carefully so that you do not damage either of the two mandibles.

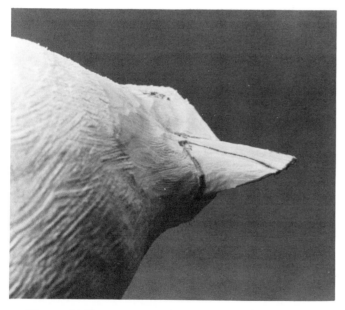

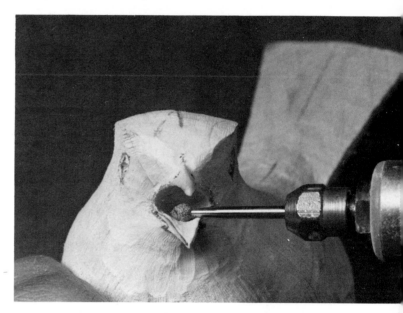

Figure 41. Here you see the contour of the underneath part of the lower mandible.

Figure 42. Flow the chin up to the base of the lower mandible. You can see the gentle contours of the chin area.

Figure 44. Ream out the interior of the gape (the area between an opened upper and lower mandibles) at least 1.0 inch deep from the tip of the beak. Work slowly and carefully, especially when inserting and removing the ruby carver so that you do not nick the edges. Make the interior of the upper and lower mandibles concave—ribbon putty will be used later to form the details of the interior surfaces and hold a carved tongue.

Figure 45. There is a small depressed area on each side of the lower mandible. Create this depression using a narrow ruby carver.

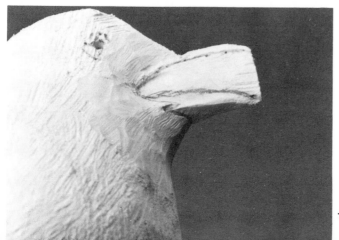

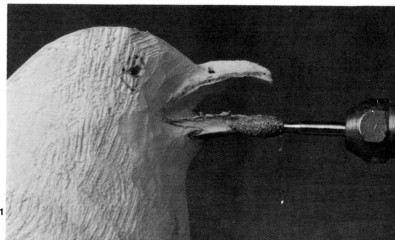

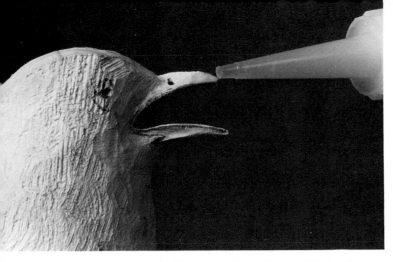

Figure 46. If you chip the end or edges of the beak, you can repair it with super-glue and baking soda. Apply super-glue to the chipped area, as seen here the tip.

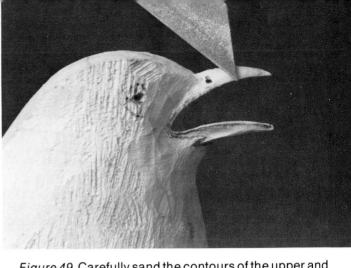

Figure 49. Carefully sand the contours of the upper and lower mandibles with a trimmed emery board. It is not necessary to sand the interior surfaces.

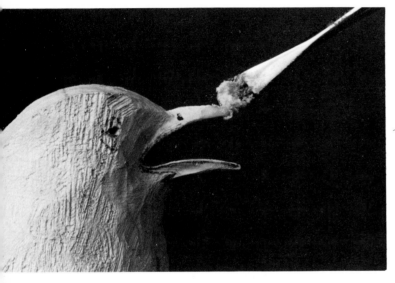

Figure 47. Apply baking soda (the ordinary kitchen variety) to the super-glued area.

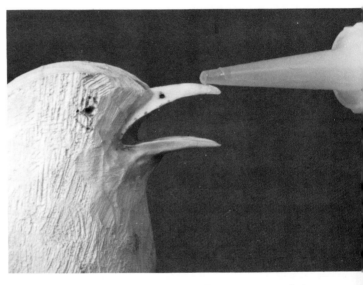

Figure 50. Super-glue both the upper and lower mandibles inside and out. After the glue has hardened, fine sand the outside surfaces with a folded piece of 320 grit of abrasive cloth.

Figure 48. Keep alternating super-glue and baking soda until you have sufficient length, width and height of the chipped area. You will not be able to control the shape of the build-up. Allow approximately 10-15 minutes for the super-glue to harden completely. Sand to shape with abrasive cloth, emery board or ruby carver.

Figure 51. Using a small diameter piece of tempered wire or a wire drill in the flexible shaft machine, drill both nostril holes in each side of the upper mandible, making sure that they are equidistant from the culmen and the base of the beak. Resand the depressions on each side of the beak to get rid of the residue remaining from the drilling process.

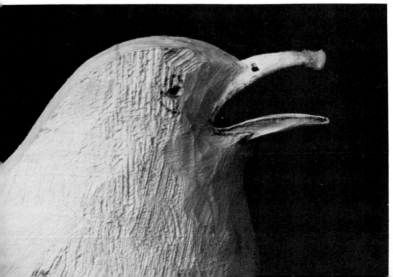

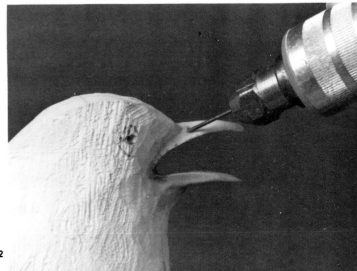

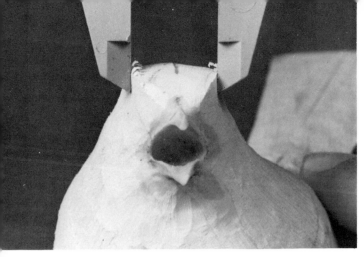

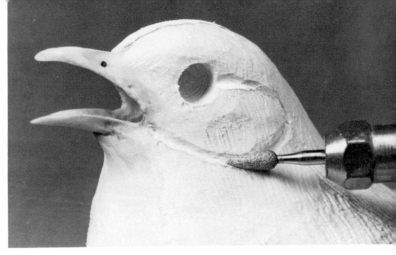

Figure 52. Working above and through the eye areas, narrow the crown down until you get the proper top of the head and the above the eye dimension (.65 of an inch). Using some type of a straight-sided carbide cutter on the flexible shaft machine, take scooping cuts (just as in knife work) from the cheek area to the top of the head. Do not round the head as yet, but keep the planes on the sides of the head relatively straight up and down. There should be a slightly depressed area for each eye to sit in. Keep the head balanced with equal amounts of wood on both sides of the center line. You should check for balance and symmetry from the head-on view.

Figure 55. Draw or trace and pinprick the ear coverts on both sides of the head, using the line drawing profile pattern for reference. Using a narrow diameter ruby carver on the flexible shaft machine, cut a channel along the ear covert lines.

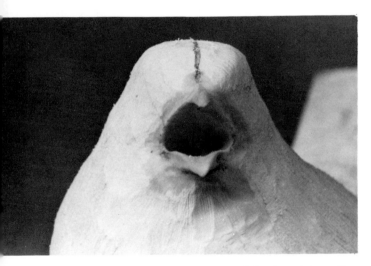

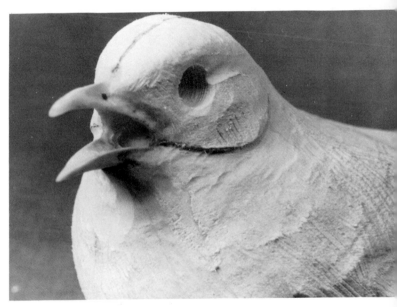

Figure 53. Gently round the top of the head, from the forehead all the way back to and including the back of the neck area. Recheck the entire head for symmetry and balance.

Figure 54. Using a drill or a carbide bit on the flexible shaft machine, make a 6 mm eye hole on each eye center mark. Recheck the eye area, making sure that the eyes are balanced from the top plan view as well as the head-on view. Adjust the eye holes if necessary.

Figure 56. Flow both sides of the neck up to their respective ear covert channels, so that you have a gentle contour from the shoulder area through the neck area and on up to the ear coverts.

Figure 57. On the ear coverts themselves, round over the sharp edge that the channel created.

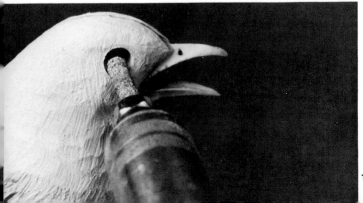

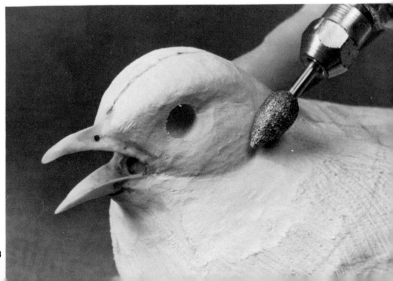

58a

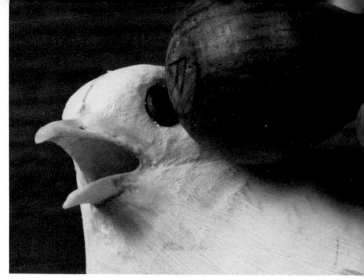

Figure 60. Here you see the wooden handle of an awl pressing the eye to its proper depth. Use something that will not scratch the surface of the glass eye.

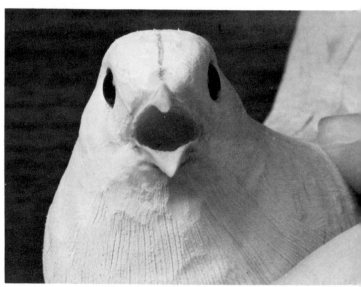

Figures 58a and b. Here you can see how these two procedures have created the fluffy roundness needed in the cheek area. Check for balance of the ear coverts from the head-on view.

Figure 61. Notice how inserting the eyes immediately gives life and sparkle to your carving. Recheck the entire head, making any adjustments as needed.

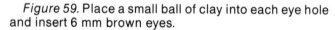

Figure 59. Place a small ball of clay into each eye hole and insert 6 mm brown eyes.

Figure 62. Now that the head has been completely roughed out, you will want to provide some type of protection for the fragile upper and lower mandibles. Here you can see a cork stopper roughly hollowed out.

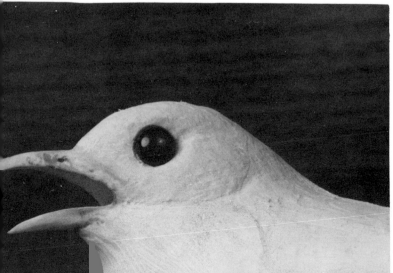

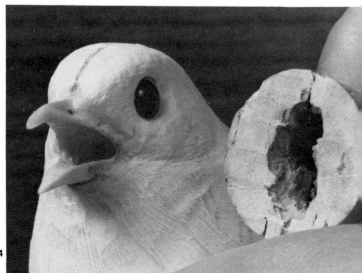

There is no one right way to do feather landscaping. You can use your imagination and artistic license to exaggerate and enhance the motion, fluidity and naturalness of your feather contouring. When laying out your feather landscaping, think in terms of big sweeping curves and shapes to heighten interest in the breast, belly and lower tail coverts. Think in terms of high and low points. Avoid the fish scale or brickwall type of contouring. Anything regular or fixed becomes rigid and monotonous. Feathers do tend to flow in rows, but not to the point of predictability—vary the direction of the flow to create motion and fluidity. Each side of the bird shoud "read" differently. Do not have the high and low points the same on both sides.

Figure 63. Place the cork on the beak, so that during subsequent operations, a thump on the beak will not do any damage. A folded piece of heavy cardboard taped around the beak will also provide protection.

Figure 64. Here you can see the breast and belly of a catbird. Notice the high and low points of the feather contouring (also known as feather landscaping or "lumps and bumps"). Close observation reveals that there is variation in the flow of the groups of feathers as well as of individual feathers within the groups. There is no definite pattern of this feather contouring on a study skin or a live bird. If you have a bird (dead or alive) and blow on the breast and belly feathers, they will fall into different patterns with different high and low points each time you puff away. Every time a bird fluffs his body contour feathers, they will fall into different patterns with varying high and low points—also remember that the wind will affect the flow of the patterns. Naturally, during colder weather every bird will fluff out its feathers for warmth—the contours will be much more exaggerated than during warmer conditions.

Every feather grouping will have a high point, flowing out to the lower areas. Every feather also has a definite contour—that is, it is convex on the top surface and concave underneath. If you closely examine a body contour feather, you will see that it not only has curvature from side to side, but also from top to bottom.

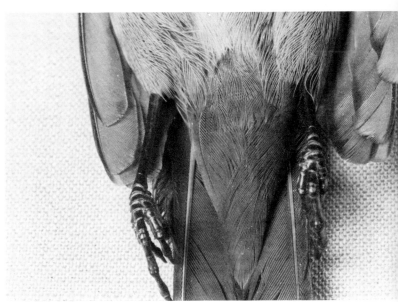

Figure 65. Here you can see the vent area and lower tail coverts of the catbird.

Figure 66. Draw in large sweeping feather groups on the breast, belly and lower tail coverts. Keep drawing and erasing until you have a "look" that you think is natural and fluid.

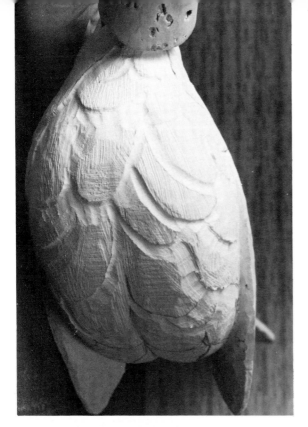

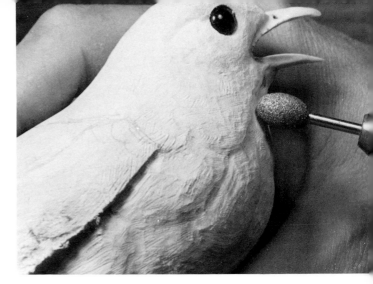

Figure 69. When working on the chin area, you will have to remove the beak protector. Work carefully so that the handpiece of the flexible shaft machine does not knock against the mandibles.

Figure 67. Using a ruby carver and the flexible shaft machine, channel along the lines that you have selected for the low points. Remember that there should be a variety of high and low points of differing depths and heights, keeping in mind that each feather group comes out from underneath the preceeding one, progressing from the head back to the under tail coverts. Using a strong, one-directional light source helps to create shadows and highlights when working on the feather landscaping as well as when stoning.

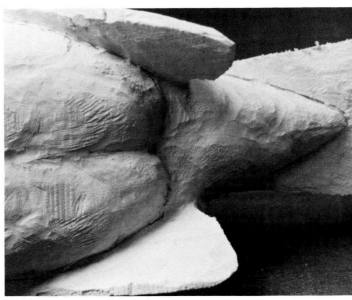

Figure 70. Here you can see the subtle contouring in the vent area and lower tail coverts.

Figure 71. Draw in the mantle line, scapular line and the line where the breast feathers flow over the front portion of the wings.

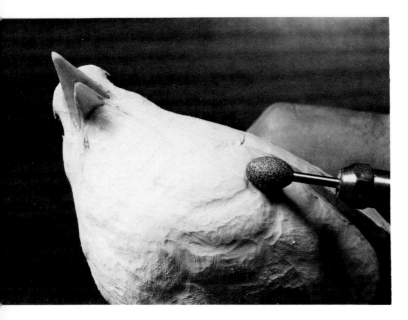

Figure 68. Round over the high points of the feather groups and flow down to the bottom of the channels. For further shaping and smoothing, a bullet-shaped stone or small, worn tootsie roll in a flexible shaft machine is useful. Remember when smoothing contours, to run the stone or tootsie roll with the grain.

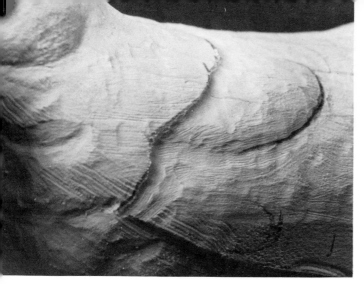

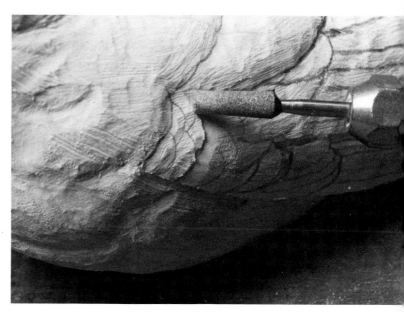

Figure 72. Using a medium-sized ruby carver and the flexible shaft machine, make channels on the mantle line, the scapular lines and the lines where the breast feathers flow over the front portions of the wings. Round over the scapulars to the bottom of the channel on both wings. Flow the wing out from underneath the scapulars. Flow the wings out from underneath the little patch of breast feathers that are covering the front part of the wings. You are creating the effect of the wings coming out from underneath these little patches of breast feathers. The entire wing on both sides should have the effect of coming out from underneath the mantle by flattening the channel on the wing side.

primaries. From the top plan view pattern, draw or trace and pinprick the tertials and the tips of the primaries.

Using a sharp-edged cylindrical stone on the flexible shaft machine, create the sharp division between the secondaries and the primaries, so that you have the effect that they are two different groups of feathers.

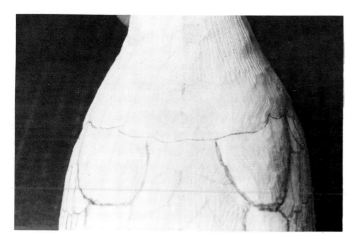

Figure 73. Gently flow the mantle toward the scapulars and the wings, so that you are creating the effect of the mantle laying on top of the wings.

Figure 74. Layout the feathers on both wings. Draw or trace from the profile pattern and pinprick the lesser, middle and greater secondary coverts, the alula, the primary coverts and the edges of the secondaries and

Figure 75. Using a small sharp-edged cylindrical stone on the flexible shaft machine, relieve the wood behind (proceeding towards the wing tip) the lesser secondary coverts on both wings. You are creating the effect of one group of feathers laying on top of another group. Flow the underneath group (in this case, the middle secondary coverts) out toward the tip of the wing.

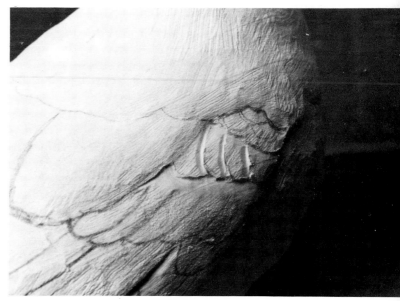

Figure 76. Working on the next group (the middle secondary coverts), relieve the wood behind its line and flow out toward the greater secondary coverts. Using the sharp-edged cylindrical stone, carve around each of the feathers within the group on both wings.

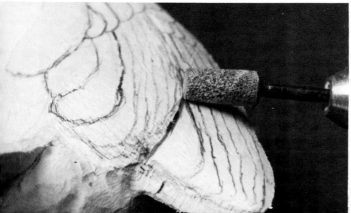

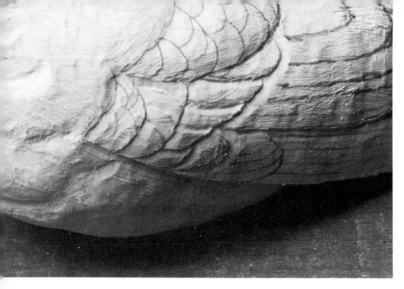

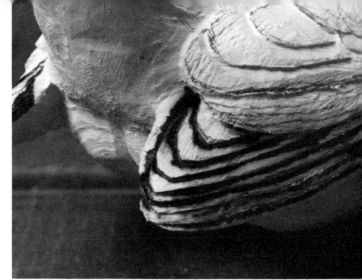

Figure 77. Carve around the next group (the greater secondary coverts) on both wings. Flow the area beyond the greater secondary coverts toward the secondaries. Carve around each one of the individual feathers within each group.

Figure 79. With the burning pen, burn along each one of the primary feather lines by laying the pen on its side and creating a small shelf.

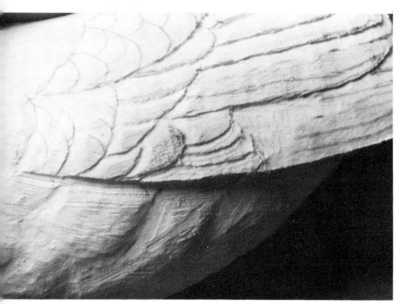

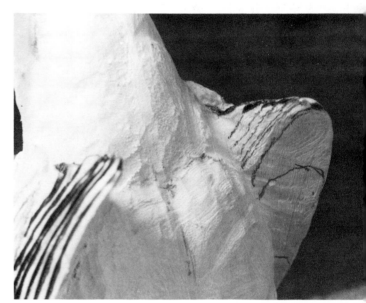

Figure 78. You are proceeding to delineate each of the different groups of feathers within the wing from the front of the wing to the back or tip. This is anatomically correct; that is, one group laying on top of the other. Within each group, you are carving the uppermost feather first and then proceeding to the one underneath.

Carve around the alula and the primary coverts on both wings. Flow the area beyond the primary coverts toward the tip of the wing. Using a stone, carve each of the individual primary coverts on both wings.

Carve around each of the tertials on both wings. If you lay the sharp-edged cylindrical stone on its side, you will be able to create the overlapping effect.

Figure 80. Using the underside plan view pattern for reference, draw in the primaries that are exposed underneath the lower wing edges. There may be a little extra wood beyond the primaries that will need to be removed.

Figure 81. Making sure the top and bottom edges of the primaries match, burn in the bottom edges of the primaries by laying the burning pen on its side.

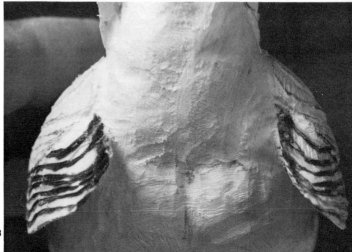

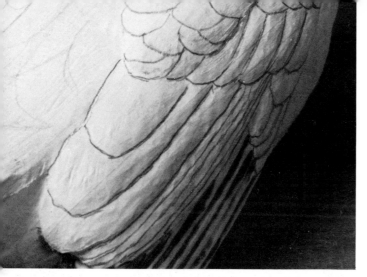

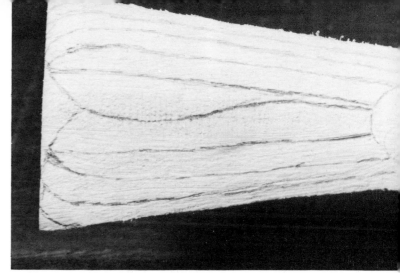

Figure 82. Using a folded piece of abrasive cloth, round over each feather you have relieved. Taking these sharp edges off creates roundness to each of the individual feathers. You will notice that there is a smooth flow from one group to another, from one feather to another.

Figure 85. Draw or trace and pinprick the upper tail layout. You can use the top plan view pattern for reference. You will notice that the two center tail feathers intersect: one feather will cross over its neighbor midway from the upper tail coverts to the tip of the tail.

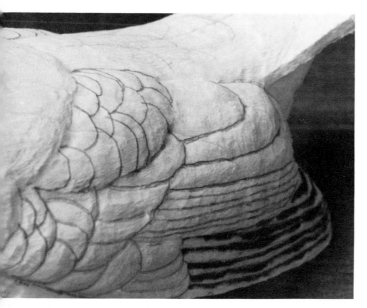

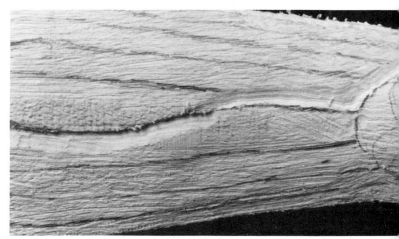

Figure 83. Redraw the secondary edges that may have been sanded away.

Figure 86. Using a ruby carver on the flexible shaft machine, relieve the wood on the trailing edges of both center tail feathers. This will be, in essence, an s-shaped cut. First cut around the trailing eddge of the top feather. Its base, the closest to the upper tail coverts, is fully exposed. Then cut around the trailing edge of the feather whose tip is fully exposed. Sometimes when a bird closes its tail, the barbs are not tightly knit together, allowing one feather to split through another.

Figure 84. With the burning pen laying on its side, burn in each edge of the secondaries.

Figure 87. Round over the trailing edges of both center tail feathers.

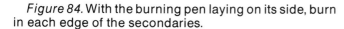

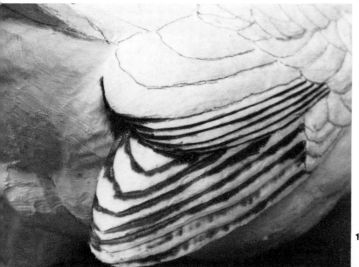

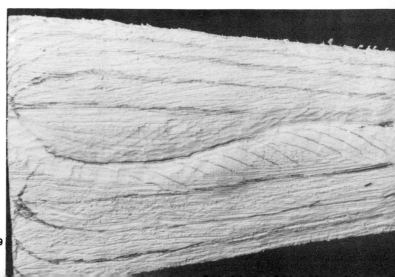

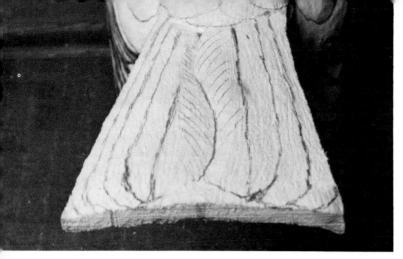

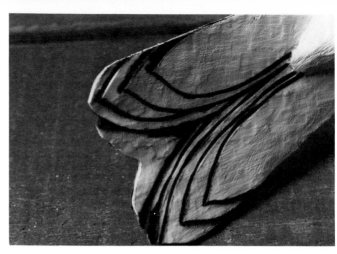

Figure 88. Here you see the end view of the tail. Notice how relieving the trailing edges of the center feathers and rounding them over creates a convex contour to the top of both feathers.

Figure 91. Draw or trace and pinprick the underneath surface of the tail feathers. With the burning pen, trace down the outside edges of the tail to create the effect of a stack of feathers. Laying the burning pen on its side, begin burning the edges on the underneath surface of the tail, starting at the outside edges working your way toward the center. The center part may need to be thinned with a ruby carver and the flexible shaft machine.

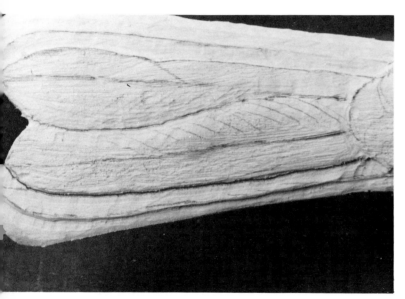

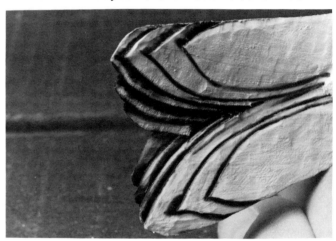

Figure 89. Continue relieving around the edges of the tail feathers, progressing from the centermost feathers to the ones on the outside. Cut away the excess wood on the tips of the feathers.

Figure 92. Here you see the underneath surface of the tail with all the edges burned in.

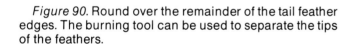

Figure 90. Round over the remainder of the tail feather edges. The burning tool can be used to separate the tips of the feathers.

Figure 93. Draw in the feathers that are exposed on the underneath surface of the wings. Making sure that you match up the edges on the tips of the primaries, lay the burning pen on its side and burn in the edges of the primaries underneath the lower wing edges.

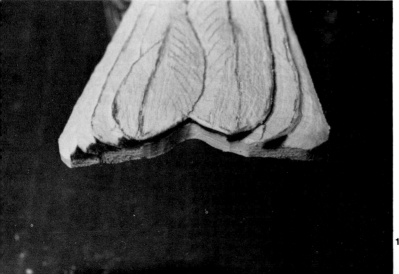

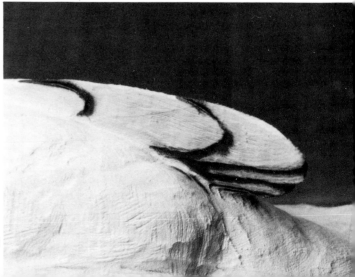

Figure 94. Here you can see the lower back and the upper tail coverts of the catbird. Notice the variations of the feather flow.

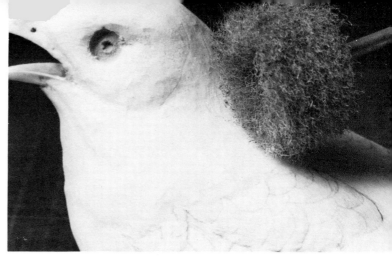

Figure 97. The defuzzer abrasive pad on the flexible shaft machine will remove any fuzz remaining from the sanding. Again, remember to run the defuzzer with the grain.

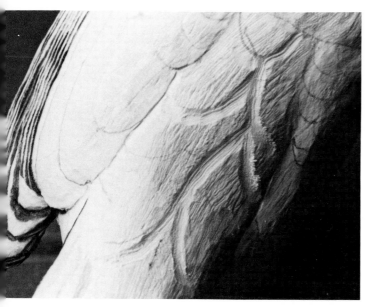

Figure 95. Draw in some sweeping curves for different groups of feathers down the back and upper tail coverts. Using a ruby carver and the flexible shaft machine, make channels along these lines. Remembering that you want to vary the high and low points, round over each of the high areas, and flow them down to the bottom of the channels.

Figure 96. Remove the eyes temporarily for the sanding and texturing procedures. Using a worn tootsie roll, sand the body of the bird, making any changes in the contours as needed. A strong, one-directional light source will not only enable you to check for rough areas but also will allow you to see the effects of the contouring more easily. Remember to sand with the grain.

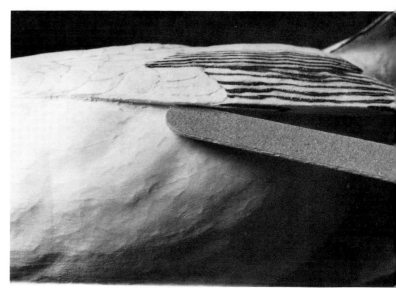

Figure 98. To sand underneath the lower wing edges, you can use an emery board or a folded piece of abrasive cloth.

Figure 99. Lay out the feather patterns on the breast, belly and lower tail coverts to be stoned. Remember to vary the sizes and shapes of the feathers, since monotony and rigidity will be the result if all the feathers are the same size and shape.

At times, you will become aware that you may need a change here or there. Take the time to make the changes, since you will be happier with the bird in the end and it will likely be a better piece.

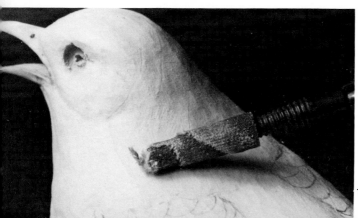

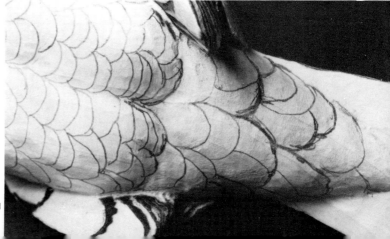

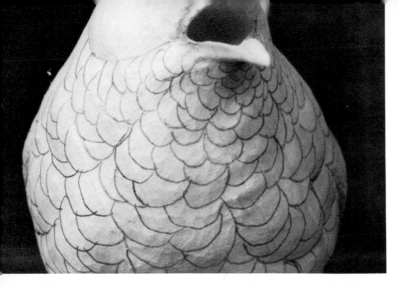

Figure 100. Here you can see the feathers on the breast drawn in.

Indent burning is a technique in which the burning pen is pressed more firmly at the base of the feather than at its edge. Instead of burning from the tail of the bird forward, you can burn from the head of the bird backward. Using the indent burning technique and burning from front to back will create more of a ruffly, scraggly look.

Here you can see the effect of indent burning on a flat practice board. Notice how it appears that almost every feather has been carved in, when in actuality just more pressure with the burning pen was put on the base of the feather than at its tip.

There is no rule that says you must burn a certain area or stone a certain area. This is for each individual to choose. Decide what kind of a look you want and brainstorm the possibilities.

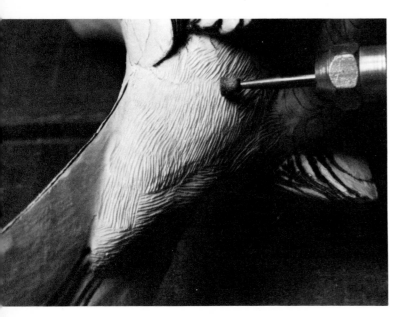

Figure 101. A small inverted cone stone is used to texture the lower tail coverts, beginning at the base of the exposed tail feathers and working forward so that the stoned feathers overlap one another. Remember to vary the directional flow of the feathers to create interest and fluidity. Stone up to the vent area.

Figure 102. At the vent of the catbird, I wanted to create more of a ruffly appearance. To create more depth at the base of each feather and a more fluffy look, I decided to do indent burning.

Figure 103. Here you can see the effects of smooth burning on a flat board. This burning was done from back to front with no added pressure of the burning pen at the base of the feather.

Figure 104. The indent burning is completed on the vent area.

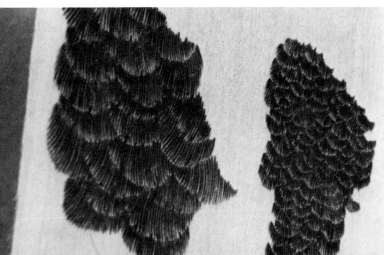

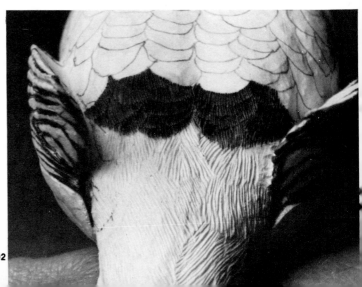

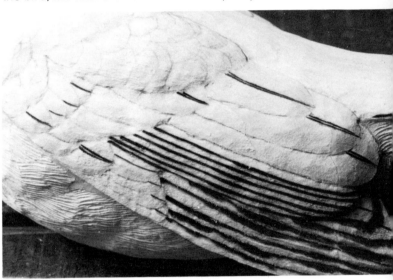

Figure 107. As you work your way up the breast and into the neck area, you will notice that the size of the feathers becomes smaller. With the smaller feathers, it is a little difficult to get much curvature to each stoning stroke. You can still create interest in the areas of small feathers by varying the flow of the feathers. On the chin of the bird, the feathers have a hair-like quality.

Figure 105. Continue stoning the belly of the bird, working your way forward and upward. Be aware of the grain change that occurs at the upper part of the belly/lower part of the breast. With the bird being bandsawed out with the grain running the length of the body, there will be a change from flat grain at the upper belly/lower breast to the end grain on the breast. At this point, it becomes necessary to turn the bird end for end, so that you are stoning in the opposite direction. This may seem awkward at first, but with a little practice it will seem

Figure 108. Draw in the quills on the major feathers of the wings. With the burning tool, burn the quills keeping two burn lines very close together and even running them together the last quarter of an inch at the tip of the feather. Quills can be burned by starting at the base of the feather and burning toward the tip or by starting at the tip. Try both ways to see which seems most comfortable to you.

Where you have a small feather or just the tip of a feather, such as in the middle secondary coverts, a single burn line for the quill is sufficient.

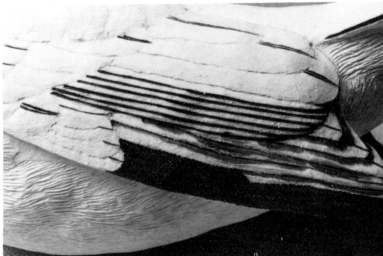

Figure 106. Stone your way up the breast towards the chin.

Figure 109. Begin burning the barb lines on the lowest exposed primary. Keep your burning as fine and close as possible for a velvety look. Work your way up and forward on the wing by burning the feather below first and then the one on top. You want to curve the burning stroke as you draw it away from the feather above and draw the burning pen down the trailing edge a little toward the tip of the feather.

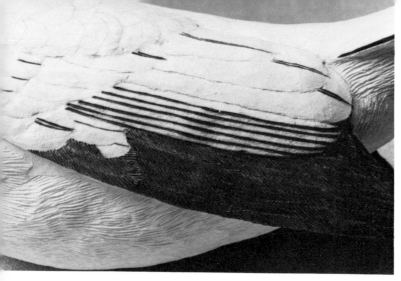

Figure 110. The primaries have been completed. The primary coverts will be burned next.

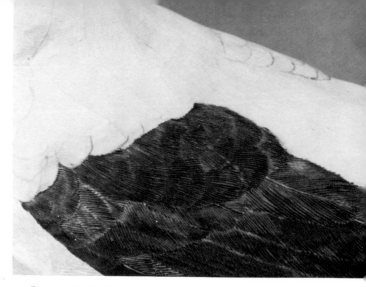

Figure 113. The scapulars are complete up to the mantle.

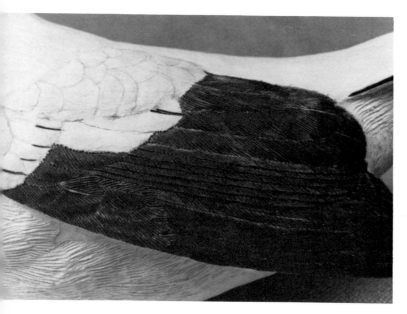

Figure 111. The burning has progressed up the wing and forward toward the front. The stacked secondary edges should be burned with short, curvy strokes that bend toward the tip of the feather.

Figure 112. Draw in the feathers in the scapular group. Begin burning in the barb lines at the base of the scapulars and work your way forward.

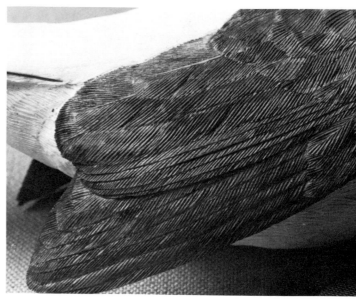

Figure 114. Randomly go back over a few of the barb lines with the burning pen to make them a little deeper and wider to create splits in some of the feathers. Do not overdo feather splits, as this can lead to a ragged appearance. Some of the smaller splits can be painted in.

Figure 115. Draw and burn in the quills on the undersides of the primaries on both wings. Burn in the barb lines of these feathers working from the tips of the primaries to their bases.

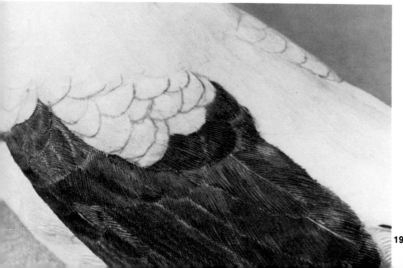

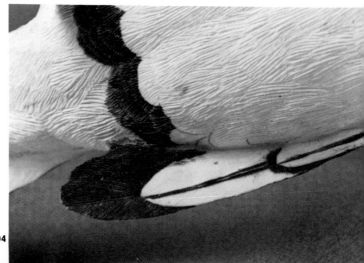

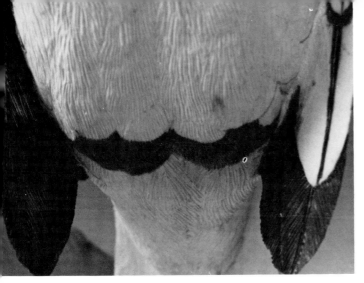

Figure 116. Notice how the burning is progressing from each under surface to its neighbor on top.

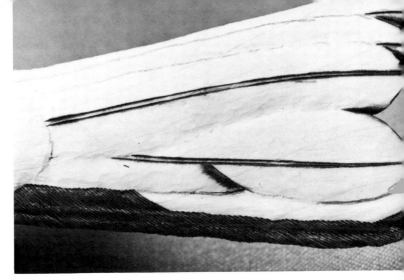

Figure 118. Begin burning the barbs of the tail feathers, starting at the outermost tail feather and working your way toward the center. Burning the feathers underneath first produces a smooth effect.

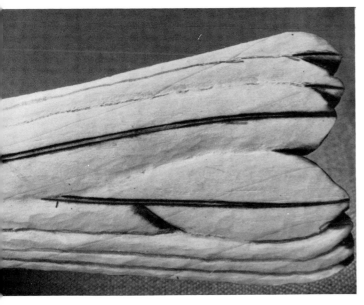

Figure 117. Draw in the quills on the upper surface of the tail. Just as you did on the major feathers of the wing, burn two lines very close together on the drawn quill line to raise the quill. The two lines should flow together a quarter inch from the end of the feather. On the tail feathers with just the tips showing, a single burn line will be sufficient to indicate the quill.

To create the effect of part of a feather passing underneath the adjacent one, lay the burning pen on its side and burn from the quill to the edge. Making sure that the bend of the feather is the same curvature that the barbs will be. At the edge of the feather where this takes place, there should be a small notch where the barbs are missing.

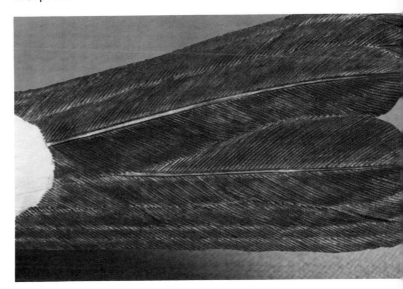

Figure 119. The tail is completely burned. With the burning pen, go back over a few of the barb lines to make them a little deeper and wider to create splits in some of the feathers.

Figure 120. Draw and burn in the quills on the feathers on the under surface of the tail. Beginning in the center of the under tail, start burning in the barb lines and work your way laterally toward the outermost feathers on both sides.

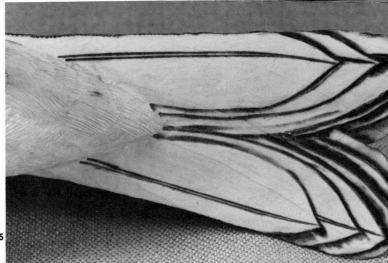

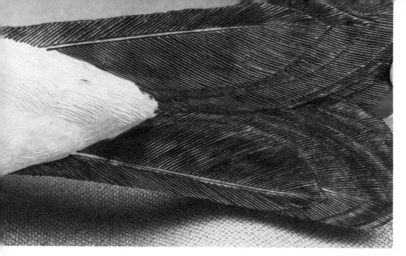

Figure 121. The under tail is completed.

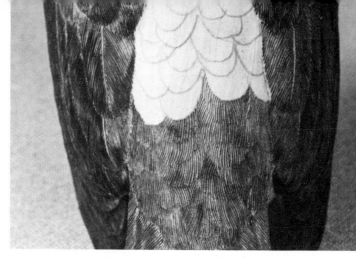

Figure 124. Begin burning the barbs in the feathers on the top side of the bird at the edge of the lower tail coverts and proceed to burn the feathers up the back.

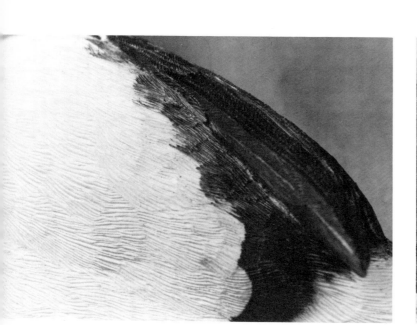

Figure 122. With the burning pen, burn in the feathers in the area near the underneath primaries that the stoning could not reach. Blend the burning into the stoning little. Also burn the edges of the lower tail coverts that the stoning could not reach.

Figure 123. Draw the feather pattern on the upper tail coverts, back, mantle, neck and head. Remember to vary the amount of exposed feather. The feathers should not all be the same size or shape.

Figure 125. Proceed to burn in the barbs on the mantle, upper back, neck and back of the head.

Figure 126. At the shoulder and neck areas, carry the burning into the stoned areas a little bit. Notice the smooth effect you get from burning over-lapping feathers.

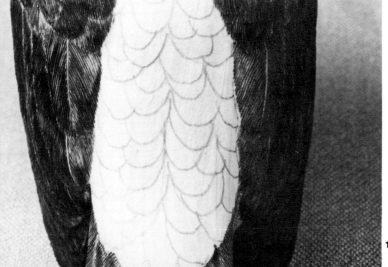

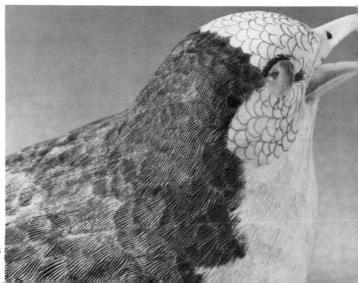

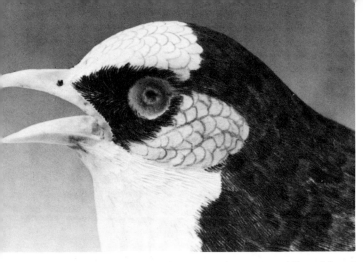

Figure 127. The area between the eye and the side of the base of the beak is textured by burning the edges of the hair-like feathers. These feathers appear at the corners of the eyes and flow toward the beak, curving up toward the forehead and crown and down toward the area below the eye and the ear coverts.

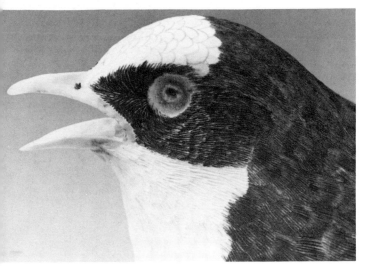

Figure 128. Finish burning the barbs of the feathers of the ear coverts, crown and forehead. Because these areas contain very small feathers, it is difficult to get much curvature in the burning strokes. To create interest and fluidity here, vary the flow of the feathers.

Figure 129. The burning on the head is complete.

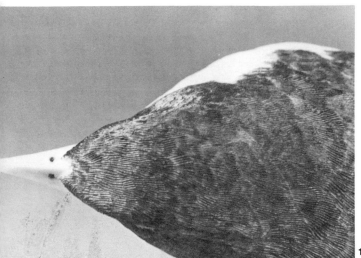

Figure 130. Burn the barbs in the chin feathers that could not be reached with the stoning. When all the burning is complete, clean the surface with a natural bristle toothbrush.

Figure 131. To create the tongue, cut a small sliver with a gouge from a scrap piece of tupelo.

Figure 132. Draw a tongue on the gouged sliver making it .5 of an inch in length and .15 of an inch at its widest point.

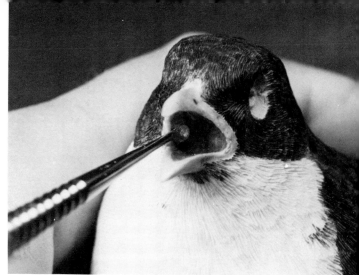

Figure 133. Carefully cut out the tongue with a sharp knife. Using the flexible shaft machine and a small stone carefully create a depression in the top center. Sand the tongue smooth with 120 grit abrasive cloth. Gently curve the tongue to shape with your fingers and super-glue it in this position. Carefully fine sand with 320 grit abrasive cloth.

Figure 136. The back of the throat is not a smooth surface but has a wrinkled appearance. Using a dental tool, pull the putty out to the tips of the mandibles covering the entire inside surface of both. At the base of the upper mandible, there is a small slit with small mounds on both sides.

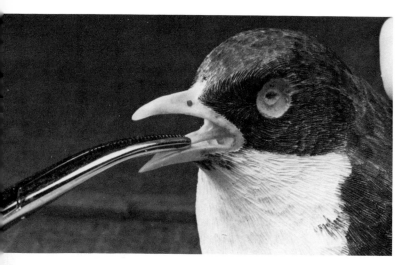

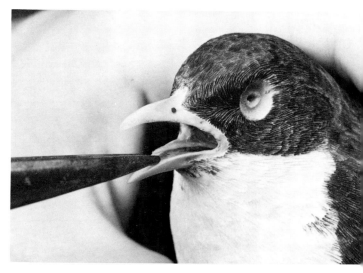

Figure 134. Gently holding the tongue with tweezers or a surgical clamp, check the tongue for proper length. The tip of the tongue should be .3 of an inch from the tip of the beak.

Figure 135. Mix up a small amount of the Duro epoxy ribbon putty. Remember to cut out the little piece where the two colors meet and mix with your fingers until you get an even green color.
Press the putty down the throat to cover all of the surfaces.

Figure 137. When the interior surfaces are contoured, place the tongue base into the putty at the base of the lower mandible. Make sure the tongue is seated sufficiently into the putty to hold it.

Figure 138. Check the balance of the tongue placement from the head-on view to make sure it is in the center of the mandibles and not twisted. Let it harden for several hours. When the putty has hardened sufficiently, place a drop of super-glue at the base of the tongue to further reinforce the bond to the putty.

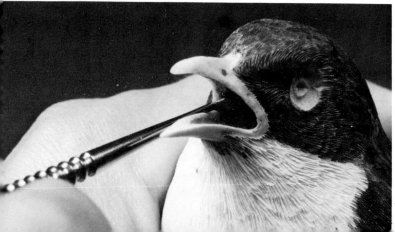

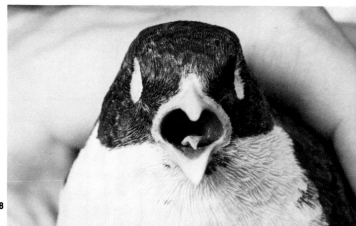

Figure 139. Replace the eyes, using a small amount of clay. Recheck the eyes for balance from the top plan view as well as the head-on view.

Carefully clean any excess clay from around the eyes with a sharp-pointed clay tool or a dissecting needle. Any excess clay around the perimeter of the eye will keep the putty from adhering to that area.

Figure 140. Using the natural bristle toothbrush, clean the area around the eye so that there are no remaining remnants of clay.

In setting the eyes in birds, remember that the eyes are an integral part of the head with only a fractional part of the eye actually exposed. It is always amazing to see how large the eyes actually are when seeing a study skin being prepared. Even in a small bird, the eye is approximately the same size as a medium-sized blueberry. The eyes in the carving should not be so bulbous that the bird looks popeyed and yet not so deep that you have to look down into the head to see them. Observe the live birds at your feeder so that you will have first-hand knowledge of eyes as well as other parts of the bird.

Check the positioning of the eyes in your carving. Look at them from every angle to make sure that they are not too deep nor too shallow and that they are balanced.

The life of the bird is captured in the head, but more particularly in the eyes. Taking the time and effort to execute a lifelike look about the eyes and head is well worth it. When viewing a carving, one's own eye will travel to the head first and more specifically to the eyes.

Most all perching birds have dark brown eyes except for the obvious exceptions such as the Brewer's blackbird whose eyes are yellow, the red-eyed vireo whose eyes are red, etc. Often, carvers will insert a black eye because the eye looks dark, when in actuality, the eye is a dark brown one.

Figure 141. When you are satisfied that the eyes in your carving are balanced and the right depth, mix up a small amount of the Duro epoxy ribbon putty. Cut out the little piece where the two colors meet and mix between your fingers until you get an even green color. Roll a small piece of the putty between your fingers of one hand and the palm of the other to make a small "snake". Using a clay tool, dental tool or dissecting needle, push the roll of putty into the crevice around the eye.

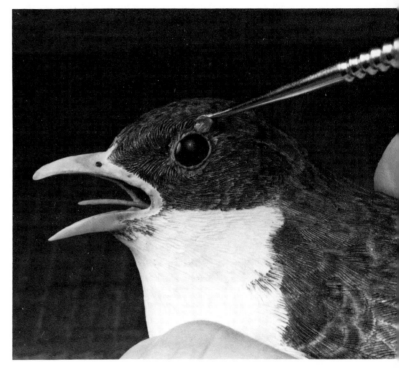

Figure 142. When working with the putty, push whatever tool you are using into the oily clay which will keep the putty from sticking to the tool. Remember that the eye ring around the eye is oval, not perfectly round. Pushing the clay around with the tool, form the eye ring. Remove any excess putty as you are working. As you gradually pull the putty into the surrounding burned grooves, the eye ring may become too prominent. It should be just slightly elevated from the adjacent area.

If you find that you have too much putty to blend outside on the burned area (more than .1 of an inch), remove some. You want as little putty outside the eye as possible. If an edge of the drilled eye hole begins to show through, cover it up.

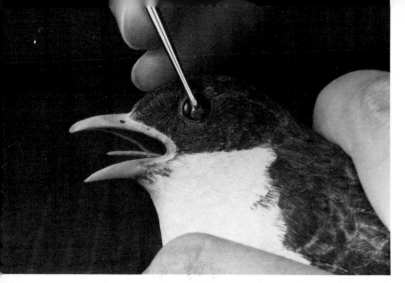

Figure 143. If the putty eye ring starts hugging the eye too tightly, pull it away with your tool.

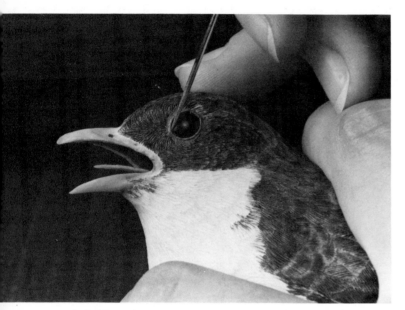

Figure 144. The eye ring itself is not smooth, but has a little bumpy texture similar to wrinkled skin.

Figure 145. Recheck the blending area around the eye where the putty is pulled into the adjacent burning. You want a smooth transition between the eye and the surrounding area.

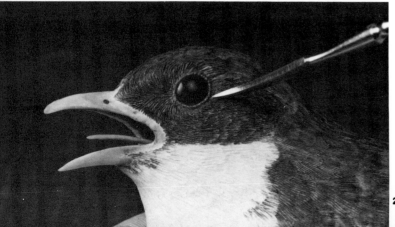

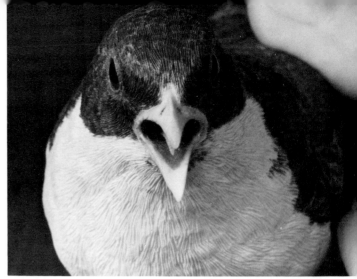

Figure 146. Proceed to applying the putty to the other eye when you are satisfied with the first one. Be careful, when working on the second eye, not to obliterate the putty around the first one.

Again, check the eyes for balance from several different views. If something is not quite right with the eyes, it is easier to reset one or both at this point than to have to dig them out after the putty has hardened.

Figure 147. After the putty around the eyes has hardened, spray the stoned areas (lower tail coverts, belly, breast, underneath neck and chin) with a **light coat** of Krylon Crystal Clear 1301. Let this dry for a few minutes.

Figure 148. Using a defuzzer pad on the flexible shaft machine, lightly clean up the stoned areas running the abrasive pad **with the grain.** This should rid the stoned areas of any remaining fuzz. The Krylon seems to harden the little fuzzies and nubbies so that the defuzzer can whisk them off.

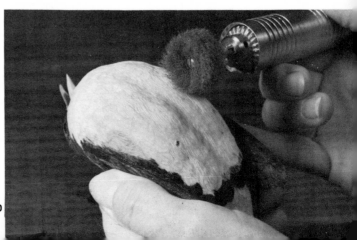

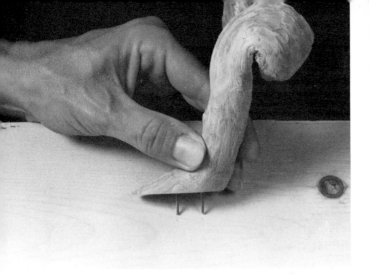

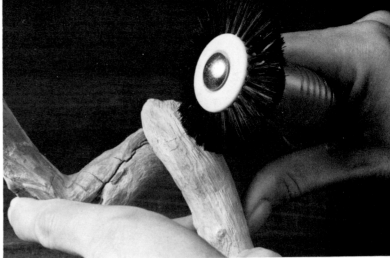

Figure 149. After selecting the piece of driftwood on which to mount the carving, it is best to attach the driftwood to a "working" base so that any procedures you do on the feet do not ruin any prepared ground or the permanent base that you prepare. You will want the driftwood to attach to the working base in the same position and angle that it will be attached to a permanent base or prepared ground.

The piece of driftwood selected for the catbird needed bandsawing so that it would sit in the prepared ground at a particular angle. To alter a piece of driftwood to fit a base at a particular angle, you can use a knife, bandsaw, flexible shaft machine and carbide bit or a disc or belt sander.

Drill two 1/16 inch diameter holes in the driftwood. Insert two short pieces of 1/16 inch diameter wire. By using two pieces of wire rather than one, the driftwood will be kept from turning on the base or in the prepared ground. Press the two pieces of wire that are in the base of the driftwood into the soft wood of the working base. Drill 1/16 inch diameter holes at these marks. Check to see if the wires of the driftwood fit properly into the drilled holes—if not, redrill the holes in the working base until you get a proper fit.

Figure 150. This particular piece had a small crack that needed reinforcing. Super-glue was used to saturate the crack and the surrounding area. Check your driftwood carefully to make sure that there are not weak spots.

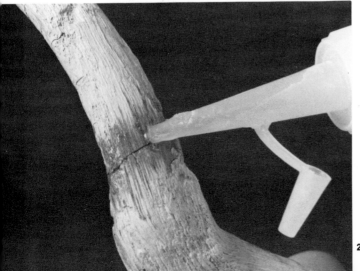

Figure 151. After the super-glue has dried, clean up the driftwood using the laboratory bristle brush on the flexible shaft machine. You will notice that the brushing not only cleans the driftwood up, but also burnishes it to a nice patina. If you desire even more sheen, you can wax the driftwood with a good furniture paste wax and buff it with a cloth or brush. If you want to change color, you can paint with acrylic washes or apply some desired color of shoe polish and then buff.

The piece of driftwood can be altered with the bandsaw or flexible shaft machine. If there is a branch that juts out at an inappropriate place, saw it off and rough up the stump using a propane torch and wire brush on the flexible shaft machine.

You can get creative and imaginative with driftwood by fashioning interesting additions to it, such as a fascinating knot, knothole or entire added branch. It is easier to make a knothole in the driftwood if you have one in another piece of driftwood that you can use as a model. Using a carbide bit, make the hole in the piece of driftwood to be used for the carving. The area around the hole can be textured using the ruby carver, grinding stones or cutters on the flexible shaft machine. The burning pen can also add interesting textures. After you are satisfied with the hole's contours, paint the area to blend it with the surrounding wood with acrylic washes.

To make an added branch, use a wire armature to which you can add plastic wood, autobody (the kind used to fill dents in cars) or ribbon epoxy putty if it is a small addition. After contouring, paint the branch to match the existing driftwood using acrylic washes.

There are many ways you can alter existing driftwood—painting, contouring, sandblasting, wire brushing, etc. There are no limits. Let your imagination fly. You can even create your own driftwood by carving it yourself. It is perhaps easier if you have other pieces of driftwood from which to model, but this is not mandatory.

Figure 152. Using a small amount of super-glue or glue from a hot-melt glue gun, attach the driftwood to the working base.

Figure 154. Drill a 1/16 inch diameter hole into the body of the bird at each mark. The holes should be approximately ½ inch deep into the body. Insert a long piece of 1/16 inch diameter wire into these holes. Holding a rule next to the wire, mark the tarsus length (1.0 inches for a catbird) from the ankle joint. At the bottom joint of the tarsus where the toes attach, allow approximately ½ inch extra to go into the piece of driftwood. You can use a permanent ink marker or a file to mark these places.

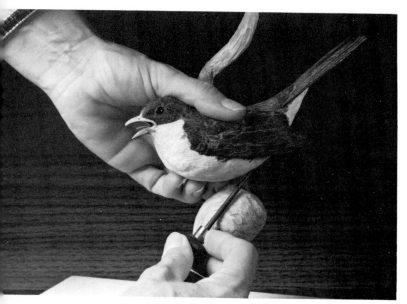

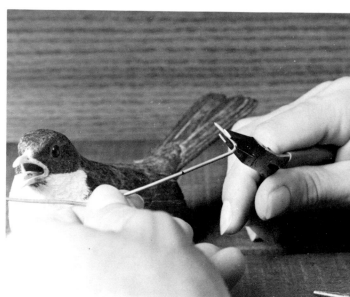

Figure 155. Using needle-nose pliers, make the appropriate angle and bend the wire to go into the body.

Figure 153. Holding the catbird in the desired position above the piece of driftwood, mark the spot on the belly that you want the tarsus to exit the feathers. Do both tarsi this way. Studying live birds outside at your feeder or in the park will enable you to learn in what positions the feet come out of the body contour feathers at different points. Understanding the anatomy and functioning of the tarsi is crucial in positioning the bird. Nothing will replace first-hand knowledge from time spent oberving and studying bird activities and behavior.

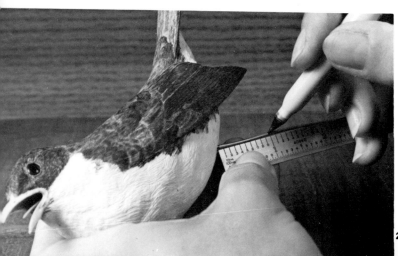

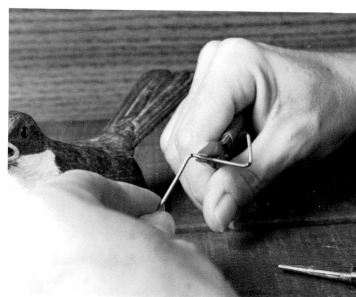

Figure 156. Holding the tarsus with the needle-nose pliers to keep the tarsus perfectly straight, make the bend at the toe joint (the point at which the wire goes into the driftwood).

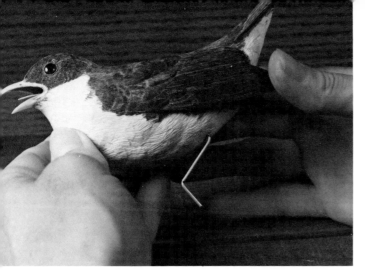

Figure 157. Insert the wire tarsus into the hole in the body. Proceed to the other tarsus and repeat the procedure.

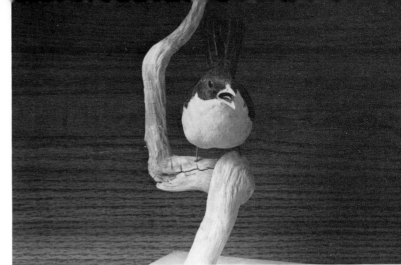

160a

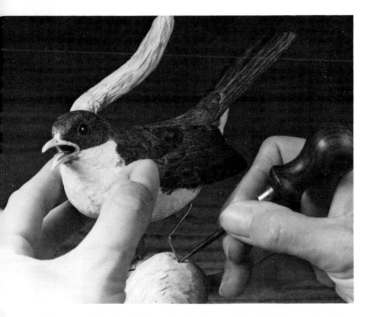

Figure 158. Hold the bird above the driftwood in the position that you want it to stand. Using a pencil or awl, mark the points where the wires will be inserted into the driftwood. Using a drill bit one size larger than the diameter of the wire allows easier insertion and removal from the driftwood. Drill two 5/64 of an inch diameter holes into the driftwood at the same angle as the bend of the feet wires.

Figure 159. Place the bird's feet wires into the holes.

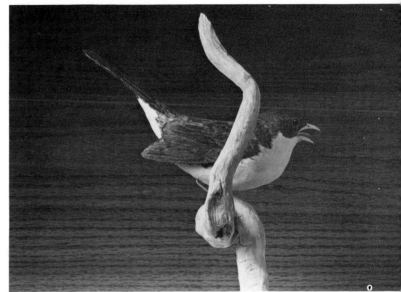

160b

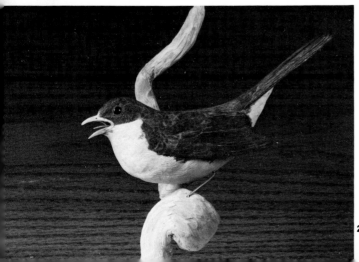

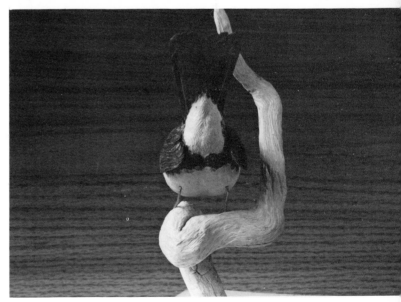

Figures 160a, b, and c. Check the bird's balance from all viewpoints. Now is the time to change the position, if necessary. You may have to redo one or more of the bends in the wires. Keep working with it until you have a well-balanced bird.

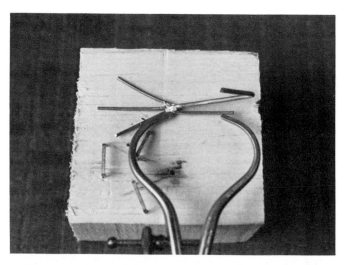

Figure 161. In a small scrap of wood, drill 1/16 of an inch diameter hole slightly shorter than the length of wire that goes into the driftwood, so that the main toe joint is slightly above the surface of the piece of scrap wood. Insert one of the tarsus wires.

Using 16 gauge copper wire, cut one piece of copper wire slightly longer than the inner toe and hind toe combined and another piece slightly longer than the middle and outer toe length combined. Using cast toes as a model, make a v-shaped bend for the middle and outer toes and a slight bend in the inner and hind toe wire as in the photo. These two wires are simply the armature to hold the putty in shape and in place. On the inner and hind toe wire, file a small notch at the juncture point of the two toes and the tarsus. On the outer and middle toe wire, file a small flat surface at the juncture point of the two toes and the tarsus. Lightly sand the areas to be soldered. Without touching these areas with your fingers, staple both wires in their proper position with the tarsus.

Figure 163. Using a cast foot as a model, cut all the toes to their proper length. Do the other foot, making sure that the hind toe is to the inside of the tarsus.

Figure 164. Using small needle nose pliers, shape each of the claws.

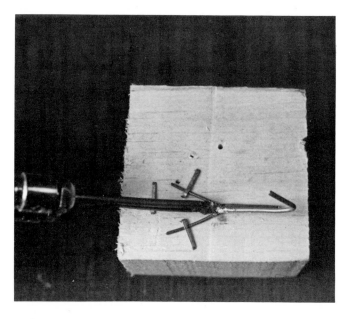

Figure 162. With these wires firmly in place, both of your hands will be free for the soldering procedure. Put a small amount of paste flux at the solder points. Using a soldering gun or pen, heat the joint and then apply the solder.

Figure 165. Using the flat area at the base of the needle-nose pliers, squeeze each of the claws to flatten them.

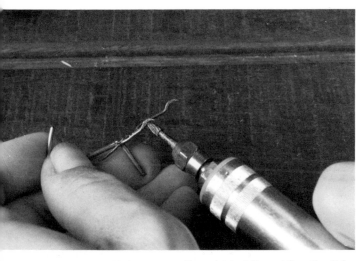

Figure 166. Using a small carbide bit and the flexible shaft machine, shape the underneath area of each of the claws.

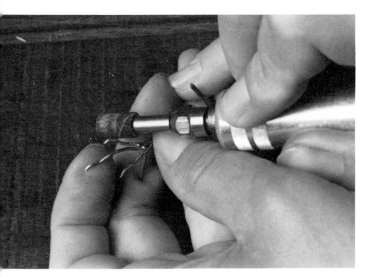

Figure 167. Using a file or a sander on the flexible shaft machine, shape the top of each of the claws.

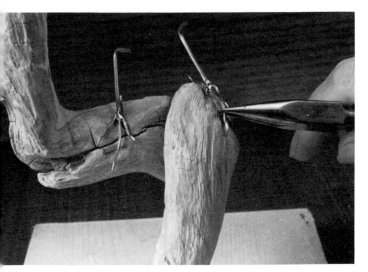

Figure 168. Place both feet in their respective holes in the driftwood. Using needle-nose pliers, shape each of the toes at the joints to fit the driftwood.

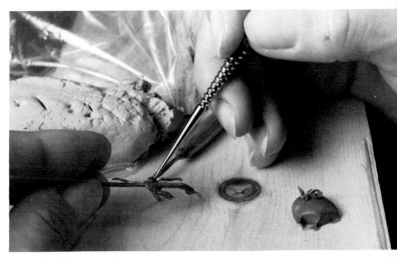

Figure 169. Mix up a small amount of the Duro epoxy ribbon putty. Using a cast foot as a model, apply putty to all of the toes. Using dental or clay tools, work the putty to shape starting at the predominent pad at the base of the claw and work your way back to the main joint at the base of the tarsus. An X-Acto knife blade or the knife blade end of a dental tool is useful in creating the joint lines on the top surface of the toes. Do not actually cut the joint lines but rather roll the edge of the knife blade on the putty pressing in the shape.

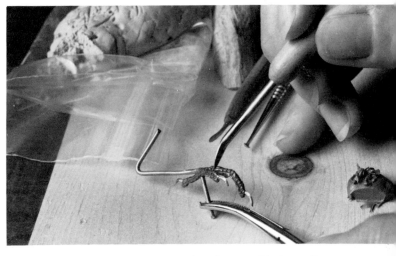

Figure 170. Here you can see the clay used to keep the putty from sticking to the tools. While working on each foot, hold the wire (that is to be inserted into the driftwood) with a surgical clamp or vise grips.

Figure 171. After completing all of the toes, proceed to applying putty to the tarsus. Remember that the tarsus is scaled in front and smooth posteriorly.

After the feet are shaped and textured, place in their respective holes in the driftwood to harden.

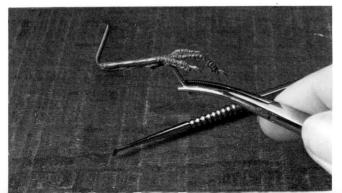

Figure 172. After the putty has hardened, put super-glue in the holes in the belly. Work quickly so that the super-glue does not harden before you get the bird properly positioned on its perch.

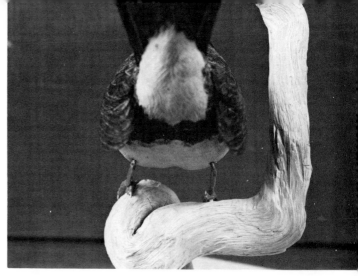

Figure 174. Check the positioning from all angles and views.

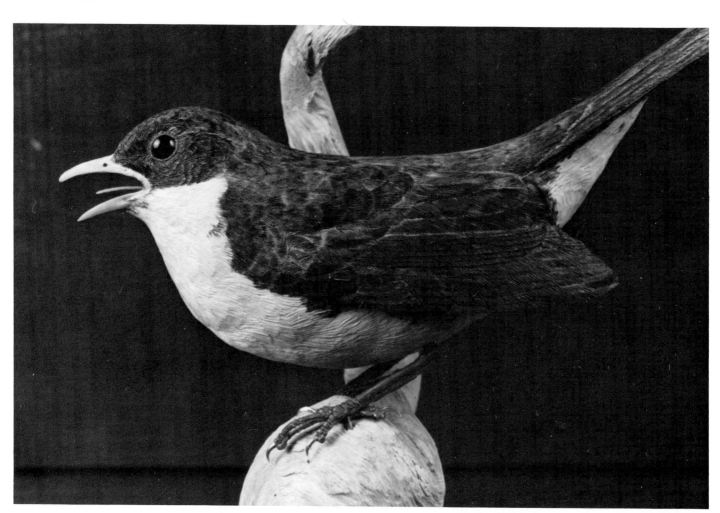

Figure 173. Place the tarsi in their respective holes in the belly and put the bird on its perch.

Figure 175. After the glue has hardened at the tarsal junction of the body joints, mix up a small amount of the Duro epoxy ribbon putty. Place a small amount at the point where the tarsus comes out of the body. There is a small tuft of feathers at the ankle joints of this and most other songbirds called leg tufts.

Figure 176. Work the putty around the entire joint of both tarsi. If the tarsus position is next to the belly, you may need to roll a dissecting needle or clay tool there to get the putty right up on the tarsus and a smooth, flowing transition to the belly. You will not need a big glob of putty for the leg tufts. It is amazing what a small amount you will need.

Figure 177. After the putty is placed around the circumference of the insertion point, begin texturing the leg tufts. You want to accomplish a short, bristly feather effect, using an **unheated** burning pen, dental tool or the pointed end of a clay tool. Try several of these to see which you can use the easiest for the best feathery effect. Pull the putty into the grooves of the stoning surrounding the insertion point. You want a smooth transition area between the belly and the leg tufts.

Allow the leg tufts to harden before proceeding to paint.

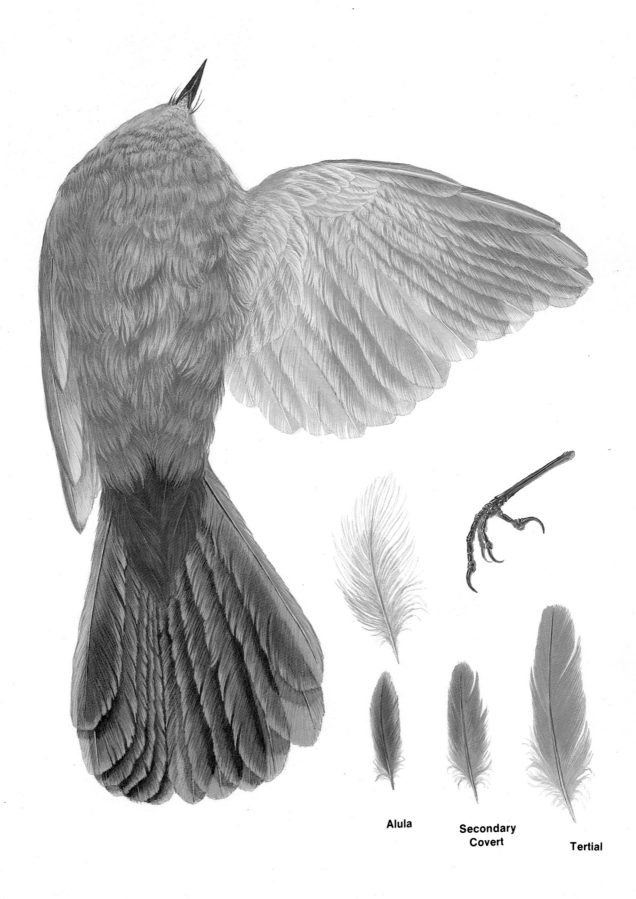

Alula

Secondary Covert

Tertial

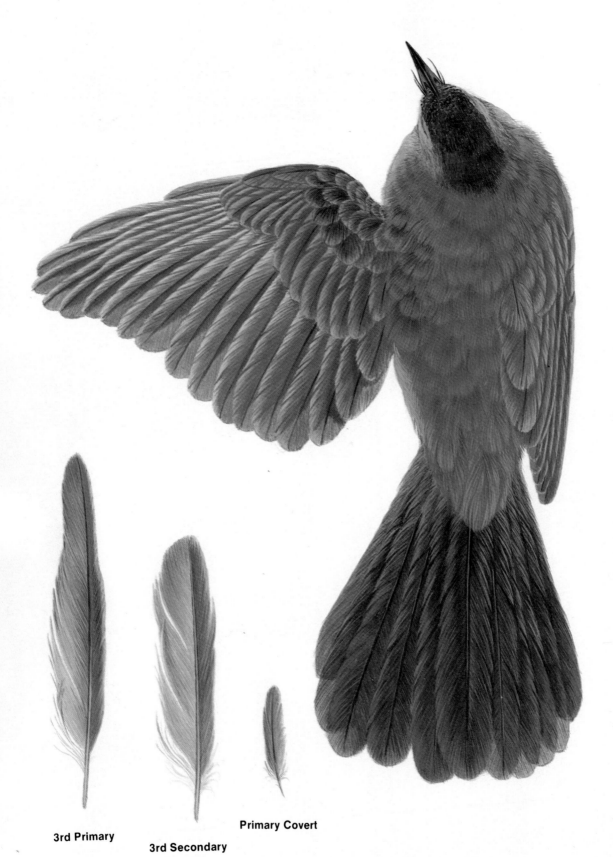

3rd Primary

3rd Secondary

Primary Covert

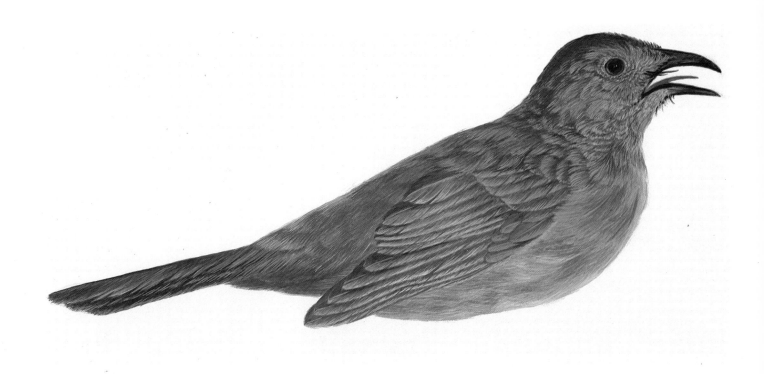

Black	Burnt umber	Raw umber	Payne's Gray
Burnt sienna	Cerulean blue	Yellow ochre	White

Head, neck, mantle, back

Raw umber
Payne's gray
White

While paint is wet work in black
on top of *head*

Wings

Raw umber
Payne's gray
White

Under tail coverts

Burnt umber
Burnt sienna
Yellow ochre

Use yellow ochre to lighten—
not white—as it turns pink

Feet

Burnt umber
White
Black

Wash with　White
　　　　　　Burnt umber
　　　　　　Yellow ochre

Upper tail coverts and *back*

Payne's gray
Raw umber
White

Tail—washes

Payne's gray
Raw umber

Last washes—Burnt umber

Under tail and *under primaries*

Burnt umber
Black
White

Inside mouth

Burnt umber
Payne's Gray
White

Along sides of *tongue* and
inside mouth—upper mandible
Burnt sienna

Dry-brush edges of *upper tail
coverts* and *back*

Payne's gray
Raw umber
White

Wash over *upper tail coverts*
and *back*
Payne's gray　　Raw umber & white

Belly—soft gray

Raw umber
Payne's gray
White

Beak

Black
Burnt umber
White

CATBIRD PAINTING

Figure 1. Here you see the subtle variations of grays on the catbird study skin.

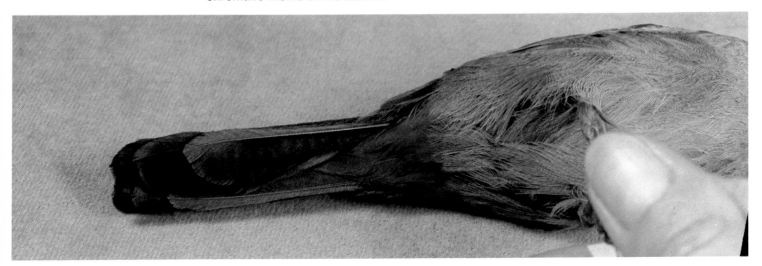

Figure 2. The lighter grays of the underside further exemplify the subtle variations in the generally monochromatic theme of the catbird.

Figure 3. One of the exceptions to the monochromatic theme is the splash of siennas on the lower tail coverts.

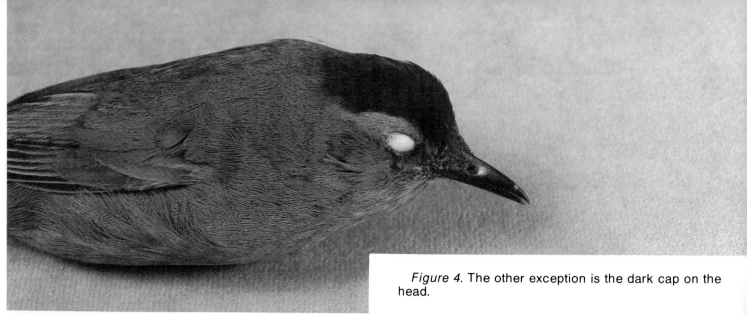

Figure 4. The other exception is the dark cap on the head.

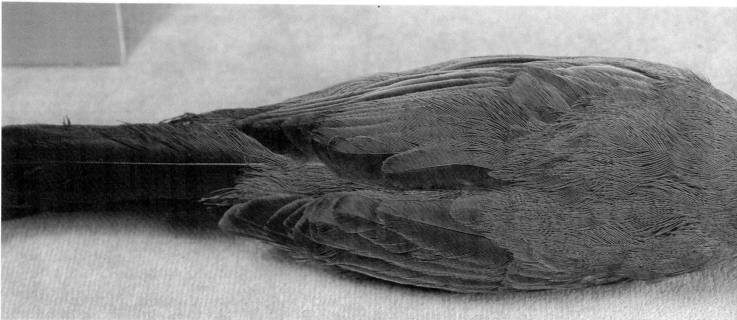

Figure 5. You see the broad expanses of the tertials and primaries on the plan view.

Figure 6. Applying gesso to the bird provides an even colored painting surface over the burned and stoned areas. Since gesso is a type of primer, it also ensures good adhesion for the application of subsequent layers of acrylic paint.

Using a stiff bristle brush such as a Grumbacher Gainsborough #5 (or equivalent), begin applying the gesso, working small areas at a time. Scrub the gesso down into the texture lines with a back and forth motion, rather than merely painting it on. Use a dry brush technique, leaving most of the gesso on your paper towel. Be careful not to leave any excess, especially on the edges of the tail and wings. Too much gesso will actually fill and obliterate the texture lines. Keep your brush damp, but do not use too much water, as it lessens the adhesive quality of the gesso. Dry brush the entire bird with the gesso, including the areas around the eyes and the feet. Usually two coats of gesso are sufficient. Use the medium heat setting of a hair dryer to dry the bird between applications.

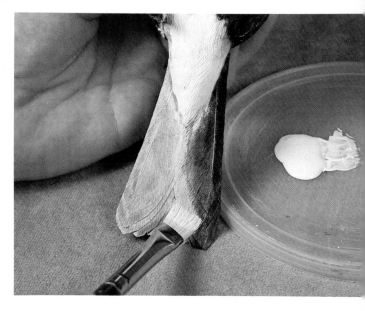

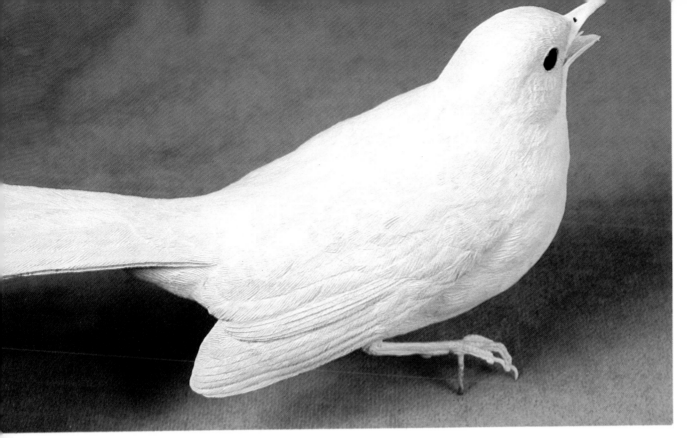

Figure 7. After the gesso is dry, CAREFULLY scrape the eyes, using the point of a sharp knife held at an angle. Cleaning the eyes periodically during the painting process enhances the lifelike quality of the carving, allowing a more realistic application of colors.

Figure 8. On the tongue and the inside of the beak and throat, paint burnt umber with small amounts of payne's gray and white. You will need to use a small brush to get to all of the contours around the tongue and the base of the throat.

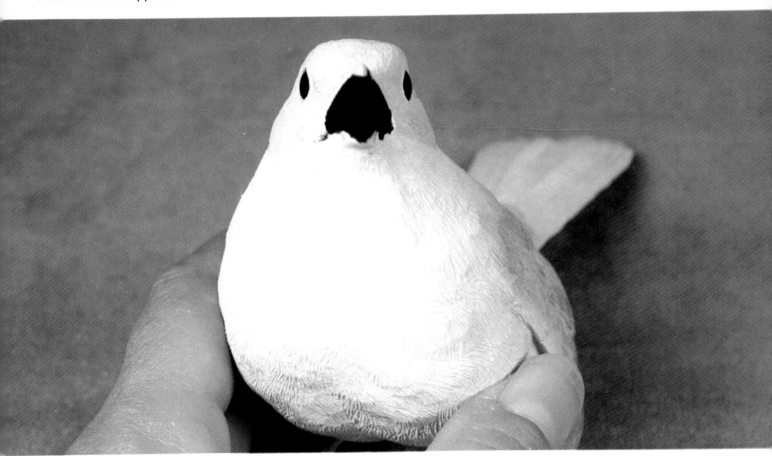

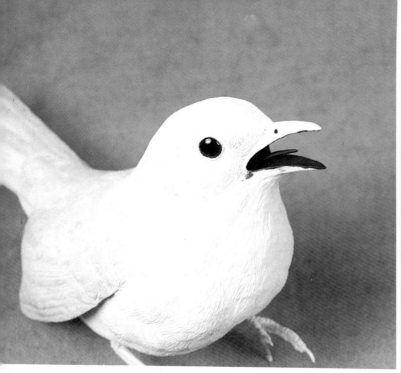

Figure 9. While the last base coat is still wet, wet-blend a small amount of burnt sienna along the sides of the tongue and the center crevice on the interior of the upper mandible.

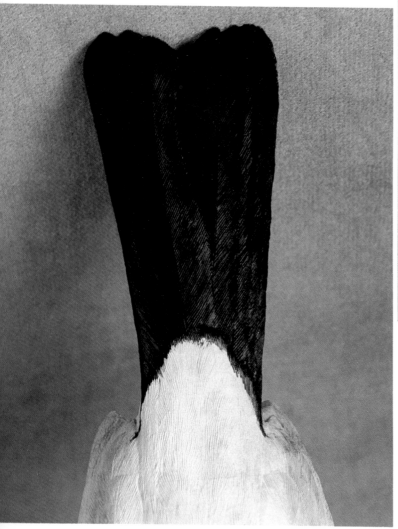

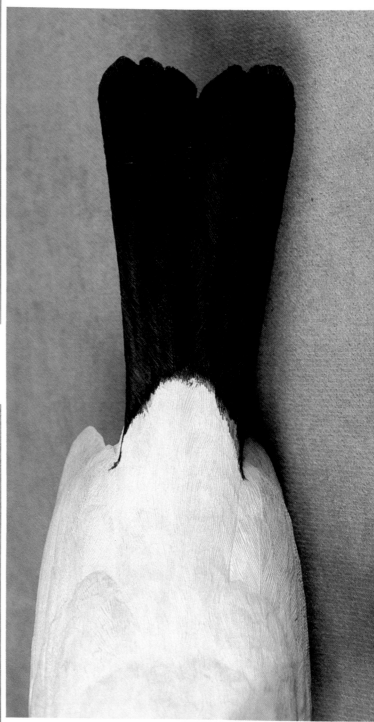

Figure 10. Blending payne's gray and raw umber to a rich black, base coat the upper surface of the tail feathers. It will take several applications to cover all of the white gesso. After the last base coat is dry, apply two thin burnt umber washes.

Figure 11. Mixing a small amount of white to the base coat color, dry brush the light edges on the outer sides of the base of the tail feathers near the upper tail coverts and the exposed trailing edge of the center feather.

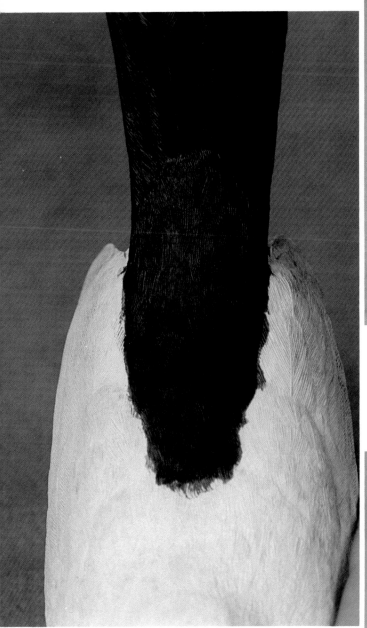

Figure 13. When the base coats are dry, add a little more white to the base coat mixture, and dry brush the edges of some of the feathers.

Figure 14. Apply a thin wash of raw umber, payne's gray and a small amount of white over the lower back and upper tail coverts.

Figure 12. On the upper tail coverts and the lower back, apply the base coats of raw umber and payne's gray with a small amount of white.

Figure 15. Combining raw umber, payne's gray and a small amount of white, apply the base coats to both wings. Keep your paint thin to avoid filling up the texture lines.

Figure 16. Apply a burnt umber wash to the primaries and the trailing sides of the tertials. Add a little more white to the base coat color to effect a rich medium gray. Dry brush the edges of the tertials, secondaries, wing bars (secondary coverts), alulas and the primary coverts. Adding a little more white to create a tint lighter gray, dry brush the edges of the primaries.

When the edgings are dry, apply a thin wash of raw umber, payne's gray and a small amount of white.

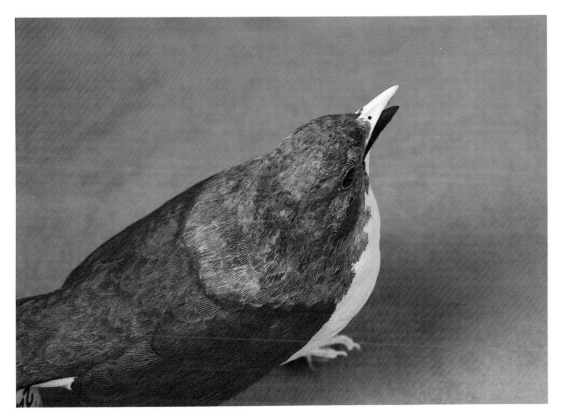

Figure 17. Blending raw umber, payne's gray and a small amount of white, apply a base coat to the mantle, upper back and head. You can see the base coats are very thin. The more thin base coats you apply in various shades and tints, the softer the area will appear. While the base coats are wet, begin working payne's gray onto the top of the head.

Figure 18. When you have sufficient base coats on the mantle, upper back and head, begin dry brushing raw umber, raw umber and a little white, burnt umber, burnt umber and a little white, payne's gray, and payne's gray and a little white. Make sure that you do not have very much paint on your brush. You are just adding a hint of these various colors on top of your base coat. If you start getting too light, work in more of the darker shades. If you start getting too dark, work in more of the lighter tints.

Apply a thin black wash to the top of the head.

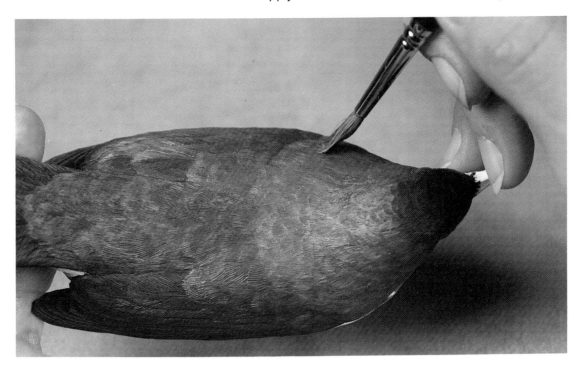

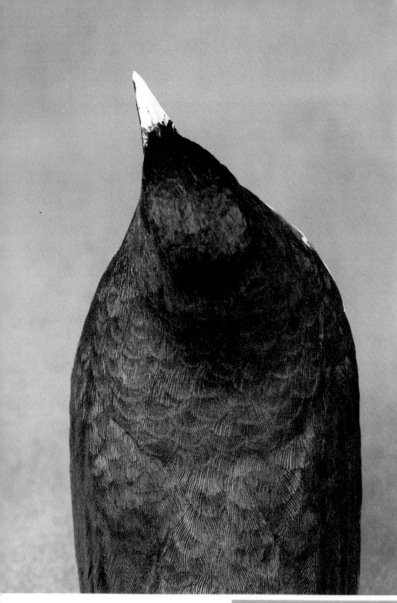

Figure 19. Adding more white and more water to the base coat color (raw umber, payne's gray and a small amount of white), paint in some of the edges on the feathers on the mantle, upper back and neck, using a small liner brush. Make sure your paint is very watery so just a hint of lightness appears on the semi-circular feather edges.

Figure 20. Mixing raw umber, payne's gray and white to a medium gray, apply the base coats to the belly, breast, under neck and chin. In the shoulder area, blend the lighter gray of the underparts with the darker gray of the upper back and mantle, by pulling the light color into the dark and the dark color into the light.

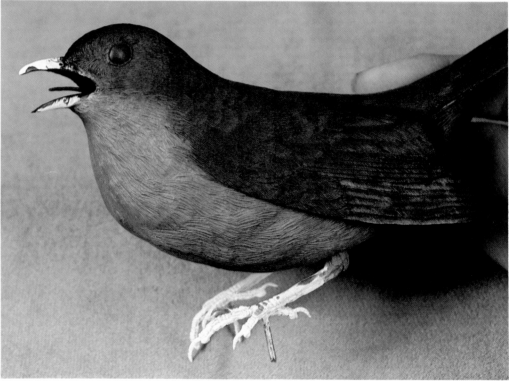

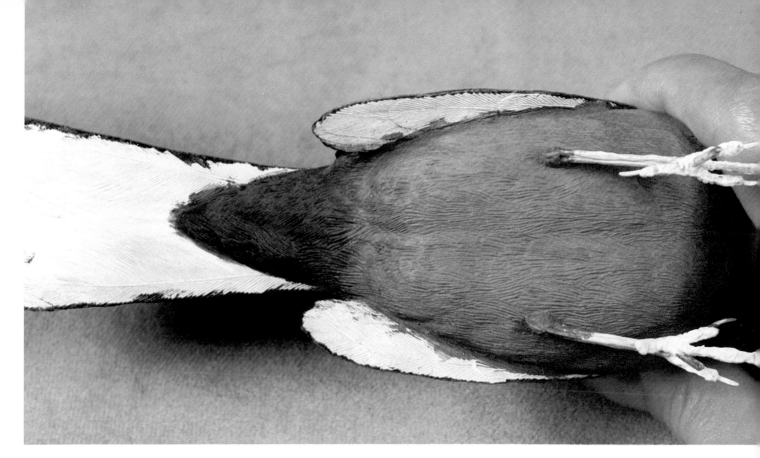

Figure 21. Mixing burnt umber and burnt sienna with a small amount of yellow ochre to lighten, apply the base coats to the lower tail coverts, blending into the gray base coats of the belly in the vent area.

Figure 22. Dry brush the edgings on the breast, belly, under neck and chin, using the base coat color with more white added. The lower tail coverts can be edged by dry brushing with white and raw umber.

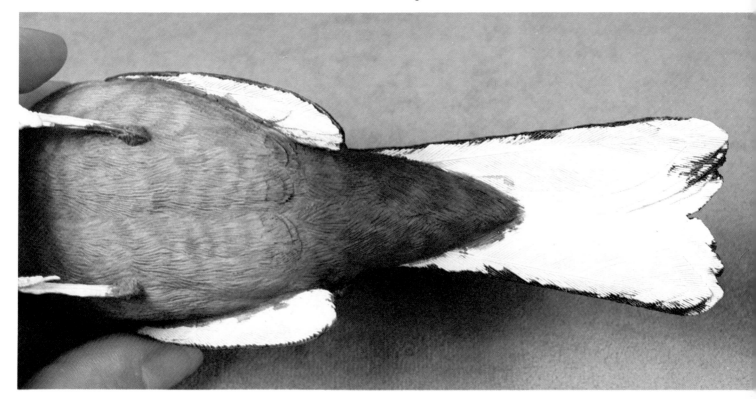

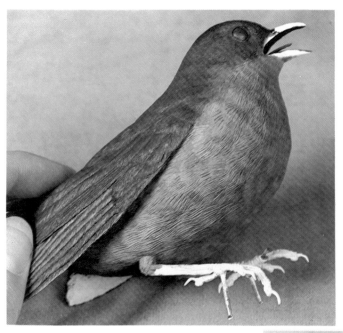

Figure 23. Make a watery wash of the belly and breast base coat color and apply over the light edgings. Wash back over the lower tail coverts with a watery wash of its base coat color.

Figure 24. Blending burnt umber, black and a small amount of white, apply the base coats on both the under tail and the underneath area of the primaries.

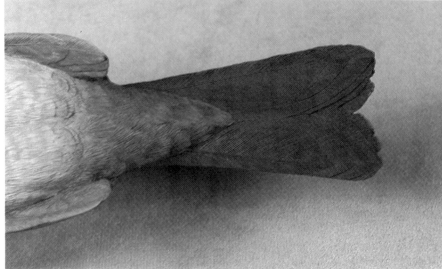

Figure 25. Apply a watery black wash on the under tail. On the underneath area of the primaries, apply a watery wash of burnt umber and white, achieving a silvery gray.

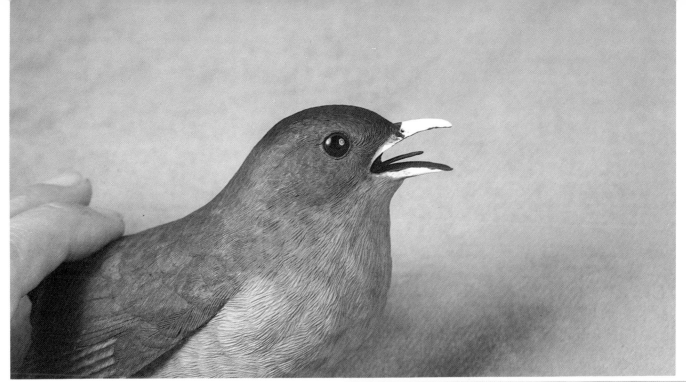

Figure 26. Carefully scrape any paint off of the eyes. With a small liner brush, apply a watery black wash inside of the eye lids.

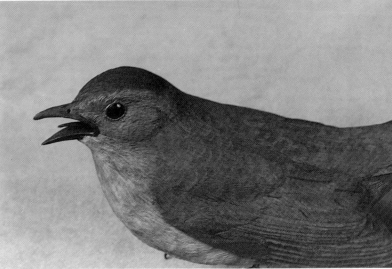

Figure 27. Adding small amounts of burnt umber and white to black, paint the outside of the upper and lower mandibles. Keep the paint thin so that you do not leave brush marks on the smooth surface.

Blending burnt umber and payne's gray to a very dark brown, paint the quills on both wings and the quills on the upper and under surface of the tail feathers.

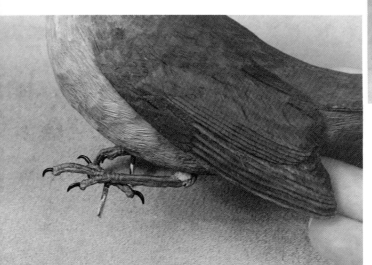

Figure 28. Blending burnt umber with small amounts of white and black, apply the base coats to the feet. Keep your paint thin so it does not fill the texture lines on the tarsi or toes. After the base coats are dry, apply a watery wash of burnt umber, white and yellow ochre. The claws should be painted a dark brownish gray made with burnt umber, payne's gray and a small amount of white. Brush the entire surface of the feet with a small amount of gloss medium added to a puddle of water, creating a slight sheen on the feet. The claws should be painted with straight gloss medium to effect a shiny surface.

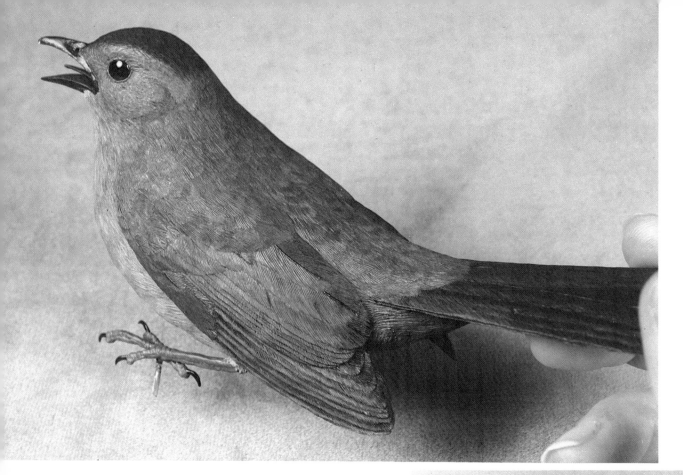

Figure 29. Apply a half and half mixture of matte and gloss mediums to the beak, effecting a satin gloss. Both gloss and matte mediums appear milky-looking when wet, but they dry clear.

With a small liner or scroll brush, apply straight gloss medium to the quills of both wings and to the quills of the upper and lower surfaces of the tail feathers.

Generally check over your bird for any areas that may need lightening or darkening. The feather splits on the wings and tail feathers can be darkened using very thin burnt umber and payne's gray.

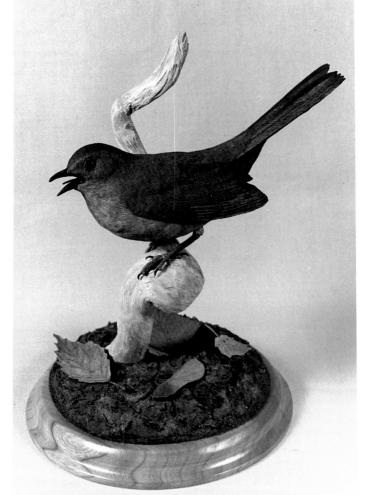

Figure 30. When you have finished painting the bird, you are ready to mount the completed carving onto the prepared driftwood. Mix up a small amount of 5-minute epoxy and glue the feet in their respective holes. If any of the glue should seep out of the holes onto the surrounding driftwood, it can be touched up with acrylic paint after the glue has hardened.

Habitat

The more knowledge one possesses about a bird—its behavior and habitat—the more realistically the carver can portray it. Knowing how to mount a bird in its natural habitat requires knowledge of the specie's natural environment. For example, putting a chickadee carving on a sandy shore setting would be, in general, inappropriate to its natural habitat. Researching your subject cannot be stressed enough. What the carver knows about birds, their habitats and environment is crucial in creating the most natural and realistic setting.

The habitat for a carving can be as simple as a single blade of grass or as complex as an entire slice of mountainside. A naturalistic setting should complement the bird, not overpower it. Adding pieces of habitat that reflect colors or shapes of the bird will enhance the entire composition.

When you are duplicating natural settings, it is helpful to have models to work from. When working on leaves, for example, it is easier to paint them realistically if you have actual leaves to study. While walking through the woods or parks, observe, sketch and photograph bits and pieces of nature that you want to include in a habitat setting.

Figure 2. Assortment of acorns.

Figure 3. Holly sprig.

Figure 1. A variety of fall leaves.

Figure 4. A maple seed and a small weed seedling.

Figure 5. To keep the routed-edge or turned base from getting blemished when working on the setting, prepare the ground separately. After completing the setting, attach the ground to the base. A 1/4" piece of plywood or masonite slightly smaller than the routed-edge base will be needed for the ground. A piece of paper trimmed to coincide with the base's shape can serve as a pattern for the plywood cut-out.

Figure 6. For a turned base, use a compass to determine the diameter of the plywood cut-out. Make sure it is slightly smaller than the turned base.

Figure 7. After tracing the pattern of a freeform base or drawing the diameter with a compass for a turned base, cut out the plywood using a bandsaw, jigsaw or coping saw.

Figure 8. Checking the size of the cut-out. Round over the edge using the flexible shaft machine with a tootsie-roll sander.

Figure 9. Holding the plywood in position on the base, drill two holes slightly larger in diameter and deeper in length than two shortened aluminum nails. The length of the nails should be longer than the depth of the plywood but not through the base. One-half inch long nails are sufficiently long for holding 1/4 inch plywood in place. After measuring the length of the nails, place a piece of masking tape on the drill bit to ensure that the proper depth will be drilled. At least two nails and holes are needed to hold the ground in place. For a large base and ground (more than 6 or 7 inches), you will need 3 or more nails, depending upon the size and shape of the ground.

Figure 13. Mix burnt umber acrylic paint with sufficient modeling paste to make a medium brown mixture. Another color could be used to create a special colored ground.

Figure 10. With the nails holding the plywood in place, mark and drill the holes in the piece of driftwood. Clip the wires in the driftwood so they are 1/4 inch in length.

Figure 14. To provide texture, add sand to the modeling paste mixture. Pencil shavings, sawdust or wood shavings can also be used.

Figure 11. Using 5-minute epoxy, glue the driftwood to the plywood and the heads of the nails. Be careful that none of the glue seeps down the nail or pin holes and glues the plywood to the base. The plywood must be removable so further work can be done without marring the turned base.

Figure 12. After the glue has hardened, remove the plywood from the base. While you are finishing work on the plywood, intermittently apply several varnish coats to the base.

Mix a sufficient quanity of autobody compound to cover the base. This is the kind used to fill dents in cars and found at most auto supply stores. Apply to the plywood. Quickly shape the autobody into naturalistic contours.

Figure 15. Apply the sand and modeling paste mixture over the autobody on the plywood. Using a hair dryer on a medium setting, let the modeling paste dry until it is slightly crusty on top but still moist underneath. Allow three to four minutes for drying. Using a knife or dental tool, shape the surface until you have naturalistic contours. If you put the modeling paste on very thick (1/4 inch or more) in some areas, it will crack as it dries, simulating the cracks in dry earth. Allow it to dry several days before further painting. If the modeling paste is thin, overnight drying is usually sufficient.

Figure 16a and b. Notice that the color of the ground is a medium value brown. You can see the cracks in the modeling paste that resemble cracks in dry earth.

16a

16b

Figure 17. Apply a very watery burnt umber wash, letting it soak into the cracks and crevices. For faster drying, use a hair dryer on a medium setting.

Figure 18. After the wash is dry, dry brush burnt umber around the edges of the base. Blending white with a small amount of burnt umber, dry brush the raised portions of the ground, by dragging the flat of the brush along the surface. Other colors may be added, such as white with yellow ochre or white with burnt sienna, to highlight the contours of the ground, depending upon the desired color scheme of the entire composition. For example, in a carving of a goldfinch, you want to reflect some tint of yellow in your ground. Once you apply the highlights, you see the depth created in the ground.

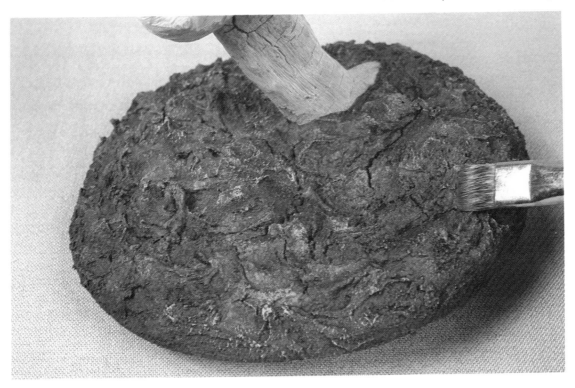

LEAVES

In the fall when leaves are the most vibrant colors, collect as many kinds, shapes, colors and sizes as you need. Preserve them for future use, by placing them in a phone book with several pages in between. Weight them with a heavy object and allow several weeks to dry. The colors will not stay true to life; however, there will be sufficient color from which to paint.

Figure 21. Using a stack of newspapers as a cushion for the leaf, press the veins in with a dull awl. Contour the leaf with your fingers to whatever shape you need for the habitat.

Figure 19. After cutting out a leaf pattern, trace it onto 36 gauge copper and cut out with scissors. Brass may be used, but since it is somewhat more brittle, the leaf will be more difficult to shape. Thin gauged copper can be purchased through mail-order art supply companies or at large craft stores.

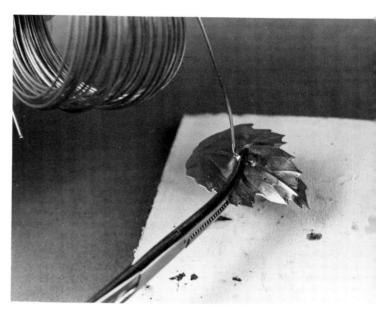

Figure 22. On the back of the leaf at the attachment point, solder a small piece of angled copper wire (see soldering tips). Cut the wire 1/4 inch long. After the leaf is painted, a hole can be drilled in the ground and this wire inserted using super-glue to firmly anchor the leaf.

Figure 20. After the leaf is cut out, press the crinkled edges out flat on a board using a dental or clay tool.

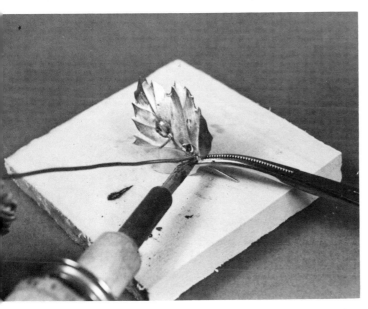

Figure 23. Solder a short piece of wire to the base of the leaf to simulate a stem.

Figure 26. Using a tongue depressor or popsicle stick, burnish the edges of the strip smooth.

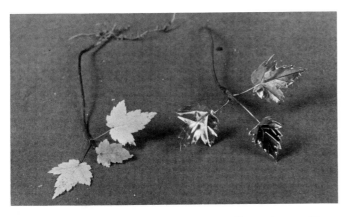

Figure 24. On the left, you see a small maple seedling. On the right is a copper simulation of that seedling, fashioned using the same techniques: cutting out a pattern, cutting out the copper, smoothing the edges, pressing in the veins, shaping the contour and soldering the stems together.

GRASSES

Figure 25. Cut grass blade-shaped strips from a sheet of 36 gauge copper or brass.

Figure 27. Using a stack of newspapers as a cushion, press the midline vein in with a dull awl.

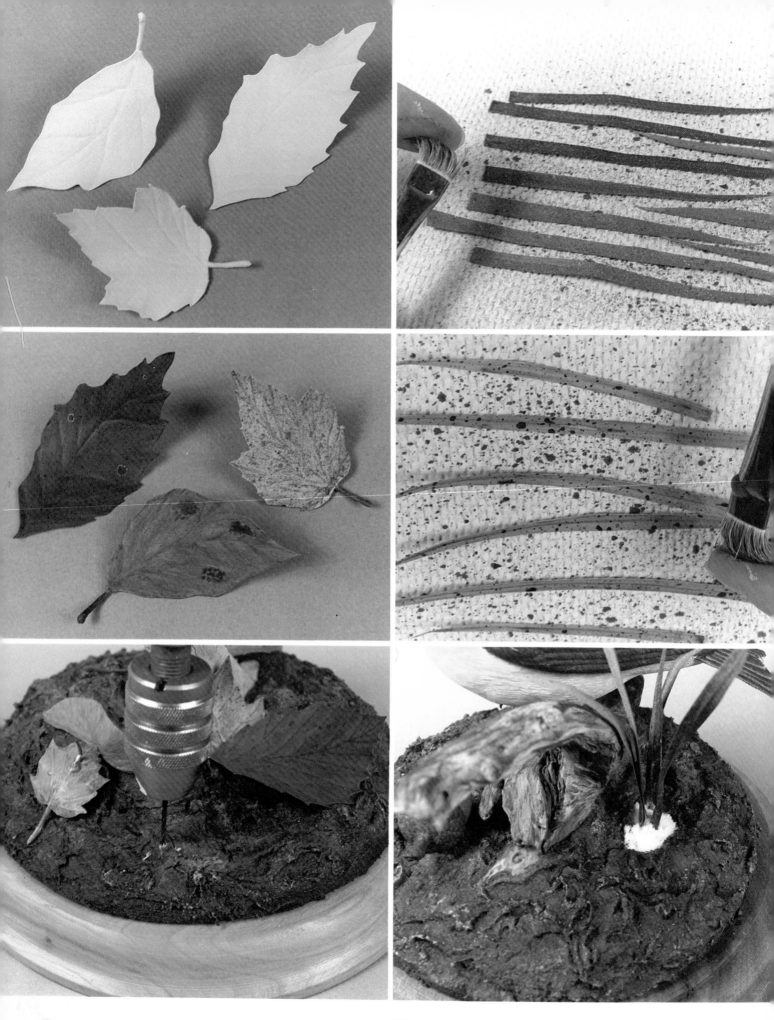

LEAVES

Figure 28. After heating a leaf cut-out with a hair dryer, apply several thin coats of gesso until the copper is solidly covered.

Figure 29. Base coat a reddish leaf with napthol crimson mixed with a small amount of raw umber. Darken the veins using a small liner brush and burnt umber. Highlight selected areas between the veins with a combination of very thin white and raw sienna lightly dry-brushed. Using a short, stiff-bristled brush and watery black paint, splatter the surface of the leaf by raking your finger across the ends of the bristles.
Base coat a brown leaf with several coats of burnt umber and raw sienna. Darken the veins and stem with burnt umber. Highlight the areas between the veins with a mixture of very thin white and raw sienna lightly dry-brushed. Lightly splatter burnt umber over the surface.
A yellow-green leaf should be edged with a scant amount of napthol crimson combined with burnt umber. Apply very thin washes of blended cadmium yellow light and raw umber until you have a very subtle yellowish green color. Using a liner brush, darken the veins with very thin raw umber. Blend raw umber with just a hint of payne's gray and lightly splatter the leaf surface .

Figure 30. Drill a hole in the prepared ground and using super-glue, attach each leaf in place.

GRASSES

Figure 31. After applying several coats of gesso, blend chromium green oxide and cadmium yellow light and apply to some of your grass blades. Apply chromium green oxide and burnt umber to others. Apply a mixture of chromium green oxide, cadmium yellow light and white to still others. These three blends will give you three different values creating clumps of grass which will appear more realistic. Add details such as darkened edges and veins with watery burnt umber. To splatter, draw your finger along the end of a short, stiff-bristled brush loaded with watery black and burnt umber.

Figure 32. After several coats of gesso, apply washes of raw sienna, small amounts of blended burnt umber and white for a dry grass look. Details such as darkened edges and veins are added with watery burnt umber. Splatter the group of grass blades with a watery mixture of burnt umber and black.

Figure 33. Roll the base end of each blade into a tight circle using small needle-nose pliers and your fingers. Drill a hole sufficiently large enough for the number of blades of grass you intend to insert. Fill the hole three-quarters full with super-glue. Insert the blades of grass and sprinkleenough baking soda to absorb the super-glue. After allowing several minutes for this to harden, blow off the excess. Touch-up the baking soda area with acrylic washes corresponding to the colors of the surrounding ground.

SMALL ROCKS

Figure 34. Place a small amount of Durham's Wood Putty in a plastic or paper cup. Add a small amount of water, a little at a time.

Figure 35. Stir and keep dropping water into the putty until it begins to clump together. You will notice that there are many irregularities on the simulated rock's surfaces, just as with natural ones. Smooth pebbles are created by molding the surface between your fingers.

233

Figure 36. Before the rocks dry, put short pieces of wire into the larger ones. The wires will enable you to anchor the rocks firmly to the prepared ground. After the rocks are dry, brush off any putty that remains on the surface.

Figure 38. Split the shaped seed to the proper thickness as the real seed.

SUNFLOWER SEED

Figure 37. Trace the outline of a sunflower seed onto a small piece of basswood, with the grain running the length of the seed. Using a sharp knife, carefully trim away the excess wood around the perimeter.

Figure 39. Thin the outer edges. After the rough contours are shaped, super-glue the seed to the sharp end of a clay tool or dissecting needle, which will allow you to sand and paint the seed more easily.

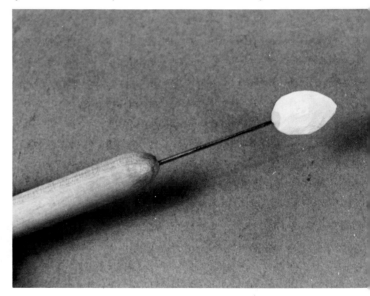

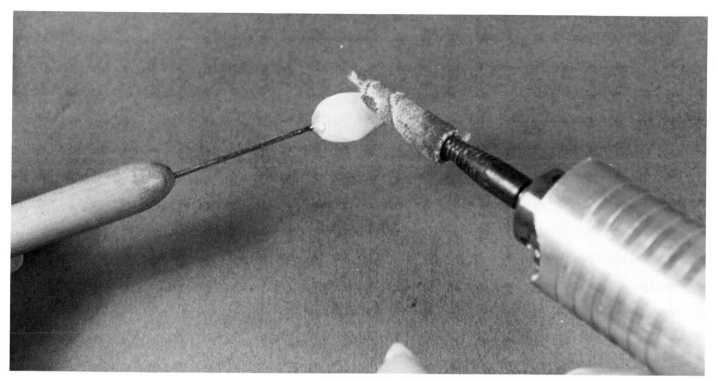

Figure 40. Carefully sand the seed with the flexible shaft machine and a worn tootsie roll at slow speed. To seal and harden the seed, coat it with super-glue and allow to dry. Fine sand with a piece of 320 abrasive cloth.

ACORNS

Figure 41. Cut small blocks of basswood slightly larger than the size of a real acorn.

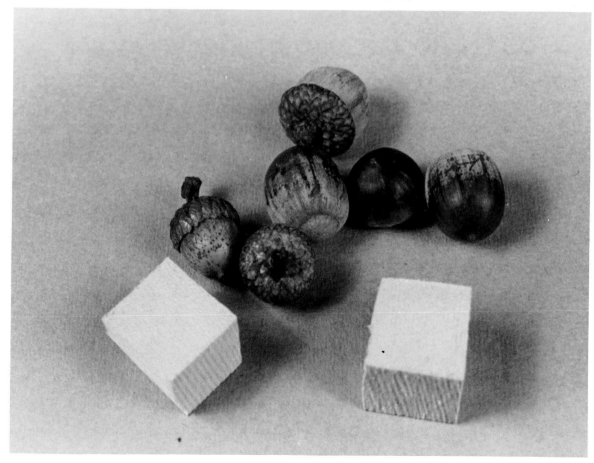

Figure 42. With a knife, cut the square block into a round cylinder with the grain running the length of the cylinder. Punch a hole in the center of the end of the cylinder with an awl.

Figure 43. A small screw-type mandrel will hold the acorn to be turned on the flexible shaft.

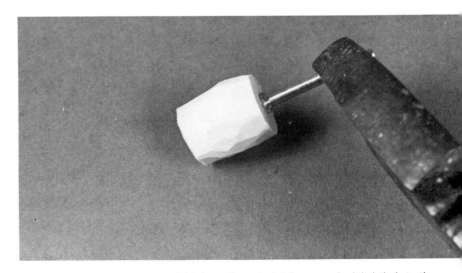

Figure 44. Using pliers, twist the mandrel tightly into the starter hole.

Figure 45. Place the mandrel into the handpiece of the flexible shaft machine. You will need to wear goggles and mask for this procedure. Holding a bench knife at a 90° angle to the surface of the cylinder, **carefully** rough shape the acorn, running the machine at a **slow, steady pace.** The knife will not actually cut the wood but rather it will scrape it as it is turning.

Figure 46. When you have the acorn rough shaped, hold a piece of 100 grit abrasive cloth to the slowly turning acorn to round its contours and finish obtaining the proper shape. Proceed to use progressively finer cloth until the acorn's surface is as smooth as possible.

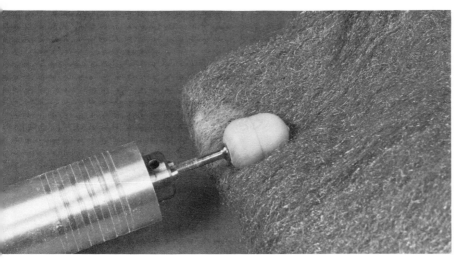

Figure 47. Polish the surface of the acorn by holding it lightly against fine steel wool with the flexible shaft machine running at medium speed. Be careful not to burn your fingers, by too high a speed.

Figure 48. With the burning tool pen on medium heat, lay it at an angle and burn in the rounded diamond pattern on the cap.

Figure 49. Super-glue a short piece of wire into the mandrel hole in the cap. Mix a small amount of Duro ribbon epoxy putty to an even green color. Using a clay or dental tool, shape the stem, using the short piece of wire as an armature, and keeping in mind, the stems of acorns usually have a crinkled texture. Allow to harden, about four hours, before painting.

MAPLE SEEDS

Figure 50. Use a real maple seed as a model. On 36 gauge copper, trace first one side and then the other side, producing the two halves. When you cut the seed out, leave the top and bottom connected as shown in the photograph.

Figure 51. Using a dull awl and a cushion of newspaper, press in the details of the veins.

Figure 52. Melt a small puddle of solder on the *head* of one side.

Figure 53. Fold the seed together and hold with alligator clips. Apply paste flux to the edges of the seed which will draw the solder into them. Solder the edges of the seed together.

Figure 55. This holly berry is made of molded Duro ribbon epoxy putty. After mixing the putty, roll it between your fingers to a slightly elongated, round shape. Put a short piece of wire into one end and push the putty tightly against the wire.

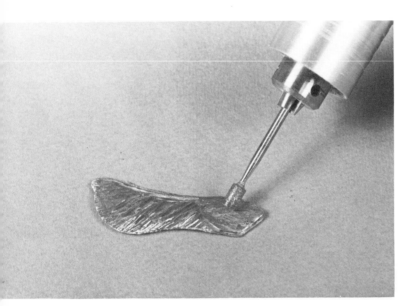

Figure 54. When the seed is cool enough to handle, use a sharp-edged stone on the flexible shaft machine to smooth any lumps of solder and to apply more texture if needed. Shape the thin, ripply edge with your fingers.

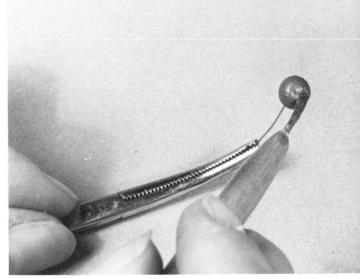

Figure 56. After allowing the putty to harden **slightly** for approximately an hour, contour the little nub on the tip and the small cap on the base. Allow to harden completely before painting.

Figure 57. Apply a watery wash of raw umber to some, a wash of black to others and a wash of medium gray (black, burnt umber and white) to still others. The watery washes will soak into the cracks and crevices, darkening them.

Figure 58. Dry-brush the highlights using either raw sienna, yellow ochre or burnt sienna and white. To enhance the realism, splatter them with white and then with payne's gray.

After the rocks are dry, drill a hole and using super-glue attach into the prepared ground.

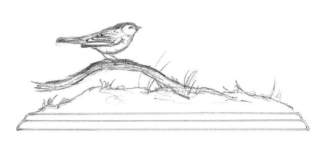

HORIZONTAL COMPOSITION

Rules of thumb:

1. Determine the visual length of your composition.
2. Add the focal point which can be on the right or left side, with the length on the opposite side or exactly in the middle with equal lengths on either side.
3. Add components around focal point to create dimension; stay within established lines.
 * When using the horizontal configuration, keep in mind transporting the piece; try to keep extensions relatively strong to avoid breakage.

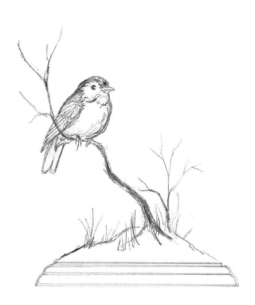

RIGHT ANGLE ASYMMETRICAL COMPOSITION

Rules of thumb:

1. In this configuration, the length is usually not as long as the height; a right angle arrangement can be high left, low right or high right, low left.
2. Add focal point, achieving as much depth and dimension as possible.
 * The carving does not always have to be the focal point as in well-camouflaged birds.
3. Add components, keeping all materials within the right angle pattern.

* Note.
 1. Keep proportional sizes of pieces in the composition.
 2. A great deal of habitat need not be added to the base of a piece.
 3. Keep in mind anything included in the habitat will be observed and in competition, will be judged.

SUNFLOWER SEED

ACORNS

Figure 59. After several coats of gesso, wash in the dark areas of the seed using a small liner brush with burnt umber, black and a small amount of white. The light areas should be washed with white and a small amount of raw umber. Each sunflower seed is different. Refer to a real one for determining the light and dark areas.

Figure 61. The primer coats for the acorn are gesso with a small amount of raw sienna. A pin vise or vise grips can be used to hold the acorn during the painting procedure. Carefully *snug up the jaws* around the stem of the acorn.

Figure 60. When the light and dark areas are dry, apply several **very watery** raw umber washes.
Remove from the tool and super-glue onto the habitat.

Figure 62. It is helpful to have a real acorn to use as a model. The base coats for the entire acorn are burnt umber and white blended to a medium value. After the base coats are dry, dry-brush a small amount of raw umber on the nut part of the acorn. Dry-brush a light value of burnt umber and white, drawing the brush from the cap to the tip of the nut. The speckled areas should be dabbed with a small liner brush and watery burnt umber and black.

Figure 63. To leave a slightly reddish cast to the nut, apply a **very watery** wash of burnt sienna and raw sienna.

Figure 65. Drill a hole into the acorn and attach a small piece of wire with super-glue. Decide on the acorn's placement on the habitat and drill a small hole.

Figure 64. After removing the acorn from the holding device, the gesso primer coats and the medium value burnt umber and white base coats should be applied to the stem. When these are dry, apply a watery wash of burnt umber mixed with a small amount of black. This watery wash will sink into the texture lines of the cap and stem. Dry-brush white combined with raw sienna for the highlights on the cap. The stem is slightly darker than the cap, and will need another wash of burnt umber with a small amount of black.

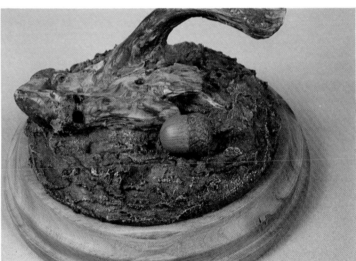

Figure 66. Attach the acorn in place with super-glue.

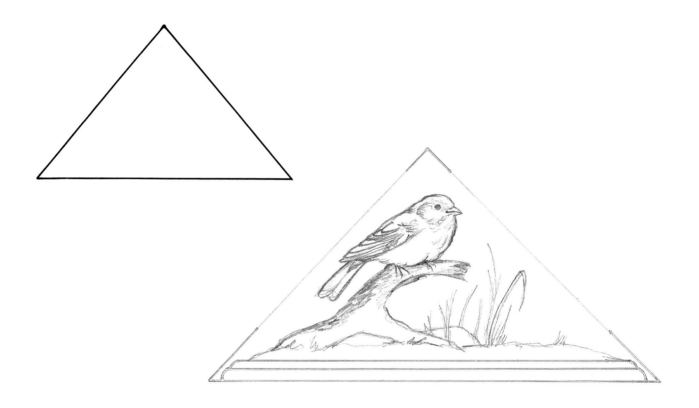

TRIANGULAR COMPOSITION

Rules of thumb:

1. Arrange habitat components and carving in a manner that the width is no greater than the height.
 * Subtle modifications can be imposed to emphasize the carving but do not lose the balance.
2. With the carving as the focal point, achieve as much weight and dimensions as possible.
 * The carving does not have to be the high point: height can be achieved by a piece of driftwood, a branch or a flower.
3. Fill in with habitat components indigenous to the subject; follow the triangular shape; be careful not to get too top heavy.

LAZY "S" CURVE COMPOSITION

Rules of thumb:

1. There is a balance between the "a" and "b" sections of the curve.
2. The visual aesthetics are established by having the focal point in the lower center of the total composition.
 * Point "a" will create a visual balance to the focal point.
3. Select additional components to balance out the "S" line patterns.

MAPLE SEEDS

BERRIES

Figure 67. After several primer coats of gesso tinted with a small amount of raw sienna, apply several base coats of burnt umber and a small amount of white to the dark seed head and along the thicker edge. When the base coats are dry, add more white to the base coat color and dry-brush over the darker value. With a small liner brush and watery paint, add detail lines radiating from the inner part of the seed head to its edge with the following six colors: (1) burnt umber, (2) burnt umber plus white, (3) raw umber, (4) raw umber plus white, (5) raw sienna and (6) raw sienna plus white.

Figure 68. Base coat the thin, ripply part of the seed with a combination of raw umber, white and a small amount of burnt sienna. Apply a very watery wash of burnt umber to soak down into the texture valleys. With a liner brush and watery paint, add detail lines flowing from the heavier dark edge to the thin, ripply edge with the following six colors: (1) burnt umber, (2) burnt umber plus white, (3) raw umber, (4) raw umber plus white, (5) raw sienna and (6) raw sienna plus white. When the detail lines are dry, apply a watery wash of chromium oxide green and white over the thin part of the seed.

Super-glue the seed on the habitat.

Figure 69. After several primer coats of gesso, apply the base coat washes of napthol red light and a small amount of raw sienna. Dry-brush the highlights using very watery napthol red light and a small amount of white. Apply a very watery wash of straight napthol red light.

For the little nub on the tip of the holly berry, use burnt umber and a small amount of black. For the cap and the stem, use a wash of chromiumoxide green, cadmium yellow light and a small amount of white.

Super-glue into the desired position on the habitat.

HABITAT REFERENCE PHOTOS

Figure 70. Sunflower seeds.

Figure 71. Grass spring.

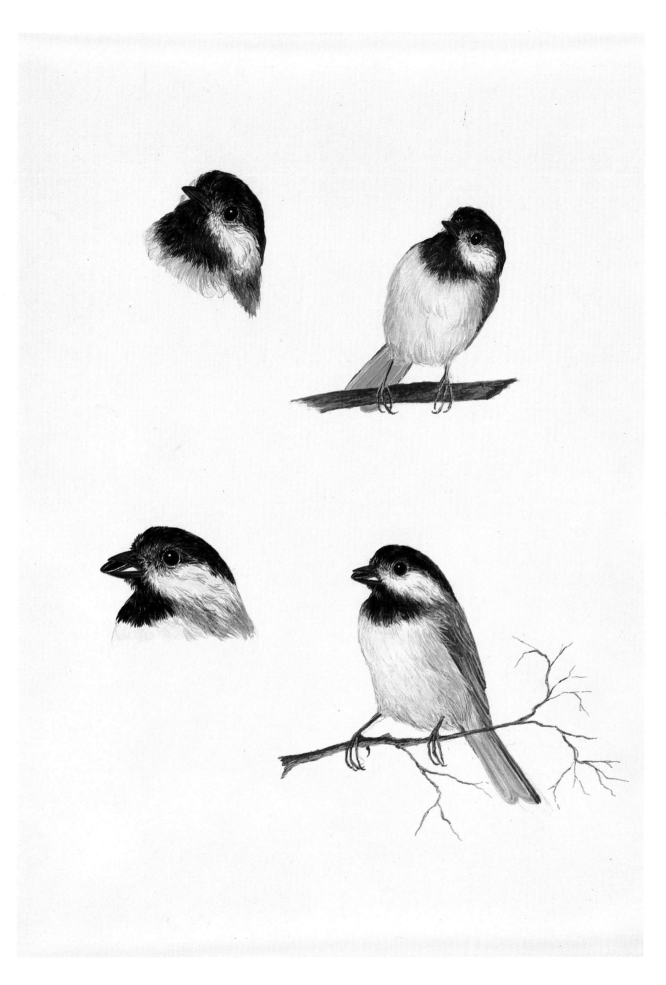

Chapter 9
Altering Patterns

With a simple profile pattern, reference measurements, a ruler and knowledge of the bird's anatomy, there are many variations of positions you can create. The tail, head and wing positions, all can be altered. There are four procedures for altering the basic pattern: (1) profile view tail position, (2) wing position, (3) head position, and (4) width of tail.

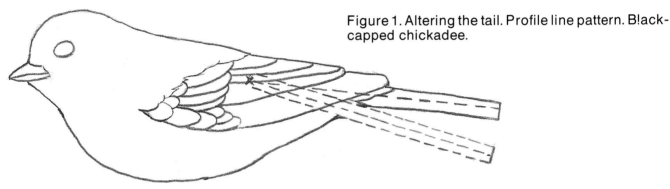

Figure 1. Altering the tail. Profile line pattern. Black-capped chickadee.

Figure 1. The black-capped chickadee is used as an example here. To alter the tail position, measure 2.7 inches (the overall chickadee tail length) from the end of the tail in toward the body and make an "x" here. You have located the attachment or origin point of the tail to the body. Using the "x" or origin of the tail, you can tip the tail up or down using the 2.7 inches measurement as the length. The primaries can remain folded on the back, creating a unique effect. The broken line marks the new pattern position for the tail.

If you leave the head in the basic position, the direction of the wood grain will have to be considered. Since the tail is long and fragile, run the grain in the direction of the tail's length. This will leave only the beak slightly cross-grain. Since the chickadee's beak is not very long, nor slender, it will not be too difficult to carve the beak slightly cross-grain. Carving the tail cross-grain would be much more difficult.

The plan view would be the same as for the original profile line pattern.

Figure 2. Dropping the wings. Profile line pattern.

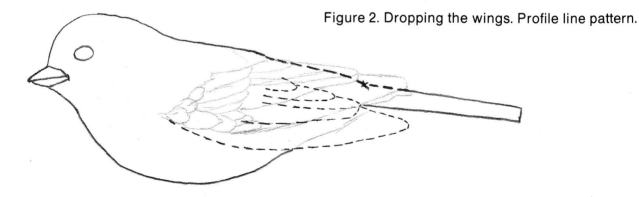

Figure 2. To drop one or both wings along the sides of the bird, trace the wing and darken the drawing lines on the reverse side of the tracing paper using a soft lead pencil. Lay the wing tracing with the darkened lines down on top of the basic profile pattern. Using the front of the wing as a pivot point, drop the end of the wing tracing down to the desired position. Using a hard lead pencil, trace along the lines of the major wing groups. This will

transfer a noticeable amount of the soft lead on the reverse side of the tracing to your new pattern, shown as a broken line on Figure 2.

Dropping the wings of the bird will expose the upper tail coverts and lower back. Measure and mark the end of the tail to the end of the upper tail coverts, place a small "x" as in Figure 2, and draw in the upper tail coverts and lower back.

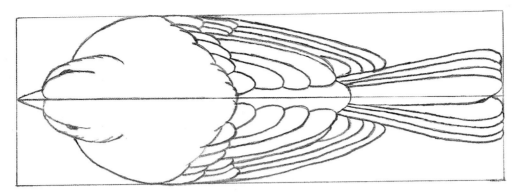

Figure 3. Dropping the wings. Top plan view line pattern.

Figure 3. The plan view pattern needs to be altered to allow for the dropped wings. To do this, trace the basic plan view pattern excluding the wings. On the tracing, measure and mark the end of the tail to the end of the wing measurement, (1.2 inches in the chickadee example). Measure and mark the end of the primaries to the end of the secondaries, .5 of an inch. Draw in the edge of the primaries to the widest part of the bird near the edge of the mantle. Draw in the secondary line. Using the basic plan view pattern as reference, measure and draw in the tertials, secondary coverts, alula and primary coverts.

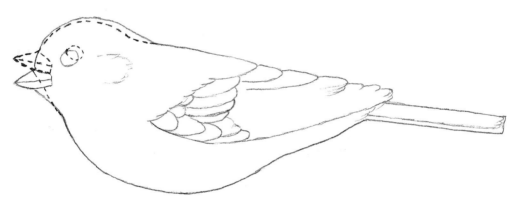

Figure 4. Altering head position of black-capped chickadee.

Figure 4. To alter the basic head position, trace the basic profile line pattern. On another piece of tracing paper, trace the head only. On the reverse side, darken the lines with a soft lead pencil. Place the head tracing over the head of the whole bird tracing from the profile line pattern. Pivot the head until you have the head tilted either up or down as desired. Using a hard lead pencil, trace the new head position. The basic plan view can be used when you change the profile head angle.

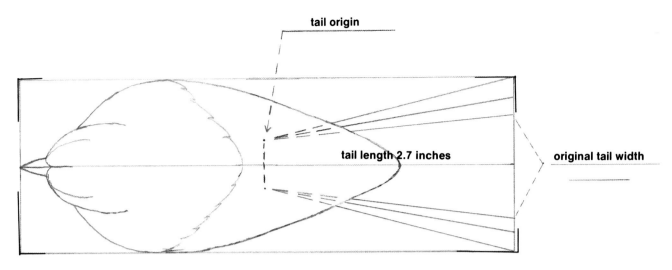

tail origin

tail length 2.7 inches

original tail width

Figure 5. Altering tail width on black-capped
chickadee top plan view.

Figure 5. The width or flair of the tail can be changed using the basic profile pattern. To angle the tail higher or lower than the basic one, you must alter the tail of the profile pattern. Any tail **width** alterations will involve the **plan view** pattern.

Trace the outside dimension block and the basic bird outlines, excluding the tail, from the basic top plan view pattern. Measure the tail length (2.7 inches) from the end line. Allow .5 of an inch for the width of the tail attachment to the body of the bird. Using a ruler, draw a new tail width. On the drawing, you can see two possible tail widths.

With this plan view, the widest possible tail width would be 1.8 inches. To extend the tail more than 1.8 inches, a wider block of wood must be used.

In addition to the chickadee, the other four birds can be altered similarly. You can lower the tail on the catbird, for example, or drop the wings on the goldfinch. The possible combinations are many. By making alterations on a pattern, you will be creating a new pattern.

Once you have carved a bird in the basic position, you can begin to experiment and create your own composition. Find an interesting piece of driftwood for the base and decide on a new position for one of the five songbirds. Alter the pattern to fit the setting and new driftwood.

Glossary

alligator clips. Small, jawed clips that hold two surfaces or parts together.

alula. Feathers that are on the thumb of a bird.

anatomy. Study of bone and muscle structure with particular regard to its effect on the appearance of surface forms and contours.

anterior. At or toward the head of the body; forward.

apterium. Tract of skin where no feathers grow.

arc. A portion of curved line.

armature. Framework or skeleton used to support clay, wax or epoxy putty.

asymmetrical. Not corresponding in form, size or arrangement of parts on either side of a center line.

attitude. A position or action of the body or part of the body.

awl. A small, pointed tool used to make holes or marks.

axillar. Pertaining to the armpit.

axillaries. Lengthened feathers originating in the armpit of a bird.

back. Upper surface of the body proper.

balance. An equal arrangement of various elements.

bar. Any crosswise color-mark perpendicular to the body's long axis.

barb. That part of the feather growing from the shaft.

beak. Bill.

belly-abdomen. That part between the breast bone and the vent (anus) of a bird.

bend of the wing. Angle formed at the wrist in the folded wing.

bevelled. Having two surfaces meeting at an angle.

blank. A block of wood bandsawed in the rough shape of a bird or animal.

blending. A method of painting in which one color gradually merges with another; the process of mixing one color with another.

booted. Having the tarsus undivided by scales.

breast. Anterior portion of under part of the trunk.

bristle. Small, stiff hair-like feather.

bristle brush. A brush made of hog hair usually used in oil painting.

burnish. To smooth, flatten or polish a surface.

cap. Top of a bird's head from the base of the beak to the back of the head.

center line. A line dividing a form into equal halves.

channel. A groove, furrow, trough or narrow depression.

cheek. Outside region of the jaw covered by the ear coverts.

color. The sensation caused by light waves of differing wave lengths striking the eye; includes hue, value and intensity.

color scheme. A particular group of colors that dominates a composition.

commissure. Line of closure of the two mandibles.

compass. An instrument for drawing circles or arcs; can be used for transferring measurements.

conical. Cone-shaped.

contour feathers. The general external plummage of a bird.

coverts. Small feathers covering the bases of larger feathers.

crest. Any lengthened feathers of the top or sides of the head.

crown. Top of the head.

culmen. Ridge of the upper mandible.

defuzzer. Small abrasive pad used on a mandrel on a flexible shaft machine.

dividers. An instrument used for dividing lines into equal segments or transferring measurements.

dry-brush. A technique of painting with a brush containing very little paint; on a textured surface, light dry-brushing leaves a small amount of paint

on the top surfaces.

ear patch. Ear coverts on the cheek of a bird.

edge. The outline or border of a feather.

extend. To straighten a limb.

eye-ring. The outside edge of the eyelid.

flank. Hind part of the side of the trunk.

flex. To bend a limb.

flow. To have smooth and gentle continuity.

flux. A paste-like substance used to help metals to fuse together.

forehead. Front of the head from the base of the beak to the crown.

freeform. Having an irregular form or shape.

gape. The opening of the mouth.

gesso. Mixture of plaster of paris and titanium white used to prepare a surface for painting.

ground. That portion of a setting simulating the earth surface.

hind toe. Hallux.

hue. The characteristic by which one color is distinguished from another.

intensity (color). The degree of purity, strength or saturation of a color.

iridescent. Glittering with many colors which change in different lights.

iris. The colored portion of the eye.

insectivorous. Insect-eating.

layout. To arrange all of the parts or colors.

leading edge. Outside edge of a feather; the first edge of a feather in contact with the wind during flight.

leg tuft. Feathered part of the lower leg just above the ankle.

length of wing. The distance from the wrist (bend of the wing) to the end of the longest primary.

lower mandible. Lower portion of the beak.

lower tail coverts. Smaller feathers underlying the base of the tail.

mandibles. The beak.

mandrel. A metal spindle inserted into an object to hold it while it is being machined or turned on a lathe or flexible shaft machine.

mantle. Plummage on the upper back of a bird.

modeling paste. A putty-like substance that can be used to produce three-dimensional forms and build-ups.

monochromatic. Having the characteristic of one color or hue with varying intensities and values.

mount. To fasten onto a base.

naturalistic. The objective representation of nature without personal interpretation.

nictating membrane. The third or inner eyelid of birds.

occiput. The back of the head.

pin vise. A device consisting of jaws that close; used to hold drill bits or other tools.

plan view pattern. A drawing showing the planes perpendicular to the side of a bird.

posterior. At or toward the hind part of the body; backward.

primaries. The group of large, stiff-quilled flight feathers growing from the hand of a bird; the tip of the wing.

primary coverts. The group of feathers lying over the bases of the primaries.

profile pattern. Side view drawing.

pteryla. A tract on the skin where feathers grow.

rectrices. Quills of the tail.

relieve. To remove wood so that form is projected or raised from a flat surface.

round over. To rid of angularity; to make curved, not angular.

sable brush. A brush made of red sable from the tail hair of the Kolinsky (Asiatic mink).

scapulars. The group of feathers over the joint of the wing and body.

scutella. Scales; regular vertical series of impressions usually found on the tarsus of a bird.

secondaries. The group of feathers growing upon the forearm.

shade. A mixture of color and black.

solder. To join or patch metal parts or surfaces.

stipple. An effect obtained by dotting or flicking the tip of the loaded paint brush on the surface.

stoning. Grinding; texturing the surface of a bird or animal using a small, abrasive bit on a flexible shaft machine or rotary machine and leaving small "v"-like indentations on the surface.

study skin. A bird whose inner parts have been removed and replaced with cotton stuffing; its outer structure is arranged in a flat format; a study skin is primarily used for color, shapes and sizes of feather plummage.

super-glue. Cyanoacrylate esther; brand names include Hot Stuff, Instant Glue or Super Glue.

symmetrical. Equal, corresponding form, size or arrangement of parts on either side of a center line.

tarsus. The whole segment between the tibia and the toes; the foot bones.

technique. Method of using a tool; characteristic appearance of a painting style.

tertials. The group of feathers with large quills growing from the humerus or elbow.

three-dimensional. Having height, width and depth.

tint. A mixture of color and white.

trailing edge. Inside or medial edge of a feather.

turned base. A wooden base whose edge has been shaped while turning on a lathe.

two-dimensional. Having only width and height dimensions; without thickness or depth.

upper mandible. Upper portion of the beak.

upper tail coverts. The smaller feathers overlying the base of the tail.

value. The lightness or darkness of a color.

vent. Small opening for the discharge of wastes; anus.

wash. A thin, watery layer of paint obtained by mixing a small amount of color with a large amount of water.

wet-blend. A method of painting in which one wet color is gradually merged with another wet color.

wing bar. one of the groups of secondary coverts (lesser, middle or greater) that cover the bases of the secondaries.

working base. A piece of scrap wood to which driftwood is attached.

Index